S0-BSK-767

Fernald Library
Colby - Sawyer College
New London, New Hampshire

Presented by

**FRIENDS
OF THE LIBRARY**

Metamorphoses in Nineteenth-Century Sculpture

Metamorphoses in

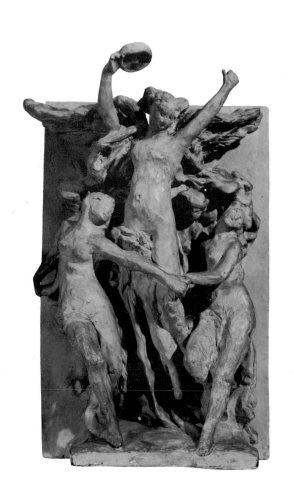 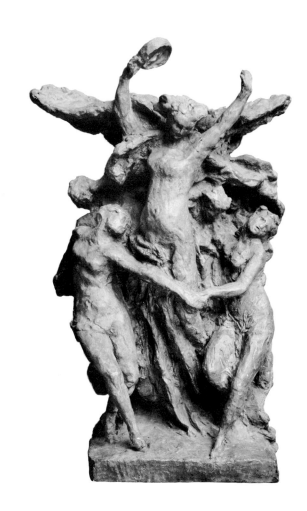

edited by Jeanne L. Wasserman

Nineteenth-Century Sculpture

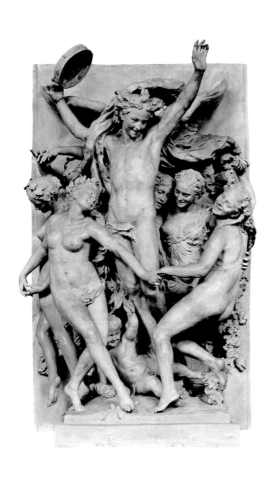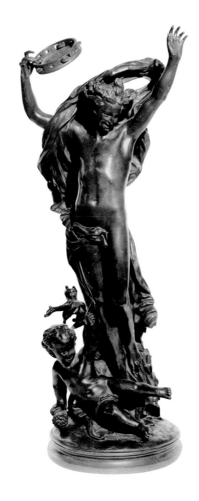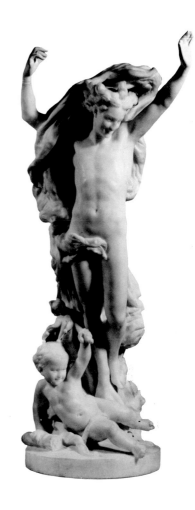

Fogg Art Museum 1975 Distributed by Harvard University Press

FERNALD LIBRARY
COLBY-SAWYER COLLEGE
NEW LONDON, N. H. 03257

NB
197.3
M48

This catalogue was prepared in conjunction with the exhibition
"Metamorphoses in Nineteenth-Century Sculpture,"
November 19, 1975 – January 7, 1976,
Fogg Art Museum, Harvard University.
Both the catalogue and exhibition were partially funded by
a grant from the National Endowment for the Arts.

Copyright © 1975 by the President and Fellows of Harvard College
"Jean-Antoine Houdon" © 1975 by H. H. Arnason
No portion of this publication may be reproduced without
the express permission of the Fogg Art Museum.

70872

Library of Congress Cataloging in Publication Data
Main entry under title:

Metamorphoses in nineteenth-century sculpture.

 Includes bibliographies and index.
 1. Sculpture, Modern—19th century—Exhibitions.
I. Wasserman, Jeanne L. II. Harvard University.
William Hayes Fogg Art Museum.
NB197.3.M48 735'.22'07401444 75–31618

Contents

Page vii Preface Seymour Slive

 ix Acknowledgements

 xi Introduction Jeanne L. Wasserman

 xv Lenders

 xvi Explanatory Notes

 1 Serial Sculpture in Nineteenth-Century France Jacques de Caso

 29 A Technical View of Nineteenth-Century Sculpture Arthur Beale
 29 Ten Terms Defined
 49 Methods of Signing or Marking Models, Molds, and
 Casts
 49 The Usefulness of Measurements, Weights, and Other
 Forms of Technical Analysis
 54 Some Thoughts on Originality

 57 Jean-Antoine Houdon H. H. Arnason
 63 *Benjamin Franklin*
 71 Hypothetical Chronology Based on Technical
 Observations Arthur Beale

 77 Antoine-Louis Barye Glenn F. Benge
 89 *Lion Crushing a Serpent*

 109 Jean-Baptiste Carpeaux Annie Braunwald
 Anne Middleton Wagner

 113 *Ugolin et ses Enfants*
 125 *La Danse*

 145 Auguste Rodin Patricia Sanders
 153 *The Man with the Broken Nose*
 169 *The Kiss*

 181 Augustus Saint-Gaudens John Dryfhout
 187 *Robert Louis Stevenson*
 201 *Diana*

219 Daniel Chester French Michael Richman
 225 *Ralph Waldo Emerson*
 247 *Memory*

259 Index
 Photographic Credits

Preface

One of the benefits students receive at the Fogg is the opportunity to work closely with specialists in the Museum's conservation and analytical laboratories. Charles W. Millard, now chief curator of the Hirshhorn Museum and Sculpture Garden, made full use of this opportunity during the course of his research for his doctoral dissertation on Degas' sculpture by consulting with Arthur Beale, conservator at the Fogg and expert on the materials and techniques used by sculptors and the artisans who make reproductions of their works.

Soon after Dr. Millard received his degree in June 1971, he traveled abroad to do additional research on nineteenth-century sculpture. A study leave of absence from the Fogg gave Mr. Beale the opportunity to join him in France. There the art historian and technical expert made pilgrimages to galleries and explored the museum storerooms to which so much nineteenth-century sculpture has been exiled.

Few of the pieces they encountered had been adequately studied or published. An exhibition of Daumier sculpture held at the Fogg Art Museum in 1969 had examined that artist's originals as well as various editions of his sculpture and the factors that led to the proliferation of later copies. Apart from its landmark catalogue, prepared by Jeanne Wasserman, honorary curator of nineteenth- and twentieth-century sculpture at the Fogg, Mrs. Joan Lukach, and Mr. Beale, little in the scant literature on nineteenth-century sculpture provided answers to the key questions the two-man team asked. Is the work an original modeled or chiseled by the hand of the sculptor, or is it a reproduction? Is it a cast made from a mold directly derived from the piece the sculptor had modeled, or is it a replica made from a mold taken from a work that has already been cast?

First-hand examination of the sculpture they studied allowed them to offer answers to some questions and hypothetical answers to others. However, many fundamental ones remained wide open. What was the sculptor's intent? What was his studio practice? Who were his patrons? Why

does so much nineteenth-century sculpture exist in reproductions done in different materials, different editions, and different sizes?

Upon his return to Harvard, Mr. Beale shared the experiences of his joint effort with Daniel Robbins, then director of the Fogg Museum. He stressed how quickly students of nineteenth-century sculpture reached a frontier of knowledge, no matter which direction they took.

Mr. Robbins responded by formulating the idea for the present exhibition. He knew that the Daumier exhibition, dedicated to a critical and comparative study of the artist's original sculptures and reproductions of them, had achieved significant results. He maintained that much more would be learned if a more comprehensive exhibition could be mounted of pieces by and attributed to sculptors whose works span the entire nineteenth century. The present exhibition demonstrates that he was correct.

From the beginning Mr. Robbins gave the enterprise his full and energetic support. He also gave the exhibition its apt title: *Metamorphoses in Nineteenth-Century Sculpture.*

Shortly after the idea for the exhibition was conceived, Professor Jacques de Caso of the University of California at Berkeley accepted an invitation to join Dr. Millard and Mr. Beale in a survey of the vast field to determine which artists should be included and which sculptures should be assembled for intensive study. Because of the pressing responsibilities of his new post at the Hirshhorn Museum, Dr. Millard was later forced to withdraw from active participation in the project.

Throughout, Mrs. Wasserman has masterfully coordinated the exhibition and catalogue. Her work on the Daumier sculpture exhibition gave her unrivaled preparation for her task. But little, short of organizing, without assistance, the beachhead at Normandy, could have prepared her for the formidable job of bringing together the series of precious originals and reproductions of works done by six nineteenth-century sculptors with the six scholars who have expert knowledge of their

works. She has synchronized the essays and entries in the catalogue with untiring devotion. Equally important: her strength and enthusiasm have helped sustain the numerous individuals who have worked on the project.

The expenses of the present endeavor have been largely defrayed by a generous grant from the National Endowment for the Arts. The Fogg Art Museum gladly acknowledges its deep debt to the Endowment for enabling it to dedicate an exhibition and catalogue to a little-known subject that deserves wider recognition.

SEYMOUR SLIVE
Director, Fogg Art Museum

Acknowledgments

We are deeply indebted to the lenders to this exhibition for their extraordinary generosity in parting with their objects—in most cases, for almost a year—so that we could study them prior to the publication of the catalogue.

In addition to the scholar-consultants who made direct contributions to this study and publication, we are grateful for the interest and encouragement of many other art historians. Particularly helpful were Charles W. Millard, chief curator of the Hirshhorn Museum and Sculpture Garden; Albert E. Elsen, Professor of Art and Architecture, Stanford University; H. W. Janson, Professor of Fine Arts, New York University; Ruth Butler, Associate Professor, University of Massachusetts at Boston; and Alfonz Lengyel, Professor of Art, Northern Kentucky State College. For invaluable help while pursuing their own studies in Paris, we are grateful to June Hargrove and Daniel G. Rosenfeld.

Dealers who have helped us locate objects and have generously shared their knowledge with us include Michael Hall of Michael Hall Fine Arts, Inc., Robert H. Kashey of the Shepherd Gallery, M. Roy Fischer of Wildenstein & Co., Inc., John Tancock of Sotheby Parke-Bernet, all in New York; and Pierre Fabius of Fabius Frères, Paris.

Museum directors and curators in this country and abroad have been exceptionally helpful in making objects available to us, and we are indebted to them all. Special thanks are due Jean-René Gaborit, curator of sculpture, Musée du Louvre; Olga Raggio, chairman of the Department of Western European Arts, Metropolitan Museum of Art, New York; and William R. Johnston, assistant director, Walters Art Gallery, Baltimore.

This project could never have been realized without the expert and untiring help of the members of the Fogg Museum staff, especially Suzannah Doeringer. We have made particularly heavy demands on the time and skills of the Registrar and the Department of Photography. We are greatly indebted to Jane Watts, registrar, and her assistant, Jane Oliver, who have managed the complicated logistics of bringing the nearly 150 objects to the Fogg, many of them more than once. We are also grateful to James Ufford, who has reproduced the photographs taken from old texts, and Michael A. Nedzweski, who has put at our disposal his expertise in the photography of sculpture and worked tirelessly to make the special photographs of objects and their details which were so necessary to illustrate our text. We owe special thanks to Janet Cox, the Fogg's editor, who worked with us at every stage in the preparation of this publication, to her assistant, Marylène Altieri, and to Stephen Harvard, designer for The Stinehour Press.

And finally, our thanks and admiration to the *Metamorphoses* staff and those graduate students in art history who have worked long hours, including evenings and holidays, to sort out the complications of this study and meet the relentless deadlines of the publication and exhibition. For their executive and editorial help we thank Gillian Levine, Joyce McDaniel, and Lisa Dennison Tabak; and for research assistance and additional editorial help we are grateful to Mrs. Horace Frost, Alice Friedman, Ronald Onorato, and Catherine Meier.

J.L.W.

Introduction

The problems of originality and dating have plagued the study of sculpture since editions were first made. This is particularly true of the nineteenth century, when the proliferation of editions in bronze, plaster, and even terra cotta became accepted practice, although identifying marks on casts were seldom made, and documentary information is almost totally lacking. That art historians and scholars have neglected the study of nineteenth-century sculpture is demonstrated by the small number of books that comprise the literature on the subject. The slender volume by Luc-Benoist entitled *La Sculpture romantique* (Paris: Renaissance du livre, 1928) remains the most useful source. The only general book on nineteenth-century sculpture to appear so far is *La Sculpture au dix-neuvième siècle* by Maurice Rheims (Paris: Arts et métiers graphiques, 1972). The scholar, therefore, must resort to exhibition catalogues, foundry records, and artists' account books (when they can be found)—all of which may contain minimal and often puzzling information.

Surprisingly, the same problems apply to the sculpture editions of this century as well. Not only art historians, but contemporary curators, collectors, and dealers often are unable to determine if a plaster, a terra cotta, or a bronze has been cast from the artist's original model with his approval during his lifetime, or if it is an unauthorized posthumous cast or even a *surmoulage* (a cast made from a cast rather than the original model). These problems, seen in the context of the art market, pose moral as well as aesthetic questions so grave that in April 1974, Albert E. Elsen, art historian and president of the College Art Association of America, assembled a group of sculptors, museum directors and curators, art historians, dealers, and lawyers who collaborated on the drafting of a "Statement on the Standards for Sculptural Reproduction and Preventative Measures to Combat Unethical Casting in Bronze." The published statement suggested specific measures to discourage the perpetuation of unethical practices in bronze casting. It was received favorably by the art press, giving the necessary recognition and exposure to this long-neglected problem.

A new method of approaching the mysteries of sculpture editions and the questions of originality was demonstrated in 1969 by the Fogg Art Museum exhibition and publication *Daumier Sculpture: A Critical and Comparative Study*. Here, for the first time, technical resources and visual evidence were used to supplement the meager documentation available from art-historical sources. We discovered that very few of the commonly accepted attributions of sculpture to Daumier were based on reliable documentation; that all of the bronze editions were posthumous! Only through the study of the techniques of creating sculpture and the methods of producing editions in various media were we able to recognize how Daumier worked, the tools he used, and the mark of his hand. Although this visual evidence reinforced the small number of documented sculptures attributed to Daumier, it cast serious doubts on the posthumous attributions, and many of these problems still remain unsolved. Nevertheless the discoveries that were made about the sculptural oeuvre of Daumier have encouraged us to carry this combined art-historical and technical approach further into the study of nineteenth-century sculpture.

Metamorphoses in Nineteenth-Century Sculpture depends on close collaboration between the art historian and the technical specialist. Based on a preliminary survey of the nineteenth-century sculpture available in over one hundred American and Canadian museum collections, we have selected six artists ranging chronologically from Houdon to Daniel Chester French, spanning the period not only in time but in the use of a variety of typical materials and techniques. Having chosen the artists, we invited the collaboration of art historians whose knowledge of these artists has been invaluable in the selection of the sculpture sequences for our project. Working together, we have attempted to bring some order out of the chaos of multiple editions, proceeding wherever

possible from the original image to its metamorphoses in bronze, plaster, and terra-cotta editions, through enlargements and reductions, replicas and reproductions. In their essays we have asked our scholar-consultants to elaborate on the artists' studio practices, their reliance on assistants and artisans, and their attitudes toward reproduction. All have responded with enthusiasm to this unorthodox approach.

Unorthodox also have been the arrangements we have made for the many loans to the exhibition, since all the objects in each sequence have had to be assembled at the Fogg Museum for study prior to the publication of this catalogue. This has meant that objects have had to be borrowed for the unusually long period of almost a year, or else, as in some cases, they have been borrowed for study, returned, and then borrowed again for the exhibition. Others have been borrowed either for study only or for exhibition only, and still others, because of their great size or extreme fragility, have not been borrowed at all. The complicated logistics have created tedious difficulties for the lenders as well as for the office of the Fogg's Registrar, and we are enormously indebted to them all for their patience and help.

When the sequences for each artist were finally assembled at the Fogg, the appropriate scholar-consultant traveled to Cambridge to study the objects with us in the Conservation Laboratory under the direction of Arthur Beale, acting chief conservator. These confrontations with the objects by art historian and technical specialist together proved in every case to be the crucial point of the study. The intense visual comparisons among objects that had never before been viewed side by side, supported by every available scrap of historical documentation, afforded new insights in many instances, and dramatized the imponderables in others. But whatever problems remain unsolved, each sequence produced its special revelations.

Houdon serves as an appropriate introduction to our study, since he carried eighteenth-century traditions and techniques into the nineteenth century. Although the Franklin sequence includes only eight examples, they show the portrait from a stage very close to the original, through several editions, ending with the Fogg's small replica. In addition, they are executed in every medium—plaster, terra cotta, bronze, and marble. H. Harvard Arnason's essay, partially excerpted from his book, *The Sculptures of Houdon*, recently published by the Phaedon Press, provides information which has helped Arthur Beale establish a hypothetical chronology for the Franklin portrait busts we have assembled.

The Barye sequence of more than twenty casts of the *Lion Crushing a Serpent* is one of our longest, thanks to the overwhelming number of Barye sculptures in American collections. Glenn F. Benge, who traveled to the Fogg from Rome where he is currently associate professor at the Tyler School of Art of Temple University, wrote his two-volume doctoral dissertation on the Barye sculptures in America. Nevertheless, Mr. Benge's week with Arthur Beale in Cambridge and at the Walters Art Gallery in Baltimore yielded new discoveries about Barye's working methods. Already familiar with the plaster models which Barye revised for future editions by means of wax overlays, they discovered that the sculptor also made unique bronze casts of his works to be used as master foundry models. Thus the intermediary step of another mold was eliminated, and subsequent bronze casts preserved in detail much of the rich surface treatment of Barye's original. This explains the extraordinary quality of certain artisan casts. The *Lion and Serpent* sequence ranges from this highest form of the bronze founder's art to its eventual deterioration, as seen in the later reductions, which were mass-produced.

The Carpeaux sequences we have chosen represent two of his most famous works. The editions made from various single figures taken from his monumental group *La Danse*, commissioned for the facade of the Paris Opéra, demonstrate the typical nineteenth-century practice of isolating separate elements of a group and developing them individually. One of the most fascinating sequences we have assembled includes the seven clay, plaster, and bronze casts of Carpeaux's early study for the *Ugolin*, created when he was a stu-

dent recipient of the Prix de Rome. Mme Annie Braunwald, curator of sculpture at the Musée du Petit Palais, Paris, points out that this early plaster study, left behind at the Villa Medici in Rome, was made into an edition posthumously by Carpeaux's daughter, who gave casts to several museums. In contrast to the smooth, polished surfaces of the finished version of the Ugolin group (represented in reduced size by the bronze cast in the Chrysler collection), the rough treatment of the early sketch was highly appealing to twentieth-century taste, which accounts for the apparently large number of casts in this posthumous edition.

Although deeply interested in our project, Mme Braunwald unfortunately could not come to the United States to examine with us the Carpeaux works assembled at the Fogg Museum. She was most generous in sharing her vast knowledge of Carpeaux with us, although she had access only to photographs of these particular works and the information furnished by the lenders. By great good fortune, Anne Middleton Wagner, a doctoral candidate in Fine Arts at Harvard who is planning to write a dissertation on Carpeaux, met with Mme Braunwald in Paris, and at the same time studied in depth the great Carpeaux exhibition mounted at the Grand Palais in May 1975, as well as its catalogue, on which Mme Braunwald has collaborated. With this assistance and the opportunity to study the actual sequences with Arthur Beale, Anne Wagner has written the essay on Carpeaux.

Of Rodin's vast oeuvre, we have limited ourselves to but two subjects—the early *Man with a Broken Nose* and *The Kiss*. The six casts of *The Kiss* demonstrate the range of scale in the many editions of this popular work from the approximately 85-cm. size of Rodin's original clay model to the 25-cm. size of the Collas mechanical reduction. We have also had the opportunity to compare editions taken from the original clay with those derived from the marble enlargements. The richness of American collections in Rodin sculpture has allowed us to assemble the second largest sequence of our study—some fifteen casts of *The Man with the Broken Nose*. One of our most dramatic moments occurred when we first ob-

served this assemblage lined up on a counter in the Fogg's Objects Conservation Laboratory. Only then did we recognize the variety of the mounting angles represented by the different editions and the effect these had, not only on the height measurements, but on the expressive impact of the portrait itself. Change in the tilt of the head, which was quite possibly a decision made by the foundry and not the sculptor, expands the range of mood conveyed by this portrait of "Bibi" from a lively characterization to one of tragedy, deep contemplation, or sophisticated worldliness. Through her careful, detailed study of Rodin sculpture, Patricia Sanders, Ph.D., our Rodin consultant, was able to isolate some twenty variations of this early portrait and its later version, *The Little Man with the Broken Nose*, dividing them into two groups and seven types.

We have included the American sculptors Augustus Saint-Gaudens and Daniel Chester French principally because the preservation of their studios as museums has given us access to a wealth of original material including plaster studies, molds actually used in casting, and such documents as letters and account books. In addition, Saint-Gaudens bridges the gap between the beaux-arts tradition of European sculpture and the forthright realism of the American school. He used both French and American bronze foundries and, because of his experience with the sophisticated technical craft perfected in French bronze foundries, contributed to the improvement and growth of this new industry in the United States. Daniel Chester French worked only with American foundries, although early in his career he, like Saint-Gaudens, used marble carvers in Italy. Both men, like their European colleagues, executed important commissions for monuments and extracted individual figures or parts of figures from these monuments to be used as separate editions.

Saint-Gaudens' portrait of *Robert Louis Stevenson* and French's *Emerson* bring into the twentieth century the tradition of the portrait of a famous personage turned into popular icon, as exemplified by Houdon's *Franklin* almost exactly a century before them. John Dryfhout, curator of the Saint-Gaudens National Historic Site, Cornish, New

Hampshire, performed for us the formidable task of tracing the portrait relief of Stevenson from plaster to bronze to copper electrotype, in editions in five sizes, with both round and rectangular formats. In addition, Mr. Dryfhout shows how Saint-Gaudens considered as unique each cast of the editions he supervised, by making minor variations in details, thereby leaving the mark of his hand.

From the numerous available casts of French's portrait of Emerson, Michael Richman, art historian for the National Trust for Historic Preservation, Washington, D.C., helped us assemble ten busts that illustrate the changes in the portrait from the lively early marble at Harvard University to the later bronze editions on which the label "Emerson" has been cast into the plinth. In addition, Mr. Richman's essay traces the later metamorphosis of the work into a seated statue with an idealized face, and finally back to the bust cast from the idealized head of the statue. In this sequence, the metamorphosis has come full circle.

Jacques de Caso, Associate Professor of the History of Art at the University of California, Berkeley and Associate Visiting Professor at Harvard in 1974–1975, has guided and encouraged us through every phase of the study. His introductory essay to the catalogue not only provides an overview of the sculptural practices of the nineteenth century and their legal implications, but also reproduces important historical documents never before published. In his technical essay, Arthur Beale defines some of the terms used by sculptors, art historians, and technicians to describe the creation of sculpture and sculpture editions, discusses the relative usefulness of signatures, weights, measurements, and other technical analyses in the study of editions, and concludes with some thoughts on originality.

For those who see the exhibition, the question of the relative merits of the sculptor's "original" work and its various cast editions will be made less puzzling by the physical fact of being able to make the visual comparisons. For future scholars confronted with these problems, it is our hope that the publication of this study will furnish helpful guideposts on a little-traveled road. That the artist's signature is not always one of these is demonstrated in a letter from Carpeaux to a friend in which he wrote: "You know, my dear Louis, that I'm not too clumsy to make a portrait, because I made one for M. Duret which he just signed." On the other hand, as our study indicates, cast editions were an accepted practice for the sculptors of the nineteenth century. Therefore yet another guidepost might be the comparative merits of a lifetime cast approved by the artist vis à vis a posthumous cast or even a replica. Saint-Gaudens has written emphatically to this point in a letter of May 9, 1902 to the writer J. L. P. Hill:

I cannot allow anyone but myself to have the casts made. . . . a copy of work of mine would bear my name and you will understand what I would feel about it as you would feel about a distorted publication of your writings.

JEANNE L. WASSERMAN

Lenders

B. G. Cantor Collections, Beverly Hills, California

Mrs. Philip H. Faulkner, Dublin, New Hampshire

H. Peter Findlay, Inc., New York, New York

Dr. Barnet Fine, Stamford, Connecticut

John Howell—Books, San Francisco, California

Mr. and Mrs. J. William Middendorf, II, Washington, D.C.

Jay M. Morganstern, Hartsdale, New York

Mrs. Barbara Morrison, Taunton, Massachusetts

Mr. and Mrs. Joseph M. Tanenbaum, Toronto, Canada

Anonymous Lenders

University of Texas at Austin, Austin, Texas

The Baltimore Museum of Art, Baltimore, Maryland

The Walters Art Gallery, Baltimore, Maryland

The Boston Athenæum, Boston, Massachusetts

Museum of Fine Arts, Boston, Massachusetts

Rose Nichols House, Boston, Massachusetts

The Brooklyn Museum, Brooklyn, New York

Baker Library, Harvard Business School, Cambridge, Massachusetts

Fogg Art Museum, Harvard University, Cambridge, Massachusetts

Harvard College Library, The Houghton Library, Cambridge, Massachusetts

Harvard University Portrait Collection, Cambridge, Massachusetts

Concord Free Public Library, Concord, Massachusetts

United States Department of Interior, National Park Service, Saint-Gaudens National Historic Site, Cornish, New Hampshire

Denver Art Museum, Denver, Colorado

The Detroit Institute of Arts, Detroit, Michigan

Exeter Public Library, Exeter, New Hampshire

Dartmouth College, Hopkins Center Art Galleries, Hanover, New Hampshire

The Indianapolis Museum of Art, Indianapolis, Indiana

Nelson Gallery, Atkins Museum, Kansas City, Missouri

Upland Country Day School, Kennett Square, Pennsylvania

Los Angeles County Museum of Art, Los Angeles, California

J. B. Speed Art Museum, Louisville, Kentucky

Maryhill Museum of Fine Arts, Maryhill, Washington

Walker Art Center, Minneapolis, Minnesota

Newark Museum, Newark, New Jersey

Yale University Art Gallery, New Haven, Connecticut

New Orleans Museum of Art, New Orleans, Louisiana

Metropolitan Museum of Art, New York, New York

Chrysler Museum at Norfolk, Norfolk, Virginia

Smith College Art Museum, Northampton, Massachusetts

Musée du Louvre, Paris, France

Philadelphia Museum of Art, Philadelphia, Pennsylvania

Museum of Art, Carnegie Institute, Pittsburgh, Pennsylvania

Princeton University Library, Princeton University, Princeton, New Jersey

Museum of Art, Rhode Island School of Design, Providence, Rhode Island

The Fine Arts Museums of San Francisco, San Francisco, California

The St. Louis Art Museum, St. Louis, Missouri

Stanford University Museum of Art, Stanford, California

Chesterwood (a Museum Property of the National Trust for Historic Preservation), Stockbridge, Massachusetts

Corcoran Gallery of Art, Washington, D.C.

Gertrude Clark Whittall Foundation Collection in the Library of Congress, Washington, D.C.

National Collection of Fine Arts, Washington, D.C.

National Gallery of Art, Washington, D.C.

National Portrait Gallery, Smithsonian Institution, Washington, D.C.

Williamsport Area School District, Williamsport, Pennsylvania

Sterling and Francine Clark Institute, Williamstown, Massachusetts

Explanatory Notes

All illustrations in the text are numbered sequentially within each chapter. The abbreviation "fig." is used in all essays with the exception of Arthur Beale's "A Technical Examination of Nineteenth-Century Sculpture," in which the abbreviation "no." is used. Multiple views of the same object are given letter designations in addition (e.g., fig. 7a). Objects which appear in the exhibition but are not illustrated in the text are noted in the catalogue checklist at the end of each section. We have given these objects the number of the illustrated objects to which they most closely relate, with a letter designation (7b).

All relevant information for illustrated objects appears under the photographs. Full catalogue entries for objects not illustrated appear in the checklist.

Markings noted in the figure captions and catalogue entries are reproduced from the objects as accurately as possible within the limits of conventional typography. When possible we have checked these markings with the objects themselves; in other cases we have relied on information supplied by the owners.

Selected bibliographies appear at the ends of the essays and relate in most cases to the sculptural sequences discussed.

JACQUES DE CASO

Serial Sculpture in Nineteenth-Century France

"L'intervention des machines ... a été une époque et l'équivalent d'une révolution; les moyens reproducteurs sont l'auxiliaire démocratique par excellence ... si l'on me disait qu'après la machine qui sculpte et la machine qui coud, on a trouvé une mécanique qui peint, je n'en serais pas surpris et j'y applaudirais. ..."

Cte de Laborde, *De l'Union des Arts et de l'Industrie* (1856)

The intent of this exhibition is so ambitious that it amounts to a challenge. Just as one might try to unravel chain mail, it presents works of sculpture with individual identities which differ from other works that share a common origin and appear, at first sight, *the same*. The exhibition raises questions as fascinating as they are unfamiliar, questions that concern the historian of art and the social historian to an equal degree. For the first time in the history of sculpture, this exhibition focuses on the particulars that express uniqueness in multiplicity. That is to say, it illustrates the relationship that exists between the single *exemplaire* of a work and the series of which that *exemplaire* is a part. Furthermore, the exhibition relocates artistic creation in a time frame that may seem surprising but nonetheless is real—one not necessarily determined by the individual artist nor limited to his life span and personal activity.

Finally, this is the first exhibition to relate the work of sculpture that is "repeated," which I shall herein call "serial sculpture," to the aggregate of conditions that allowed its repetition in assorted materials, different scales, and diverse styles and modes—all at various points in time. The exhibition thus throws light on variations, changes, and modifications in the work of sculpture and the artist's variety of intentions. In like manner it seeks to demonstrate the influence on the artist's creations exercised by a number of related factors whose importance, for the most part, has until now escaped our attention. And in demonstrating that serial sculpture does not mean uniformity or simple multiplication but rather a "dynamic" repetition, this exhibition underlines the uniqueness of these works and the vitality of their transformations.

Serial sculpture, by its very nature, comprises an extremely rich area for study. Of necessity we have here reduced this material to some few works by a select number of artists who represent typical, significant, or important cases for our inquiry; what went on in France and America during the eighteenth, nineteenth, and twentieth centuries applies with variations to other countries as well. The number of works presented within each series chosen could also have been augmented but for various limitations. It was decided, for instance, to present sculptures which accent the transformations of works in series; artistic transformations are evoked only to the extent that they relate to and can be explained by manipulations dictated by techniques. Other limitations have been imposed by very real material difficulties; for one thing, the disappearance of serial sculptures, absorbed, often destroyed—consumed, you might say, by their time. There was also understandable reluctance in individuals and institutions alike to lend very fragile objects.

The questions this exhibition raises relate primarily to the technical transformations the work of sculpture in a series undergoes. An understanding of the problems at issue will be possible, I believe, only if we make no effort to separate the study of these artists from the study of their works. Serial sculpture is not to be approached by dividing our considerations into these two customary categories. The first type of consideration would relate the serial sculpture to the artist, his views on art, what he wanted to present, what he expected from the exercise of his profession, etc. The other usual category comprises the interaction between the artist and his time, considerations that include the imperatives of patronage, the various demands upon time and talents which artists must accept, reject, or modify. Instead of pursuing these opposite extremes, we must study the tensions, interstices, and interactions between

them to understand or explain serial sculpture and its significance, in the past and today.

Casting in plaster: By way of preamble to any consideration of the metamorphoses of serial sculpture, one determinant factor must be emphasized. Beyond any intention on the artist's part of multiplying a given work with an eye to its commercial exploitation, all creation in sculpture, except for direct carving, is achieved serially. We see this at every stage of a work which is realized by adding or removing material. Such a work only exists through and by virtue of a series of actions, a successive emptying and filling of spaces. These operations accompany every change in material or scale, and of course modifications in formal arrangement. The transitory, perishable result which is achieved in malleable material, usually clay or wax, may be transformed into a more durable result in plaster at any moment between the preparatory state and the state the artist considers "finished." This unique work in plaster becomes another point of departure: once cast, it in turn can be multiplied in a series of plasters.[1] These latter plasters can be subjected to artistically or technically inspired modifications, becoming themselves individualized models from which separate series may be executed in any material. Any creation in malleable material is therefore multiplication by passage from one condition to another.

In a full-scale study of any sculpture's states of becoming, so to speak, one must never lose sight of the sculptor's alter ego, the *mouleur réparateur* who handles these plasters. His competence in saving, repairing, and retouching the plaster models and the fragile molds constantly being damaged in casting operations constitutes an indispensable condition for the sculptor's work at its most crucial point, that is, when a form actually comes into being. These highly specialized assistants were jealously annexed by sculptors who were anxious to retain for themselves the services of the best.[2] When Houdon embarked for the United States to prepare studies for his statue of George Washington, he had two assistants accompany him, one of them his caster.[3] The profession of plaster caster flourished as the nine-

teenth century's large commercial enterprises began popularizing antique and modern casts both for institutional and private purchasers.[4] These men and the casters working in bronze foundries played leading roles in this commercial warfare. The mold was an object of speculation and value no less than the sculpture itself. It was used as material proof in the countless lawsuits concerning sculptural counterfeiting.[5] Incidentally, the terms *surmoulage* or *contre moulage*, as applied to descriptions of works in any material, were used in several senses in the nineteenth century. In the vocabulary of art criticism, they generally express a judgement on the quality of the work's surfaces.[6] Alternatively, these terms may mean simply that the work in question was obtained by casting from another work. But in legal vocabulary the words describe an activity pursued to obtain illicit profit.[7]

Supply and demand: The domain of serial sculpture can be defined as spanning two extremes. On the one hand, the conditions surrounding the creative processes which allow us to consider the works as already created in multiple, thanks to molding operations; on the other hand, the deliberate multiplication of works for wide circulation in public and private whether for profit or not. More comprehensive studies of serial sculpture will examine the interactions between these two poles: studio multiplication due to technical manipulation, and multiplication for the market.

Houdon illustrates the basic situation, the simplest relationship between sculptor and client. His contract with the singer Sophie Arnould stipulates multiplication of her portrait in three materials. It limits the number of *exemplaires* and protects the buyer and her heirs against any exceeding of this number. It is understood that sculptor and client deny each other any right to exploit the work for commercial gain.[8] This simple contract, expressing the terms of a simple transaction, is found duplicated over and over throughout the nineteenth century.

Relations between artists and clients became more complicated around 1800, however; from then on we see sculpture increasingly affected by

certain historical and social factors. The profession of sculptor was opened up to a much greater number of practitioners as sculpture found an ever-expanding place in society. All the same, the practices of the eighteenth century persisted. That century had known—in principle—work produced in serial form (reduced dynastic monuments, official portraits, sometimes even private ones). Celebrated works of the past were also reduced and took their place in public and private collections.[9] At the end of the eighteenth century The Manufactory at Sèvres was even producing and selling reductions of modern works at the behest of the government. Small-scale sculpture was as fashionable in that century as it was to remain in the nineteenth. Counterfeiting flourished; Houdon complained about it bitterly. The taste for sculpture was growing everywhere in Europe around the turn of the century, in response to the widespread fad for antique statuary which the neo-classical movement provoked. Museums for sculpture were set up, and governments encouraged didactic public sculpture—the statue and the sculpted monument both—to be integrated into ambitious new architectural and urban settings. As the number of artists grew, exhibitions included more and more sculpture, introducing it to an ever broader segment of society. In the late eighteenth and the nineteenth century, thanks to the copy and the reduction, sculpture began to find a place in private homes, thereby reaching a market that best reflected the increase in wealth; demand for it quickened greatly. The commercial exploitation of sculpture thus became a large-scale enterprise. Public capital (i.e., the government) as well as private—that of the artists, the metallurgical industry, and retail dealers in this case—was invested in art both for profit and in order to further the development of industry.

Hallmarks and signatures: The commercial exploitation of a sculpture, as sculptors or their industrialist collaborators saw it, generally involved its reduction in size. The unique work, which was the first to bear the name or title of the sculpture which the artist and industrial producers hoped to popularize (the model), was executed in the material and dimensions the client had specified. These were the sculptor's decisions where the piece was meant to be submitted to the public. Usually the sculptor would exhibit the work in plaster in the Salons or at expositions and await a government or private commission to make possible its execution in a durable material. It was often the success of this plaster that made the work popular. As a general rule, when the model was larger in scale than a statuette, reductions would follow[10] and, with these, the series. The chronology of these steps in production can seldom be established with certainty today except through documents. From those still extant come our only ideas of how often and on what scale sculptures were serialized.

To form an idea of the market a popular work enjoyed, we must turn to the bills from the producer of the different reductions Carpeaux had made of his bust and statue of the *Prince Impérial* from 1865 on.[11] Without documentation one can only speculate on the date a series appeared or the number of *exemplaires* produced after a given model, no matter which sculptor of the nineteenth century we consider.[12] When numbers occasionally appear on these works, they indicate neither the number of *exemplaires* already cast nor the maximum number projected.[13] Numbers or letters sometimes relate to bookkeeping systems and sometimes to the chaser's initials or in-house codes identifying the team of workers responsible for a particular run or round of production. They refer in other cases to the number of the piece in a sales catalogue. A date, when one occurs, is usually the date the original model was created, not that of any particular edition.

In brief, then, our only constant is this significant fact: the theoretical and critical literature on art, and the abundant material treating the interdependency between art and industry, stand completely and consistently mute concerning the extent of series in sculpture. Obviously, therefore, identifying a given *exemplaire* within its series is, by the very nature of serial sculpture and the way it was practiced, futile. A work of sculpture laying claim to uniqueness is customarily identified as such from the inscription on it, bills of sale,[14]

etc. The serial sculpture, by contrast, bears few marks. When it is signed at all, the signature usually comes with the mold and relates to how the work was made and nothing more. Only the original work used as the model for an edition carries a signature to which we may attribute legal, financial, or perhaps spiritual value. In allowing artists' signatures to appear on *exemplaires* nonetheless, the law sided with artists and producers.[15] Such signatures could be "faked" or actual, and were used or omitted at the producer's discretion.[16]

In like manner, the seal of an artist's studio, the hallmark of the foundry, or the merchant's trademark were all employed with what can only be called an utter inconsistency: some doubtlessly authentic works carry none of them. Producers and their distributors must have realized, however, that any such mark would reinforce their efforts to prevent counterfeiting.[17]

Serial sculpture and sculptors: The sculptor's position in society and his relationships with his patrons in the nineteenth century are better known than in the eighteenth century. The social status of the most famous and highly regarded sculptors had slipped a bit, perhaps, from the days when monarchs had awarded special honors to the sculptors of their dynastic monuments. Still, Houdon, Canova, and Thorwaldsen enjoyed a personal prestige in their lifetimes that no painter of the period attained. At the same time, the quest for a commission for work the public would see was, as always, an agonizing situation documented in the biography of every sculptor.[18] Only the government or the wealthy patron could commission the execution in marble or bronze of a work that required considerable time and expense for advance preparation; however, the sculptor's success in the eyes of the public at large generally presupposed such commissions. It was the commissioning of unique works that often made series possible.

The attitude of sculptors toward the idea of the series is more difficult to summarize. It would appear that sculptors abandoned one attitude in favor of another one over the course of the nineteenth century. At first they were inclined to permit multiplication of unique works, but only in limited editions in which the artist sought to impart something of the original's uniqueness to each *exemplaire*. Afterwards they began to regard the unique piece as separated from its progeny, the series; this new attitude allowed the artist to accept *exemplaires* as reminders, reflections almost of his original work, coexisting with the originals on different artistic and commercial levels. Chronologically speaking, the second viewpoint seems to have become predominant during the 1840s. We can identify precise factors responsible for the change: (1) a significantly increased demand by a wider public for reductions at a low price; (2) a change in fashion, toward affordable, small-scale sculptures instead of the silversmith's creations as *objets d'art* for the household; and (3) the discovery of new, non-precious materials (zinc and terra cotta) and of new reproduction techniques (machine-made reductions and electrotyping).

Sculptors showed only the mildest interest in serial sculpture and its potential until the 1840s. There were personal as well as economic reasons for this, we must suppose, for the popular appeal of many earlier works could have justified their reproduction in great numbers. The explanation now defies investigation, since the documents have disappeared. We know, for example, that the commissions the Baron Bosio (1768–1845) undertook were notably well paid ones and that Bosio's extreme wealth excited frequent comment. One-shot replicas, we might call them, of Bosio's best-liked and most successful pieces were executed for particular clients, but these were very limited repetitions with something of the unique artistic character and financial value of the originals. Apparently these works were not produced serially and in large editions until after Bosio's death.[19]

A more purist position in regard to the series is evident in the career of Simart (1806–1857). His works include a large number of monumental sculptures, fewer statues than most sculptors of his period produced, and very few small-scale pieces. His was an austere talent; serialized works had no place in his idea of sculpture. Although a

personality of considerable importance in the art world of his day, neither he nor any businessman-producer exploited his works for commercial purposes during Simart's lifetime.[20]

Simart's case is similar to Rude's (1784–1855). To his friends, the austerity of Rude's personality and tastes was well known. One might expect from his Republican sympathies that Rude would be inclined to favor a "democratizing" exploitation of his art. The reductions of his reliefs for the *Arc de Triomphe de l'Etoile*, however, were neither made nor circulated by him. On occasion Rude would have replicas of his works made in the same scale as the original. During his lifetime he also initiated several reductions; one was his *Pêcheur napolitain*, which was to be issued in diverse sizes until the end of the century.

Artists of another type did not practice serial sculpture because their works never enjoyed the public success that made it possible. Among these was Préault (1809–1879), who was systematically denied state commissions except for a few that never achieved popularity. Préault's art reached only a small number, and most of his works have been lost through never having been executed in durable materials. Statuettes are unusual in his work.[21]

Another memorable artist of the first half of the century is A. Moine (1796–1849). Like Préault, he was famous as an innovator, but his art reflects different interests. At a time when conventional criticism was denouncing the vogue for statuettes as a threat to the art of sculpture, Moine elevated the picturesque, small-scale sculpture to the status of a major form for artistic expression. A more enlightened criticism detected in Moine's beginnings a possibility for rejuvenating the decorative arts and bringing closer that long-imagined day when the industrial producer and merchant might attract top-quality artists into their enterprises. Moine, meanwhile, suffered virtual exclusion from large commissions and was thereby prevented from executing any large-scale works to speak of. His friends blamed social failure and its accompanying financial checkmate for his suicide.[22] With the founder Susse contracting to produce and distribute his small-scale works, Moine might indeed have personified a type of artist to become common after the 1840s:[23] one whose output was more and more intended for serial production and whose links to business assumed greater and greater importance for him.

Yet another type of sculptor common before the 1840s was the one who, artisan-like, both fashioned and sold his own products. The sculptors of animals, who worked in cheap materials like plaster or clay, are cases in point. Their trade went undocumented, but at least one of their number is well known. The sculptor Graillon was remarkable in several respects. He was pointed out as a prophetic example of a "modern" artist, at home and in the social life of his day, finding the matter for his art in subjects and scenes that typify a neglected facet of the realist movement before 1840. David d'Angers left a fascinating description of Graillon and a very fair estimate of his significance as personage and as artist/artisan, fulfilled in the artistic life of his time and by his own achievements in art.[24]

The sculptor's adoption of expensive materials such as bronze forces him to accept a different way of working when he wants his works produced in quantity and put on the market. Throughout the nineteenth century there were a good many sculptors carrying on the practices of their eighteenth-century predecessors and doing their own foundry work, but they limited themselves mostly to casting small-scale pieces. Some of them had foundries which they themselves or their business associates financed. A sculptor might at times have a cast made outside his workshop and only do the finishing himself. In most cases he would market his own series. Sculptors managed to make their names as artists-in-industry, competing for the prizes the government awarded to manufacturers in the Expositions des Produits de l'Industrie and Expositions Universelles. Many felt they stood in resistance to the middleman, the statue-producing foundry owners and retailers whose commercial success was vaunted by the government as the sign of a flourishing industry. Sculptors of animals, Mène, Lechesnes, and Frémiet, for instance,[25] cast and sold their own bronzes and works in series, even issuing their own sales catalogues. Although

his foundry activity is poorly documented, A. L. Barye is our best example. Barye was not barred from large government commissions, and his career was promoted by rich patrons such as the duc d'Orléans, the duc de Montpensier, and Péreire. Barye worked almost exclusively in bronze. His understanding of sculpture was derived from the great goldsmiths and silversmiths of the first half of the nineteenth century, artists who made one-of-a-kind pieces, dividing work with precious metals into its specialized operations—modeling, casting (minimally important), and chasing. Barye's training under Fauconnier[26] nurtured that area where his art truly lay: the preparation of the model achieved through drawing and modeling.

The history of Barye's personal foundry business is still unclear, but we know that he approached bankruptcy in 1848 and was obliged to mortgage his models. Serial productions seem to have been numerous by then. In 1849 and again in 1855, Barye exhibited works he apparently cast himself, since in the capacity of "fabricant de bronze"[27] he entered works in the 1855 Exposition Universelle. With his foundry closed or inactive, he must have had casts executed outside his shop.[28] This was the common practice of most artists of his day, silversmiths included. As his sales catalogues testify, Barye handled the sale of his works himself, besides, of course, finishing them even under straitened circumstances.[29]

The years following 1835 saw a rise in sales of sculpture—especially the small-scale—along with the sudden availability of cheap materials, particularly terra cotta. The result was rampant speculation on the part of the manufacturers. Many of the sculptors began to view this situation as a chance to go into business as their own producers and sell their own works. Here Carpeaux comes immediately to mind. He does not represent any new type of sculptor vending his own works; he is most remarkable for the variety of artistic and commercial means he put to work for his own profit. He lighted the way for Rodin to follow. The financial history of Carpeaux's enterprise would be most revealing if only it were better understood. Reviewing the works he created be-fore his death in 1875, it is obvious that he introduced no new way of handling individual commissions. Like his predecessors, he employed numerous practitioners to work on his marble replicas, which were usually made in the original dimensions but occasionally reduced. In casting his bronzes, he followed the tradition of using independent founders. He turned to founders who produced works that drew attention in the Salons and whose castings are generally praised: Thiébaut, Barbedienne, Christofle. There are two unique replicas of monumental works done in the dimensions of the original *Ugolin* and *La Danse*; they sold as unique replicas, and the molds for them are reportedly destroyed.[30] All these practices were in keeping with accepted methods of the day. In his early years, for any work he thought potentially profitable for commercialization in a serial edition, Carpeaux sought a manufacturer to undertake its exploitation, with distribution and sales included. The contract, as usually drawn up, gave the artist the right to exploit the work in marble for his sole profit.[31]

Carpeaux's biographers concur in naming 1872 as the turning point when the sculptor, hounded by serious financial difficulties, busied himself and his atelier with the extensive production of replicas. Many of these were fragments detached from his monumental *Fontaine de l'Observatoire* and *La Danse*. Actually, however, one of the earliest signs of this type of exploitation to bring large profits from sales of series and low-priced reductions occurs just after 1865. That was the year Barbedienne produced for Carpeaux the series of reductions of Carpeaux's bust and statuette of the *Prince Impérial*.[32] The Atelier Carpeaux, as we refer to it today, was the organization he had functioning in 1872. It was a unique example of undisguised commercialization, complete with production manager, sales manager, catalogue prices, advertising, shows, and public auctions in Paris, the provinces, and even other countries. A system of this sort isolates the sculptor in his unique activity of conceiving and personally executing the models—and nothing more. Founding, casting, chasing, retouching, and any other work on the series are handled by laborers. This sculpture-

exploiting business was to be carried on by Carpeaux's heirs; with the potential for profit as the operation expanded in volume, it was much coveted during the sculptor's last years. We must realize, however, that in Carpeaux's view there were artistic and also material differences between the Atelier's production of works in series and another division of work—other models, over which the sculptor exercised a stricter degree of artistic control and for which special prices were charged. Carpeaux's will outlines a fresh approach to production in series in which the artist is denied any chance at all to exercise supervision. Although his widow had its terms overturned, we know Carpeaux wanted to leave the museum in his home town of Valenciennes in charge of exploiting and distributing his works after his death. He specified that "they be reproduced and spread as widely as possible" for the benefit of his heirs.[33] This is the same condition that Rodin would lay down at the time of his death in leaving his estate and works to the French government.

One last situation typical of a sculptor organizing his own market remains for consideration. In certain respects it is akin to the idea Carpeaux and Rodin expressed in their wills, separating production of a series from the artist's control over it. This often occurred in the nineteenth century when a manufacturer or retailer-dealer acquired ownership of a model and decided for himself how it should be produced in series, as we shall see. We should remember that their positions also permitted such businessmen to pressure sculptors on artistic decisions—and even, at times, largely determine the course of an artist's creations from the outset. At the instigation of his producers, Pradier put several of his works to the test of being made first as statuettes. Only after their success did he enlarge them.[34] The nineteenth-century sculptor who found himself the most completely snared by such business decisions is perhaps Clésinger.[35] His producer Barbedienne suggested many of Clésinger's subjects to him, as we know,[36] and thereby brought about the tensions that resulted in the famous lawsuits between them. The way out of such difficulties was the one Carpeaux, Carrier-Belleuse, and others found: to become their own dealers.[37]

The market for serial sculpture: A second group of interesting questions regarding serial sculpture lies, as we might guess, at the opposite end of the line from the artist. Questions of marketing, which also have to do with the works, fall into various areas: (1) the growth of private capital and of national wealth, (2) technological progress, and (3) the government's promotion and protection. These are all essentially economic factors. Taken together, they were responsible for different mechanisms that influenced the development of serial sculpture, encouraged its expansion, prepared various markets for it, and gave it a precise economic and artistic identity.

The market for serial sculpture in France in the nineteenth century consisted of the producers' firms and, at times, those of retail dealers in bronzes. These are the branches of the bronze business that organized the exploitation of series and reaped their profits in the national economy. The making and marketing of serial sculpture in plaster or terra cotta demanded less capital investment for production and less equipment, which explains their artisan-like quality and secondary importance. Manufacturers and dealers of bronze played a role of prime importance in the economy of nineteenth-century France. The profession depended on skilled labor and the use of costly industrial material. It was linked to technological progress and protected by patents on inventions. Even early observers mentioned that bronze manufacturers had to combine a quick comprehension of what was in demand with enormous capital.[38] Around the period 1835–1840, industrial exploitation became distinct from artisan-type production. The statuette in plaster was still popular. Works by Barre, Barye, Dantan, and Fratin, including some bronzes, were merchandized by specialty dealers who were sometimes bronze founders as well—de Breaux and Susse for instance.[39] Bronze manufacturers saw their production expanding in different areas: most continued to reproduce one-shot replicas of contemporary sculptures; they did not abandon to the silversmith the deluxe, unique examples which contain some elements of sculpture. Likewise they continued their production of statuettes and ornamental bronze hardware for furniture.

The technological discoveries of the 1830s were thus introduced into a thriving climate. Patents taken out by Sauvage in 1833 and by Collas in 1834 introduced machines to reduce sculptures. These and their imitations, whether authorized or not, were soon in use by the bronze manufacturers, who could thus produce exact reductions in a variety of scales. This intervention by machinery was welcomed all around, by spokesmen for the government[40] and by art critics,[41] as a unique example of how industrial technology could benefit the arts. The reduction was the vehicle of a modern art, a social, democratic one which could uplift the masses and, more so than any other, take its place in the home. The reduction soon became an object for speculation.

Exploiting the Collas Process after 1839, Barbedienne became the living symbol of serial sculpture,[42] especially after the acclaim he received at the London Exhibition of 1851. He occupied an artistic and social position of considerable importance; his advertising was cleverly orchestrated in art journals; he was honored with awards from the government. Barbedienne's enterprise used all materials, marble, bronze, and even wood. He undertook reductions and enlargement work in any material for artists, under contract. He exploited his own collection of antique and modern sculptures in different-sized reductions.[43] A silversmith himself, Barbedienne also cast unique pieces, designing his own models and surrounding himself with chosen collaborators with whom he shared the recognition he achieved. Barbedienne's immediate competition in the second half of the century—Denière, Susse, Thiébaut, Paillard, Marchand, Delafontaine, etc.—exhibited a like variety of artistic interests. The activities of these and other manufacturer-producers in the adjacent domains of bronze sculpture and ornamental objects are difficult to separate and ought, indeed, to be studied together. The number of bronze manufacturers grew with the passage of years, as did the scope of serial sculpture. Two facts stand out: on the one hand, manufacturers tried to secure well-known sculptors as collaborators to furnish their models; and on the other, they tried to lower their production costs and in-

crease demand, since low production costs allowed manufacturers to use models by first-rate artists.

In this period, between 1840 and 1850, when the manufacturers were consolidating their enterprises, there is another name worthy of mention: Christofle. At the outset his returns from an exclusive patent for electrometallurgical casting[44] brought profits soon said to be "fabulous." Electrotyping contributed to lowering the cost of serial sculpture, thus making it more widespread. Christofle himself, however, limited his use of it to the production of large-scale sculptures, silverwork, and objects in bronze, either unique or serial.[45] Electrotyping allowed the use of base metals cheaper than copper, such as zinc. These could then be thinly electroplated with a more expensive metal. In the case of copper, this permitted reducing the thickness of the casts[46] and cut down considerably on the work of chasing.[47]

Barbedienne's business, Christofle's, and that of Susse, who exploited the Sauvage reduction process, were all important in the artistic and social life of the nineteenth century. As for Barbedienne, whose name recurs constantly in the study of serial works, people praised the artistic excellence of his products and considered his enterprise practically philanthropic,[48] an exemplary adaptation of industry to the requirements of art, the artist,[49] the workers, and the public alike. Public opinion was concerned with the social implications of the large firms in the art industry. Christofle and Barbedienne were congratulated for the paternalistic attitude they displayed in running their businesses and in taking care of their workers.[50] They were credited with notably improving the moral and social condition of the worker in art.[51]

The concerns voiced in the foundry workers' professional associations, however, provide a different view of the manufacturers' humanitarianism. Barbedienne is in fact singled out as an example of a capitalist exploiting his workers. Of particular interest is the professional organization of the workers in bronze sculpture, which was strongly supported by many bronze workers employed in the production of fixtures for gas heating

and lights. Organized as the Société de Crédit Mutuel des Ouvriers du Bronze, by 1865 this group was struggling for higher wages, for the right to submit grievances against employers to outside arbitration, for shorter working days, for better health conditions at work, for lost-time indemnities, and professional training for apprentices. They also proposed arrangements for profit-sharing. This organization is recognized as having been foremost among the proto-unions of the time.[52] The widely publicized general strike of the bronze workers, which lasted from January to March 1867, was a test of their power, precipitated by Barbedienne's determination to reinstate the eleven-hour working day which other employers had agreed to reduce to ten. The strikers also had to thwart their employers' plans to discharge the workers who were members of their mutual aid association. The strike was endorsed by the Association Internationale des Travailleurs; the manufacturers were forced to capitulate.[53] Conservative opinion dwelled upon the financial risks art manufacturers had to accept, since their success in business depended upon the popularity of their models. These models represented the serial sculpture producer's real capital and their exploitation did not always correspond to expectations.[54]

The interest the government took in the manufacturers' situation, however, made a positive contribution to their prosperity. It took two main forms: one was the publicity and encouragement provided by the Expositions des Produits de l'Industrie and the subsequent Expositions Universelles; the other, the protection of the law. The impact of these exhibitions on manufacturers should not be underestimated. Early in the century the government had already instructed the jurymen bestowing medals and prizes to seek out those artists and workers who were not themselves in a position to promote their work.[55] This practice was designed to facilitate the rise of those as yet unestablished and unknown. Throughout the century the illustrated press and specialized publications also devoted much space to reviews of these expositions and kept returning to the fact that industry was now producing for the people at

large.[56] Finally, jury reports were usually published at great length and in detail and contributed importantly to commercial competition. In typically chauvinistic fashion[57] they endlessly denounced foreign competition and criticized the government's protectionist policy of taxing imports and exports of metal and finished products made of bronze.[58]

In one other area the government's impact on the market for serial sculpture is possibly still more direct: the body of legal principles and precedents pertaining to the artist and his work. At issue here is the relationship between the intellectual and material aspects of ownership of a work of art. Intervention by the state assumed its most visible and tangible form in the government's efforts to prevent counterfeiting, which continued throughout the century.[59] The law's prime purpose being the defense of property, the decisions of the courts in these matters were inspired by interpretations of the idea of intellectual property and ownership. The questions at stake were the following: How is one to understand the artist's rights over his work? Can one, or should one limit such rights? How? Are the artist's rights over his work the reward for his services to society? Are these rights "property," and if so, in what manner and to what degree can they be relinquished or bequeathed?[60] It would seem that over the course of the century judges came to consider these rights as subject to a higher notion, a law of return to the public domain. They came to insist on this, defining that domain as the field in which the artist's genius discovers the element for his work in the first place. The law then tried in one way after another to discover the limitations of this right of return.

The decisions of the courts in cases of counterfeiting sculpture set forth different aspects of the rights enjoyed by a sculptor whose works are reproducible. First, his right of ownership over the work was interpreted as absolute, inviolable, perpetual, and transmissible. The right to reproduction was seen as a sort of usufruct presupposed by possession, an inherent dividend, perpetual and transmissible also, as is property. There was also the right to exclusivity, which jurists de-

scribed as a "favor" from the law, a favor allowing the artist's rights, by implication, to take precedence over the interest of the public domain. This concept had characteristics distinct from the right of ownership and of reproduction. It affected the serial sculpture market to the degree that it protected commercial exploitation of a work at the hands of the artist, the manufacturer, the buyer, or the heirs of the artist for as long as such work remained outside the public domain.[61] The law of 1793 abolished the artist's right to his property in perpetuity, limiting its duration to the length of the artist's life, to which period was added another ten years for his heirs to turn such property to their profit. In 1810, these ownership rights were guaranteed for the lifetime of the artist and his widow and descended to their children for a period of twenty years. In 1854, the children's rights were increased to thirty years, dating from the death of the artist or his widow. The law of 1866, finally, no longer dated this span from the widow's death but imposed a uniform period of fifty years after the death of the artist. Naturally the artist's rights could be sold either by himself or his heirs, in which cases the buyer's rights would also be subject to the same period—the artist's lifetime plus fifty years. Any work he created, unique or serial, project or sketch, left in his studio at death or previously sold (in the absence of other stipulations), was thus potentially capital which his heirs or buyers could put to use for their profit.[62]

Reproducing these works for exclusive sale and profit was limited to the period set by law, since the right to exclusivity gave way eventually and the works returned to the public domain. The laws governing exclusive exploitation of anything that might be found in a sculptor's studio were extended to include his working techniques also. A claim for exclusivity in exploitation of this sort was one basis for Barbedienne's well-publicized suit against counterfeiters in 1861. Certain casters had made illicit *surmoulages* from reductions belonging to his Galerie de Sculpture Antique et Moderne. The case was tried three times, twice on appeal: the judgement finally reversed a series of precedents which had always extended the rights of manufacturers and merchandisers where their exclusive ownership of technical processes was concerned.[63] At issue were works in the public domain which had been "counterfeited" from reductions obtained by purely mechanical means —the Collas machinery. In a much criticized decision, the judges held that a workman's retouching of a machine-made sculpture does not in itself create a new work.[64]

The far-reaching intention here was to protect the public domain against encroachments by manufacturers or merchandisers with exclusive rights to some means of exploitation. As a result, making serial sculpture involved unavoidable speculation. How could the sculptor protect himself? He became vulnerable at the point when he surrendered the ownership of his work. We know that the law of 1793 which laid down the artist's rights implicitly recognized his right to cede or transfer his artistic property. Two implications of such ownership were subsequently developed. One of them considered the work in its material aspects; the other had to do with exclusive rights of reproducing a work and making money from it, this latter defined as accessory to material possession. Does the sculptor who sells his work relinquish it only from the material point of view or does he also abandon his rights over its reproduction? Reluctantly, over the course of the century, French law ruled that the buyer could exercise immaterial rights over the work—reproduction—only if the artist had specifically granted him this privilege. It was held that the artist reserves and is free to exercise his exclusive rights of reproduction in the absence of any understanding to the contrary. The burden of proving his right to reproduce a work thus rests on the buyer (and potential speculator). Legalistic debates which artists followed closely in 1839 centered on proposals to redefine this transmission to buyers of exclusive rights of reproduction. Artists feared the purpose was to favor the buyer at the artist's expense, and declared that any transfer of works unaccompanied by stipulations reserving reproduction rights to the artist would rob him of his legitimate "future expectations."[65] They even denounced the government, which acquired owner-

ship of the works it commissioned, as the possible ruination of artists if it were allowed to speculate on their works.[66]

In fact, most contracts under which rights were transferred were short, porous documents[67] that made it possible to separate the exploitation of sculpture in series from any control of the artist. The buyer entered into ownership of a product over which he exercised in full the *jus utendi et abutendi*, his rights extending to mutilation or destruction of any work he owned. Only very late in the century was a *droit moral* codified in law. As eventually formulated, the *droit moral* protected the thought or intent a work embodies against obvious distortion during and after the artist's life.[68] All previous nineteenth-century practices had established the producer as sole judge of artistic quality when a work is serialized. Unless his contract specified otherwise, the sculptor could not require the producer to satisfy his standards of artistic quality. The sculptor had no recourse, for instance, should the manufacturer decide to use his work as an element in another work altogether,[69] even though its artistic identity would have been largely altered.

Often in the second half of the century we find works of sculpture in search of a manufacturer, so to speak. Models were sold at public auction or in bankruptcy proceedings against manufacturers or other individuals.[70] Works were thus thrown on the market under circumstances where the artist could not possibly exercise any controls over production, the most obvious of these being, of course, posthumous exploitation. Here again, to make precise judgements concerning the extent of posthumous production we must document the income of the sculptors and their heirs. There was extensive posthumous exploitation in the case of three especially important sculptors in the second half of the century: Carpeaux, Dalou, and Rodin. Carpeaux is particularly noteworthy in this regard. His estate was much coveted in view of the recent laws extending the rights of artists' heirs to fifty years and because, beginning around 1870, the courts began giving the rights of such direct heirs precedence over those of other interested parties. Carpeaux's Atelier comprised a

great many works, many of which were in production already. His estate also included quantities of sketches, early projects, fragments, and so forth, and the period was discovering newfound interest in unfinished works.[71] Carpeaux's widow managed to have his will set aside in 1877, and within six years she was able to relieve the estate of its complicated encumbrances. Until her death in 1908 she was frequently criticized for having "over-reproduced" her husband's works.[72] It is likely that for at least six years after the estate was settled, the Atelier continued to function the way Carpeaux had set it up early in 1874 in several contracts with his supervisor of production, Meynier.[73] Toward the end of the century the family entrusted the business of reproducing Carpeaux sculptures to others, Ranvier, Colin, and Duval.[74] The large retrospective exhibition held at the Ecole des Beaux-Arts in 1894 was followed by an auction sale of bronze, terra-cotta, and plaster models, and the rights of reproduction were sold along with them,[75] although in certain cases these were later bought back by the family. In 1909 Carpeaux's children Louis and Louise Clément-Carpeaux, a sculptor herself, negotiated the exploitation of several works with the Frank firm of Antwerp, the contract to run for three years and apply only to rights for Belgium and Germany. With Susse on January 1, 1914, they signed a contract granting exclusive rights of reproduction in all materials for all works as yet uncommitted elsewhere,[76] such as the few reserved to the Manufacture at Sèvres. This contract was to run through October 12, 1925, when the works came into the public domain. Carpeaux's desire to leave the museum at Valenciennes a collection of his works was fulfilled by means of a series of purchases and donated to the museum by Louise Clément-Carpeaux in 1930. The exploitation of works since then by Hébrard and others has continued to the present.[77]

Serial exploitation of Dalou's oeuvre was similarly divorced from any control by its creator. Dalou entered into agreement with Susse to be his only producer on May 3, 1899. Their partnership began with the production of a statuette and, some months later, a second work. A widower, Dalou

died in 1902, and his estate passed to his mentally retarded daughter Georgette, an inmate of the charitable institution L'Orphelinat des Arts, which represented her in legal matters. A contract between Susse and L'Orphelinat des Arts for the exploitation of Dalou's works went into effect on June 30, 1903 and was to remain valid for twenty-five years.[78]

The disposition of Rodin's works was likewise carried out according to the terms of his will, the details of which have still not been published. During his lifetime, Rodin occasionally turned to producers, notably Leblanc-Barbedienne and Fumière, for serial exploitation of certain works. At times he himself had limited series cast using the lost-wax technique. On other occasions he would specify that his works were unique and ought not to be reproduced in any material—although he did not hesitate to sell reproduction rights along with certain other pieces.[79] Rodin illustrates the entire gamut of situations and attitudes regarding serial production. The details concerning his bequests of works, models, molds, etc. are not known. It is only reported that he has permitted each sculpture to be reproduced in twelve replicas, it being understood that the original dimensions are to be respected. It is difficult to imagine satisfying the requirements Rodin laid down, in view of his constant practice of reducing and enlarging his pieces. The artistic supervision over the exploitation of his oeuvre, soon in the public domain, is carried out by the curator of the Musée Rodin, who can offer purchasers a "*garantie morale.*"[80]

"*Art History*" *and serial sculpture:* We turn, at last, to the art historian's customary preoccupations: images and styles, the capital "A" artistic aspects of serial sculpture. Although full appreciation of these aspects can only come with sympathetic and detailed studies of each of our artists, I cannot stress too strongly in this connection that the artists who created serial sculpture were talents of the first rank: the works by Barye and Carpeaux are our living proof of this. The men who originated the sculptures in series were the same men whose innovations produced the most significant movements of their time.

Speaking in broadest terms, the subjects of serial sculpture are the same as the subjects of the non-serial, unique, and large-scale statuary of the period. However, choice of subject for serial works was influenced to some degree by literature, public opinion, changing fashions, and the historico-exotic styles so dear to the nineteenth century.[81] Serial sculpture absorbed all these elements into its iconography and subject matter in the same manner as our own pop imagery, posters, magazine illustrations, and so forth depict contemporary figures and situations in currently popular styles. There was the same immediacy. Victor Hugo, for instance, records in his Brussels diary that immediately following publication of *Les Misérables* he bought two bronze candelabra labeled "*Les Misérables*: Jean Valjean et Javert."[82] It is worth remarking here that serial sculpture represented one of the most interesting species of "historicism," adapting images and styles from every era and reflecting every clime and country's variety of exoticism. It is futile to assign preferences for this or that form of historico-exoticism to any given decade, because they were all put to use sooner or later and coexisted on the market. Models might be adapted from ancient ones but more often were copies of reductions,[83] which were particularly lucrative products for the manufacturers since the models were in the public domain.

Now, what about the quality of serial sculpture where "beauty" of form and execution is concerned? The notion of artistic quality in any one work was expressed only in terms of how much it cost. Cost of production was essentially the result of the materials and techniques used and the amount of attention given by the workman. A lost-wax cast is expensive because so many steps are involved in its fabrication, each requiring the attention of highly skilled artisans. Sand-casting was almost always used: from one perfect model, any number of casts could be made. As with terra cotta, each bronze *exemplaire* requires finishing, and finishing was the most discussed single point when questions of artistic quality arose.

The value of the art and its price on the market were both dependent upon the chasing it received, the type and extent as well as the competence with

which it was done. Up until 1840, when manufacturers began launching their large series of reductions, the chasing of serial sculpture was compared to and judged in terms of the chasing done for silversmiths on their elaborate expensive pieces. Critics, understandably, found that the chasing of serial sculpture left much to be desired. Cheap chasing was poorly paid work, never signed by the worker. Poor chasing was thought injurious to the artist's intent, since it could betray the conception of his work.[84] Progressive critics compared it to the "finished" or "licked" surfaces of painting,[85] since it eliminated detail. Chasing was usually excessive to make up for defects in the casting, and the mediocrity of casts deserved a fair share of the abuse. Early in the century the lost-wax process was held up for praise;[86] soon after, praise was extended to the much-improved techniques of sand-casting developed by founders such as Quesnel.[87] After 1850, however, criticism on this point was silenced. Barbedienne's casters were praised as highly as his chasers for the respect they showed the model.[88] Both artist and manufacturer, nevertheless, demanded the highly finished surface the public found pleasing. Carpeaux, for instance, gave one of his marble practitioners precise instructions on "what the public is looking for" in execution, namely, "a finish to which the artist has to make sacrifices insofar as he can without compromising the work."[89] Here, as elsewhere, we see the responsibility for serial sculpture escape the artist. Carpeaux delegated the final execution of his works to practitioners and retouchers in the Atelier.[90] These workers were transient, hired by the day and often replaced, poorly paid and anonymous. The names of the supervisors, principal workers, chasers, and other artisans in large firms are only known to us if they were allowed to share some credit for the prizes their employers received for their work. The list is short, for this practice was fairly rare.[91]

Beyond choice of subject, style, and finishing, serial sculpture offers the historian of art additional points of interest. A clear view is difficult for us to achieve today because we have only particles of information on the entire subject. Still, we could consider, for instance, how the commercial and legal systems sketched above affected the artist. Variations in subject and composition and the changes in style that we notice in Clésinger's works are direct results of the laws applicable to sculpture in series.[92] Clésinger was notorious —and even attacked—for repeating his earlier works. He introduced the minimum modifications that would enable him to capitalize on the success of a previously sold work without being liable for counterfeiting himself. Dealers charged that he depreciated the value of his first "original work" through his self-imitations.[93]

One ought also to consider the serial production of the preparatory study and of the sketch, in cases where it is apparent that these are different artistically from the final work delivered to the customer. This was a device artists must have employed frequently to increase their earnings. Consider, from this perspective, the history of Carpeaux's La Danse with all the proliferation of its elements, such as the preparatory study and the figures used separately from the original group.[94]

Serial sculpture, as this exhibition reveals, achieved an identity for itself in the nineteenth century that it maintains today. It is an art form prophetically adapted to the needs and demands of its time. It may sometimes have been sculpture without a date or without a title, sculpture even without a sculptor. But its true identity is derived from purely technical and artistic manipulations, and these partake of the very essence of sculpture.

Notes

Considerable material for this study was gathered in France in 1973–1974 during my research as a Guggenheim Fellow. I wish to thank M. R. Robinet, Conservateur en Chef, Direction des Services d'Archives du Nord, Lille, for his kind permission to use certain unpublished material on Carpeaux. Several museum curators provided me with valuable information as have several collectors whose request for anonymity I must respect in thanking them. In the U.S.A., my special thanks are due to the Library of the Fogg Art Museum; the Kress Library of Business and Economics, Harvard University; the Harvard Law School Library (International Legal Studies Section); the Sterling Memorial Library, Yale University; and the Library of the University of California at Berkeley. Their assistance has been indispensable to me and all of them have been notably generous in providing it.

1. Describing the technique of piece molding, the author of the treatise on casting in plaster (most popular in nineteenth-century France) declares: "les creux [produced by piece-mold casting] subsistent et servent à couler une certaine quantité de plâtres. Quand ces creux sont bien faits, ils peuvent en fournir plus d'une centaine. . . ." *Nouveau Manuel du Mouleur, ou l'art de mouler en plâtre . . . par M. Lebrun* (Paris, 1838), pp. 34–35.

2. Max Claudet insists upon the major difficulty of casting in plaster and the necessity of employing professionals. He called the books on the subject "incompréhensibles, ce qui n'est pas étonnant, car il est difficile ou plutôt impossible d'entrer dans les détails d'opérations si compliquées. . . . Du moulage et du modelage sans maître." *L'Artiste*, vol. 2 (1872), 250–580. Several accounts toward the middle of the nineteenth century stressed the improvements in technique. "Les procédés de moulage ont fait depuis peu des progrès immenses en France . . . en général, les ateliers parisiens sont remplis de mille petits procédés plus ingénieux les uns que les autres. Nous attribuons ce progrès à la plus grande diffusion des connaissances chimiques et physiques qu'un certain nombre de chercheurs, doués de l'esprit d'observation, s'en vont puiser dans les cours gratuits du Conservatoire des Arts et Métiers. . . ." *Industrie Française, Rapport sur L'Exposition de 1839 par J.B.A.M. Jobard*, vol. 2 (Brussels and Paris, 1842), 22–23. Opigez' invention of gelatin molding, a technique already mentioned by Jaucourt in the *Encyclopédie*, was especially remarked upon. "M Opigez est parvenu à trouver une matière ductile qui permèt d'obtenir des moulages d'objets que le plâtre ne pouvait rendre qu' imparfaitement. Les résultats auxquels il est arrivé paraissent destinés à ouvrir une voie nouvelle au moulage. Les plus petits détails sont rendus avec un fini que le plâtre est impuissant à atteindre. . . ." "Mouvement des Arts," *L'Artiste*, série 5, vol. XII (1854), 139. We know the names of several plaster casters employed by the artists under discussion: Trinque, Lacave, Breton, Vramant, Cajani, for Carpeaux; the Montagutelli Brothers, Guilloché, for Rodin. There is a detailed account of the work of casting plaster as it was done for Carpeaux between January 1873 and January 1875. It shows a great many molds done after sketches. Two of the works featured in this exhibition, *Ugolin* and *La Danse*, figure in several entries: "Mai, 1875, moule à bon creux de l'esquisse groupe de *la Danse* . . . 80 francs. Juillet, 1873, moule à bon creux du Groupe de *la Danse* . . . 1.200 francs. Août, 1874, moule à bon creux du groupe d'*Ugolin* sur le bronze . . . 190 francs." Here, to judge from its price, the reference is to a mold done from small bronze. Archives du Nord, Lille.

3. "Ces praticiens furent M. Begler et M. Micheli, le père du mouleur actuel. Je tiens ces renseignements de l'obligeance de M. Duriez." A. de Montaiglon and G. Duplessis, "Houdon, Sa vie et ses ouvrages, 1741–1828," *Revue Universelle des Arts*, no. 5 (1855), 319–320. *Les Carnets de David d'Angers édités par A. Bruel*, vol. 2 (Paris, 1958), 86–87. Begler became a practitioner for David d'Angers. *Ibid.*, vol. 1, 133.

4. Information is scant concerning large-scale casting businesses active in the nineteenth century: Panichelli, Fontana, Micheli, Desachy, Marchi, Opigez. See, however, J. de Caso, "Duban et l'achèvement de la *Galerie du Bord de l'Eau*: la frise des Frères L'Heureux," *Bulletin de la Société de l'Histoire de l'Art Français*, 1974 (1973), pp. 333–343; M. Charageat, "Un inventaire de fonds de mouleur parisien en 1880. De l'Importance du fonds Visseaux pour l'identification de sculptures du 18ème siècle," *ibid.*, 1967 (1966), 237–245.

5. "La saisie des objets argués de contrefaçon n'est pas indispensable pour établir la preuve du délit. . . . Il n'est pas nécessaire qu'un moule ait servi pour que le délit de contrefacon existe; il suffit que ce moule ait été fait. . . . Les tribunaux peuvent condamner comme contrefacteur le mouleur chez lequel on a trouvé de bonnes épreuves portant les traces d'un contre-moulage, encore bien qu'on n'ait saisi ni les moules ni les épreuves contrefaites." *Susse, Collas and Barbedienne v. Galantomini*, December 17, 1847, Cour de Paris, in *Journal du Palais*, vol. 1 (1848), 352–353.

6. ". . . c'est juger témérairement que de juger d'une manière absolue les produits sans avoir eu égard au modèle qui a servi de point de départ et qui, peut-être, avait déjà quelque chose de cette indécision qu'on retrouve dans le surmoulé." *Exposition des Produits de l'Industrie Française en 1839. Rapport du Jury Central*, т. 3 (Paris, 1839), 32. "Ces produits, appréciés au point de vue de l'exécution, sont tous également satisfaisants . . . l'on voit que l'esprit de la conservation du modèle a présidé à l'exécution du surmoulé." *Ibid.*, 26.

7. "La reproduction servile, notamment par le surmoulage

de copies ou réductions appartenant au domaine public constitue une contrefaçon." *Lavastre v. Mercier*, April 11, 1860, Tribunal Civil de la Seine. "Le surmoulage ou le contre moulage est le moyen de reproduction le plus exact et par cela même le plus perfide. Il constitue la contrefaçon à son degré le plus complet. . . ." E. Pouillet, *Traité théorique et pratique de la Propriété Littéraire et Artistique et du droit de représentation*, third ed. (Paris, 1908), pp. 600–601.

8. "Nous sous-signé A. Houdon, d'une part et Madeleine Sophie Arnould, d'autre part, sommes convenus de ce qui suit: que moi, A. Houdon, ferai le buste en marbre d'Iphigénie représentant Mlle Arnould que je promets de délivrer à ladite demoiselle Arnould en août prochain, plus que je ferai 30 copies de ce buste en plâtre sur piédouche réparés par moi, et que je lui délivrerai aussi en août prochain. Plus que je délivrerai aussi à Mlle Arnould le buste en terre qui a servi de modèle, en août prochain. Je m'engage de plus à ne faire ni donner ni vendre auquel autre pareil buste en marbre, plâtre ou terre, au delà du nombre ci-dessus, faisant ensemble 32 bustes, à quelque personne que ce puisse être que Mlle Arnould ou ses ayant cause. Et moi, Mlle Arnould promet et m'engage de payer à mon dit sieur Houdon pour les 32 bustes détaillés ci-dessus la somme de 3.800 livres. . . . De plus, moi, A. Houdon, promet à Mlle Arnould de lui fournir les bustes préparés en plâtre dont elle pourra avoir besoin en sus des 30 ci-devant mentionnés, au prix de 60 livres pièce, sous condition cependant que je ne serai pas gêné pour leur livraison, et surtout que l'on ne pourra m'en demander que jusqu'à concurrence de 20 au plus. Fait double entre mous à Paris, le 5 avril 1775." Cited by G. Giacometti, *Le Statuaire Jean-Antoine Houdon et son époque, 1741–1828*, vol. I (Paris, 1918), 326–327. No *exemplaire* in plaster or in clay is known to exist. Two marbles were listed in eighteenth-century sales: *Exposition du Centenaire de Houdon* (Paris: Galerie Buvelot, 1928).

9. See F. J. B. Watson, *The French Bronze, 1500–1800* (New York: M. Knoedler & Co., 1968).

10. "En ce qui concerne la statuette que j'ai vue dans votre atelier . . . je vous ai dit, en thèse générale, que je n'achetais jamais rien dans les petites dimensions que j'avais sous les yeux et vous vous souvenez même que je voulais prendre la *Tendresse Maternelle* qu'à la condition que vous la feriez *vous-même* [Barbedienne's stress] dans la mesure que vous appelez la demi-nature. C'est à ce propos que pour me décider, vous avez offert de retoucher une augmentation que je ferais à l'aide de mes machines. Par exception à mes habitudes et un peu à regret, j'accepterai cette condition. . . ." F. Barbedienne to Carpeaux, February 15, 1870. "Le travail de grandissement, dont je me suit chargé, se fait sans aucune interruption, et malgré tout, il ne sera terminé que dans le courant de la semaine prochaine, ce qui dépasse de beaucoup nos prévisions par la longueur et l'importance du travail d'augmentation qui ne peut se faire qu'avec les plus grands soins. Le moulage que j'aurai à faire pour vous donner une épreuve en bon plâtre prendra bien encore une dizaine de jours. Ce ne sera donc qu'à la suite de cette opération que je réclamerai votre intervention pour l'achèvement du dit groupe." Barbedienne to Carpeaux, May 20, 1870. Archives du Nord.

11. Carpeaux commenced his studies for the statue and the bust of the *Prince Impérial* toward the end of 1865. *Sur les traces de Jean-Baptiste Carpeaux*, nos. 169–179 (Paris, March–May, 1975). L. Clément-Carpeaux has remarked how very important this commission was to Carpeaux in financial terms. Carpeaux wrote to a friend that his brother "est chargé de faire l'exploitation de la statue du Prince Impérial. Ou nous sommes en train de faire fortune ou de nous ruiner . . ." (October 1867). Émile Carpeaux was relieved of his marketing responsibility in November 1867, and Carpeaux's father, Joseph Carpeaux, assumed charge of producing and marketing the fifteen models that included the statuette and bust of the *Prince Impérial*. Their business card read: "Bronze d'Art. Dépôt de Bronze, 74 rue Boileau, Auteuil-Paris, Station du Point du Jour. Reproduction artistique des oeuvres de J. Bte Carpeaux, sculpteur, éditées par Joseph Carpeaux Père, Marbre, Bronze, Terre Cuite, Galvanoplastie, Aluminium." *La Vérité sur l'oeuvre et la vie de J. B. Carpeaux 1827–1875*, vol. I (Paris, 1934), 213–214, 222. It is confusing to sort out how many of these works were produced by Barbedienne because the same work is listed under different headings corresponding to different stages and types of fabrication. Barbedienne submitted bills from November 1864 to December 1870. This is the transcription for work on the *Prince Impérial* and excludes everything else. It is given for the year 1868. "1868. janvier 15: Reçu un effet au 1er mai, 1868, 3.000 (Avoir) février. Disposé en surmoulé le modèle de la statuette du Prince Impérial, 22.00, avril, 30. Disposé en surmoulé un buste du Prince Impérial sur modèle grandeur nature, 9.20. Disposé pour surmoulé une statuette du Prince Impérial No. 2, 85.00. Disposé pour surmoulé une statuette du Prince Impérial No. 3, 52.00. Deux statuettes du Prince Impérial No. 3, 460.00. Six statuettes du Prince Impérial No. 4, 720.00. Bronzage de huit statuettes du Prince Impérial No. 4, 32.00. Bronzage de 16 bustes (Prince Impérial?) No. 3 et 4, 18.00. juin 10, Bronzage d'un buste du Prince Impérial, 8.50. juin 11, Bronzage d'un buste Prince Impérial, 8.50. juin 29, Fonte sur plâtre et ciselage une statue du Prince Impérial disposée en surmoulé, 740.00. juillet 8, Bronzage de 13 bustes du Prince Impérial, 18.50. Gravure des 13 bustes cidessus et dorure des lettres, 46.00. juillet 31, Bronzage de deux statues du Prince Impérial No. 4, 8.00. Gravure de ces deux statuettes, 9.00. Bronzage de 23 bustes du Prince Impérial No. 4, 16.00. Bronzage de 3 statuettes No. 4, 48.00. Gravure de 8 bustes et de 3 statuettes, 48.00.

novembre 27, Bronzage d'un buste Prince Impérial No. 1, 5.00. décembre 11, Bronzage et gravure de 3 statuettes Prince Impérial, 28.00. décembre 20, Bronzage de 2 bustes Prince Impérial No. 1, 5.00. Bronzage d'un buste Prince Impérial No. 2, 2.00. décembre 23, Bronzage d'un buste Prince Impérial No. 1, 2.50. Bronzage d'un buste Prince Impérial No. 3, 2.00. Gravure de ces deux bustes, 8.00. décembre 31, Bronzage de 10 bustes Prince Impérial, 8.00. Gravure 6.00. Bronzage d'une statue Prince Impérial No. 2, 10.00. Bronzage d'une statue No. 3, 8.00." I am preparing for publication *in extenso* the extant bookkeeping records of the Atelier Carpeaux.

12. In one clause, the contract between Victor Paillard and Carpeaux concerning production and marketing of the group *L'Impératrice Protégeant les Orphelins* stipulates: "... chaque épreuve devra porter la marque ou cachet de M. Carpeaux. Registre sera tenu des frais de chaque épreuve et de son prix de vente par M. Paillard ainsi que du nombre des épreuves vendues. Ce registre sera montré à M. Carpeaux ou à son mandataire à toute réquisition." Archives du Nord.

13. None of the nineteenth-century critics who mention Barye's numbered *exemplaires* raise the issue of the total number of *exemplaires* produced in a given series. Barye had been dead eleven years when in 1886 Edmond de Goncourt writes in a preface to *Collection Auguste Sichel. Bronzes de Barye. Epreuves de choix*: "... voulez-vous ... une preuve de la beauté des épreuves ... vous l'avez ici donnée avec le poinçon du Maître. C'est ainsi que par les numéros poinçonnés, frappés au marteau, au-dessous de la signature Barye, vous rencontrerez dans cette vente une vingtième épreuve de l'*Ours couché*, une seizième épreuve de *Thésée et le Minotaure*, deux [sic] neuvièmes épreuves de l'*Épagneul en arrêt sur un lapin*. ..." Consider the implications of these words.

14. For example: "No. 158. Statuette en terre cuite: la *Femme Adultère* de J. Cambos. Signée et portant l'inscription: épreuve unique en terre cuite, exécutée pour Alexandre Dumas fils, 1870. Salon de 1869. Haut., 77 cm." *Catalogue des Tableaux ... Sculptures ... Alexandre Dumas*, March 2 and 3, 1896 (Paris: Georges Petit).

15. "L'éditeur auquel un artiste a cédé la propriété d'une oeuvre de sculpture, en se réservant seulement le droit de reproduction en marbre, peut en faire des réductions, mais il doit mettre le nom de l'artiste aussi bien sur les épreuves réduites que sur celles conformes à l'original." *Ferrat v. Lemaine*, December 31, 1862, Tribunal Civil de la Seine. "En ce qui touche les conclusions tendant à ce qu'il soit fait défense à Barbedienne d'éditer avec le nom de Clésinger les réductions de ses oeuvres: – Attendu que les réductions nombreuses faites jusqu'à ce jour ont été marquées de la signature de l'auteur des oeuvres reproduites; – Que plusieurs de ces réductions ont même été

livrées à Clésinger, qui les a toujours acceptées sans protestations; – Attendu que le droit de réduction implique la reproduction avec tous les accessoires de l'oeuvre et par conséquent avec la signature de l'auteur; – Attendu que Clésinger, au cas où Barbedienne n'aurait pas reproduit sa signature, aurait été fondé à lui reprocher de dissimuler au public qu'il fut l'auteur des oeuvres originales qui étaient réduites; – Attendu, enfin que l'oeuvre originale étant signée par Clésinger, la reproduction de la signature, puisqu'elle est le résultat inévitable du procédé de reproduction ... Par ces motifs ... Déclare Clésinger mal fondé dans sa demande et l'en déboute. ..." *Clésinger v. Barbedienne*, December 12, 1866, Tribunal Civil de la Seine.

16. "... le 23 février 1870, il était stipulé [in an agreement between Clésinger and Société Marnyhac] que toutes les oeuvres originales de Clésinger ne pourraient être mises en vente qu'après il les aurait approuvées et qu'il y aurait apposé sa signature, et que son décès survenant, il suffirait, pour remplacer son autorisation, de celle d'un membre de l'Institut. ... par des conventions passées datées du Ier septembre 1873, Clésinger cédait à nouveau à la Société Marnyhac et Cie le droit d'exécuter, autant de fois qu'elle le voudrait, en marbre grandeur nature et au 2/3 nature, les oeuvres désignées dans le contrat, et dont elle avait les modèles en plâtre; qu'il autorisait la même Société à apposer sa signature sur tous ces marbres de quelque grandeur qu'ils fussent; qu'en outre, il lui cédait tous les modèles qu'il créerait, à dater de ce jour, avec la faculté pour elle d'en disposer selon ses convenances, de les exécuter; de les reproduire en toute grandeur, et toute matière; et d'y apposer sur chaque marbre et autres matières, sa signature J. B. Clésinger." *Estate of Clésinger v. Marnyhac & Cie*, May 27, 1887, Tribunal Civil de la Seine. "... le 25 janvier 1873, Falguière cédait à la Société Marnyhac et Cie la propriété exclusive d'un certain nombre de ses oeuvres, avec faculté de disposer des modèles, de les exécuter, de les reproduire en toutes grandeurs et en toutes matières, et de placer sur chaque épreuve la signature *Falguière* avec le lieu et l'année de la production." *Falguière v. Marnyhac*, May 27, 1887, Tribunal Civil de la Seine.

17. "Nous ne saurions trop engager les artistes et les éditeurs à apposer leur nom ou leurs marques sur les épreuves qu'ils livrent au commerce; cela aura le double avantage de rendre plus difficile la vente des objets contrefaits en permettant aux tiers eux-mêmes de reconnaître les contrefaçons et de donner plus d'efficacité à la répression lorsqu'au délit de contrefaçon viendra se joindre celui d'usurpation de nom." A. Huguet, "Observations," *Annales de la Propriété Industrielle, Artistique et Littéraires* (1856), p. 25. (*Cour de Paris*, January 3, 1855, March 10, 1855, February 28, 1855, May 12, 1855.)

18. "M. Simart s'est élevé ce jour-là d'une noble façon. ... Que va devenir ce beau marbre? Trouvera-t-il au moins

un acheteur? Hélas! Le jeune homme qui a fait sortir de ce bloc informe une pareille statue a mis là non-seulement tout son talent, tout son courage, mais encore toute sa fortune . . . dans ce marbre taillé à si grand frais, je retrouve toutes les misères, toutes les luttes de la jeunesse. . . . Cette statue n'est pas vendue; et comme elle est la seule ressource présente de l'auteur, il faut qu'elle soit vendue à tout prix. Or c'est là justement que les artistes de talent sont attendus; il y a derrière eux, pour exploiter leur misère, non pas seulement des marchands mais, il faut le dire, il y a le Ministère de l'Intérieur . . . dans ces endroits souverains qui sont leur dernier refuge, les oeuvres des artistes sont marchandées. . . ." J. Janin, "Le Salon de 1840," *L'Artiste*, 2ème série, T. 5 (1840), 269–281. Janin's reference is to Simart's *Oreste*, one of the most highly acclaimed pieces in the Salon of 1840. Purchased by the government, it was installed in the Rouen Museum in 1841.

19. At the time of Bosio's death, critics emphasized how wealthy he had become: ". . . un des derniers représentants de l'art impérial et de celui de la Restauration, le prince de la sculpture pendant ces deux périodes . . . ses oeuvres lui valurent le titre de Sculpteur de l'Empereur, aux appointements de 8.000 livres, plus une baronnie d'Empire . . . la Restauration ne changea rien à la position du baron statuaire, elle arrondit, au contraire, le nid de feuilles de lauriers et d'or que lui avait tressé l'empereur. . . . Tant de travaux eurent leur récompense; la richesse les paya amplement de retour. Le baron Bosio est peut-être l'unique exemple dans ces temps-ci, d'une fortune princière conquise à la pointe du ciseau. Ses marbres, ses bronzes, ses bas-reliefs lui rapportèrent, à ce qu'on assure, deux millions. Mais ces deux millions, où sont-ils aujourd'hui?" G. Guénot, "Le Baron Bosio," *L'Artiste*, 4ème série, T. 4 (1845), 65–66. Documents corroborate this statement beyond any question. Bosio's widow was virtually penniless after his death and was granted government subsidy she had to request. L. Barbarin, *Étude sur Bosio, sa vie et son oeuvre* (Monaco, 1910), pp. 134–141. Published documents fail to bring up the circumstances under which three of Bosio's most popular pieces, *Salmacis*, *Henri IV enfant*, and *Jeune Indienne* (the latter a marble displayed at the Salon of 1845) were marketed by Barbedienne in three different sizes: two-fifths, three-tenths, and two-tenths. They appear in Barbedienne's sales catalogues during the Second Empire along with the *Vénus Endormie* which was likewise available in three scales and identified as *Inédit*.

20. Previous cataloguings mention only these following reductions: "11855, Réduction groupe de la Vierge et de l'enfant Jésus. Réduction de la statue de la Philosophie. Quatre statuettes esquisses, Muses de la musique ou Poésies – chez Daguet, mouleur, rue Guénégaud. Nota: ces statuettes n'ont été mises en vente que depuis la mort de Simart." G. Eyriès, *Simart* (Paris, n.d.), pp. 493–494.

21. "Les statuettes de M. Préault et celles de M. Leharivel-Durocher . . . ," Ph. Burty, *La Presse*, May 3 and 5, 1865, were exhibited at the *Exposition de l'Union Centrale des Beaux-Arts Appliqués à l'Industrie*, Paris, 1865, cited in *Le Beau dans l'Utile. Histoire Sommaire de l'Union Centrale des Beaux-Arts Appliqués à l'Industrie* (Paris: Union Centrale, 1866), p. 114.

22. "Antonin Moine, avant février 1848, faisait des figurines et des statuettes pour le commerce. Figurines, statuettes, nous en étions là. Le commerce a remplacé l'État. Comme l'histoire est vide, l'art est pauvre; comme il n'y a plus de figures, il n'y a plus de statues. Antonin Moine subsistait assez chétivement de son travail. . . . Vers 1847, le commerce de luxe, qui contient l'art et la fantaisie, allant déjà assez mal, il avait joint aux figurines des portraits au pastel. Une statuette par ci, un pastel par là, il vivait. . . . La misère arrivait, et l'espérance s'en allait." V. Hugo, *Choses Vues*, March 31, 1849.

23. "*L'Artiste* et Susse avaient montré, dans sa primeur, ce talent qui a passé, comme tant d'autre par cette publication et cette *boutique* en attendant une consécration plus haute." A. Royet, *L'Avenir Républicain* (Saint-Etienne), March 25, 1849.

24. "1854. 6 septembre à Dieppe. J'ai été visiter le sculpteur Graillon. Sa boutique est située dans la grande rue. Dans cette boutique sont exposées une grande quantité de ses oeuvres qui sont presque toutes des petits chefs d'oeuvres de naiveté. Ce sont des scènes de la vie privée du peuple, exécutées avec une grande finesse et une vérité parfaite, d'une variété toute particulière. Ce sont des figures dignes de Téniers, elles portent le cachet de la misère. . . ." Hardly unknown to his contemporaries Graillon lived in Dieppe and was included in the Salon of 1849 (No. 2250. *Un groupe de mendiants*, terre cuite) and in the 1855 Exposition Universelle (No. 5065 to 69: *Mendiants*, bas-relief, ivoire; *Jeux d'enfants*, bas-relief, cachalot; *Buveurs*, bas-relief, ivoire; *Mendiants*, bas-relief, bois; *Mendiants*, bas-relief, bois). In the study of the period's political art and "social realism" his sculpture is centrally important. Graillon left an interesting account of his early years: "Je ne trouvai même pas de quoi employer mes bras comme ouvrier sculpteur. . . . L'idée me vint d'ouvrir une boutique au centre de la ville. A force de lutter contre la misère, j'en étais presque arrivé à me dégoûter des arts. J'eus un instant l'idée de me faire brocanteur. Je me disais à part moi que je pourrais remettre en état toutes les vieilleries qui me passaient entre les mains, et fabriquer en même temps quelques objets qui me donneraient une existence assurée. . . . Nous étions alors au mois de juin 1842; quelques étrangers commençaient à circuler dans les rues de Dieppe. L'idée me vint de faire des gueux, et de les mettre sur mes fenêtres. Ils se placèrent à vil prix, j'en conviens, mais je les vendis et je m'empressais de leur donner des succes-

seurs. . . ." "P. Graillon, Sculpteur Dieppois; sa vie racontée par lui-même," *Revue des Beaux-Arts. Tribune des Artistes*, vol. 1 (Paris, 1850), 244–250, 263–266. In his remarkable eulogy of Graillon, David deplored his aspirations to produce monumental sculpture: "Cependant, il faut toujours que nous payions un peu notre tribut à la pauvre faiblesse humaine. Notre artiste, selon moi, n'a pas de rivaux dans son genre; la nature l'a pétri pour cette mission, mais la malheureuse visite de Bonaparte lui a tourné la tête, il voudrait faire des statues colossales; c'est là actuellement sa seule ambition, son côté divaguant. . . ." *Les Carnets de David d'Angers*, vol. 2, 438–443.

25. "Bronzes d'art et d'ameublement. M. Frémiet est un de ces rares artistes dont le talent se complète de la connaissance approfondie du métier; aussi est-ce comme industriel qu'il a tenu à exposer . . . c'est bien son intelligent éditeur, M. More, qui, pour tous ces travaux, est son précieux collaborateur, mais c'est M. Frémiet lui-même qui prépare ses modèles, s'occupe des réductions, surveille la ciselure et décide, enfin, les patines. . . ." H. Vian, Rapporteur, *Exposition Universelle Internationale de 1900 à Paris. Rapports du Jury International, Groupe XV, Industries diverses. Première Partie, Classes 92 à 97* (Paris, 1902), p. 484.

26. "Fauconnier n'était ni dessinateur ni sculpteur . . . on lui doit une collection de bons modèles pour l'imitation de divers animaux. L'auteur de ces bons modèles était M. Barye, dont le talent, deviné par Fauconnier, est devenu le premier dans le genre auquel il a su faire une si grande place. . . ." *Exposition Universelle de 1851. Travaux de la Commission Française sur l'Industrie des Nations, XXIII Jury, Industrie des Métaux Précieux, par M. le Duc de Luynes* (Paris, n.d.), pp. 61–62. "Les premières expositions de la Restauration montrèrent ces jalons d'une voie nouvelle où l'on allait entrer. En 1819 (peut-être en 1824?) on voyait donc . . . de Fauconnier . . . déjà, suivant moi, Fauconnier se plaçait nettement et carrément en tête des orfèvres; déjà Barye, son élève, son apprenti, faisait pressentir ce qu'il serait un jour. Les efforts que s'étaient imposés Fauconnier étaient inouïs." F. D. Froment-Meurice, cited by Ph. Burty, *F. D. Froment-Meurice, Argentier de la Ville, 1802–1855* (Paris, 1883), p. 13.

27. He is cited as a remarkable founder of the time, together with Denière, Eck et Durand, Delafontaine, Collas et Barbedienne, Paillard, Villemsens; E. Bérès, *Etudes Economiques Pratiques. Compte-Rendu de l'Exposition Industrielle et Agricole de la France en 1849* (Paris, 1849), p. 148.

28. "A toutes ces oeuvres élégantes ou magnifiques qui font des magasins du Boulevard Poissonnière un véritable Musée, l'éditeur a eu la bonne fortune de joindre plusieurs bronzes de Barye. Nous avons aperçu dans un coin des jaguars. . . . qui, lorsqu'ils seront publiés, augmenteront l'estime des artistes pour M. M. Collas et Barbedienne et l'admiration pour Barrye [sic]. . . ." L. Clément de Ris, "Mouvement des Arts," *L'Artiste*, 3ème série, vol. 10 (1853), 89.

29. "Quant à la reproduction de son oeuvre en métal, j'admettrai volontiers que les soins de la fonte puissent être distraits du labeur de celui qui crée le modèle. Un grand artiste que nous admirons tous, M. Barye, pense autrement. Il ne se remêt à personne du soin de fondre ses ouvrages; il ne les quitte qu'achevés; il est dans le vrai." E. Guillaume, "La sculpture en bronze" (lecture given at the *Union Centrale des Beaux-Arts appliqués à l'Industrie*, April 29, 1868). Barye's dealings with the founders who did his casting, de Braux, Eck et Durand, Honoré and Eugène Gonon, Richard et Quesnel, Thiébaut, Barbedienne, are not documented. We may anticipate information of interest from the *Journal* of Émile Martin, Barye's financial backer and himself a founder associated with the Imphy Bronze Works during the 1830s.

30. C. Theunissen, "Les terres-cuites de Carpeaux," *La Grande Revue*, 16ème année, No. 12 (June 25, 1912), 829.

31. "Modèle du groupe *L'Impératrice protégeant des Orphelins*. Entre les soussignés M. Carpeaux, sculpteur demeurant 52 rue Madame d'une part, et M. Victor Paillard, fabricant de bronzes à Paris, rue Saint-Claude No 8, d'autre part, il a été convenu ce qui suit, savoir: M. Carpeaux a composé et exécuté le groupe en plâtre du modèle en bronze, pour ledit groupe être exécuté à *compte à demi* entre les parties soussignées. Dans le cas où l'on voudrait réaliser la vente du modèle en bronze ainsi constitué (ce qui ne pourrait se faire que du consentement des parties), le prix sera partagé par moitié entre Messieurs Carpeaux et Paillard. Monsieur V. Paillard est autorisé à retirer le dit modèle en plâtre déposé, chez Mrs Colas [sic] et Barbedienne et en acquitter le prix de réduction de deux cents francs, laquelle somme sera immédiatement portée au compte de M. Carpeaux et à valoir sur la part de bénéfices qui pourra résulter de la vente des surmoulés dont il va être parlé. De l'exploitation des épreuves. L'exploitation des épreuves *surmoulées en bronze ou toute autre matière plastique* étant spécialement réservée à M. Victor Paillard, celui-ci devra en tenir un compte exact et le représenter à toute réquisition à M. Carpeaux sculpteur qui s'interdit d'en reproduire aucune épreuve en quelque matière que ce soit. Le bénéfice résultant de la vente dudit groupe sera partagé par moitié entre les parties, et le compte en sera arrêté tous les six mois. Fait double entre les parties pour être exécuté de bonne foi, Paris le 12 décembre 1855. Approuvé. . . . Chaque épreuve devra porter la marque ou cachet de M. Carpeaux [see above, note 12]. L'artiste se réserve expressément la faculté de pouvoir reproduire son oeuvre en marbre et en photographie. Dans le cas de

vente du modèle, le prix en sera partagé entre M. Paillard et M. Carpeaux." Archives du Nord. "Société Christofle et Cie Paris, 4 décembre, 1867. Monsieur Carpeaux, En réponse à votre lettre du Ier décembre, nous vous remettons le prix du *Petit Prince*, (No 4, haut. o. 28) sous ce pli. Quant au groupe d'*Ugolin* nous n'avons pas cru devoir l'examiner. La difficulté des coupes et l'importance de la monture nous ayant fait penser qu'il n'y aurait pas d'économie à l'exécuter en galvano. Il en est de même du *Pêcheur Napolitain*, mais à un autre point de vue. Le prix revient auquel vous avez dit l'avoir fait établir en fonte ne nous permettant pas de songer au galvano pour son exécution." Christofle to Carpeaux, Archives du Nord.

32. "31 juillet 1869. Monsieur Carpeaux. Comme je suis en train de réviser les écritures de nos livres, de faire les balances et d'évaluer les bénéfices, je vais vous donner les chiffres des affaires que nous avons faites en ventes purement commerciales, pendant les années précédentes et celle courante : nos ventes depuis le commencement du commerce jusqu'à la fin de 1867 . . . 36.867. Comme pendant ce temps les affaires étaient fort mal dirigées, il ne faudrait pas prendre sur le chiffre annoncé plus de $^{1}/_{4}$ de bénéfices, soit . . . 9.216. Nos ventes en 1868 . . . 37.381,50. Les affaires étant déjà mieux menées, vous aviez moins de frais—ce qui fait qu'en moyenne nous pouvons certainement porter en bénéfices, moitié du chiffre de vente, soit, 18.690,75. Nos ventes en 1869 jusqu'à ce jour . . . 32.435,50. Nous atteignons un chiffre que je trouve fort joli à cause du manque d'intérêt que l'on a donné au commerce, à cause du délaissement complet depuis mars. Nous pouvons hardiment prendre $^{3}/_{5}$ des bénéfices, soit : 19.461,30." Archives du Nord.

33. "Je lègue au Musée de Valenciennes, ma ville natale, tous mes modèles en plâtre et les dessins de mes oeuvres . . . mais à la condition que, sous la surveillance du conservateur, mes oeuvres seront reproduites et répandues aussi largement que possible." L. Clément-Carpeaux, *La Vérité*, vol. 2, 39.

34. "De son vivant, le sculpteur Pradier avait cédé à différents éditeurs le droit de reproduction de ses oeuvres. La plupart avaient été créées dans les dimensions de simples statuettes, et ce n'est qu'après les avoir mises dans le commerce par le moulage qu'il reproduisait, en grand, celles qui avaient obtenu le plus de succès." *Annales de la Propriété Industrielle* (1877), p. 114. "Les artistes créent le modèle, soit d'après leur propre inspiration, soit d'après les indications des industriels qui les emploient et qui composent d'abord un premier dessin, en se conformant aux exigences de la fabrication." P. Poiré, *La France Industrielle, ou description des industries françaises . . .*, ch. VI, "Bronzes d'art" (Paris, 1880), p. 613.

35. "Il est mort pauvre comme Houdon. . . ." H. Houssaye, "Clésinger," *L'Artiste*, vol. 1 (1883), 81.

36. "Pourquoi séparerions-nous ces deux noms que nous sommes accoutumés depuis si longtemps à réunir—le fabricant et l'artiste, l'inspirateur et le créateur, le capital et le talent—deux compagnons, deux amis des bons et des mauvais jours ? Aujourd'hui qu'abandonné à ses propres ressources, sans protection, sans travaux, sans admirateurs, mais aussi sans flatteurs, M. Clésinger vit à Rome. . . . N'est-ce pas M. Barbedienne qui lui sert à la fois de correspondant et de banquier. . . ." A. Busquet, "Visites Parisiennes II, M. M. Barbedienne et Clésinger," *L'Artiste*, nouvelle série, T. 2 (1857), 252–253. Clesinger's frequent lawsuits, the publicized one he undertook against Barbedienne especially, demonstrate the tight financial and artistic ties between artists and producers and the legal complications that could arise from transfer of right to the works. "En ce qui touche les droits d'auteur réclamés par Clésinger sur les réductions faites de plusieurs oeuvres de sculpture : – Attendu que . . . il a déclaré restreindre sa demande aux réductions du *Taureau Romain*, la *Sapho debout*, la *Diane au repos*, l'*Hercule Enfant*, la *Bacchante*, la *Cléopâtre* et le *Buste de Femme*; – Attendu à l'égard du *Taureau Romain*, la *Sapho debout*, la *Cléopâtre*, et le *Buste de Femme*, qu'ils sont la propriété de Barbedienne, à qui Clésinger les a vendus sans aucune réserve; . . . – Attendu à l'égard de la *Diane au repos* et de l'*Hercule Enfant*, que Clésinger, en les aliénant au profit de tierces personnes, s'est réservé de les reproduire, et qu'il a cédé ce droit à Barbedienne, en juin 1857, pour *Hercule*, et en novembre 1860 pour *Diane*, en renonçant à toute rétribution d'auteur; – Attendu à l'égard des bustes de la *Bacchante*, que si Barbedienne n'est pas le propriétaire de l'original, Clésinger lui en a donné un buste-copie; – Attendu que Barbedienne a pu légitimement faire des réductions de cet exemplaire, devenu sa propriété; En ce qui touche les bustes des deux Césars; – Attendu que, par les conclusions du 14 novembre 1866, Clésinger s'est désisté de toutes prétentions à leur propriété. . . ." In the *Annales* there appeared on the legal issues involved a commentary: "Le retentissement considérable qu'a eu cette affaire est dû moins à l'importance du procès lui-même qu'aux attaques et insinuations dirigées par un grand artiste contre l'un des plus honorables fabricants de bronzes de Paris, et à la production d'une correspondance intime de plusieurs années, qui non seulement a mis à néant tous les griefs du demandeur, mais l'a fait taxer d'ingratitude, en mettant en relief les services que lui avait rendus le défendeur avec une persistance et un désintéressement qui auraient dû écarter à jamais toute pensée d'un procès." 1867, pp. 401–406.

37. "Encore une vente! Vous allez encore une fois envahir l'Hôtel Drouot. . . . Vous prétendez désormais faire vos affaires vous-même, et supprimer les intermédiaires entre vous et le public ? Vous voulez l'affranchissement de

l'artiste ? A quoi sert-il en effet, qu'un artiste ait accumulé (comme vous l'avez fait) tant d'efforts heureux . . . si tout ce travail et toute cette gloire doivent le laisser aux mains et aux caprices des intermédiaires. . . ." G. Maillard, "A M. Carrier-Belleuse," *Catalogue des marbres et terres cuites*, Hôtel Drouot, June 4, 1874. "S'il a jamais connu l'embarras des richesses, ce n'est pas au début de sa carrière . . . Carrier ne cessait pas de fournir des modèles aux ateliers des orfèvres et des fabricants de bronze. Les Denière, les Christofle, les Barbedienne, et d'autres encore, ont jusqu'à la fin utilisé le crayon et l'ébauchoir de l'infatiguable inventeur. . . ." P. Mantz, *Carrier-Belleuse. Catalogue des Oeuvres Originales, Projets de Monuments . . . composant l'oeuvre de Carrier-Belleuse . . . ,* Hôtel Drouot, December 19, 20, 21, 22, and 23, 1887.

38. J. Janin, "Exposition des Produits de l'Industrie. Deuxième Article," *L'Artiste*, 2ème série, T. III (1839), 54.

39. "Pourvu que les bronzes que M. Fratin se propose de livrer à la spéculation des fabricants soient semblables à ceux que nous avons vus, le public ne sera plus admis à donner pour excuse qu'il achète de mauvais modèles, faute d'en trouver de bons." "Animaux en bronze de M. Fratin, fondus par M. Quesnel," *L'Artiste*, 1ère série, vol. 9 (1835), 281–282. (Le dépôt de ces bronzes est chez M. De Breaux, rue d'Alger No 3.) "La sculpture mise à la portée de nos petites habitudes d'intérieur et de nos fortunes divisées à l'infini n'est pas un problème aussi difficile à résoudre qu'on se l'imagine. . . . Les artistes se condamnent à orner leurs appartements de ces objets que les goûts réprouvent, plutôt que de descendre des hauteurs de leurs spéculations et de remettre l'art usuel dans la bonne voie en lui fournissant les modèles qui lui manquent. Il me semble donc que M. Fratin mérite des éloges pour avoir enterpris de faire de la sculpture à l'usage de nos appartements. . . . Ce sont autant de modèles dont l'industrie pourrait s'emparer pour ses bronzes et ses pendules. . . ." R., "Animaux en plâtre, par M. Fratin, (Chez Susse, Place de la Bourse)," *L'Artiste*, 1ère série, T. VIII (1834), 32–33. "Les petits animaux de M. Fratin ont déjà envahi le cabinet et le salon, et tous les intérieurs élégants dans lesquels, grâce à M. Dantan, grâce à M. Barre, grâce à M. Fratin, grâce à M. Barye, la sculpture a été la bienvenue. . . . Et puisque nous parlons de la statuaire de salon, cette charmante et nouvelle fantaisie . . . M. Pradier, qui comprend à merveille tous les caprices de la foule, voyant tous les succès de la petite statuaire, s'est mis, lui aussi, à produire toutes sortes d'ingénieux petit-chefs-d'oeuvres qui ont donné à son nom autant de retentissement que ses grands ouvrages. . . ." J. Janin, "Salon de 1839. Sculpture," *L'Artiste*, 2ème série, T. 2 (1839), 301–311.

40. "L'intervention des machines a été, dans cette propagande de l'art, une époque et l'équivalent d'une révolution; les moyens reproducteurs sont l'auxiliaire démocratique par excellence. Contester cette action est d'un aveugle; dédaigner cette influence serait d'un insensé; ne pas prévoir l'avenir de cette association du génie des arts avec la puissance des nouveaux moyens de reproduction à bon marché, c'est d'un esprit borné. . . . Une fois dans cette voie, aucun progrès ne doit étonner; et, si l'on me disait qu' . . . après la machine qui sculpte et la machine qui coud, on a trouvé une mécanique qui peint, je n'en serais pas surpris et j'y applaudirais. . . ." Cte de Laborde, *De l'Union des Arts et de l'Industrie*, T. 2 (Paris, 1856), 75–76.

41. "L'inventeur est un de ces hommes de génie . . . ce que l'imprimerie a fait pour le poème retrouvé d'Homère, M. Colas [*sic*] a su le faire pour la *Vénus de Milo*. Il l'a vulgarisée; il l'a mise à la portée de tous; il a fait non pas une de ces images en l'air, horribles et nauséabondes copies que les plâtriers colportent sur leur tête . . . il a fait une image vivante de ce grand marbre. . . ." J. Janin, "Exposition des Produits de l'Industrie," *L'Artiste*, 2ème série, T. III (1839), 17–23.

42. "Tout a été dit, ou à peu près, sur ce merveilleux initiateur, absolument incontesté maintenant. . . . Sa maison date de 1839. La *Vénus de Milo*, réduction en plâtre, fut son premier et pendant quelque temps son unique travail. . . . En 1836, deux autres chercheurs, partis de points différents et se rencontrant par hazard à un mois de distance, prirent des brevets pour reproduire mécaniquement et mathématiquement la ronde bosse. Ils s'appelaient Collas et Sauvage. Barbedienne, ouvrier de la fabrique décorative . . . s'associa Collas. . . . Depuis douze ans, l'institution travaillait et végétait parmi quelques élus, lorsqu'en 1851, Barbedienne inconnu mais inspiré osa envoyer à Londres l'immensité magnifique de Lorenzo Ghiberti, un exemplaire de vingt mille francs obtenu par le procédé Collas, et sa grande bibliothèque en bois noir et bronze qui était à la fois une innovation et une rénovation." A. Luchet, *L'Art Industriel à l'Exposition Universelle de 1867* (Paris, 1868), pp. 332–337. "Barbedienne est aujourd'hui une des gloires françaises, il occupe au sommet de cet art industriel dont on a fait un nouveau mot, sinon une chose nouvelle, une place universellement enviée. Il n'est dans aucune profession, dans aucun pays un homme qui par les mêmes chemins ait acquis une telle renommée. . . ." L. Falize fils, "Exposition Universelle. Les Industries d'Art au Champ de Mars, II. Les Bronzes," *Gazette des Beaux-Arts*, vol. 2 (1878), 613.

43. E. Cantrel, "La Monnaie de l'art. Les bronzes de Barbedienne," *L'Artiste*, nouvelle série, vol. 8 (1859), 179–181.

44. "Le but de la galvanoplastie est de précipiter et de fixer par l'action d'un courant galvanique un métal en dissolution, notamment de l'or ou de l'argent, du cuivre, du zing ou de l'étain, sur un objet donné, que cet objet soit un moule dans lequel l'empreinte à obtenir ne restera pas adhérente, ou qu'il soit une figure quelconque, qu'il s'agira de recouvrir à demeure d'une couche métallique

d'une épaisseur limitée." A. Guettier, "Bronzes et Fontes d'Art. Ouvrages d'art en métaux," *Etudes sur l'Exposition de 1867. Annales et Archives de l'Industrie au 19ème siècle*, 3ème série, fasc. 11 à 15 (Paris: E. Lacroix, n.d.), 333.

45. A. Luchet, *L'Art Industriel*, p. 347.

46. "L'apparition du zinc dans le domaine des beaux-arts est un fait entièrement contemporain . . . le zinc est cassant et très oxydable. . . . Il y eut un moment où l'avenir du zinc d'art, comme on l'appelle aujourd'hui, fut gravement compromis. Fort heureusement, et bien à point, la galvanoplastie arriva et permit de le revêtir d'une couche de cuivre. A l'aide de ce déguisement, qui lui donnait les apparences du bronze, le zinc-imitation du bronze fut accueilli, surtout à cause du bon marché. Une autre amélioration vint simultanément consolider et développer son existence. Ce fut à Paris qu'on vit surgir l'heureuse idée de couler le zinc dans des moules en bronze. . . . Avec le sable, il faut un moule pour chaque objet: donc, pour reproduire dix exemplaires de la même figure, il faut dix fois recommencer le même moule; tandis que dans le creux en métal on peut couler un nombre infini d'exemplaires. . . . Aujourd'hui pour tous les modèles qui doivent se reproduire en très grande quantité, on ne fait plus que des creux en bronze; pour toutes les pièces tirées à quelques exemplaires seulement, on se sert encore du moule à sable, malgré tous ses inconvénients. . . ." F. Barbedienne, "Bronzes d'art. Fontes d'art diverses," *Classe 22. Exposition Universelle de 1867 à Paris. Rapport du Jury International publié sous la direction de M. Michel Chevalier, T. 3. Groupe 3, Classes 14 à 26* (Paris, 1868), pp. 283–313. "L'écart du prix du bronze et du zinc d'art n'aurait pas été suffisant pour faire accepter largement ce dernier par la consommation . . . la reproduction d'un grand nombre d'exemplaires de la même oeuvre permet au fabricant de ne rien épargner pour la confection des modèles et de confier leur exécution à des statuaires de premier ordre." P. Poiré, *La France Industrielle*, p. 624.

47. "La galvanoplastie appliquée directement à la reproduction des oeuvres d'art, est une industrie spéciale, qui ne procède d'aucune autre et qui est appelée, dans une limite plus ou moins restreinte, à se substituer à la fonderie des bronzes. . . . on obtient des épaisseurs réduites que la fonte de donnerait pas; on évite la ciselure, qui est chère et qu'aucune opération mécanique ne saurait donner. Mais, justement, à cause de ces avantages, exclusivement mécaniques, et par cela même d'une portée plus industrielle qu'artistique, on produit des oeuvres généralement peu solides . . . et l'on obtient que des surfaces molles, pâteuses, quelque patine qu'on emploie ou quelque retouche qu'on opère." Guettier, *Etudes sur l'Exposition de 1867*, p. 334.

48. "La maison Barbedienne occupe actuellement 400 ouvriers et 20 artistes. . . . Sa fonction est de produire l'unité dans l'ameublement . . . la fabrique de la rue de Lancry est une cité où vingt industries se marient et s'emboîtent. . . . Tout cela est régi par un système de comptabilité qui prend la pièce à sa naissance et la conduit jusqu'au magasin de vente, supputant et déclarant heure par heure ce qu'elle a coûté en capital, travail et intérêts. Tout cela, et c'est mieux encore, visiblement animé par une affection collective qui harmonise et relie ces dignités humaines si diverses et leur donne une tournure de commun respect, d'estime réciproque, qu'il serait consolant de trouver partout. . . . Un but touchant et élevé, que certains pourront trouver révolutionnaire et insensé; car ce n'est pas la richesse, mais la sainte et noble restauration du beau." A. Luchet, *L'Art Industriel*, pp. 333–337.

49. ". . . quand l'artiste fait appel à l'industrie, il ne rencontre pas moins de générosité: Cavelier a vendu à Barbedienne, pour 3.000 francs, le modèle de sa *Pénélope*, et il prélève 250 francs sur chaque épreuve; or, il s'en vend une trentaine tous les ans. Pradier se serait grassement enrichi dans l'industrie, si la mort ne l'avait pas arrêté dans sa carrière, et ses oeuvres font la fortune de Susse et de vingt bronziers." De Laborde, *De l'Union des Arts*, vol. 2, 55.

50. "C'est surtout au point de vue philanthropique que ces messieurs [Christofle et Cie] ont rendu et rendent chaque jour de grands services à l'humanité et au commerce. Depuis 1845, date de la création de leur établissement, le chiffre des affaires faites chez eux, s'élève à la somme fabuleuse, mais bien exacte, de 107.161.412 francs et 15 cent. Il a été argenté plus de huit millions de couverts qui ont retiré 10.500.000 francs de circulation. Si une pareille quantité de couverts avait été exécutée en argent massif, elle aurait retiré plus de cent millions de numéraire. . . . Ces messieurs veillent avec une sollicitude pleine de bienveillance et d'intérêt sur leur nombreux personnel. La maison Christofle n'est-elle pas comme la mère protectrice de quinze cent ouvriers; elle leur donne un salaire honorable, elle leur fournit un service médical, elle organise des épargnes, elle fait des prêts sans intérêts, elle décerne des récompenses et des pensions." "L'Art appliqué à l'Industrie. Orfèvrerie galvanique," *L'Artiste*, vol. 3 (1867), 458–462.

51. "La moralité des ouvriers est en proportion de l'intelligence nécessaire à leurs travaux, ou de la fatigue qu'ils imposent. L'insalubrité des ateliers des doreurs, la fatigue extrême du travail de la fonderie, font contracter aux ouvriers de ces professions des habitudes et un régime pernicieux. . . . Avant la Révolution, le métier de fondeur se transmettait héréditairement. Cette tradition s'était conservée sous l'Empire; il en résultait que les enfants contractaient de bonne heure les vices de leur père . . . si aujourd'hui cette profession ne se montre pas

encore l'égale des autres, le tort doit en doit être imputé à ce qui reste d'hommes élevés sous l'empire de l'hérédité." S. Flachat, *Exposition de 1834*, pp. 44–45.

52. J. Barberet, Bronziers, *Le Travail en France. Monographies Professionelles*, vol. 2 (Paris, 1886), *passim*.

53. The workmen out on strike denied newspaper accounts that claimed they "non seulement demandent une part dans les bénéfices de l'établissement où ils travaillent, mais ils veulent obliger les patrons à ne recevoir aucun modèle s'ils n'a pas été accepté aussi par les ouvriers; les patrons refusent cette condition que serait la dégradation de l'art. On parle de soixante-neuf fabriques qui ont rendu les livrets aux ouvriers; quelques arrestations auraient eu lieu à la suite de menaces." *La Presse*, February 26, 1866, cited by Barberet, *Le Travail en France*, p. 131.

54. "La valeur des modèles est, comme l'outillage artistique, inappréciable. Elle varie suivant l'importance de la maison et le degré de réputation des artistes qui les ont créés. Mais c'est toujours une valeur considérable; un capital *dormant* qui, pour une partie, peut rester plusieurs années sans rapporter un centime." Barberet, *Le Travail en France*, p. 241.

55. S. Flachat, *L'Industrie, Exposition de 1834*, p. 46.

56. "Nous sommes heureux de constater comme un fait acquis, que les objets de vente possible et facile même ont seuls paru cette année, à l'exclusion des pièces dites d'exposition si souvent et si justement reprochées aux fabricants dans les expositions précédentes." L. Feuchère, "Bronzes," *Rapport du Jury Central. Exposition des Produits de l'Industrie Française en 1844*, vol. 3, 30.

57. "Voici une branche d'industrie qu'il serait difficile de disputer à la France, ou plutôt à sa capitale; car Paris fabrique annuellement pour 25 millions de bronzes dans lesquels la matière première n'entre guère que pour un tiers; le reste devient le salaire de l'invention et de 6.000 ouvriers." Jobard, *Rapport sur l'Exposition de 1839 . . .*, p. 1. "L'industrie des bronzes d'art est essentiellement française et surtout parisienne; aucun autre pays n'a une production comparable à la nôtre, ni au point de vue de l'importance, ni au point de vue du goût. . . ." *Exposition Universelle Internationale de 1889 à Paris, Rapport Général par M. Alfred Picard*, vol. 5 (Paris, 1891), 160.

58. "Les industries de la classe 22 (Bronzes d'art; fontes d'art diverses; objets en métaux repoussés) occupent environ 11.000 ouvriers; les uns travaillent à façon, les autres à la journée; pour ceux-ci, le salaire varie de 4 fr. 50 à 8 fr. Des exceptions en assez grand nombre dépassent de beaucoup ces chiffres. Le travail à façon subit la loi de l'offre et de la demande et se traite à forfait. . . . L'exportation qui était en 1863 de 44 millions, est descendue en 1864 à 40 millions, et en 1865 à 32 millions. . . . Il faut attribuer cette diminution si notable de nos exportations aux efforts que font l'Angleterre, la Belgique, l'Allemagne et même la Russie, pour établir chez elles la fabrication du bronze, du zinc et de la fonte de fer. . . . Dans cette fabrication, le métal entre approximativement pour les $2/9$ du prix de revient, et les sept autres neuvièmes appartiennent au travail manuel, à répartir entre les ouvriers mouleurs, fondeurs, ciseleurs, monteurs, tourneurs etc. . . ." F. Barbedienne, *Exposition Universelle de 1867 à Paris. Catalogue Général publié par la Commission Impériale. Première Partie . . . Groupes I à V* (Paris, Londres, n.d.), pp. 42–44. "Nous voulons exprimer hautement un voeu dont la réalisation contribuerait au développement et à la prospérité des industries artistiques; ce voeu consiste à préparer, sans retard, la suppression de ces mesures fiscales qu'on nomme *droits protecteurs*. . . ." F. Barbedienne, "Bronzes d'Art . . . Chapitre VII. Observations sur la liberté des transactions internationales," *Exposition Universelle de 1867 à Paris. Rapports du Jury International*, T. 3 (Paris, 1868), 311–313.

59. "3 Avril. Les *Misérables* paraissent aujourd'hui. Les journaux arrivent pleins de citations. 12 avril. Les *Misérables* sont à la troisième édition. 15 avril. Les journaux anglais et belges annoncent que les *Misérables* vont être saisis. 29 avril. Il y a onze contrefaçons des *Misérables*." V. Hugo, *Choses Vues*, 1861.

60. E. Pouillet, *Traité Théorique et Pratique de la Propriété*, pp. 23–33.

61. *Ibid.*, pp. 169–172.

62. "M. Susse a continué ainsi l'exploitation des oeuvres de Pradier, non seulement jusqu'à la mort de l'artiste, arrivée le 5 juin 1852, et dix ans après, mais jusqu'en 1872, c'est-à-dire pendant trente ans. . . . Il a fait des mises de fonds énormes, vingt, trente fois la valeur des modèles achetés. Les succès ont été divers. Quelques reproductions eurent un écoulement rapide, mais d'autres, entassées en magasin, attendent encore que la fantaisie d'un amateur vienne les en tirer. . . ." Senard, attorney for Susse Fils, *Pradier v. Susse*, December 31, 1874, Cour de Paris, cited in *Annales de la Propriété* (1875), p. 356.

63. *Miquini v. Landy*, May 26, 1838, Cour Royale de Bordeaux; *Collas and Barbedienne v. Galantomini*, December 17, 1847, Cour de Paris; *Collas and Barbedienne v. Galantomini*, September 1, 1848, Cour de Paris.

64. "Sans être une *oeuvre de génie*, la réduction Collas est à sa manière une oeuvre d'art par les difficultés qu'elle présente, par l'intervention qu'elle exige d'un artiste habile, et surtout par l'influence qu'elle peut avoir sur la civilisation future. Elle est une oeuvre d'art comme une traduction de Virgile une oeuvre littéraire. A tant de titres, elle doit être considérée comme une novation et elle doit être protégée, non seulement dans l'intérêt de

M. Barbedienne ou de tout autre, mais dans l'intérêt de tout le monde." Ch. Blanc, "Le procès Barbedienne," *Gazette des Beaux-Arts* (April 1862), pp. 384–389. ". . . qu'il nous soit permis de signaler la confusion que la confirmation du jugement jetterait dans toute l'industrie des bronzes. De tout temps, les bronziers ont été réputés propriétaires, sans obligation de dépôt, des modèles qu'ils ont réciproquement créés d'après des sujets antiques. . . ." Pataille, cited in *Annales de la Propriété* (1863), pp. 35–55. The court's decision was denounced in a statement carried by *La Réunion des Fabricants de Bronze* (meeting on December 16, 1861). Another project was signed by many of the statuette and *objet d'art* producers and inserted in the record of court proceedings. *Ibid.*, pp. 41–42.

65. "Mais les talents jeunes et inconnus, qui songera à eux. . . . Quel sera le dédommagement à eux réservé par l'avenir, au retour de cette modicité de prix, qui est une des nécessités, mais aussi une des plaies de la jeunesse et de l'obscurité . . . si . . . ils ont aliéné à tout jamais la propriété intégrale." U. Ladet, "De la propriété en matière d'art," *L'Artiste*, 2ème série, T. VII (1841), 72. "Le prix d'un tableau, d'une statue, quelque grand qu'il soit, disparaît le plus souvent devant les bénéfices considérables produits par les reproductions," A. Vaunois, *De la propriété artistique en droit français* (Paris, 1884), p. 293. "Vaunois rappelle que, de nos jours, Ingres vendit son tableau de l'*Odalisque* 1.200 francs, et en céda ensuite le droit de reproduction au prix de 24.000 francs; que, de même, le sculpteur Cavelier tira 80.000 francs de la cession du droit de reproduction de sa *Pénélope* dont il avait vendu l'original 10.000 francs seulement." Pouillet, *De la Propriété*, p. 401. "L'intérêt de ces amateurs est presque toujours contraire à celui des artistes . . . ils s'enrichiront donc, eux qui n'auront d'autre droit que d'être riches, tandis que la femme et les enfants de l'auteur seront en proie à la misère, parce que la loi, intervertissant les rôles naturels, aura créé un droit pour le riche amateur et n'aura laissé à l'artiste pauvre qu'une faculté dont la nécessité et le besoin lui interdiront presque toujours l'usage." "Du droit des Peintres et des Sculpteurs sur leurs Ouvrages" (read by H. Vernet at the Académie des Beaux-Arts on September 14, 1839), *L'Artiste*, vol. I (1878), 213–227.

66. "Il y a nécessité impérieuse d'assimiler le gouvernement et la Liste Civile à tous autres acquéreurs. En effet la jurisprudence vient d'admettre, dans l'intérêt fort mal entendu de l'art, que les oeuvres vendues au gouvernement ou à la Liste Civile tombaient dans le domaine public. Il en a résulté que l'art a été sacrifié à l'industrie. Les plus belles oeuvres, vendues souvent au gouvernement sans bénéfices, quelques fois même à perte, comme il arrive surtout en matière de sculpture, ont été livrées à l'industrie, qui, en les reproduisant à profusion et toujours d'une manière incorrecte, a prostitué les plus beaux

modèles et compromis la réputation des artistes. Elle leur a enlevé le seul moyen qu'ils eussent de bénéficier de leurs productions." "A Monsieur le Directeur. Observations adressées par les artistes à la Chambre des Députés sur la nouvelle loi relative à la Propriété Intellectuelle," *L'Artiste*, 2ème série, T. 3 (1839), 168–170. Signatories included: E. Blanc, Avocat; Pradier, Dumont, Richomme, Nanteuil, David (d'Angers); membres de l'Institut: Duret, Dantan aîné, Foyatier, Barre, E. Delacroix, Raggi, Duseigneur, Droz, Charlet, Etex, Flandrin (Hippolyte), Flandrin (Paul), etc. "Il s'agit, tout simplement, gardons-nous de l'oublier, pour la Liste Civile, d'escamoter la loi à son profit; et cela est si vrai qu'on espère abuser de l'obscurité et de l'insuffisance de la loi, pour en tirer des déductions merveilleuses. . . ." U. Ladet, "De la Propriété en matière d'art," *L'Artiste*, 2ème série, T. 7 (1841), 112.

67. Example of a *cession*: "Reçu de Messieurs Susse Frères de Paris la somme de deux Mille Cinq Cents francs pour vente à eux faite d'un modèle représentant Une Jeune Femme jouant avec un perroquet et Deux figures d'enfants aux fleurs. Avec droit de reproduction par tous moyens et procédés quelconques. Paris, le 24 de [?], 1842. J. Pradier." Private Archives, France.

68. "Le droit moral ayant pour but de sauvegarder la personnalité de l'auteur, à travers l'oeuvre, manifestation de cette personnalité, il paraît conforme à la nature de ce droit qu'il survive à l'auteur, du moins dans une certaine mesure. Sa fonction demeure la défense de la pensée de l'auteur. Il assure le respect dû à sa mémoire. Son exercice doit tendre au maintien fidèle de l'oeuvre dans la forme d'expression que l'auteur lui a donnée, et c'est en son nom que les nouveaux titulaires du droit moral l'invoqueront pour interdire les altérations, modifications, mutilations de l'oeuvre." A. Le Tarnec, *Manuel de la Propriété Littéraire et Artistique*, 2ème édition (Paris, 1966), p. 64.

69. "La Cour . . . considérant que l'appelant soutient seulement que Barbedienne aurait abusé de la reproduction en défigurant ses oeuvres par une exécution mauvaise; que les modèles en bronze, travaillés par des ouvriers inhabiles, seraient entachés de défauts très graves, qu'ils transmettaient à toutes les épreuves: – Que, pour remédier à cet état de choses, qui porte préjudice à sa réputation, l'appelant demande qu'il soit interdit de faire figurer sa signature sur les réductions en bronze, à moins que les modèles n'aient été par lui rectifiés et restaurés, et soumis à son contrôle. . . . Déboute l'appelant de toutes ses demandes." *Clésinger v. Barbedienne*, November 26, 1867, Cour de Paris. "Le Tribunal. . . . Attendu que cette vente, faite sans autres conditions, donnait à Lemaire, fabricant de bronzes, le droit de tirer des modèles dont il était le propriétaire tout le parti que comportent les usages du commerce, sans pourvoir toutefois les déna-

turer; – Qu'il pouvait ainsi, comme le font tous les fabricants de bronzes, faire subir à ces modèles diverses réductions qui en facilitent la vente sans que le mérite artistique de l'oeuvre soit sensiblement diminué; – Qu'il pouvait également soit les mettre en vente isolément, comme simples objets d'art, soit leur donner une destination utile en les faisant entrer dans la composition d'un candélabre dont ils demeuraient l'oeuvre capitale . . . les griefs de Ferrat à cet égard ne sont pas fondés." *Ferrat v. Lemaire*, December 31, 1862, Tribunal Civil de la Seine. "Il a été jugé . . . que l'artiste, qui a vendu son oeuvre sans réserve moyennant un prix convenu, soit au gouvernement, soit même à un particulier, doit être considéré comme ayant cédé non seulement la propriété de l'objet matériel, mais encore le droit de reproduction." Pouillet, *Traité de la Propriété*, p. 406. "Il a été jugé . . . que la vente d'une statue n'entraine pas aliénation du droit de reproduction, alors que, par ses actes contemporains de ladite vente, et notamment par l'exécution d'une réduction destinée au commerce, l'artiste a clairement montré son intention de conserver la propriété artistique de son ouvrage. . . ." *Ibid.*, p. 414. "Il a été jugé . . . que la possession d'un modèle d'une oeuvre de sculpture implique jusqu'à preuve contraire le droit exclusif de reproduction, alors surtout que l'achat du modèle a lieu dans une vente publique . . . qu'en l'absence d'une stipulation contraire dans le contrat de vente d'une statue originale, le droit de reproduction passe à l'acquéreur et ne reste pas au statuaire. . . . mais s'il est vrai, en principe, que la vente d'une oeuvre d'art emporte abandon au profit de l'acquéreur du droit de reproduction, néanmoins le fait par l'auteur, même après cette vente, de faire plusieurs éditions de son oeuvre sans que l'acquéreur ait élevé aucune réclamation, a pu être considéré par les juges du fait, tout au moins vis-à-vis des tiers, comme la preuve que l'auteur a conservé le droit exclusif de reproduction. . . ." Pouillet, *Traité de la Propriété*, p. 408. "Il a été jugé . . . que lorsqu'une statue est placée sur un monument public et national . . . le droit de reproduction est un droit qui appartient au domaine public . . . qu'il est d'autant plus naturel que la vente faite sans réserve par un artiste au gouvernement entraîne désaisissement pour lui du droit de reproduction, qu'il ne peut ignorer que les objets d'art ainsi achetés, destinés aux études et à multiplier les beaux modèles, sont, à partir de leur livraison, considérés comme propriété publique et, dès lors, comme pouvant être reproduits ou copiés au profit de l'industrie . . . que l'artiste qui a vendu son oeuvre au gouvernement, sachant qu'elle était destinée à la décoration d'un monument public et qui ne s'est pas expressément réservé le droit de la reproduire, doit être considéré comme ayant transmis à son acquéreur la pleine et entière propriété de la chose vendue avec ses accessoires, ce qui comprend le droit de reproduction. . . ." *Carpeaux*, April 24, Paris, in Pouillet, *Traité de la Propriété*, pp. 411–412.

70. *Catalogue des Marbres, Terres Cuites, Bronzes, Maquettes, Esquisses, Modèles, Moules, Oeuvres Originales de A. Carrier-Belleuse dont la vente avec droit de reproduction aura lieu par suite de décès . . . les lundi 20 et mardi 21 mars, 1893. Catalogue des Modèles Bronze Originaux et Plâtres Avec Droits de Reproduction. Oeuvres Remarquables de Clésinger et Falguière A Vendre par suite de liquidation et en vertu de deux jugements . . . Hôtel Drouot . . . les 5, 6, 7, 8, et 9 décembre 1887. . . .* Conditions Générales de la Vente: 1) Elle sera faite au comptant. . . . Conditions relatives aux oeuvres de Clésinger et de Falguière. 1) Les acquéreurs devront exploiter commercialement les oeuvres par eux acquises. 2) Il devront appartenir à la nation française ou à toute autre nation ayant passé avec la France des traités permettant la perception de droits d'auteur à l'étranger. N.B. En ce qui concerne les *conditions spéciales* de la vente, relative aux oeuvres de Clésinger, Falguière et Pollet, s'en référer au *cahier des charges.* . . . Spécialement, les originaux en bronze seront vendus avec droit de reproduction en matière d'édition, et les modèles en plâtre avec droit de reproduction en matière d'originaux. Oeuvres de Clésinger. Les droits de reproduction pour les oeuvres de Clésinger sont fixées ainsi qu'il suit: Droit de reproduction A. Droit de reproduction en toute matière d'édition et réduction en marbre, terre cuite et albâtre. Droit de reproduction B. Droit de reproduction absolu et sans limite en matière d'édition et en matière d'originaux, avec droit d'en exécuter une aussi grande quantité que bon semblera, sous cette réserve que les originaux seront en marbre, grandeur nature et $^2/_3$ nature. C. Droit de reproduction en toutes matières et en toutes grandeurs. *La reproduction en biscuit est formellement interdite pour tous les modèles de Clésinger.* [Note 1:] Les acquéreurs auront à payer aux ayant-droit de Clésinger comme redevances: 15% sur le produit net de la vente des oeuvres d'édition, 17% sur la reproduction des oeuvres originales (marbre ou terre cuite)." One hundred fifty-two models were offered for sale by Clésinger, some in seven sizes.

71. The sketch remained popular and sold well right to the century's end. "Les peintres, comme les sculpteurs, conservent les esquisses de leurs ouvrages; ces esquisses se vendent fort cher et sont très recherchées des amateurs. . . ." E. Blanc, "Observations . . ." *L'Artiste*; "De la Propriété en matière d'art . . .", *L'Artiste*, 2ème série, т. 7 (1841), 169. Although seldom noted, works left unfinished whether due to the artist's death or sometimes, with portraits, his model's, were indeed exhibited at this period. Rodin's decision to submit to the 1864 Salon his fragmentary *Homme au Nez Cassé* was certainly influenced for instance by an earlier and excellent example, the *Mercure* of J. L. Brian. That Brian froze to death in his unheated room was widely believed after his demise in January 1864. His fellow sculptor Cavelier saw the

work with an arm still missing and had a plaster mold made of it. Brian's friends got the work accepted by the Salon of 1864 where it was awarded the *Grande Médaille d'Or*. In the *Explication des Ouvrages de Peinture, Sculpture* (Paris, 1864), his entry reads: "Feu Brian, Jean-Louis . . . 2521. *Mercure*; statue inachevée, plâtre."

72. L. Clément-Carpeaux, *La Vérité*, vol. 2, 266.

73. A contract drafted for Carpeaux and Meynier on July 16, 1873 specified: "Les oeuvres reproduites et complètement terminées par M. Meynier aux prix ci-dessus seront soumises à l'examen de M. Carpeaux ou de son représentant lesquels seront les seuls juges de l'état des travaux et de leur acceptation." Archives du Nord. Another contract signed on November 5, 1873 indicated that ". . . M. Samuel Meynier . . . a accepté un emploi à partir du Ier janvier 1874 pour une durée de six ans consistant dans la direction complète de son atelier et la reproduction entière de ses oeuvres soit en marbre, bronze, terre cuite ou toute autre matière que M. Carpeaux introduira dans la reproduction de ses oeuvres . . . M. Carpeaux a reconnu que M. Meynier mettant son brevet de la machine outil à sculpter complètement et exclusivement à son service, il lui serait compté a raison de dix francs par chaque jour de travail . . . M. Meynier devra exécuter par la pratique en marbre les statues, bustes et statuettes dont M. Carpeaux lui confiera l'exécution conjointement avec M. Bernard . . . M. Meynier ayant pour emploi la direction complète des ateliers pour la surveillance de la machine, l'exécution des marbres, bronzes et terres cuites ou autres matières propres à la fabrication des oeuvres de M. Carpeaux. Il s'engage en outre à recevoir les commandes, en l'absence de M. Carpeaux, de faire les dépôts dans Paris, préparer les ventes à l'étranger, de faire les expéditions dans les départements et à tenir le journal des productions journalières et d'en suivre leur parfaite exécution." Archives du Nord. Another contract drafted after January 1, 1874 specified: "L'embauchage et le renvoi des ouvriers employés à la reproduction des oeuvres est confié à M. Meynier. Aucun différent entre eux et lui ne peut être jugé par M. Carpeaux. Tout ouvrier employé directement par M. Carpeaux pour l'aider dans ses travaux de modelage sera payé par M. Carpeaux et n'aura absolument rien à voir avec M. Meynier." Archives du Nord.

74. P. Poiré, *La France Industrielle*, p. 624; *Exposition Universelle Internationale de 1900. Rapport du Jury*, pp. 480, 490.

75. *Atelier Carpeaux. Catalogue. Modèles en bronze, terre cuite et plâtre, vendus avec droit de reproduction en bronze et marbre, composant l'Atelier Carpeaux dont la vente aura lieu. . . . le samedi 2 juin 1894* . . . (also sales of models on May 31 and June 1, 1894).

76. Private Archives, France.

77. ". . . des bronzes sur lesquels on appose effrontément une signature apocryphe (récemment Carpeaux)." Chantelou, "Au fil des Ventes. La sculpture contre le multiple," *Le Monde* (Paris), January 12, 1968, supplement to No 7153.

78. Private Archives, France.

79. "*L'Idylle*, bronze, patine brune, No 133. 'Ce modèle est unique et ne pourra jamais être reproduit en aucune matière. Je m'engage à briser le modèle en plâtre qui a servi à la fonte, aucun autre n'existant.' Lettre de Rodin à Antony Roux, 20 juillet 1891. *Iris*, plâtre original du bronze No 136, 'Reçu de M. Antony Roux la somme de . . . pour un groupe *Iris* dont il a la propriété entière' . . . 21 septembre 1885. No 148, *La Baigneuse*, plâtre original du bronze No 147, 'Reçu de M. Antony Roux la somme de . . . pour une petite figure *Jeune Fille au Bain*. Je la livre comme original, m'interdisant la reproduction. Deux ou trois épreuves ont été données en plâtre antérieurement à des amis. Signé: Rodin, 24 septembre, 1888,' *Glaucus*, plâtre original du bronze No 149. 'Reçu de M. Antony Roux la somme de . . . pour un modèle *Glaucus*. . . . Je m'engage à n'en plus faire, ni en bronze, ni en marbre, l'original étant à Monsieur Roux, qui ne peut non plus en faire plusieurs ni en bronze, ni en marbre, 22 juillet, 1891.'" *Collection Antony Roux, Catalogue . . . Galerie Georges Petit . . . les 19 et 20 mai, 1914*.

80. "Nous sommes un organisme d'État, placé donc sous contrôle comme tout établissement national, ce qui d'ailleurs constitue une garantie morale. Nous appliquons ici la volonté de Rodin: il voulait que son oeuvre atteigne un vaste public et en conséquence avait permis que chaque sculpture soit reproduite à douze épreuves, étant sousentendu que seraient respectées les dimensions. Mais vous n'ignorez pas que le sculpteur, dès 1900, cédant aux pressions des clients et des collectionneurs a procédé à des agrandissements, des réductions et plus tard même à des mutilations d'un grand nombre de ses oeuvres ce qui augmente considérablement encore les possibilités d'édition. . . . Pour chaque épreuve commandée, nous allons chercher le 'moule à bon creux' . . . Tous ces travaux sont extrêmement minutieux et je les surveille moimême personnellement. . . . L'oeuvre est toujours délivrée marquée du *copyright*, de la signature du fondeur et de la date d'exécution de la fonte. Nous remettons également toujours à l'acheteur un certificat d'origine, contrôlé par la Cour des Comptes, en même temps qu'un numéro d'inventaire." "Rénovation du Musée Rodin," *Le Figaro* (Paris), March 7, 1968.

81. "Ajoutons que cette exhibition offre la réunion de toutes les écoles, grecque, romaine, renaissance, Louis XIV, rocaille. . . ." S. Flachat, *L'Industrie. Exposition de 1834*, p. 46. "Les bronzes semblent se modeler sur la littérature: quand celle-ci était classique, les styles grecs et romains dominaient. Sous l'Empire ou sous le davidisme, c'était

Marius méditant sur les ruines d'un ouvrage de Leroy; Épaminondas expirant sur un *blanc* de Jappy, Socrate attendant, la coupe en main, la dernière heure d'un cadran de Lépaute; c'étaient Coclès, Périclès, Androclès; Isocrate, Théocrate; Hippolyte, Démocrite, Héraclite. A la restauration, la flatterie coula en bronze le siècle de Louis-Le-Grand pour honorer Louis le Gros. Le romantique arriva dans les bagages de d'Arlincourt et de Victor Hugo; le gothique ou l'art chrétien comme on dit, suivit Chateaubriand, M. de Caumont et les antiquaires de la Morinie. Le chinois apparut un instant à la suite de Kalproth et de Stanislas Julien; l'égyptien à la suite de Belzoni et de Champollion; sous peu nous aurons le bédouin, le kabyle et le cougouli. Nous verrons osciller des compensateurs entre les *portes de fer* et sonner l'Angelus au minaret de *Mazagram*. Les Amours soufflant des bulles de savon ou aiguisant leurs flèches commencent à disparaître pour faire place aux gracieuses châtelaines et aux élégants chevaux de Vernet, qui seront dans tous les temps et dans tous les pays, de fort jolis morceaux de sculpture. Cette variation dans les modes et dans le goût, en fait de bronze, est sans doute ce qui assure pour longtemps le monopole de cette industrie à la France. Les artistes parisiens ont cela de particulier qu'ils se ploient avec une merveilleuse facilité aux caprices du jour. Tel compositeur qui se trouvait *emberlucoqué* depuis deux ans dans les ornements fantastiques de la rocaille ou du moresque, est prêt à passer le lendemain aux lignes sévères de Vitruve ou de Michel-Ange, aux somptueuses broderies de l'*Alhambra*, de *Bélem* ou de *Batalia*; à l'élégante ogive et aux frêles colonettes du moyen-âge; maniant d'une main également sûre l'*étrusque*, l'égyptien et le grec, le persan et l'indou, le *boro-budor*, le *palenque* et le *branbanan*: voilà ce qu'on ne trouve pas en Angleterre; la mode est parisienne avant tout." Jobard, *Industrie Française . . . 1839*, pp. 23–24.

82. *Choses Vues*, July 4, 1865.

83. "Les progrès furent moins rapides dans l'industrie plus spéciale du bronze d'ameublement. . . . Une autre cause fut encore la reproduction à outrance des objets anciens des XVII et XVIIIèmes siècles . . . dans l'impossibilité d'obtenir des fabricants rien de comparable aux pièces qui nous restaient de ces belles époques, les amateurs prirent le parti de les faire copier. Il faut bien reconnaître que le résultat fut d'abord excellent . . . mais le goût de ces reproductions s'étendant chaque jour, et les premiers fabricants qui s'y étaient consacrés obtenant de vifs succès, on devait rapidement arriver à l'abus et ce fut bientôt à qui copierait l'ancien, non plus le mieux, mais le plus économiquement, c'est à dire fort mal." *Rapport du Jury International. . . . Exposition Universelle . . . de 1900, Première Partie*, pp. 460–461.

84. "Voici le *Pêcheur Napolitain* de Duret. La pensée de l'artiste a-t-elle été au delà de l'exécution du fondeur? Son modèle avait-il plus de grâce, plus de fermeté, plus

de cette vivace et fine nature des enfants du Midi? Mais peut-être est-ce au ciseleur qu'il faut rendre grâce de cette délicatesse et de cette pureté? Nullement, le ciseau a seulement effacé les coutures des pièces de moulerie. . . . Supposez une fonte mal faite . . . la trace du ciseau ne pourrait pas se dissimuler, et aussi bien pour les artistes que pour les praticiens, l'altération de la pensée serait évidente. Ainsi, la statue perdrait considérablement de son prix; et cependant l'intervention nécessaire du ciseleur en aurait notablement augmenté la dépense." S. Flachat, *L'Industrie . . . 1834*, p. 37.

85. "Nous avons trouvé dans la discrétion avec laquelle ces différents ouvrages ont été retouchés par le ciseleur la trace d'une intelligence de l'art à laquelle les fondeurs ne nous ont malheureusement pas habitués. Les bronzes qui sortent d'ordinaire de leurs mains pour être livrés au commerce sont préalablement polis, frottés par le ciseleur comme s'ils avaient été soumis à l'action du tour; en un mot, ils sont dénaturés au point que l'accentuation des formes et le sentiment de l'artiste disparaissent entièrement. Il n'y a pas de sculpture si forte et si naïve qu'elle soit qui ne devienne froide et décolorée en passant par les mains de ces malencontreux ciseleurs, et ce qui n'est pas moins à déplorer, c'est que le public s'habitue à cet aspect poli, luisant et frotté dans les bronzes, et n'en veut plus souffrir d'autre; son goût s'y affadit et s'y perd, comme à se familiariser avec le faire léché en peinture." "Exposition de l'Industrie Française," *L'Artiste*, Ière série, T. 7 (1834), 183.

86. "L'exécution, en fonte, au moyen de la *cire perdue* ne laissait rien à désirer; c'est une rénovation des procédés en usage dans les beaux temps de l'école florentine du moyen-âge. On les avait malheureusement abandonnés pour ne plus fondre qu'*en sable*. Ce dernier mode ne produisant que d'imparfaits résultats, mettait l'auteur dans la nécessité de livrer son bronze aux mains d'un ouvrier ciseleur; et celui-ci alors frottait, lissait, grattait, râtissait à sa guise; alors, adieu toute trace du talent créateur, adieu la souplesse des chairs. . . . Aucun bronze que ce soit, fondu depuis les trente dernières années, ne vaut-il mieux que les objets d'ameublement, bougeoirs, pendules . . . qui encombrent les boulevards. . . ." "Salon de 1831," *L'Artiste*, T. 2 (1831), 14.

87. "On a cru pendant longtemps que la fonte au sable ne donnerait jamais qu'une reproduction approximative du modèle; M. Quesnel a prouvé le contraire, et non pas par un seul exemple. . . ." "Animaux en bronze de M. Fratin, Fondus par M. Quesnel," *L'Artiste*, Ière série, vol. 9 (1835), 281–282; *Exposition des Produits de l'Industrie Française en 1844. Rapport . . .*, T. 3, 33. "Après la fonte, c'est la ciselure qui occupe la place la plus important. . . . Nous avons déjà vu disparaître un grand nombre de procédés malfaisants, d'erreurs accréditées par l'ignorance, tel que l'emploi systématique de certains outils qui

troublaient la forme au lieu de l'épurer." F. Barbedienne, *Rapport du Jury International . . . 1868*, T. 3, 289–290.

88. "Chaque bronze, en sortant du moule, est revenu au ciseau, ce qui lui donne cette finesse, cette légèreté dans les arêtes qu'une mécanique inintelligente ne pourra jamais obtenir." L. Clément de Ris, "Mouvement des Arts," *L'Artiste*, Vème série, vol. 10 (1853), 89.

89. "Mai 1874 . . . certes, la *Suzanne* que vous lui avez livrée est bien comprise, mais vous savez que dans la reproduction des oeuvres il y a une exécution que le public cherche, c'est le fini, or nous devons y sacrifier dans la mesure qui ne compromet pas les oeuvres. . . . S'il reste une révision à faire sur cette *Suzanne*, donnez-la, ou laissez à M. Meynier le soin de la faire terminer selon son désir." Carpeaux to Bernard, Archives du Nord.

90. See note 73, *supra*.

91. F. Barbedienne, "Du rôle des collaborateurs dans les industries du métal artistique," *Exposition Universelle de 1867. Rapport du Jury International*, T. 3, 308–310.

92. "Sa *Bacchante* de cette année est une soeur, et une soeur jumelle, même, de la femme piquée par un serpent exposée l'année dernière. C'est évidemment le même modèle qui a posé . . . ces deux pendants sont trop ressemblants pour ne pas se nuire, s'ils étaient placés à côté l'un de l'autre: même attitude couchée, même contournement de la ligne. . . ." A.J.D., "Beaux-Arts. Salon de 1848," *L'Illustration. Journal Universel*, T. XI (1848), 212. ". . . une grande terre cuite représentant une femme couchée. Chacun connaît, de nom sinon de vue, car ce marbre est depuis trente ans dans une collection particulière, la *Femme piquée par un serpent*. Clésinger a refait cette figure avec d'importantes modifications. C'est comme une seconde pensée de la *Femme piquée*, et cette nouvelle oeuvre égale la première, si elle ne la dépasse pas. Le petit aspic de bronze . . . est remplacé par un serpent de grande taille. . . ." H. Houssaye, "L'Exposition des oeuvres de J. Clésinger," *L'Artiste*, I (1879), 316–317.

93. "Le *Taureau* dit l'*Appel* est-il le même que le *Taureau Vainqueur*? Clésinger, s'est-il contrefait lui-même? "Chronique," *L'Artiste*, T. II (1878), 359–360. "Attendu que les experts [Bonnassieux and Chapu] constatent que si les deux groupes à comparer offrent de l'analogie dans la silhouette générale, l'idée même de la composition est différente; que, d'autre part, les mouvements respectifs, les attitudes ne sont pas les mêmes; qu'il résulte de ces énonciations que le groupe refusé doit être considéré comme une oeuvre distincte. . . ." *Heilbronner v. Clésinger*, August 17, 1877, Tribunal Civil de la Seine. "S'il est facultatif à un artiste de se répéter dans ses oeuvres, alors qu'il est resté le seul et unique propriétaire de son oeuvre, il n'en est plus de même, lorsqu'il a aliéné son droit de propriété et de libre reproduction. Il en est surtout ainsi lorsque l'artiste a aliéné des oeuvres au profit d'un commerçant dont la spéculation porte principalement sur la reproduction et à l'égard duquel toute reproduction ou imitation servile de l'original constituerait une contrefaçon ou tout au moins un fait de concurrence illicite. Toutefois, dans les arts plastiques et spécialement la sculpture on doit tenir compte de la difficulté de créer des types absolument nouveaux et il suffirait à l'artiste, pour échapper au reproche de contrefaçon ou de plagiat, de varier la pose, l'expression et les accessoires des sujets déjà traités par lui ou par d'autres, de manière que ses nouvelles productions puissent être considérées comme des oeuvres originales et distinctes." *Heilbronner v. Clésinger*, May 3, 1878, Cour de Paris, in *Annales* (1879), pp. 167–172. ". . . l'auteur . . . sans se faire pour cela le plagiaire de soi-même ou d'autrui . . . se complaît, suivant les tendances de sa fantaisie ou de ses études, dans des créations d'un même genre ou d'un genre analogue; – Qu'il suffit alors, pour distinguer celles-ci, que la pensée en soit autre, ou que les formes diffèrent ou que les dissemblances . . . ne permettent pas . . . une confusion de nature à déprécier la valeur de la première oeuvre originale, ou à écarter l'acheteur des magasins de l'industriel ou du commerçant cessionnaire. . . ." *Ibid.*

94. "Le Tribunal: – Attendu que Carpeaux, auteur de l'un des groupes qui décorent la facade du nouvel Opéra, a fait saisir, le 2 septembre 1869, dans les magasins de Randnitz, photographe, les épreuves reproduisant cette oeuvre et leurs clichés. . . . Attendu . . . que Carpeaux, en vendant au Ministère de la Maison de l'Empereur le groupe qu'il s'engageait à exécuter, ne s'est point réservé le droit de le reproduire par la photographie ou par tous autres procédé, qu'il a aussi transmis à son acquéreur la pleine et entière propriété de la chose vendue avec ses accessoires, ce qui comprenait le droit de reproduction; – Attendu que, sans qu'il soit besoin d'examiner si la commande faite à Carpeaux a eu pour effet de conférer à son oeuvre le caractère d'une propriété publique pouvant être reproduite par tous, il résulte de ce qui précède que les saisies dont il s'agit ont été pratiquées sans droit ni qualité par Carpeaux. . . ." *Carpeaux and Appert v. Randvitz and Ledot*, April 24, 1872, Cour de Paris et Tribunal Civil de la Seine.

1a. Nineteenth-century sculpture-modeling tools as
depicted in a publication of the period (William
Ordway Partridge, *The Technique of Sculpture*
[Boston: Ginn and Company, 1895])

1b. Nineteenth-century plaster-working tools (*ibid.*)

A Technical View of Nineteenth-Century Sculpture

This technical "introduction" to the broad subject of *Metamorphoses in Nineteenth-Century Sculpture* is actually an epilogue to the joint analysis, by scholar and technical specialist, of the works and sequences of works we will examine in this publication. Only the exchange of questions and answers generated by these discussions could result in the information and conclusions to be found in this essay and in the chapters that follow.

As incomplete as some of the findings may have been, at least in broad retrospect we can firmly outline the most useful topics discussed. Foremost among these is chronology. Working with accurate historical information, a technical specialist can sometimes help suggest an order of manufacture in a sequence of multiples. Another important topic deals with the purpose of a given model or cast. In the course of our studies for this publication, the original uses of a number of objects have been firmly identified. Out of close comparative technical analyses arises an inevitable discussion of the merits of a particular cast and the part the artist might have played in its manufacture. These discussions cannot avoid some appraisal of quality and frequently may deal with the possibility of proving the "originality" of a given work.

In short, the cooperative efforts of art historian and technical specialist can produce information relevant to the age, quality, and uniqueness of the work under consideration. Needless to say, it is these factors which not only enhance our enjoyment of an object but also are the criteria for establishing its monetary value.

TEN TERMS DEFINED

Words often used in common by historians, artists, and technical specialists to describe sculpture and sculptural procedures do not always have the same meanings. It is the intent in defining and discussing ten most often used terms to establish, at least within the bounds of this publication, a foundation on which further discussion can be built with a minimum of confusion. The procedures described below apply primarily to nineteenth- and early twentieth-century practice. Although the present tense will be used for convenience and consistency, some of the techniques and materials described are no longer in common use.

1. Modeling

When applied to sculpture, the term *modeling* refers to the manipulation of a plastic material such as clay, wax, or plasticine, otherwise known as plastiline (a combination of non-drying plasticizers and dry clay apparently invented in the nineteenth century). Plaster can be modeled as it solidifies, but direct plaster technique is rather uncommon because of the short working time of the material in its plastic state.

Modeling is often spoken of as an additive process, whereas carving is strictly a subtractive one. In fact, although technique may vary from artist to artist, modeling is not always strictly additive. Modeling tools are designed as much to remove plastic material as to add or shape it (nos. 1a, 1b). Modeling should be considered more in terms of the flexibility of the material involved rather than addition.

Some writers refer to subtle passages of stone carving as modeling; and the same term is used to refer to dimensional illusion in drawing or painting. Modeling in these senses should not be confused with the technical term, even though interconnections are obvious.

2. Carving

Although this term can be applied to a technique employed on a plastic material, *carving* most frequently refers to the removal of material from a rigid substance such as stone, wood, bone, or ivory. The important principle to remember is that carving is essentially subtractive. However, elements of a single sculpture may be carved separately and later joined mechanically, as with arms, legs, or separate figures comprising a complicated sculpture group.

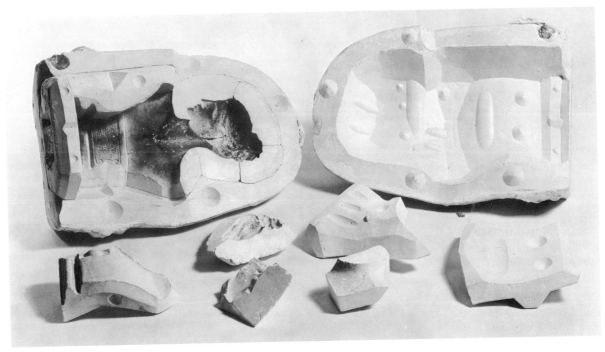

2. Plaster piece mold and "mother mold" (*Diana of the Tower*, Augustus Saint-Gaudens)

4a. Detail of a plaster cast showing the parting cut marks of a gelatin mold (*Ralph Waldo Emerson*, Daniel Chester French)

4b. Detail of another plaster cast of the same sculpture (no. 4a) showing the same parting line and an additional cut line from a second gelatin mold made from this model

3. Molding

A mold takes the negative impression of a form. *Molding* or mold-making may be accomplished by a number of techniques in a variety of materials. Although it is possible to model or carve negatively, and thus make a direct mold (as was the method used in ancient clay or stone seals), the normal practice begins with a model. The model itself can be either plastic or hard, even made of stone or bronze.

Plaster: The most common mold material is plaster, often called "plaster of Paris" (partially calcinated or dehydrated gypsum). Molds made of plaster take two basic forms: "waste molds" and "piece molds." As the name implies, waste molds are used once to produce a cast, and are then broken away in the process of revealing that cast. Waste molds for three-dimensional sculpture are usually made in two or more large sections, to facilitate removal from the model. For waste-molding the model must be made of a plastic material such as clay, wax, or plasticine. Undercut areas in the original model are inevitably damaged when large waste-mold sections are removed. Sometimes if the model is not seriously damaged, an artist may choose to repair it. If the model is made of clay, it may be preserved by firing in a kiln to change it to more durable terra cotta. The reason the mold must be broken away from the cast is to preserve the fragile undercut areas in the cast.

Another technique for preserving undercut areas in both the model and the cast is to create separate mold pieces for each undercut form. Piece-molding can be performed on a model made of almost any material. The many separate mold parts of a "piece mold" are keyed to fit together and held in place by an outer (so-called) "mother-mold" (no. 2). A piece mold made of plaster can be used to make countless casts, and the same mold can be used to make casts of different materials. Casts from a plaster piece mold are most frequently made of plaster, wax, clay, or clay intended to be fired as terra cotta.

Gelatin: Gelatin or glue molding is another technique designed to deal with undercut forms. In this case, the mold material is flexible and can be pulled away from a model in large cut sections (no. 3). The date of invention of this technique may fall within the first half of the nineteenth century. Published articles show the technique in use in the United States by 1865.

The model from which a gelatin mold is to be taken should be fairly durable, usually either plaster, bronze, or terra cotta, although it is possible to make a special gelatin mold on a wax or plasticine model. The flexible gelatin mold requires a rigid outer plaster retainer-mold to hold it in place while a cast is being made. This combination of plaster retainer-mold and gelatin mold is fashioned in the following way. The model is first completely covered with a plastic material, such as clay, of a thickness equal to the thickness desired for the ultimate gelatin mold. Next, the plaster retainer-mold in two or more large sections is constructed over the covering plastic material. When the retainer has solidified it is removed. The model is then cleared of plastic material and the plaster retainer-mold put back in place over the model. The resulting space, formerly occupied by the plastic material, is filled with

3. Gelatin mold being removed from plaster model. Plaster retainer mold sections can be seen in the foreground and background (*Podenas*, Honoré Daumier).

5a. Bronze metal plaquettes being used as founders' models in a simple two-piece sand mold. The iron frame containing the sand is called a "flask."

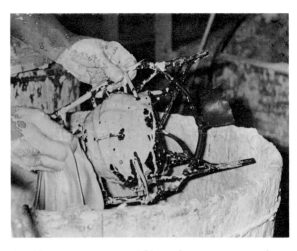

6a. Fine investment material is used to coat a wax cast (*Podenas*, Daumier).

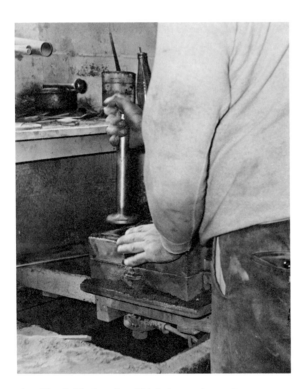

5b. Top half of sand mold is being made over bronze models (no. 5a).

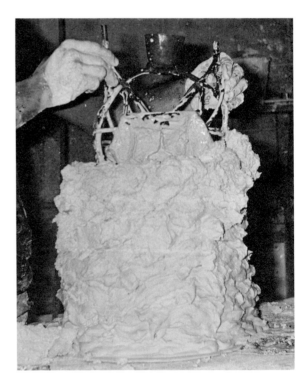

6b. Thinly invested wax cast (no. 6a) is placed into large cylindrical mold made of coarse investment material (see no. 15).

warm liquid gelatin or glue. When the liquid material cools and solidifies to a cohesive but flexible state, the outer retainer-mold is removed. The new gelatin mold is then cut with a sharp knife into two or more large sections, corresponding at least in part to the large sectional units of the retainer-mold. The gelatin mold sections are then carefully peeled away from the model (see no. 3). Casts made from gelatin molds are usually plaster or wax. Depending on the complexity of the mold, the material to be cast, and the skill of the caster, a fragile gelatin mold can be reused an average of six times or even ten or more times (nos. 4a, 4b). It cannot be stored, since the gelatin loses shape as it dries out.

Sand: "Sand-molding" is a foundry technique for casting in metal. The material used varies in composition but can generally be described as a cohesive plastic fine-grained sand. "French sand" is a natural reddish brown sand, found near Paris, which is famous for its excellent molding properties. Sand-molding is very similar to the plaster piece-molding technique previously described. Iron or wood "flasks" serve as outer retainers for the sand-mold pieces or sections (nos. 5a, 5b). Models for sand-molding are usually made of plaster or bronze, but occasionally of wood, wax, or terra cotta. Most sand-molds must be heated to consolidate the sand and to drive off moisture before hot liquid metal can be poured into them. Sand molds can be used only once, being destroyed in the casting process.

Investment: Investing is the molding process for the "lost-wax" (*cire-perdue*) metal-casting technique (nos. 6a, 6b). The model is always made of wax and is completely surrounded by a single investment mold. When the mold is heated the wax model melts and runs off, hence the name "lost-wax." Investment molds are often described as being made of "refractory" material, which simply means that they can resist the intense heat of molten metal (no. 7). There are a number of formulas for investment material. Plaster and clay are fundamental binders in many investments while a list of secondary ingredients would include sand, asbestos, organic matter, and "luto" (crushed, previously fired investment).

4. *Casting*

The negative impression in a mold, which was originally occupied by the model, is replaced or filled by *casting* in an appropriate material. Most casting is done with materials in either a cold liquid or molten state. Clay in a plastic state is pressed into a mold to make a cast.

Plaster: Plaster casts are usually made in either plaster or gelatin molds. Separating or "parting" substances are employed to facilitate release of plaster molds from plaster casts. Casting with plaster primarily involves working with the material in a liquid state when it can be poured or brushed into a mold. Small sculpture can be cast solid by pouring directly into the mold.

If a cast is to be made hollow, the plaster is poured and then rolled back and forth, coating the mold as it hardens, or brushed on in a pasty state. For a sculpture of complex configuration that is to be hollow-cast, mold sections may be coated separately, assembled, and the adjoining seams poured and roll-coated. Once the entire surface of the mold is coated, subsequent layers of plaster, which must serve as structural reinforcement in a hollow cast, often contain strengthening elements such as hair or fiber. When accessi-

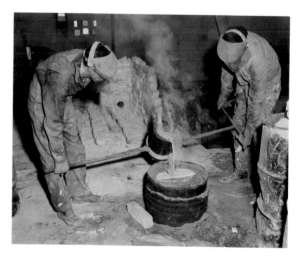

7. Molten bronze is poured into previously fired investment mold surrounded by compressed sand and a steel retainer.

33

FERNALD LIBRARY
COLBY-SAWYER COLLEGE
NEW LONDON, N.H. 03257

8. Damaged plaster piece-mold cast reveals internal metal armature (*Diana*, Saint-Gaudens).

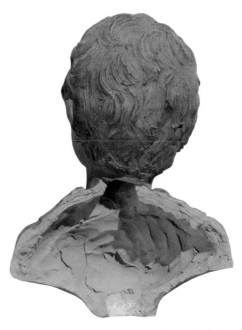

9. Back of mold-made terra cotta shows hand-fashioned internal support elements (*La Danse*, Jean-Baptiste Carpeaux)

10a. Damaged mold-made terra-cotta bust which has split at original sectional joint. Tool marks can be seen along break where joint was roughened to receive coat of clay slip (*Bust of Child*, Jean-Antoine Houdon).

10b. Back section of damaged bust (no. 10a) revealing clay slip (now fired) on surfaces of join

bility permits, final layers of pasty-state plaster may be applied with tools or by hand.

Solid-cast plasters with thin protruding elements are frequently reinforced with internal metal armatures. These support armatures may be placed in position while mold sections are still open and accessible. When these molds are assembled or closed the cast can then be poured solid (no. 8).

Clay or terra cotta: Strictly speaking, terra cotta cannot be cast; however, most clay casts are fired and ultimately become terra cottas. Clay is usually cast in plaster piece molds. Depending upon its composition and consistency, clay can be cast in one of two ways—"slip-casting" or "press-molding." Slip-casting involves pouring liquid clay or slip directly into a mold in the same way as plaster might be cast. Excess water is absorbed into the plaster mold and multiple layers of slip are added until the desired wall thickness is obtained for the cast.

Press-molding employs clay of the approximate consistency of modeling clay, which can be pressed or "squeezed" into an open piece mold. In order to minimize shrinkage distortion, clay casts are usually made hollow. Clay support elements may be added, where accessibility permits, to strengthen the overall form (no. 9). Independent sections of clay are roughened at adjoining edges and coated with slip for the joining process as mold sections are assembled (nos. 10a, 10b). These mold sections, as previously described, are mother mold units which themselves hold multiple mold pieces (see no. 2). When the entire piece mold is assembled, and the clay allowed to dry slightly and shrink away from the mold, first the mother mold and then each separate mold piece is removed from the cast. At this stage in both the slip-casting and press-molding techniques, when the clay is still workable, mold lines are removed, details are sharpened or added, and inscriptions and signatures are often made.

Wax: Like plaster and clay, wax can be cast in a plaster piece mold; gelatin is also a common mold material for wax casts. Hot liquid wax is poured into a mold which is then rolled back and forth, allowing the wax to coat all surfaces to a desired thickness as it cools. When the wax cast is to be used in the lost-wax process, the thickness of the walls is controlled with the ultimate metal wall thickness in mind. When the wax has cooled and the mold is removed, mold lines may be tooled away, and reworking or marking may be done.

Metal: Casting sculpture in bronze or other metals is usually accomplished by one of two basic procedures—lost-wax and "sand-casting." Although primarily used for making decorative objects, "slush-casting" is a third alternative. In this process molten zinc, tin, or lead is slushed (rolled around) in molds made of iron or brass, coating them as the metal cools and solidifies.

The lost-wax (*cire-perdue*) process is further subdivided into "direct" and "indirect" casting. The direct method may be described as a simple substitution resulting in a unique cast. A wax model, not mold-made and therefore itself unique, is invested, and then the investment is heated to melt off the wax. The resulting space is then filled with molten metal; the original wax model is therefore lost and replaced with a metallic one. Minute details and undercuts are fully translated into metal (see nos. 11a, 11b). The indirect method is identical with the direct method in the metal-casting stage, but the wax model used is mold-made and therefore not unique—and perhaps not as sharp. The additional step involving a mold other than the investment mold constitutes the "indirectness" of the procedure.

Sand-casting normally involves a reusable model and therefore the resulting metal cast is not a unique image (see nos. 5a, 5b). In sand-casting, the sand piece mold is fashioned on the model (no. 12). If the model is complicated or large and heavy, it may be cut apart or constructed in sections to facilitate the sand-molding process (nos. 13a, 13b). Metal objects themselves may be sand-cast in separate sections and later joined in the finishing process (no. 14). Each of these sections would have its own model for sand-molding.

There are several outstanding reasons for this procedure. First, it is an obvious way to deal with complex forms otherwise impossible to piece-mold as a whole in sand. Second, if a piece should be miscast, only the part is lost and not the whole.

11a. Nearly solid direct lost-wax bronze cast (*Stag Attacked by a Lynx*, Antoine-Louis Barye, Walters Art Gallery, Baltimore, Maryland)

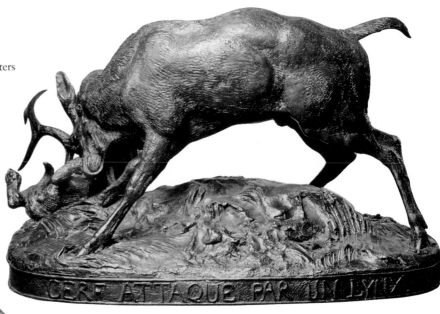

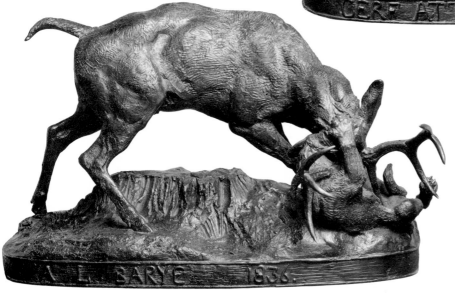

11b. Opposite side of no. 11a

12. Fine scratch marks made accidentally in the process of constructing a sand piece mold on a plaster foundry model (*Emerson*, French)

36

 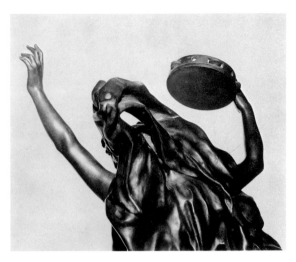

13a. Detail of a bronze foundry model used for sand molds. The individual sections of each arm, the tambourine, and the top of the drapery are secured with pins and can be easily removed (*Le Génie de la Danse*, Carpeaux).

13b. Detail of finished bronze sand cast which might have used no. 13a as a model. Joints for the arms and tambourine (loose) are visible but the drapery appears to have been cast as one section with the figure.

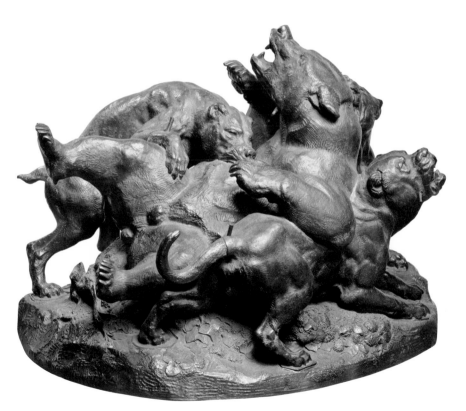

14. Unfinished bronze sand cast in which separate sections are still visible. Note tail in foreground, paws of the dogs, and jaws of the bear and dog to the right (*Bear Attacked by Dogs*, Barye, Walters Art Gallery).

15. Core investment material is poured inside a hollow wax cast (see nos. 6a, 6b).

16. Core profile of a sand-cast bronze (*Emerson*, French)

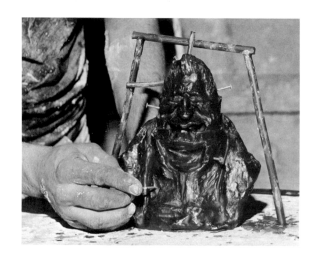

18. Chaplet is pushed into a wax cast in preparation for investing (*Podenas*, Daumier).

17. Core profile of a lost-wax cast bronze. The white material is investment (*Emerson*, French).

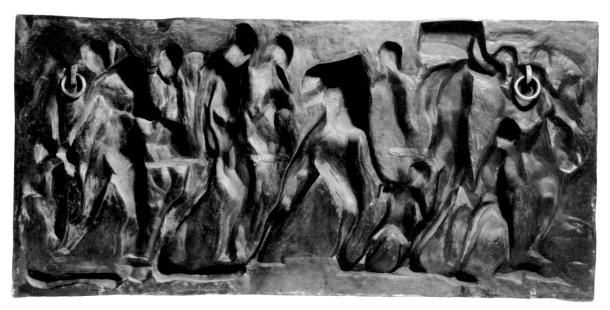

16a. Back of a sand-cast bronze relief. The hand-cut geometric quality should be noted (*Les Emigrants*, Daumier).

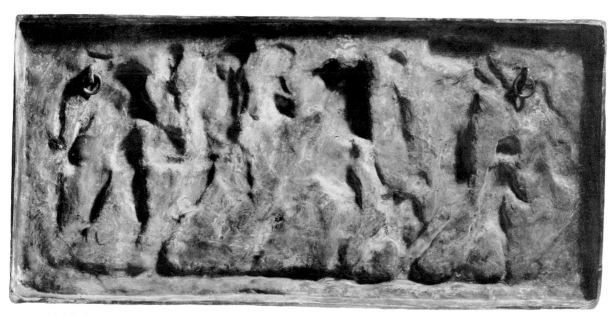

17a. Back of a lost-wax cast bronze relief. The fluid quality should be noted (*Les Emigrants*, Daumier).

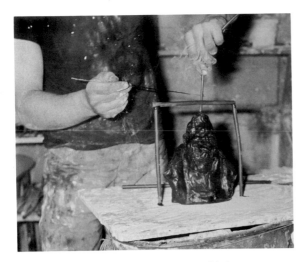

19a. Wax gating and venting system is added to a wax cast.

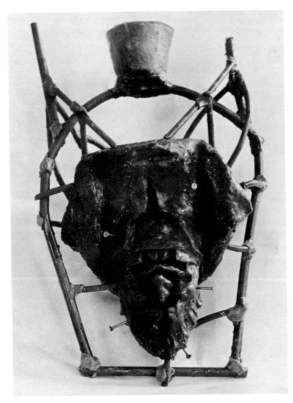

19b. Completed wax gating and venting system prior to investment. The cup-shaped form at the top is called a "sprue." It acts as a reservoir for molten metal in the pouring process.

(In practical terms this might mean a day's work lost instead of a week's.) Finally, casting in sections facilitates the making and removal of "cores" (internal mold elements for making hollow casts). A divided model does not necessarily mean that these same divisions will appear in the sand cast. As explained above, these cuts are sometimes made to assist the sand-molder in handling a complicated or heavy model when fashioning a delicate, complicated mold. When the mold is complete and the model sections removed, the assembled sand piece mold itself may then permit a monolithic cast (see nos. 13a, 13b).

Although some small bronzes and other metal casts may be made solid, most are hollow. The reason is not only one of economy and weight, but also one of structure. A large volume of metal, cooling and shrinking disproportionately to a thick volume, can become distorted and crack at the point of a junction. The technique employed in both sand-casting and lost-wax casting to make hollow casts is called "coring."

A "core" is simply a mold extension that occupies the desired space inside a cast (see no. 20). In the lost-wax process coring is accomplished by filling the inside of the hollow wax with investment material (no. 15). Occasionally, a wax model for a "direct" lost-wax cast may be modeled over a premade core. In a sand cast the core must be carefully fashioned, in sand, by hand (nos. 16, 16a). This is sometimes done by forming a model in sand and shaving it down to the size desired for the thickness of the final metal cast. As previously mentioned, the wall thickness of a lost-wax cast is controlled by the thickness of the wax rolled or brushed into the mold (nos. 17, 17a). In both cases, the core must be held in place while the molten metal is poured into the cast, so that it does not fall against the outer mold. The solution to this problem is the "chaplet." "Chaplets" are metal pins that run from inside the outer mold into the core, bridging the space in between (no. 18).

In order for molten metal to flow into a mold evenly from the bottom up and for trapped gasses to escape, a "gating" (or "ducting") and "venting" system must be constructed. In the lost-wax technique this system is made of wax and attached

to the wax model prior to investing (nos. 19a, 19b). In sand-casting the flow system is cut into the sand-mold. In both cases the system ultimately becomes a metal appendage on the cast. This appendage is removed as part of the finishing or chasing process (no. 20).

5. *Finishing or Chasing*

Molds in more than one piece, no matter how carefully constructed, will imprint their joining lines on a cast (nos. 21a, 21b). Likewise, cracks in a mold or investment will leave positive "flashing" on a cast. Chaplets, when removed, leave holes. Flow systems leave forms which must be cut off (see no. 20) and bubbles in a mold create flaws which the artist must correct. *Finishing* or *chasing* is the process of removing or otherwise dealing with disfiguring elements in a cast. By extension, it

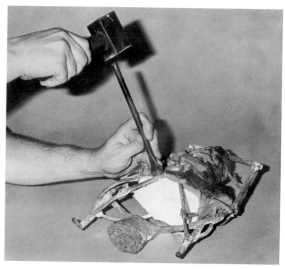

20. Bronze gating and venting system is removed from a cast. Core material can still be seen inside the cast.

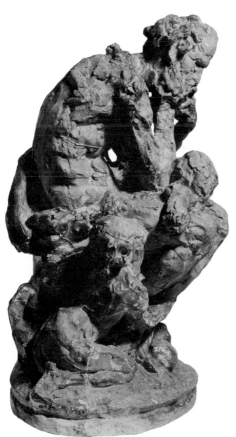

21a. Plaster piece-mold lines as seen on a plaster cast (*Ugolin*, Carpeaux)

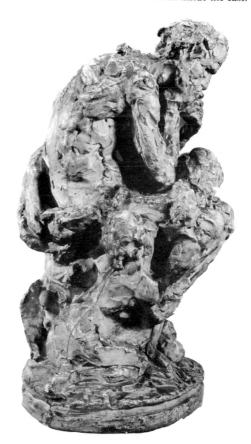

21b. Gelatin mold lines as seen on a plaster cast

41

22. Detail of a bronze cast showing "chasing" for definition (*Benjamin Franklin*, Houdon)

appears that early nineteenth-century metal casts, continuing in a tradition from earlier centuries, were also embellished during the chasing process. This decorative chasing may be very extensive, especially when performed by an artist to add textural interest or detail to his work (no. 22).

Plaster: Casts made of plaster generally require only one type of finishing, the removal of mold lines. If the casts come from a gelatin mold there are occasionally positive bubbles which may also need to be removed. This finishing is usually done while the plaster is still damp and therefore not completely hard. If mold lines are not removed and the plaster cast is itself used as a model, subsequent casts may possess multiple sets of mold lines (no. 23).

Clay or terra cotta: All finishing is actually performed in the clay state while the material is still damp and soft or at most "leather hard." Clay casts generally need a great deal more finishing than plaster casts simply because soft clay forms are more easily damaged as mold parts are removed. The difficulties inherent in working with a soft cast often lead to wide variance in detail of the terra cottas within a single edition (nos. 24a, 24b). This is especially true if a finisher does not have the model present for reference. In some instances an artist may intentionally create variances in order to make each cast "unique" (nos. 25a, 25b). In this respect, the after-work on a clay cast is comparable to the chasing of textural accents on a bronze (see no. 22).

Wax: The finishing of wax, like plaster casts, is mainly a matter of removing mold lines and minor flaws. Frequently founders' stamps and signatures are added in a wax at the time of finishing to assure legibility in the final metal image. Obviously, imprinting the soft material is much easier than engraving metal.

Metal: The finishing or chasing of metal casts begins with the removal of the gating and venting system (see no. 20). Chaplets also are removed and the resulting holes often threaded so that corresponding threaded plugs can be inserted. The parts of casts made in sections are joined, usually with threaded fastenings or tapered pins. Little welding (fusing of metal), except for "soft" sol-

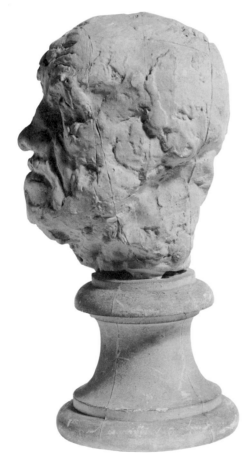

23. Proper left profile of plaster cast showing multiple mold lines (*Little Man with the Broken Nose*, A. Rodin)

dering (tin-lead), was used for joining in nineteenth-century metal sculpture. The reason is not primarily technological, but more a question of the reproductive nature of casting in the period. Welding can severely alter forms in proximity to a join and necessitate extensive chasing for correction. If left to a craftsman these "corrections" could alter the artist's work.

If attachment pins or chaplet hole plugs are located in visible areas of the sculpture, they are cut off and polished flush with the finished surface. Most metal casts emerge from the mold covered with a "fire skin" or layer of burnt mold material and oxidized metal which must be removed physically or chemically (no. 26). Mold lines and flashing are removed with chisels and files. Any serious casting flaws that appear as losses are filled with metal plugs; lead or solder is sometimes used to fill losses or seams along the joints of a cast made in sections (see no. 14). Finally, any additional details, marks, or signatures may be added by "engraving" (removing metal), "punching," or "tracing" (compressing and displacing metal). It should be noted that sand-cast metal objects have mold lines (which are almost always removed) while lost-wax casts do not have mold lines from the foundry process (the investment being one unit). One of the objectives of improved foundry techniques in the late nineteenth century was to minimize the amount of chasing necessary on a cast.

Stone: Finishing is also a term that can be applied to the final stages of carving and polishing stone sculpture. When the preliminary carving of a work has been done by a technician, the finishing stage might be undertaken by the artist himself. Fine details, textural accents, and selective polishing are all elements which are refined in the finishing.

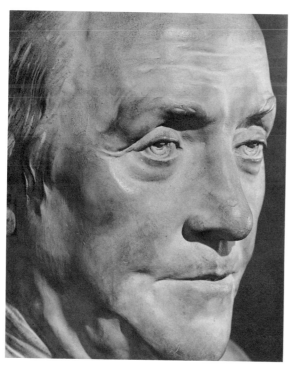

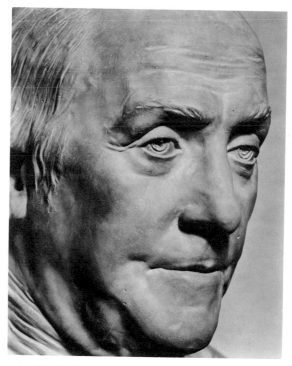

24a. Detail of a cast terra cotta showing reworking after removal from mold (*Franklin*, Houdon, Diplomatic Reception Rooms, Department of State, Washington, D.C.)

24b. Detail of a cast terra cotta very similar to no. 24a showing different reworking after removal from piece mold (*Franklin*, Houdon, The Fine Arts Museums of San Francisco, San Francisco, California)

43

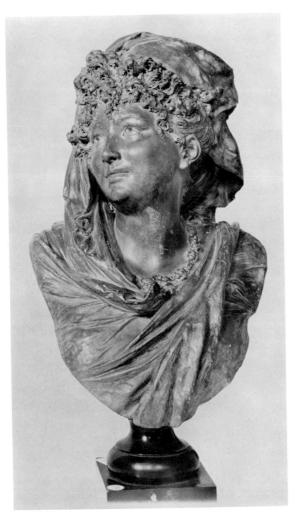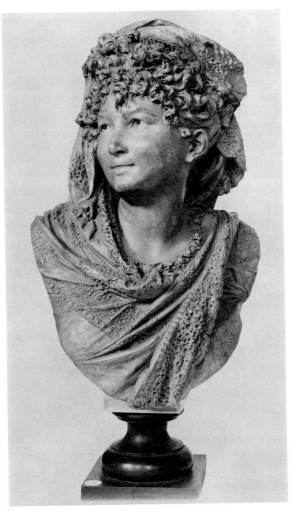

25a. Cast terra cotta showing a great deal of reworking after removal from piece mold (*Bust of a Woman*, Albert-Ernest Carrier-Belleuse, Museum of Art, Rhode Island School of Design, Providence, Rhode Island)

25b. Cast terra cotta showing wide variation of reworked detail in the treatment of the garment (contrast to no. 25a). This work is also in the collection of the Museum of Art, Rhode Island School of Design.

6. Patinating

Patina refers to either naturally or artificially induced alteration of the surface of an object. Surface alteration can be the result of actual chemical change in the material of the object, or it can be superficial, such as a covering of paint. The term patina, although primarily used in regard to metal finishes, is used to describe the alteration of the surfaces of other materials as well. Textural treatment of surface for visual effect is not patination.

Plaster: Although plaster casts can be patinated for creative definition, the more usual reasons for coloring the material fall into two categories. First, the very porous surfaces of plaster are often sealed to facilitate either cleaning or release from a mold. Second, many plaster casts are colored to imitate the appearance of other materials such as bronze or terra cotta. Shellac, wax, and linseed oil are common sealers, while more opaque oil- or resin-base paints are used for intentional coloring. Powdered metal may be included in a paint binder if a metallic surface is to be imitated. Occasionally an artist uses this treatment to give him some idea of how his work might appear in cast metal. For the same reason, modeling wax is frequently colored brown to suggest patinated bronze.

Terra Cotta: Like plaster, terra cotta is porous and soils easily. Although it is rarely painted to imitate other materials, badly soiled terra cotta may be painted to imitate its own original color. Sealers may be used on terra cotta for the same reasons as they are used on plaster. These varnishes, oils, and waxes themselves commonly discolor or darken with age and are often regarded as patina.

Metal: There are four basic ways by which the color, and sometimes texture, of a metallic surface can be altered. First, metal may simply be left to react with its environment. Natural chemical changes that are a function of each particular environment will cause the surface of metal to tarnish, or otherwise alter. Oils and salts from the human hand must be included as factors of the environment which effect a "natural" patina. Second, chemical changes to the surface of metal may be artificially induced in the foundry or studio by the application of a variety of reactive

chemicals. Solutions are painted on and heat is applied with a torch to accelerate the reactions. Most nineteenth-century bronze sculptures are colored in this way. Third, the surface of one metal can be plated with another metal. The "noble" metals, gold and silver, are commonly used for the plating of copper, bronze, and other alloys. (Strictly speaking, plating a metal should not be called patinating.)

The fourth method of coloring metal is to paint it with materials ranging from transparent to opaque. Common Renaissance practice was to hide casting flaws and repairs by mercury gilding or coloring with an opaque material. Varnishes, oils, and waxes are the binders for pigments found on many Renaissance bronzes. Improved casting techniques and chemical patination formulae in the nineteenth century were probably the major reasons for reduced dependence on painted patinas in later times. However, we should note that electroplated casts do not respond well to chemical patinations and are therefore frequently colored with a resinous material.

Depending in part on circumstances of the environment, the patina of a metal sculpture (and, for that matter, of other materials as well) is not infrequently the result of a combination of both natural and artificial alteration.

Stone: Sculptures of stone are rarely colored but they are sometimes coated with protective wax. Grime and discolored wax often become ac-

26. Removal of investment from a lost-wax bronze cast

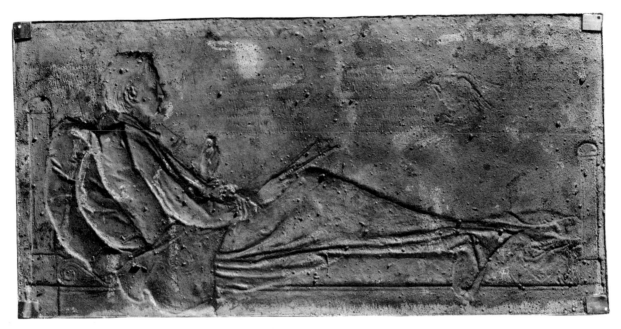

27. Reverse side of electrotype showing characteristic fine reverse details and irregular bead pattern (*Robert Louis Stevenson*, Saint-Gaudens)

28. Nineteenth-century enlarging instrument as depicted in a publication of the period (Partridge, *Technique of Sculpture*)

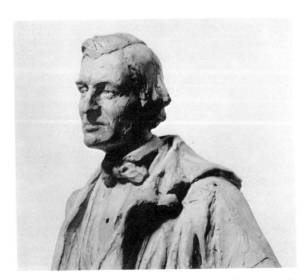

29. Metal enlargement points can be seen on the chest and shoulders of this waste-molded plaster cast (*Seated Emerson*, French)

cepted as patina. A natural chemical alteration of stone, especially in outdoor sculpture, does occur slowly in air and can cause a slight visible change in color.

7. *Electroplating and Electrotyping*

Electrometallurgy was invented in 1839 and developed in practice in the 1840s. *Electroplating* involves depositing a metal from a solution of one of its salts through the use of an electric current. The object plated is usually itself metal but can be plaster, wax, etc., if the surface has been made electrically conductive with the application of metallic powder or graphite. Alloyed metals such as brass and bronze can be deposited, but not as easily as pure metals such as copper, zinc, nickel, silver, and gold.

The process of *electrotyping* is scientifically identical with electroplating. The difference is that electroplating puts only a thin metallic film on an object while electrotyping makes a thick deposit producing a negative mold on a metallic object. A plaster or wax mold is coated on the inside with metallic powder or graphite. It is used as a cathode and placed in a metallic salt solution in which has been suspended an anode of the metal to be deposited. An electric current is then passed through the solution and the metal is deposited on the mold. As the metal builds up to the desired thickness irregular beads are sometimes formed since accidental protuberances attract more current than neighboring areas. Despite this phenomenon, electrotypes ("galvanos") are uniform in thickness, often reflecting even fine inscriptions on the reverse (no. 27). Sculptures of virtually any configuration can be made by electrotyping.

8. *Enlarging*

The process of *enlarging* sculpture, using various devices based on mathematical proportions, has its origins in antiquity. These devices are used by hand to monitor and guide the progress of enlargement (no. 28). Selected "points" on a small model serve as a frame of reference for the larger version as it is modeled in a plastic material (no. 29). Technicians may be employed to rough-out the enlargement while the artist himself is respon-

sible for the final modeling. If the enlargement is to be cut in stone, monitoring is done more carefully, with many points taken on the model. Again, this work is generally left to technicians with perhaps only the finishing executed by the artist. Although less common than reducing machines, some mechanical cutters were in use in the nineteenth century for making enlargements.

9. *Reducing*

A number of very popular nineteenth-century sculptures were *reduced* and casts were made available in different sizes. *Lion Crushing a Serpent* by Barye and *The Kiss* by Rodin are two examples. Although earlier devices existed, the invention of the Collas machine in 1836 opened the way for fast mechanical reduction. This machine, and many others like it produced both in Europe and America, operated on a principle of fixed mathematical proportion. A tracing needle that moves over the surface of a model (usually plaster or bronze) is attached by a system of linkage to a cutting stylus that reproduces the model on a reduced scale by cutting a soft plaster blank. Both model and reduced plaster image are held securely in the same plane while the device is operated (no. 30). In a complex model individual parts may be reduced separately and later joined.

30. Collas sculpture-reducing machine as depicted in a nineteenth-century publication (Paul Poiré, *La France Industrielle* [Librairie Hachette, 1880])

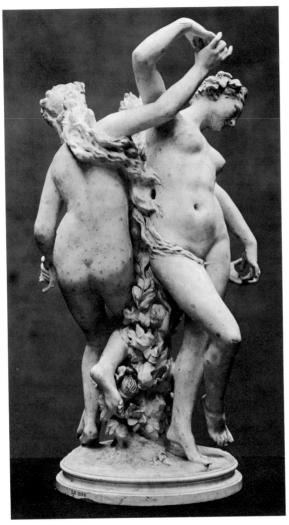

31. Hundreds of "point" marks in the form of penciled X's can be seen on this plaster model (*Les Trois Graces*, Carpeaux, Ny Carlsberg Glyptotek, Denmark).

32. Sculptor or technician using a pointing machine to translate a bust from plaster, right, to stone, left behind figure (Partridge, *Technique of Sculpture*)

10. *Pointing*

Carving, like lost-wax casting, can be performed either directly or indirectly. In direct carving, as the name suggests, the sculptor works directly with the block of stone or piece of wood. At best, he may have a small, three-dimensional sketch or model for a visual reference. Indirect carving is a mechanical process which exactly reproduces in stone, etc., a model conceived in another material. *Pointing* is the mechanical process by which this transfer of image is accomplished in stone.

Both enlarging and reducing, as well as same-size reproduction, can be done by the pointing method. Most models for pointing are made of plaster. The locations of "points" are first marked out on the model; in a large, complex work these points may number in the thousands (no. 31). Several larger raised metal points in the model often serve as general locaters for the pointing machine which must be moved back and forth between model and carving countless times before the work is complete (no. 32). The pointing machine locates and gauges the depth of holes to be drilled in the stone. When a number of holes have been drilled, the carver chisels away the surrounding stone until he reaches the bottom of the holes. In general, hole depths fall slightly short of the finished surface. The final carving may be performed by a more experienced technician or by the artist himself.

METHODS OF SIGNING OR MARKING MODELS, MOLDS, AND CASTS

Clay: Markings are usually made in clay while it is still soft. This is true of both modeled and mold-made clay objects. Markings incorporated in a mold will lack definition when impressed in a clay cast unless they are reinforced before the clay has hardened (no. 33).

Terra Cotta: Most marks in terra cotta are applied while the material is still moist clay. The clay is displaced, leaving a raised edge or burr (nos. 34a, 34b). Marks added after firing must be incised and will have fractured edges (no. 35).

Wax and plasticine: Markings in wax and plasticine appear very similar to those made in clay with a burred edge or displaced material (no. 36).

Plaster: Most markings in plaster are cast in the molds from markings in the plastic models. Because plaster hardens by crystallization (a chemical process)—and not by evaporation of water—it does not shrink in drying and carries fine detail (no. 37). On close inspection, cast air bubbles entrapped in fine raised lines can sometimes be seen (no. 38). Occasionally an inscription may be added to a plaster mold or cast by incising with a sharp cutter (no. 39). An incised inscription must be written backwards in the mold to appear correct in the cast (no. 40). Markings which go through several molding procedures may become quite blurred (nos. 41a, 41b). To insure durability, an artist may occasionally inset a struck metal seal into his plaster model (no. 42). Cast-plaster insets are also possible (see no. 38).

Metal: Marks made in a wax model often come through very clearly in a lost-wax cast since only the investment mold intervenes in the translation (see nos. 36, 43). Sand-cast metal sculpture, a more indirect process, often requires that marks be added or reinforced in the metal itself. Marks can be incised (no. 44) or stamped (no. 45). Occasionally an imprint is made in the core of a sand mold and as a result appears as a raised positive mark inside a cast (no. 46). Specific dedications and numbering, if not found in the model for a sand-cast, are frequently incised (engraved) or stamped in the metal cast (nos. 47a, 47b). Small detailed stamps may be struck separately in metal and later set into the metal cast (see nos. 47b, 48).

Stone: Markings in stone are carved and may be added at any time (no. 49).

THE USEFULNESS OF MEASUREMENTS, WEIGHTS, AND OTHER FORMS OF TECHNICAL ANALYSIS

Measurements: Throughout this publication you will notice dimensions. The ritual of recording measurements of sculpture and reporting them in catalogues and scholarly publications is as common as pagination. What value are they to us? In an art sales catalogue it is useful to know if the object under consideration will fit in one's living room. In a scholarly exhibition catalogue dimensions help us visualize scale. When doing research

33. Mold-impressed signature which was not strengthened in the wet clay stage of a terra cotta (*Franklin*, Houdon)

34a. Signature written in the wet-clay stage of a terra cotta, has a distinct burred quality (*La Danse*, Carpeaux).

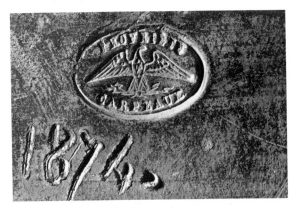

34b. Stamp impressed in the wet-clay stage of a terra cotta has displaced the clay and left a ridge (*Les Trois Graces*, Carpeaux).

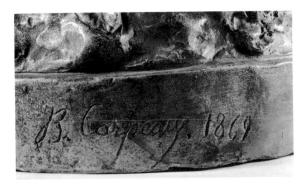

35. Incised signature in a terra cotta has a fractured appearance (*Amour à la Folie*, Carpeaux).

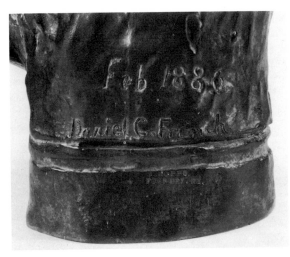

36. The burred quality of the signature in this lost-wax bronze cast indicates that the signature was made in the wax stage (*Memory*, French).

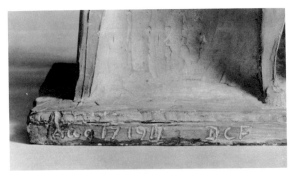

37. Marking in a plaster waste-mold cast which faithfully reproduces what was written in the plastic model (*Seated Emerson*, French)

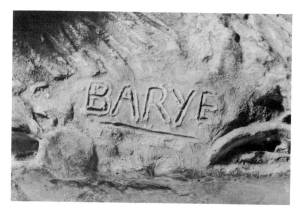

38. Cast-plaster inset which shows the raised edge of its plastic model. Small air holes in the raised areas are evidence of casting (*Tiger Attacking a Peacock*, Barye).

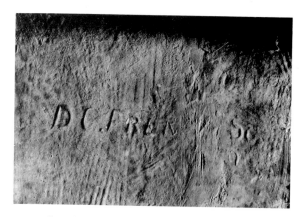

41a. Blurred signature as seen in a plaster cast several times removed from the original model (*Emerson*, French).

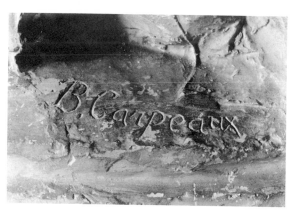

39. Signature incised on a plaster cast (*Ugolin*, Carpeaux)

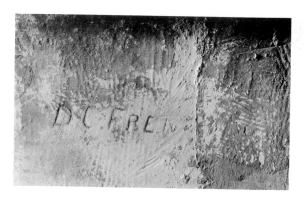

41b. Detail of a signature from another cast of a group, including no. 41a, made from a gelatin mold

40. Inscription incised in reverse in a plaster piece mold (*Diana*, Saint-Gaudens)

42. Struck copper inset in a plaster cast (*Stevenson*, Saint-Gaudens)

43. Founders' stamp as it appears in a lost-wax bronze cast. The stamp was impressed in the wax stage (*Podenas*, Daumier).

44. Founders' signature incised in a sand-cast bronze (*The Kiss*, Rodin)

45. Founders' mark stamped into a bronze (*Lion Crushing a Serpent*, Barye)

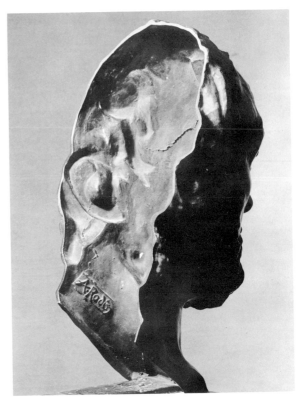

46. Raised signature cast inside a sand-cast bronze. A. Rodin, cachet, was impressed into the sand-mold core (*Man with the Broken Nose*, Rodin, Smith College Museum of Art, Northampton, Massachusetts).

47. Struck metal inset found on a sand-cast bronze. It designates that the model for the bronze was a Collas reduction. The inscription above the inset was made by engraving in the bronze (*The Kiss*, Rodin).

47a. Numbers die-stamped into a bronze but surrounded and separated with incised lines (*Podenas*, Daumier)

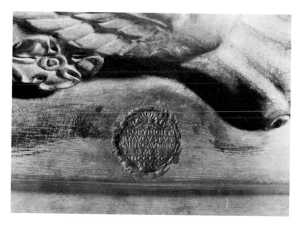

48. Struck metal copyright inset held in a sand-cast bronze by peening (*Diana*, Saint-Gaudens)

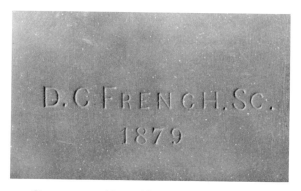

49. Signature carved in marble (*Emerson*, French)

they may be useful for identifying similar types or casts. How reliable are published dimensions? One can almost assume error of as much as ten per cent. Taking even the height dimension of a sculpture can baffle the most intelligent individuals.

What use are very accurate height dimensions? They are of virtually no use at all. Most cast sculptures are cast upside down and finished off on the bottom to permit them to rest flat (see no. 19b). Arbitrary finishing can cause several centimeters of height difference in casts of an edition. Integrally cast bases add further complexity and frequent confusion to height measurements. The mounting angle of a sculpture can drastically effect the perpendicular height. A sequence of Rodin's *Man with the Broken Nose*, studied for this publication, is an excellent example of this problem.

Comparative measurements made with calipers on fixed points in a group of similar works can be extremely useful, especially in determining chronology. Several examples can be drawn from the laboratory studies performed for this publication.

First, careful four-point measurements were made on each of the nine bronze examples of Barye's *Lion Crushing a Serpent* "Reduction No. 1" (non-mechanical). All the casts were very close in size (less than a one-millimeter difference in 35.5 centimeters) except for one from the collection of the Walters Art Gallery which was about one per cent larger than the other eight casts. We had found a master bronze model and could accurately relegate these other casts to the classification of *surmoulages* (casts that use other casts as models). Collaborative evidence of fine detail and traces of French sand found on the Walters piece confirmed what the dimensions had suggested.

A second example of the usefulness of accurate comparative dimensions can be seen in the hypothetical chronology worked out for the Houdon *Franklin* sequence. In this case, five dimensions were taken with calipers on fixed points on each of seven objects: two terra cottas, two plasters, two bronzes, and one marble. Dimensions varied widely (up to 5.7 cm.) but did suggest an order of manufacture when considered in terms of the indi-

vidual materials involved. Clay shrinks on drying and when fired loses, altogether, about ten per cent of its volume. Bronze shrinks on cooling about one and one-half per cent, as noted in the previous example with the *surmoulages*. In short, a basic understanding of the behavior of materials can make measurements useful.

Weights: Although no accurate weight measurements were made of the objects involved in this study, general weight differences were observed and discussed. A few of these observations may be worthy of note.

Plaster painted to look like terra cotta, and terra cotta colored to hide soil marks, sometimes can be distinguished by weight. Terra cotta is the denser and heavier material. Hollow-cast objects present obvious problems when using simple weight measurements.

Metal casts raise several weight questions. A solid or nearly solid heavy metal sculpture sometimes indicates that an original solid wax model was simply invested to make a direct cast (see nos. 11a, 11b).

Distinguishing by means of weight between lost-wax and sand-cast metal objects is very difficult. Although one might expect a lost-wax cast, with its more uniform wall thickness, to be lighter than a sand cast (see nos. 16, 17), this is not always the case. In the process of coating a mold of complex configuration, wax can entirely fill thin forms which when cast become solid metal.

Electrotypes, on the other hand, can often be identified by their very even thin walls. These objects are generally of light weight.

Visual analysis: Observation of identifiable materials and techniques is sometimes useful for dating an object, assuming that the dates of invention of these materials and techniques have been firmly established. Unfortunately, this is not very helpful for nineteenth-century lost-wax and sand-cast bronze sculpture, since both techniques were used during this period. Identifying traces of material such as unfired French sand, gelatin, or plaster on an object is often helpful in determining the use of that object. For example, in the course of this study several founders' models were discovered with the evidence of unfired French sand inside the object.

Scientific analysis: Although some samples of material were collected as part of this study, time and circumstance have not permitted even a preliminary report to be published at this time. The less sophisticated techniques of radiography (x-ray) and examination under ultraviolet light were used to supply supporting evidence. The potential usefulness of information to be gained from scientific analysis should in no way be minimized. There is still a great deal to be learned about the materials and methods of nineteenth-century sculpture.

SOME THOUGHTS ON ORIGINALITY

In nineteenth-century sculpture, originality cannot be determined by the criterion of simple chronology. Soft and fragile first models rarely survive to permit us to be that close to the artist. When they do survive, it is often apparent that the artist's intent for these models was a transitory statement on the road to a finished work in another material. Perhaps, then, originality (or uniqueness) should be considered in terms of the medium which was foremost in the mind and hand of the artist at each given point in the metamorphosis of the work. Different kinds of materials lend themselves to different kinds of statements. Our studies have shown that it was entirely possible in the nineteenth century to have more than one "original" work associated with a single subject. If this observation is valid, some of the questions to be asked as criteria for originality might be as follows. First, did the artist conceive this work as complete and appropriate in this material? Second, did the artist initiate a direct action which would realize the work in this material? Third, did the artist finish or approve the work himself?

Uniqueness is never a question of degree but often a matter of kind. In the endless chain of repetition of nineteenth-century sculpture, a few exemplary works stand out. These works represent the ultimate statement: perfect marriage of method and material. When they are in proximity to their echoes, even the less discerning eye will see the difference.

Bibliography

I wish to acknowledge the following individuals for their assistance in the preparation of this essay. First, I would like to thank Nedo Cassettari, Materials Technician, School for the Arts of Boston University, who served as a consultant. Mr. Cassettari examined a number of the objects with me and made observations based on his years of experience as mold maker and plaster caster with the firm of Caproni Brothers, Boston. Mr. Paul Cavanaugh, owner of the Paul King Foundry, Johnston, Rhode Island, generously permitted us to photograph both sand-casting and lost-wax-casting procedures in his foundry. A number of these photographs appear as illustrations in my essay. Barbara Kroll and Evie Holmberg, apprentices in the Department of Conservation, were invaluable aids in dealing with the innumerable details associated with the examinations of some one hundred and forty objects. Finally, I would like to thank Cyril Stanley Smith, Institute Professor Emeritus, Massachusetts Institute of Technology, for reading my essay and offering constructive suggestions.

Coleman, Ronald L. *Sculpture: A Basic Handbook for Students*. Dubuque, Iowa: Wm. C. Brown Company Publishers, 1968.

Harvard, Henri. *Les Arts de l'Ameublement: les bronzes d'ameublement*. Paris: Librairie Charles Delagrave (n.d.).

Hoffman, Malvina. *Sculpture, Inside and Out*. First ed. New York: W. W. Norton and Company, 1939.

Partridge, William Ordway. *The Technique of Sculpture*. Boston: Ginn and Company, 1895.

Poiré, Paul. *La France Industrielle, ou description des industries françaises*. Third ed. Paris: Librairie Hachette et Cie., 1880.

Quimby, Ian M. G., and Earl, Polly Anne, eds. *Technological Innovation and the Decorative Arts*. Winterthur Conference Report, 1973. Charlottesville, Virginia: The University Press of Virginia, 1974.

Rich, Jack C. *The Materials and Methods of Sculpture*. New York: Oxford University Press, 1947.

Wasserman, Jeanne L., assisted by Lukach, Joan L. and Beale, Arthur. *Daumier Sculpture: A Critical and Comparative Study*. Exhibition catalogue, May 1 – June 23, 1969. Cambridge, Massachusetts: Fogg Art Museum, Harvard University, 1969.

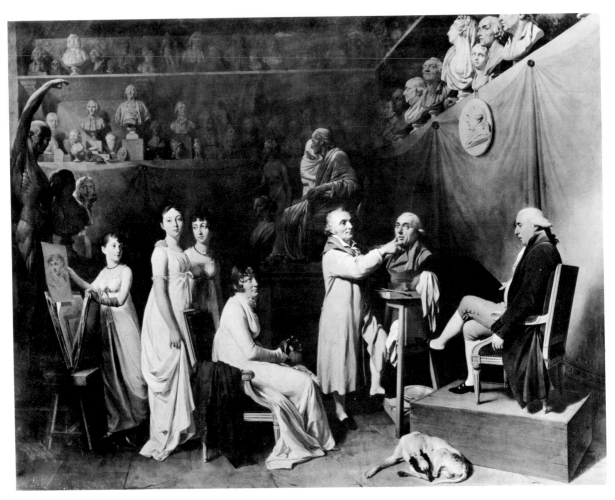

1. *Houdon's Studio*
 By Louis-Leopold Boilly
 Collection of the Musée des arts decoratifs, Paris,
 France

Jean-Antoine Houdon
(1741–1828)

The eighteenth century in France was one of the greatest eras in the development of portrait sculpture, and unquestionably the foremost practitioner of this art was Jean-Antoine Houdon. Houdon (fig. 1) was born on March 25, 1741 at Versailles, the son of Jacques Houdon and Anne Rabache. Jacques Houdon came from peasant stock, and Anne's father and brothers were gardeners in the parks of Versailles. Thus the sculptor did not have the advantage of belonging to one of those great dynasties of sculptors—the Lemoynes, the Coustous, and the Adams—who dominated so much of eighteenth-century French sculpture. At the time of his son's birth, Jacques Houdon was a simple concierge at the Versailles *hôtel* of the Comte de Lamotte, controller-general of the King's parks. Of Jacques' three sons and four daughters, only Jean-Antoine, the fourth child, achieved fame as an artist, although the oldest son, Jacques-Philippe, did have some reputation as a designer and decorator. Since Jacques-Philippe served his apprenticeship in the decorative arts with the sculptor Michel-Ange Slodtz, he may have had some influence in Jean-Antoine's choice of a career.

The determining factor, however, was a fortunate accident. In 1749, the Comte de Lamotte's house in Paris was leased to the Crown to serve as the École des élèves protégés, a highly select school for those students of the Academy who had taken a first prize in painting or sculpture and were preparing for a sojourn at the French Academy in Rome. Jacques Houdon was permitted to continue as concierge of the new school, and consequently Jean-Antoine literally grew up among artists. By 1756, Houdon, officially enrolled in the school of the Royal Academy of Painting and Sculpture, had received a third prize in sculpture, and in 1761, at the age of twenty, a first prize for a bas-relief entitled *La Reine de Saba apportant des présents à Salomon*. His principal master was René-Michel (known as Michel-Ange) Slodtz, but he also worked with other academicians such as Jean-Baptiste Lemoyne and Jean-Baptiste Pigalle. The award of first prize admitted him to the elite group of six students at the École des élèves protégés in the years before he went to Rome, 1761–1764. The curriculum included not only the study of techniques (for the sculptors, particular attention was given to the carving of marble), but also lectures on history and mythology designed to enlarge the cultural background of the students, particularly for the period of classical antiquity.

When Houdon began his studies in sculpture under the system of the Academy, he was set upon a course already rigidly defined. Dominated by the French example, the system was practiced throughout Europe. In fact, Houdon lived his life within this system, as did almost every artist who hoped to gain patronage or to advance in any manner. Before proceeding to Rome in 1764 on his Prix de Rome fellowship, he had been studying at the Académie Royale de peinture et de sculpture and its elite offshoot, the École des élèves protégés, for some eight years. During much of this period, according to the prescribed system, he worked as a student apprentice in the studios of several academician-sculptors. Although Michel-Ange Slodtz is the only name mentioned in surviving documents, the pattern of teaching within the Academy, with its regular rotation of professors, exposed the artist to works and ideas of other sculptors and painters; visits to the Louvre and other royal and private collections exposed him to works of art from other countries and past traditions. Nevertheless, it must be emphasized that nothing is known of Houdon's personal style until late in his stay at Rome. All the earlier student works have disappeared, even his *Reine de Saba*, for which he received the first prize in 1761.

Few documents survive from the Roman sojourn, and only five known statues. One of these is the *Vestal*, c. 1767–1768, of which there are several examples in different materials; these may be

later replicas by the artist of the original statue. Eighteenth-century sculptors did not have the passion for uniqueness of their twentieth-century counterparts, and, as will be noted with Houdon's busts of Franklin, the major technical and stylistic questions center around the problem of distinguishing between pieces from the artist's own hand, studio pieces, and later replicas or forgeries.

The other sculptures produced in Rome were *L'Écorché (the Anatomical Figure)*, 1766; *Saint Bruno*, 1766–1767, Santa Maria degli Angeli, Rome (reduced plaster sketch, Schlossmuseum, Gotha, East Germany); *Saint John the Baptist*, 1766–1767; *Priest of the Lupercalia, c.* 1768. Other works recorded in the Salons of 1769 and 1771 may very well date from the Roman period.

In the few works that survive from Houdon's study in Rome one can see not only complete control of his medium, but also a wide range of experiment, ranging through precise realism, classic idealism, and Baroque expression. Curiously, there are no specific portraits recorded, unless the *Peasant Girl of Frascati* can be so considered.

It may seem strange that this master of portrait sculpture should have recorded no portraits before 1769, when he was twenty-eight years old. The explanation for this, however, is not difficult to find. Most of his subjects would have been prescribed by the curriculum at the French Academy in Rome, and when Houdon returned to Paris in 1768, he was still hoping to make his reputation as a sculptor of grand themes taken from history, religion, or classical mythology. These were the themes designated by the academic system as the noblest pursuits of the artist, the themes thought to lead most directly to recognition by posterity and, of course, to greater profit for the artist. Subjects in painting and sculpture were severely categorized by the Academy, and portraiture was placed down the list somewhere with the still-life. Houdon became a portrait sculptor in part because of the shrinking opportunities for large-scale sculpture during the eighteenth century. We know that he was continually seeking large-scale commissions and, throughout his life, whenever he referred to his own sculptural achievements, it was usually the few statues, such as the *Diana* or *L'Écorché* or *Saint Bruno*, that he singled out.

Houdon returned to Paris in 1768 as soon as his mandatory four years at the Academy in Rome were completed. He was quickly accepted as an *agréé* of the Academy and made his first submissions to the Salon of 1769. These were primarily works from his student years in Rome. It was only with the Salon of 1771 that he presented the first work in his series of the great men of the Enlightenment. This was a portrait of Denis Diderot, the encyclopedist, *philosophe*, a leader of the French Enlightenment, and the most perceptive French critic of art during the eighteenth century. Diderot's portrait was painted, drawn, sculpted, and engraved time and again, but our permanent image of him derives from the portrayal by Houdon. This was to become true of Houdon's entire gallery of outstanding leaders of the Age of Reason.

Houdon, like most of Diderot's portraitists, chose to portray him without a wig (in the eighteenth-century phrase, "not wearing his hat"). This may have been on the insistence of Diderot, who customarily demonstrated his hatred for wigs by wearing them askew. It also enabled the artist to follow the formula of a Roman portrait of a philosopher or a man of letters, presenting Diderot with abbreviated torso, undraped to the collar bone, *à l'antique*. The twist of the head, angled from the torso, the slightly parted lips, and the wide, penetrating eyes give the work a marvelous quality of alertness and immediacy.

With the *Diderot* the problems of sculptural reproductions become explicit. The artist himself produced many different versions in terra cotta, plaster, marble, and bronze. Some of these were reproduced by others during Houdon's lifetime, and they have continued to be reproduced and forged down to the present day. It is relatively easy to make molds from an existing plaster, bronze, or marble and, from these, replicas in various materials. It should be noted that when he portrayed an important nobleman, politician, or intellectual, Houdon generally produced as many replicas as the market would bear. After finishing a bust, he often presented a terra cotta or plaster at the next Salon, and then would present the marble and sometimes a bronze at later Salons.

His usual custom was to sign and date terra cottas, marbles, and bronzes, in either cursive or roman letters. On plasters and sometimes on terra cottas, he used a wax seal reading, ACADEM. ROYALE DE PEINTURE ET SCULPT. HOUDON SC. He was, however, erratic in the matter of signing and dating, although perhaps not more so than most of his contemporaries. Even authentic plasters do not invariably have the seal; some are signed, some have both signature and seal. Later works are frequently signed in cursive letters but not dated. An analysis of signatures from unquestionably authentic works by Houdon does provide some useful corroborative evidence in the matter of judging authenticity. For some obscure reason, many nineteenth-century forgers of Houdon's works were, happily, quite careless in their renditions of his signature.

The portrait of Diderot, and Diderot's subsequent encouragement of the artist, resulted in an increasing number of portrait commissions. His next highly influential patron was Catherine the Great of Russia, to whom he was probably recommended by Diderot, and of whom he made an impressive official portrait (Hermitage Museum, Leningrad). By the time of the Salon of 1775, Houdon had realized that the individual portrait rather than the sculptural monument was to be his most regular commission, and his talents as a portraitist had become so apparent that important commissions were coming in from high French government dignitaries and noble ladies. He continued to seek out more monumental commissions and to produce figure sculpture and decorative ensembles such as fountains, but it was in the individual portrait bust that his primary reputation was established and has persisted. Some of his most successful sculptures on a larger scale were tombs such as those of the Galitzin now in Moscow, and that of the Comte d'Ennery, now in the Louvre—all remarkable prototypes of historical neoclassicism.

The seven identified portrait busts in the Salon of 1775 represent an enormous expansion of Houdon's powers as a portraitist, as the individuals portrayed demonstrate the increased number of the artist's patrons among the French nobility and in the world of the arts. With these seven, Houdon's extraordinary ability to identify the individual character of the sitter, his station in life, and even his profession becomes evident. For Houdon, there is never any narrow portrait formula. The *Marquis de Miromenil*, Minister of Justice, is shown in his magisterial robe and wig which lend him the amplitude of Baroque portrayal, but his sobriety creates a distinct aura of professional competence.

Anne-Robert-Jacques Turgot, who was one of the most distinguished French economists of the eighteenth century, was also a cultivated and sympathetic man, a patron of the arts and letters. Houdon's portrait shows him in court dress, very very much the aristocrat, but the intensity of his gaze suggests great seriousness of purpose. Although character analysis in portrait painting and sculpture is a dangerous game, this can be seen as the face of an idealist and a somewhat impatient idealist at that, in contrast with his portrait of *M. de Miromenil*, which exudes a sardonic wit coupled with a degree of complacency, or with the *Diderot*, which emanates restless energy and insatiable curiosity.

Another instance of Houdon's concern for relating the design of the torso and accessories of dress to the individual portrayed is to be seen in the *Gluck*, presented in the Salon of 1775. Gluck was a great musician, an artist, and therefore was given the attributes of genius. His face was deeply pockmarked, and the sculptor used this fact to establish his theme. He clothed him in a heavy coat, the texture of which was an overall pattern of slashed grooves, free and direct in their expressive impact. Here there was no attempt to simulate the appearance of the actual material, but rather, in an almost Rodinesque manner, to bring out the quality of the clay. The open shirt, the unbuttoned vest, the short, disheveled hair, and the alert, tilted pose of the head all contribute to the expression of genius. Two versions of the bust have survived: one with truncated shoulders, the other with full shoulders and indications of the upper arms.

The Salons of 1775 and 1777 included some of Houdon's most delightful portraits of women,

portraits which showed him at his most elaborately and decoratively rococo, possibly because his patrons were ladies of the Court. The *Comtesse du Cayla*, in the Frick Collection, New York, is one of the most delightful likenesses in Houdon's oeuvre. His ruthless eye did not permit him to flatter a sitter, even a lady of noble birth, but when he was faced with someone as lovely as the Comtesse, with all the charm and freshness of youth, he was clearly inspired to extra effort. Entirely different, but equally fascinating, is *Mlle Sophie Arnould*, the famous actress and singer, shown in the role of Gluck's *Iphigenia in Aulis*. *Mlle Arnould* is also one of Houdon's most rococo concepts: theatrical in pose and expression, at once delicately feminine and chastely abandoned.

A fascinating sidelight on the Sophie Arnould portrait is provided by the contract between the singer and the artist, a document of unparalleled value. In the contract, dated April 5, 1775, Houdon agreed to deliver the marble the following August. Further, he agreed to make for Mlle Arnould *thirty* copies in plaster to be "repaired" (in the sense of finished) by himself; and to deliver to her the terra cotta which had served as a model. He promised to make no further busts in any material for anyone else, but to furnish her with additional plasters as she might need them, at a small additional fee. This is clear proof of the incredible proliferation of duplicates authorized and supervised by the artist. It is also remarkable that almost all traces of the plasters, not to mention the unique terra cotta, have disappeared. While it was somewhat unusual for an individual to order so many replicas, and in many instances the sitter wished to restrict rather than to multiply the number of copies, Mlle Arnould had a wide circle of friends and lovers. In the case of models who were great public figures, such as Voltaire, Rousseau, or Franklin, we know that the artist himself produced his portrait busts almost indefinitely, and these have continued to be copied down to the present day.

With the Salon of 1779, Houdon entered fully into that field of achievement with which he is most frequently associated: the recording of great men of his time. Previously most of his portrait subjects had been members of the nobility, wealthy bourgeois, foreign princes, and members of the French royal family. He had already made the portraits of three notable contributors to the art and thought of the eighteenth century—Diderot, Turgot, and Gluck—and one of Catherine of Russia. From 1779, however, until Houdon's last Salon of 1814, almost every Salon included portraits of the great figures of the late eighteenth and early nineteenth centuries, portraits that in many cases have established our permanent visual images of these individuals. Those represented in the Salon of 1779 included Molière, Jean-Jacques Rousseau, Voltaire, and Benjamin Franklin.

The bust of Molière, father of the Comédie-Française, is one of the most brilliant of Houdon's characterizations, and fully disproves the cliché that his inspiration lagged when he was called upon to make a posthumous portrait. It is true that Houdon had an obsession for the meticulous study of nature, and normally made life-masks or, for Rousseau, Mirabeau, and other recently deceased notables, death-masks. He measured the heads of his subjects; for the statue of George Washington in Richmond, Virginia, he took all dimensions. In the case of Molière, dead one hundred years, exact resemblance was not the major objective, since Houdon was more concerned with presenting him as a symbol of French theater than with an archeological reconstruction. The head, framed in long, freely flowing hair, is sharply turned in a pose which suggests an immediate action or movement with extraordinary vividness. The eyes are sharp and alive, the mouth open slightly as though in speech.

When Jean-Jacques Rousseau died suddenly on July 2, 1778, Houdon was summoned, and on July 3 he made a death-mask on which he based his portrait. The sculptor apparently had not known his subject personally, and his interpretation is rather startling in the light of what is known of Rousseau's personality. Rousseau was the great romantic of the eighteenth century, and like many romantics, a man of intense feeling but little humor. The inconsistencies, emotionalism, and even *naïveté* of many of his ideas were disguised by the brilliance of his writing. Houdon's Rousseau, who

looks out from deeply set eyes, is a man of strong, searching intellect with even a suggestion of sardonic humor.

The portrait of Rousseau was probably the most popular of Houdon's portraits after that of Voltaire. It was produced in several variations of material and dress, many of which still survive. The philosopher is shown in modern dress, draped or undraped *à l'antique*, in marble, terra cotta, plaster, and bronze. In the version in modern dress, Rousseau is simply clad and wearing a perruque; the bust includes indications of the shoulders and upper arms. The version undraped *à l'antique* is truncated to the shoulder blades like the *Diderot*, and the short hair is combed forward. The one draped *à l'antique* is similarly abbreviated, but the torso, instead of ending in a curve, is squared off in a block-like effect. There is also a band encircling the hair, which conveys the image of a Roman philosopher. This block or herm version of the upper torso represents a new departure adapted from certain ancient busts, and was to become characteristic of the neo-classic portrait bust. An unusual number of bronze busts of both Rousseau and Voltaire exist, since this was the period when Houdon was becoming deeply involved in bronze-casting. Needless to say, there are also many later bronze replicas of these subjects.

More than any other writer, it is Voltaire who symbolizes the spirit of the French Enlightenment. As a philosopher, dramatist, poet, social scientist, and propagandist, he stayed in touch with every progressive trend in Europe and with those who supported new ideas or opposed repression in any form. After a period of semi-exile, Voltaire returned to Paris in triumph in February 1778. Houdon immediately arranged for sittings, took a life-mask, and seems to have worked with incredible speed, even for him, turning out an assortment of busts in different materials and presentations. As soon as it was known that he was modeling Voltaire's likeness, he was probably inundated with orders. Judging by the number of surviving busts deriving directly from Houdon or from his studio, Voltaire was by far the most popular subject he ever attempted. It was fortunate that he arranged his sitting so quickly, since Voltaire, sick, old, and exhausted, died in May 1778, immediately after the last sitting for the statue. This life-size statue, of which there are marble versions in the Comédie-Française and in the Hermitage in Leningrad, was commissioned by Voltaire's niece, Madame Denis, and by Catherine the Great. Although many attempts have been made to define Voltaire's expression as seen in Houdon's many interpretations, it is probably beyond definition. He is captured at a moment of transition, and it is this that imbues not only the face but the entire figure with the intense sense of an inner life.

The portrait busts of Voltaire (the first of which actually preceded the seated statues), including those produced by Houdon himself, in his studio under his supervision, and those made by others after his death, far exceed in number those of any other subject. Every large or small theater, academy, library, or other learned society and educational institution throughout France, and many throughout the rest of Europe and America, wanted a bust of him. Houdon himself presented one plaster to each of the forty members of the French Academy. The busts emerged from his studio until the end of his life—even in those years from 1814 to his death in 1828, when the sculptor was old and inactive and his work was carried on by assistants. These busts, like others by Houdon, have continued to be copied thereafter, in this case on a scale impossible to evaluate.

In 1777, Houdon was made a full member of the Academy of Painting and Sculpture. The other event of the latter 1770s in Houdon's personal life seems to have been his affiliation with the Masonic Lodge of the Nine Sisters. This took its name from the Muses, identifying it as a lodge particularly frequented by artists and men of letters. Voltaire was a member, as was the Russian patron of the arts Count Stroganov and the Americans Benjamin Franklin and John Paul Jones. Freemasonry flourished in the eighteenth century both in Europe and the United States, and frequently served as a gathering-ground for liberal intellectuals. Several leaders of the American Revolution, including George Washington, were Masons. In France, as

in other absolute states, Masonic organizations were regarded with suspicion as potential centers of sedition. For Houdon, the affiliation led to his portraits of Franklin and Jones, and through Franklin to his acquaintance with Thomas Jefferson, which in turn resulted in the commission for the statue of George Washington.

In 1785, Thomas Jefferson succeeded Benjamin Franklin as American Minister to France. He was already in Paris in 1784, and toward the end of that year he was delegated by the state of Virginia to find a sculptor to portray George Washington. Houdon was chosen by Jefferson, in consultation with Franklin, and thus received one of the most important commissions of his life, the marble statue of George Washington in the Capitol at Richmond, Virginia. Houdon traveled to the United States with Franklin in the latter part of July 1785 and made the preparatory studies for the Washington statue, including a life-mask, a terra-cotta bust, and one or more plaster busts. From these studies emerged what is perhaps the finest portrayal of Washington in existence, one that embodies a curiously reflective and inward quality which may not accord with our general impression of Washington, but which adds a dimension to our conception of him.

The artist also created a substantial number of portrait busts of Washington based on his studies, of which the most important surviving examples are the marble in the collection of Mrs. Sarah Hunter Kelly, New York City, the terra cottas at Mt. Vernon and in the Louvre, and the plaster in the Boston Athenæum. The Mt. Vernon terra cotta is probably that which the artist actually modeled from life at Mt. Vernon.[1]

The plaster in the Boston Athenæum is one of the group bequeathed by Jefferson to his granddaughter, Mrs. Joseph Coolidge. The terra cotta in the Louvre is particularly important for the present study since it retains clearly the ridge marks of a piece mold. It was not finally *réparé* by the artist and may well have been the model that he kept in his studio.

Of Jefferson himself, Houdon exhibited a bust in the Salon of 1789, of which a number of plaster versions exist, in addition to the superb marble in the Boston Museum of Fine Arts. In this, the eyes are large and cut unusually deep, shadowed under heavy brows in a manner which gives them an exceptional sense of vitality. The portrait is the perfect reflection of the aristocratic, intelligent man of affairs that we know Jefferson to have been and, at the same time, shows a face of great sensitivity.

Finally, in the Salon of 1804, Houdon exhibited plasters of two friends, Joel Barlow and Robert Fulton, the last of his American portraits. Both of these are strong, vital portrayals indicating little or no decline in the sculptor's powers. Barlow was a poet as well as a statesman and liberal thinker, and his close friend Robert Fulton was not only a talented painter but an inventor of great ability whose development of the steamboat *Clermont* was an important step in the progress of the Industrial Revolution. A point of interest in these two busts is the prosaic nature of the men's clothes which marks the beginnings of a new, perhaps more democratic era.

Houdon lived his life within the system of the French Academy of Painting and Sculpture, a system that was only briefly interrupted by the French Revolution, during which time the Royal Academy became the Institute of France.

On his return from the United States, Houdon married and had three daughters, all of whom he portrayed in delightful portrait busts. His commemoration of the great men of his time continued until 1814, when he retired—although there is some evidence that his assistants continued to produce replicas of his portraits. Among the later busts, aside from those of the Americans, were portraits of the philosopher Condorcet (1785), Louis XVI (*c.* 1787), the economist Necker (1790), the revolutionary Mirabeau (1791), and a superb portrait of Napoleon (1806).

Benjamin Franklin

Houdon's portrait of Benjamin Franklin has become so much a part of the iconography of America that it is difficult to analyze it objectively. It has appeared for generations on American currency, stamps, national memorials of every description, as a symbol of thrift and economic wisdom for banks and other financial institutions.

Benjamin Franklin (1705–1790) had visited France in 1766 and 1769. He returned to Europe in 1776 to negotiate a treaty of alliance between France and the United States, and remained as Minister to France until he returned to America with Houdon in 1785. During this period he became to French intellectuals of the liberal wing a symbol of America, the "New-Found Land," of the democratic ideal and of the American Enlightenment. His homely wit and simple manners (which he may have played up somewhat for the French Court), his Quaker dress, and his delight in the company of lovely ladies made him immensely popular in the Salons of Paris.

The basic type of *Franklin* portrait by Houdon shows him in plain, modern dress, without shoulders and, as is customary with the abbreviated type, rounded at the bottom. Innumerable examples of this type exist, in sculptures of varying quality. The fine marble in the Metropolitan Museum of Art, New York, signed and dated *houdon f. 1778* (see figs. 3, 3a), has a sufficiently interesting history to merit mention here. When Houdon returned from the United States in November 1785, after having visited George Washington at Mount Vernon, he left a number of sculptures behind in Philadelphia in the care of Robert Edge Pine, the painter, hoping that they might be sold. Pine died in 1788 and others took up the task of disposing of them. On January 20, 1802, Pierre Samuel du Pont de Nemours, who was friendly with Houdon and his wife, wrote to Thomas Jefferson, soliciting his interest in selling to the Virginia Congress the bust of Franklin, now in du Pont de Nemours' possession. But there was little money available, and not enough interest in buying works of art so soon after the Revolutionary War. Du Pont de Nemours' son finally sold the bust to John Church Cruger about 1836. From Cruger it passed to his daughter and son-in-law, Dr. Samuel Bard, and then to their son, John Bard, who presented it to the Metropolitan Museum in 1872. Whereas this marble has an unbroken, well-documented history, many of Houdon's portrait busts have changed hands with even greater frequency and, unfortunately, records of the transactions have not survived or else have been concealed.

The marble *Franklin* in the Metropolitan Museum shows him in contemporary dress, simple and puritanical, and has a somewhat rigid frontality suggesting a quality of forthrightness. The eyes look up into the distance. He wears his own hair, thin on top and flowing down over his ears and shoulders. The wrinkles at the corners of the

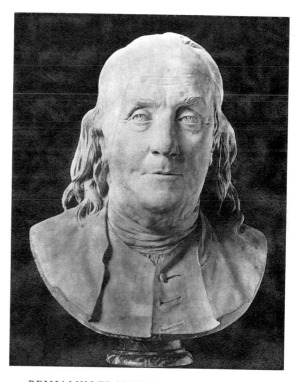

2. BENJAMIN FRANKLIN
Terra Cotta; H. *c.* 41 cm. (without base)
Markings
 houdon f. 1778

Musée du Louvre, Paris, France

Possibly the original model

(not in exhibition)

eyes are emphasized, the lips are slightly parted in what might be the beginning of a smile. The entire expression is one of benevolence, wisdom, and humor. Curiously, viewed from certain angles, these characteristics are replaced by an expression that can only be described as somewhat weary and apprehensive (see fig. 3a). However, long experience in photographing portraits by Houdon makes one acutely aware of the fact that, with different angles and lighting, they can be made to assume a wide variety of expressions.

Although there is no evidence that Houdon ever attempted to present Franklin *dénudé*, the subject, by far the most popular of his American portraits,

interested him sufficiently that he later made a variant, *en philosophe, drapé à l'antique*. This is possibly the Franklin listed in the *livret* for the Salon of 1791, one plaster of which is in the Boston Athenæum (see fig. 11) and another in the Musée des Beaux-Arts at Angers (see fig. 12), both of good quality but neither signed or dated. The bust at Angers was given to the museum by the sculptor David d'Angers, a disciple of Houdon, in the mid-nineteenth century. This is a larger bust than the one in contemporary dress, and shows Franklin draped in a senatorial robe. It might be described as a modified version *à l'antique*, since he wears the robe or cloak over his normal dress. In fact,

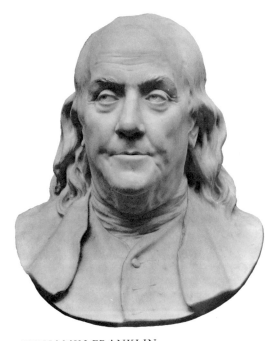

3. BENJAMIN FRANKLIN
Marble; H. *c.* 44.5 cm. (without base)
Markings
 back, incised: houdon f. 1778

Metropolitan Museum of Art, New York, New York
Gift of John Bard, 1872

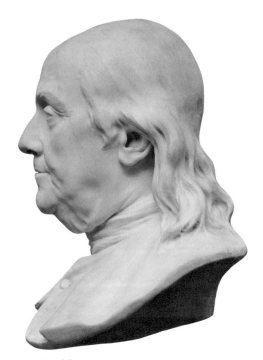

3a. Profile of fig. 3

Houdon seems simply to have adapted the earlier bust to an image in which a larger torso including shoulders and upper arms is draped in a robe, according Franklin the dignity of an ancient philosopher. This presentation became more frequent as Houdon adapted his portraits to the increasing neo-classicism of the end of the century.

The history of the Boston plaster of Franklin also merits some discussion here as an instance of the problems of history and provenance. The Boston Athenæum owns three plaster busts by Houdon, this *Franklin*, and portraits of Washington and Lafayette. It originally owned four, the fourth being a bust of John Paul Jones, perhaps

the one now in the Boston Museum of Fine Arts. There is also another *Franklin* in modern dress, on loan to the Athenæum from the American Academy of Arts and Sciences, which conceivably was at one time the property of the Athenæum (see fig. 5). The *Washington*, *Lafayette*, *John Paul Jones*, and one *Franklin* came originally from the collection of Thomas Jefferson. They were willed to Jefferson's granddaughter, the wife of Joseph Coolidge, Jr. of Boston, and were deposited by Mr. Coolidge in the Athenæum in 1828. The Trustees' records at the Athenæum for March 11, 1828 note that it had been voted that the busts of Jones, Franklin, and General Washington belong-

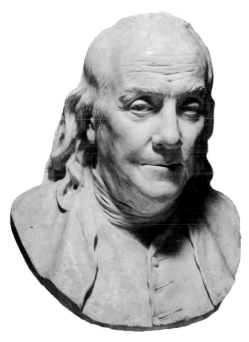

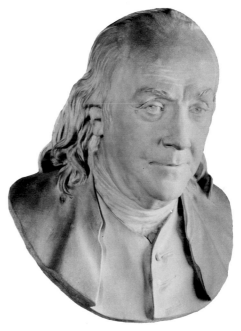

4. BENJAMIN FRANKLIN
 Plaster; H. *c.* 45 cm. (without base)
 Markings
 proper right side: houdon f. 1778

The St. Louis Art Museum, St. Louis, Missouri

Appears to be made from a gelatin mold. Comparable in dimensions to the Metropolitan marble. Acquired via Arnold Seligmann, Rey and Co., New York, 1935; sold at auction Galerie Charpentier, Paris, June 12–14, 1933; formerly in the collection of the Duke of Saxe-Weimar.

5. BENJAMIN FRANKLIN
 Plaster (small version, painted); H. *c.* 44.7 cm. (without base)
 Markings
 houdon f. 1778

The Boston Athenæum, Boston, Massachusetts

Painted plaster apparently cast from a plaster piece mold. The general dimensions of the cast are slightly smaller than those of the St. Louis plaster.

ing to Joseph Coolidge, Jr. be received as a deposit. The treasurer's journal for October 1828 states that Mr. Coolidge had been paid $100 for the *Lafayette*. In 1912 the Coolidge heirs formally presented the other Jefferson Houdons to the Athenæum.

There is some question as to which of the two *Franklins* came from Jefferson, but the probability is that it was the earlier version in modern dress. In scale and format this *Franklin* is comparable to the other three busts; all four are supposed to have been on display in the tea room of Jefferson's home, Monticello. The draped *Franklin* is very probably the bust given to the American

Philosophical Society in Philadelphia in 1800 by Colonel Jonathan Winters. In 1802, the Society, having other busts of Franklin in its possession, presented it to the American Academy of Arts and Sciences in Boston which shared quarters with the Boston Athenæum between 1817 and 1899. When the Academy moved to its own quarters, the bust of Franklin was left behind. In 1911, the Athenæum gave the Academy the smaller Franklin bust, and this was returned to the Athenæum in 1955 on indefinite loan when the Academy sold its building. Although labels may have been mixed up during the nineteenth century, there is no question of authorship, and virtually none about the provenance and history of these Franklin busts.[2]

There is little direct information on Houdon's technique, but it must be assumed that he followed the normal practices of the eighteenth century for sculpture intended to be reproduced in different materials. We know that he made clay models from life. For portraits intended to be reproduced in any number, such as the *Benjamin Franklin*, the normal procedure in the eighteenth century was to make a piece mold in plaster of Paris which would serve as the negative mold for a considerable number of replicas. There is some question whether or not Houdon first fired his clay into terra cotta and made the piece mold from the terra cotta. In the contract with Sophie Arnould, he refers to the fact that he is delivering to her the original model, which must have been a terra cotta. Since we know that the artist liked to present his subjects exactly life-size, and since terra cotta shrinks approximately ten per cent in the process of drying and firing, this might imply that the original soft clay was slightly larger than life-size. Without a piece-by-piece comparative measuring of all versions of Houdon's sculpture, however, it is difficult to answer this question.

From the piece mold, the artist normally made a number of plaster casts as well as some terra-cotta casts. On their emergence from the mold, the plasters and clays were retouched, finished, or *réparé* by Houdon himself. A plaster cast and possibly the original terra cotta normally remained in his studio as a model for subsequent works. Obviously his assistants did a large part of

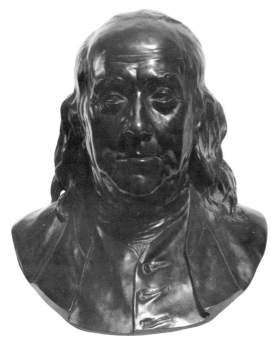

6. BENJAMIN FRANKLIN
 Bronze; H. *c.* 39.5 cm.
 Markings
 lower back, cold-worked or sharpened in bronze:
 houdon (cursive)

 Collection of Mr. and Mrs. J. William Middendorf II, Washington, D.C.

 An eighteenth- or early nineteenth-century bronze, possibly sand-cast in the sculptor's own foundry. There is a similar bronze in Philadelphia.

the work in preparing the molds and making the plaster casts. Once again, in the contract with Sophie Arnould we have the guarantee by Houdon that the plasters are "*réparé par l'auteur lui-même.*" With a few exceptions, such as those early student works in the Schlossmuseum, Gotha, the plasters were normally painted the color of terra cotta or, occasionally, that of bronze.

The marbles were developed from the plaster models, roughed out by an assistant through a system of pointing to secure exact measurements. Then the sculptor himself finished the marble, adding the nuances of surface which are the mark of his hand.

At this point it should be emphasized that, as far as can be determined, the technique used by Houdon followed exactly those practices developed at least as early as the seventeenth century and continued in much academic sculpture to the present day. The technique of Rodin or Lipchitz was not markedly different from that of Houdon.[3]

Houdon took great pride in having revived the art of bronze-casting in France, which had lagged during the latter eighteenth century, owing perhaps to a lack of patronage and the consequent departure of technicians.

In a letter to the painter Bachelier dated October 1794, the artist described his work in bronze-casting:[4]

. . . Resuming the account of my work, I should say

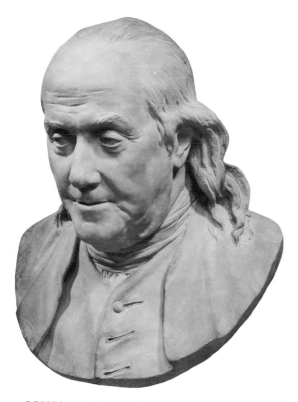

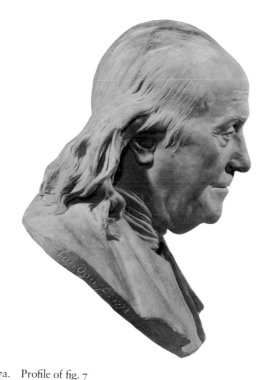

7a. Profile of fig. 7

7. BENJAMIN FRANKLIN
 Terra Cotta (mold-made); H. *c.* 38 cm. (without base)
 Markings
 proper right side, impressed from mold: houdon f. 1778

 The Fine Arts Museums of San Francisco,
 San Francisco, California
 Gift of M. H. de Young Museum Society

Appears to be "pressed" terra cotta cast as part of an edition that includes the sculpture which belongs to the Department of State. Both would have been made from a plaster piece mold. The size of this piece suggests a relationship to the model used for the Middendorf bronze (see fig. 6). Former collection, William Templeton Veach, Bonnetable (Sarthe), France

that I have devoted myself essentially to two studies, which have occupied my entire life, to which I have devoted everything I have earned, and which would have been most useful to my country if I had had any support and if I had had the means; *anatomy* and *bronze casting of sculpture*.

Long housed in the ateliers of the City, I profited by this position by being at the same time *sculptor* and *metal founder* (in modern times the two professions were always exercised by different individuals), and by reviving in my country this useful art, which could have been lost, since all the founders were dead when I began to concern myself with it. I constructed furnaces, I trained workmen, and after many fruitless and costly attempts, I succeeded in casting two statues: the *Diana*, of which one cast still belongs to me, and my *Frileuse*. In 1787 I was evicted from these ateliers by Breteuil, and within three weeks I had bought a

house across the street and constructed new furnaces, and there I cast my *Apollo*.

Since the Revolution, not having any work [major sculpture commissions] (never having worked except for private collectors or foreigners, except for the *Tourville*), I wanted to support my atelier, and keep in my country the valuable workmen who would have taken their talents to neighboring countries. I spent a small fortune on bronze casting in order to continue my work in this medium: I cast busts of the great men: Molière, Buffon, Voltaire, Rousseau, etc. . . . , always carried along by the love of my art, by the desire to leave a lasting monument to posterity and a subject for young artists to study.

Despite my obligations as the father of a family, I cast my great *Écorché* in 1792. When the statue on the dome of the Pantheon was cast [the *Renommé* (*Fame*) by Dejoux], it was necessary to seek a founder in my atelier: an excellent man but one who had only

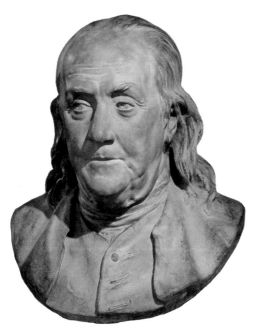

8. BENJAMIN FRANKLIN
 Terra Cotta (mold-made, painted); H. 39 cm. (without base)
 Markings
 red wax seal from Houdon atelier

 Diplomatic Reception Rooms, Department of State, Washington, D.C.

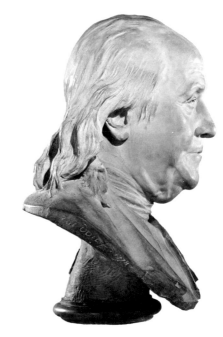

8a. Profile of fig. 8

When compared with the Fine Arts Museums of San Francisco terra cotta, these dimensions suggest that the two pieces may have come from the same mold.

(not in exhibition)

worked with me, one who owed everything to me alone, to my perseverance, my money, and my guidance, my knowledge of this art. He was trained as a foundryman with me.

There, Citizen, is the report you have requested of me.

As a result I may be considered in the double role of *sculptor* and *founder*. In the first I am a creator; in the second, I can execute the creations of others in a permanent form, far less expensively than anybody else. Never having had any money to carry on this work except my own savings, I have been careful to keep expenses down and to eliminate anything extraneous.

Houdon does not give us any details concerning the actual techniques that he used, but there is little doubt that he employed the classic *cire-perdue* technique for the large, unique pieces such as the *Apollo*, the second version of *L'Écorché*, and the two large *Diana*s (as well as the colossal bronze statue of Napoleon at Boulogne, which was destroyed). Since we know that he made a considerable number of small bronzes—versions of the *Diana*, the *Vestal*, and portrait heads which were reproduced at least several times—we may assume that these were made by a form of sand-casting, suitable for reproductive sculpture.

Bronzes definitely from Houdon's hand, such as those mentioned, as well as the *Diderot* at Langres and the *Lenoir* in the David Weill collection, Paris, demonstrate certain characteristics that differentiate them from the innumerable replicas of the later nineteenth and twentieth centuries. We know from unquestioned Houdon bronzes that it was his custom to finish the sculptures in an extremely dark, almost black patina, following the tradition extending from the Renaissance, and to retouch them with a scraping tool which provided a rather rough and even primitive finish in comparison with later nineteenth-century and twentieth-century replicas. A number of the bronzes are probably later replicas, although our knowledge of the history of bronze-casting during the late eighteenth and early nineteenth centuries

is still so rudimentary that this is difficult to determine. It seems clear that all eighteenth-century portrait busts in bronze were left open at the back. The practice of completely enclosing and finishing a bronze portrait in the back seems to have been started early in the nineteenth century. However, the fact that a bronze bust *is* open at the back is no guarantee that it is definitely a work of the eighteenth century. Nineteenth-century forgers, or even those innocently making replicas for some commemorative purpose, would normally reproduce this feature if they had an authentic bronze before them.

The *Franklin* portrait in the Middendorf collection (see fig. 6) conforms to the artist's normal technique and is the only bronze portrait of Franklin which this author would accept as an original from the hand of Houdon. It should be compared with the highly finished and polished Barbedienne replica (see fig. 9).

Owing to Franklin's immense popularity, there have been an extraordinary number of replicas of the bust made during the nineteenth and twentieth centuries, usually in bronze but also in marble and terra cotta. Giacometti, one of the early biographers of Houdon and a sculptor himself, tells us that his master, the sculptor Gustav Deloye, had made for the collector Walferdin a mold of the terra-cotta bust which is now in the Louvre (see fig. 2). From this mold a number of terra-cotta casts were made, carefully finished by Deloye, and so perfect is their quality that they are now taken for originals. The only distinction that might be found would be in the dimensional shrinkage owing to firing.[5]

Aside from the busts studied here, there exist many other versions of the *Franklin* in plaster and terra cotta. Particularly notable is the Walferdin terra cotta in the Louvre and the plaster in the Schlossmuseum at Gotha. In the last the signature is unusually sharp. It is of particular importance, since it is part of the large collection of Houdon plasters purchased by the Duke of Saxe-Gotha directly from the artist himself.

Notes

1. See Charles Seymour, "Houdon's Washington at Mt. Vernon Reexamined," *Gazette des Beaux-Arts*, XXXIII (March 1948), 137–158.

2. The large draped *Franklin* in the Boston Athenæum has been thoroughly studied by Jean Montague Massengale in "The Angers-Athenæum Bust of Benjamin Franklin by Houdon." (Master's thesis, Department of Fine Arts, New York University, February 1965). See also, Jean Montague Massengale, "A Franklin by Houdon Rediscovered," *Marsyas: Studies of the History of Art*, XII (1964–1965), 1–15, Figs. 1–20. Mrs. Massengale, who was largely instrumental in rescuing the draped *Franklin* from anonymity at the Athenæum, believes that this, rather than a 1778 version, is the one that belonged to Jefferson. She also dates it *c.* 1786. Although I differ with her conclusions as to provenance, possibly as to date, and with a number of other details of interpretation, hers is a most valuable study, which should be consulted on the entire question of the Franklin portraits by Houdon.

 Mrs. Massengale cites the view that Houdon's 1778 bust did not involve actual sittings by Franklin. This is based on a letter dated Paris, November 8, 1783 from Houdon to an unknown correspondent (American Philosophical Society, *Franklin Papers*, XXX, no. 77) also cited by Hart and Biddle in *Jean-Antoine Houdon*, p. 103. The letter begins:

 Sir:

 The day after you had the kindness to present me to Dr. Franklin . . . etc.

 The implication is that if Houdon had portrayed Franklin in 1778, it would not have been necessary for him to be reintroduced in 1783. This is an interesting question, but in terms of my knowledge of Houdon's method of working and the fact that the Masonic Lodge of the Nine Sisters was a relatively intimate organization, I find it difficult to believe that Houdon could not have arranged at least a sitting or two. This does not mean that the artist was necessarily on intimate terms with the American Minister to France; so in 1783 a particular appointment might well have been made through an intermediary.

 Neither case can be proved from existing evidence, so I only express my opinion. Having seen and photographed in depth virtually every version in existence of the 1778 *Franklin* (including both true and false), I believe this to be one of the most sensitive and subtle interpretations produced by the artist in the period when he was at the height of his powers as a portraitist.

3. The *Encyclopédie* of Diderot includes discussion and many valuable plates which indicate the normal approach of the eighteenth-century sculptor. For the general techniques here summarized, see also: Jack C. Rich, *The Materials and Methods of Sculpture* (New York: Oxford University Press, 1947).

4. First published in full by Georges Giacometti in Ernest Gaudouin (pseud.), *Quelques notes sur Houdon* (Paris: Nouvelle imprimerie, 1900).

5. Georges Giacometti, *La vie et l'oeuvre de Houdon*, II, 54.

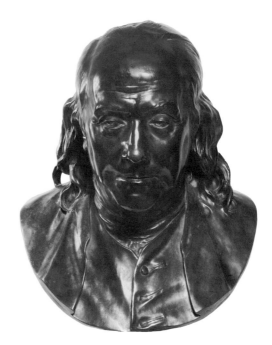

9. BENJAMIN FRANKLIN
Bronze; H. *c.* 43 cm. (without base)
Markings
 base, scratched in: 2996
 proper right side, cast and cold work strengthened:
 houdon f. 1778
 proper left side, incised: F. BARBEDiENNE.
 FONDEUR. PARIS.
 FRANCE.

Baker Library, Harvard Business School, Cambridge, Massachusetts
Gift of Lewis K. Sillcox

Sand cast with closed back, base cast separately. Black over green patina. This is probably a nineteenth-century cast.

Benjamin Franklin Hypothetical Chronology Based on Technical Observations

Only a few of many possible examples of Houdon's *Benjamin Franklin* were available for careful measurement and technical examination. For this reason, and because of the lack of documentary material, only a hypothetical chronology can be proposed.

The bust that may be the earliest example under consideration is a terra cotta in the collection of the Musée du Louvre, Paris (fig. 2). Molds could have been made from this piece at two possible stages: initially, when the clay was still wet, and later after drying and firing when its overall dimensions had shrunk by some ten per cent. Unfortunately, this terra cotta has not been examined in the Fogg laboratory. We can only conjecture about its being the master example.

Operating on the assumption that there were at least two separate molding campaigns which used the original model, we can distinguish between works associated with the wet clay stage of the original and others associated with the terra-cotta stage. As explained in my technical essay for this publication, a wet clay model might be repaired by the artist and preserved if it was not seriously damaged in an initial waste-molding. However, clay loses considerable size when dried and fired. There is very good technical evidence that Houdon's student, David D'Angers, saved his original portrait models in this way, while he used the waste-molded plaster originals as models for pointing marbles. If we further assume that the student learned this procedure from his teacher, we may then have an explanation of why the marble Houdon *Franklin* in the collection of the Metropolitan Museum of Art, New York (figs. 3, 3a) is apparently larger than the Louvre terracotta "original."

Size measurements of a Houdon *Franklin* plaster in the collection of the St. Louis Art Museum (fig. 4) are similar to the Metropolitan marble. Further technical evidence confuses the dating of this object. Mold lines suggest that the cast was made from a gelatin mold, a technique whose invention has not yet been accurately dated. Fine

detail of a "burred" quality indicates that the cast is not too far removed from a plastic model. The distorted, oval shape of the pupils of the eyes is puzzling. Traces of reddish color on the cast may indicate that it was once painted to imitate terra cotta. A great deal more technical and documentary research needs to be done to put this cast in proper sequence.

Another plaster cast, examined as part of this study, is from the collection of the Boston Athenæum (fig. 5). It appears to be the product of a piece mold, although this is difficult to determine because of overpaint. Multiple fixed-point dimensions compared with the St. Louis plaster show

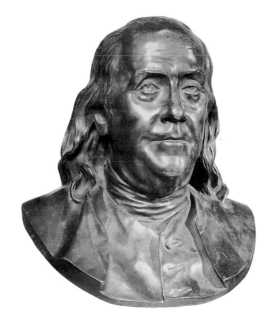

10. BENJAMIN FRANKLIN
Bronze; H. *c.* 35 cm. (without base)
Markings
 edge of right shoulder: houdon f. 1778

Fogg Art Museum, Harvard University, Cambridge, Massachusetts
Bequest of Grenville L. Winthrop

The signature is mostly cold worked. Closed back. The model for this bronze was a mechanical reduction.

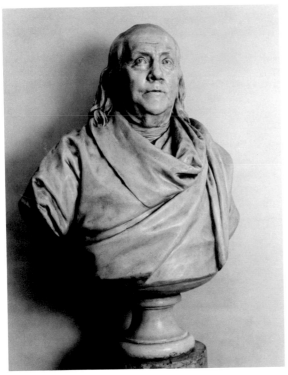 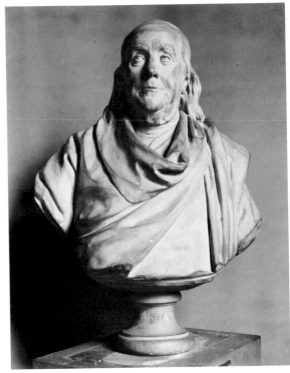

11. BENJAMIN FRANKLIN
 Plaster (large version; in classical dress); H. *c.* 83 cm.
 (with base)
 No markings

 The Boston Athenæum, Boston, Massachusetts

 The general dimensions of the head almost exactly
 match the other plaster Franklin in the Boston
 Athenæum (see fig. 5). Although the angle of the head
 is changed and details of the hair are altered, it is
 possible that the mold for the face has been used for
 both.

12. BENJAMIN FRANKLIN
 Plaster; H. *c.* 84 cm.
 Markings
 back: red wax seal from the Houdon atelier

 Musée des Beaux-Arts, Angers, France

 This cast appears to be made from the same mold as
 the large plaster *Franklin* in the Boston Athenæum
 (see fig. 11).

 (not in exhibition)

the Athenæum plaster to be about two per cent smaller. This size difference might be explained as a shrinkage factor of casting materials. Unfortunately, the two per cent figure cannot be directly related to one particular transitional material. The possibilities are countless and very speculative.

A somewhat clearer relationship based on measurements can be discovered in the remaining casts that were studied. A bronze from the collection of Mr. and Mrs. J. William Middendorf II, Washington, D.C. (fig. 6) is an average of eleven per cent smaller than the Metropolitan marble and the St. Louis plaster. This would suggest that the bronze indirectly used the terra-cotta state of the original as a model. Ten per cent would be accounted for by the drying and firing of the clay "original" and one per cent by the cooling shrinkage of the bronze. Evidence which would suggest this bronze is an early cast is to be seen in the degree and type of chasing found in details of the eyes, buttonholes, and hair (see fig. 6, and no. 22, technical essay).

Two terra-cotta *Franklin* busts, one in the Fine Arts Museums of San Francisco (figs. 7, 7a) and the other in the collection of the Department of State, Diplomatic Reception Rooms, Washington, D.C. (figs. 8, 8a), are nearly identical in size. They are probably casts made from the same piece mold. Their overall dimensions are roughly nineteen per cent smaller than the largest work studied. I believe this would suggest that they too use the terra-cotta state of the original as a model, the original clay having shrunk about ten per cent and the clay casts themselves another nine per cent

when fired. The one per cent discrepancy could be explained by an improved clay formula. Carpeaux's terra-cotta casts used a clay composition especially designed to reduce shrinkage.

Two apparently nineteenth-century bronze casts of the Houdon *Franklin* were measured and studied. The first, from the collection of Baker Library, Harvard Business School, Cambridge, Massachusetts is a Barbedienne sand cast (fig. 9). The measurements of this bust are smaller but comparable to the Metropolitan marble. They would appear to have used the same model type with bronze shrinkage accounting for most of the difference in measurement. The alternative possibility is that this bronze used a mechanically enlarged model. The other bronze examined used a mechanically reduced bust as its foundry model. This cast from the collection of the Fogg Art Museum, Cambridge (fig. 10) is twenty-seven per cent reduced from the size of the Metropolitan marble.

One final set of measurements was made on a head of a large version of *Franklin* in a classical dress also from the collection of the Boston Athenæum (fig. 11). These dimensions showed the head of this bust to be of the same size as the head of the other Houdon *Franklin* belonging to the Athenæum (see fig. 5). Although the angle of the head of the large version is changed in relation to the torso, details of the faces of these two plasters appear identical, as if made from the same mold. Evidence that a complete piece mold was made for this larger version is found in the fact that another cast exists in the collection of the Musée des Beaux-Arts, Angers, France (fig. 12).

Selected Bibliography

The works listed below relate specifically to the Benjamin Franklin sculptures. A more general bibliography can be found in H. H. Arnason, *The Sculptures of Houdon* (London: Phaidon Press; New York: Oxford University Press, 1975).

American Philosophical Society. *Franklin Papers*, XXX, no. 77.

Biebel, Franklin M. "Benjamin Franklin by Houdon." *Bulletin of the City Art Museum of St. Louis*, July 1936, pp. 51–55.

Breck, Joseph. "Three Busts by Houdon." *Bulletin of the Metropolitan Museum of Art*, III (December 1912), 224–225.

Catalogue of Portraits and Other Works of Art in the Possession of the American Philosophical Society. Philadelphia: American Philosophical Society, 1961.

Chinard, Gilbert, ed. *Houdon in America*. Baltimore: The Johns Hopkins Press, 1930.

de Morant, Henry. *Sculptures du XVIIIᵉ siècle au Musée des Beaux-Arts*. Angers, n.d.

Frick, Helen C. "Madame Jean-Antoine Houdon." *Art Bulletin*, XXIV, no. 3 (September 1947), 207–212.

Gardener, A. T. "Huntington's Franklins." *Bulletin of the Metropolitan Museum of Art*, XV (Summer 1956), 16, 19.

Giacometti, Georges. *La vie et l'oeuvre de Houdon*. 3 vols. Paris: A. Camoin, 1928.

Hart, Charles Henry, and Biddle, Edward. *Memoirs of the Life and Works of Jean-Antoine Houdon*. Philadelphia, 1911.

Ingersoll-Smouse, Florence. "Houdon en Amérique." *Revue de l'art ancien et moderne*, XXXV (April 1914), 279–280.

Massengale, Jean Montague. "A Franklin by Houdon Rediscovered." *Marsyas: Studies in the History of Art*, XII (1964–1965), 1–15, figs. 1–20.

——. *The Angers-Athenaeum Bust of Benjamin Franklin by Houdon*. M.A. dissertation, New York University, February 1965.

Nelson Gallery and Atkins Museum Handbook. Kansas City, 1959.

Reau, Louis. "A Great French Sculptor of the Eighteenth Century: Jean-Antoine Houdon." *Connoisseur*, CXXI (June 1948), 78, ill. p. 76.

Rich, Jack C. *The Materials and Methods of Sculpture*. New York: Oxford University Press, 1947.

Sellers, Charles Coleman. *Benjamin Franklin in Portraiture*. New Haven: Yale University Press, 1962.

Seymour, Charles. "Houdon's Washington and Mt. Vernon Reexamined." *Gazette des Beaux-Arts*, XXXIII (March 1948), 137, 148.

Swan, Mabel Munson. *The Athenaeum Gallery 1827–73*. Boston: The Boston Athenæum, 1940.

Weitenkampf, Frank. "Notes on Some Franklin Busts." *Bulletin of the Metropolitan Museum of Art*, I (March 1906), 60–61.

Checklist of the Exhibition

3. Marble; H. *c.* 44.5 cm. (without base)
 Metropolitan Museum of Art, New York, New York

4. Plaster; H. *c.* 45 cm. (without base)
 The St. Louis Art Museum, St. Louis, Missouri

5. Plaster (small version); H. *c.* 44.7 cm.
 The Boston Athenæum, Boston, Massachusetts

6. Bronze; H. *c.* 39.5 cm.
 Mr. and Mrs. J. William Middendorf II, Washington, D.C.

7. Terra Cotta (from a mold); H. *c.* 38 cm. (without base)

The Fine Arts Museums of San Francisco, San Francisco, California

9. Bronze; H. *c.* 43 cm. (without base)
 Baker Library, Harvard Business School, Cambridge, Massachusetts

10. Bronze; H. *c.* 35 cm. (without base)
 Fogg Art Museum, Harvard University, Cambridge, Massachusetts

11. Plaster (large version; in classical dress); H. *c.* 83 cm. (with base)
 The Boston Athenæum, Boston, Massachusetts

1. Portrait of Antoine Louis Barye (1796–1875)
by Leon Joseph Florentine Bonnat (1833–1922)

Collection of The Walters Art Gallery, Baltimore,
Maryland

(not in exhibition)

Antoine-Louis Barye
(1796–1875)

Antoine-Louis Barye (fig. 1) was a French romantic realist sculptor whose career spanned the political eras of Charles X, King Louis-Philippe, the Revolution of 1848, and the reign of Emperor Napoleon III. His was the Paris of Mme de Staël and Victor Hugo, of Theodore Géricault and Eugène Delacroix as well as the romantic positivist Auguste Comte.

Barye's formative years were spent in close contact with the craft and art of the goldsmith, first in the atelier of his father, Pierre, and, when Barye was around fourteen, in that of the goldsmith to Napoleon, Martin Guillaume Biennais. Barye's sensitivity—to forms in miniature scale, to high standards of craftsmanship, and to its sources in nature and the art of antiquity—was nurtured and sharpened in a way that would allow him to take delight in such things for the rest of his career.

Briefly, in 1816, Barye studied with the Baron F. J. Bosio, an academic sculptor who applied the precision and finish of the goldsmith's art on a monumental scale, as in his life-size work in silver, the *Henri IV, enfant*, 1824 (Louvre, Paris). Perhaps in reaction against Bosio's rather frozen art, Barye soon turned to instruction from the painter Gros, a freely emotional, romantic-colorist, who had traveled in the entourage of Napoleon's Egyptian campaign as the official battle-painter. Gros' expressive freedom, his colorism, and his mode of composing tiny groups of combatants within larger battle panoramas were of lasting impact upon Barye.

Following six relatively successful years at the École des Beaux-Arts, 1818–1824, the writer Lami suggests that Barye worked with the goldsmith to the Duchess of Angoulême, one Fauconnier, for whom he created a group of about sixty diminutive animals. At this time the sculptor began his serious scientific study of animal anatomy—in the *ménagerie* of the Jardin des Plantes, in the Parisian dog-markets, and in the Cabinet d'anatomie com-parée of the Musée d'histoire naturelle. His drawings testify to his presence at dissections, his study of preserved specimens and dioramas, and his reading of scholarly works of zoology and comparative anatomy. In fact, a brief letter written by the painter Delacroix to Barye, on October 16, 1828, strongly suggests that both artists attended the dissection of a recently dead lion: "The lion is dead—Come at a gallop [one notes the pun] —It is time to get to work—Let me hear from you."

The exoticism and chilling death-struggle of the *Tiger Devouring a Gavial Crocodile* (H. c. 1.03 m., Louvre), shown in the Salon of 1831, dramatically placed his work before the public eye. An academic critic, Delécluze, predictably judged Barye's animal imagery to exist in a "less elevated mode" than that of the human figure, but hastened to add that the *Tiger and Gavial* was "the strongest and most significant work of sculpture of the entire Salon" of 1831.

Barye's famous monumental bronze *Lion Crushing a Serpent* is a work of the early 1830s, a period when Barye enjoyed the prestigious support and patronage of the royal house of France. Turning from monumental scale to that of the small bronze, he created a masterful ensemble of nine sculptural groups as a vast table decoration for the Duke of Orléans, from 1834 to 1838. Central in it were five animal hunt designs, set in exotically distant lands or remote historical periods: the hunts of the tiger, lion, bear, elk, and bull. These were accompanied by four animal combats, two of which are extant today, the *Lion Devouring a Boar* (Louvre) and the *Python Killing a Gnu* (Walters Art Gallery, Baltimore, Maryland). The concept of this table decoration really sustained the essentials of the aristocratic, eighteenth-century tradition of the master goldsmiths—in fact, the hunts were to have been cast in silver, rather than bronze, at one point. Yet Barye departed from that tradition significantly by freeing his

miniature sculpture from the earlier notion that it must embellish a useful object, such as a soup tureen, for example. Thus he allowed it to exist as a freely expressive form, in the manner of ancient and Renaissance small bronzes.

Curiously, Barye's ensemble of five hunts was rejected from the Salon of 1837. In response to the disappointed Duke of Orléans, Louis-Philippe is reputed to have observed, "I have created a jury, but I cannot force them to accept masterpieces!" Thus hurt, Barye decided to ignore the Salon, and sent no works again until 1850, although this period was most inventive for his art of the small bronze.

Barye created a monumental bronze relief of a striding lion for the July Column cenotaph, in the Place de la Bastille of Paris, from 1835 to 1840. It is called a *Lion of the Zodiac* in the documents, making it the second monumental version of the allegorical concept of the *Lion and Serpent*. Here, however, the equatorial band of the path of the sun through the Houses of the Zodiac was substituted for the less well known serpent of Hydra used in the earlier group.

During the years of royal patronage Barye's commissions were not limited to animal subjects or to bronze. Between 1840 and 1843 he created a marble figure of *St. Clotilde* (H. c. 3 m.) for the Church of the Madeleine. It marks a new interest for the sculptor in an Ingres-like classicism and elegance of mood and type. His last monumental work for the royal house of Orléans was the bronze *Seated Lion*, now placed beside a quai portal of the Louvre. This piece was cast in bronze in 1847, probably from a model created in the thirties.

Following the tumult of the Revolution of 1848, Barye again submitted works to the Salon. In 1850 he showed *Theseus Combatting the Centaur Biénor* (H. c. 1.28 m.) and the *Jaguar Devouring a Hare* (L. c. 0.95 m.), which may have been intended as allegories of the recent struggle.

State commissions came at fairly regular intervals under the Republic and the Second Empire. Eight colossal stone reliefs of *Eagles* were carved as decorations for the piers of the Jena Bridge, 1849–1850. For the cornice of the Pont Neuf,

Barye devised no fewer than ninety-seven *Decorative Masks* in 1851. Their style anticipated the florid, neo-Baroque masks of the early Rodin.

The vast project of Napoleon III to connect the Louvre and Tuileries palaces, the so-called New Louvre, offered Barye several major commissions. An extant sculptor's model of an equestrian *Napoleon Bonaparte in Coronation Robes* (Walters Art Gallery) is inscribed as "viewed and approved by Visconti," the first architect of the New Louvre. However, Louis Visconti died in 1853, soon after the start of the project, and Barye's equestrian was not realized. Under Hector-Martin Lefuel, the second and final architect, Barye created four personification groups in stone, *Peace, War, Strength,* and *Order,* 1854–1856, entitled *Napoleon Crowned by History and the Arts,* 1857; and a monumental bronze equestrian relief of *Napoleon III as a Roman Emperor,* 1861 (destroyed 1870) flanked by two stone *River Gods* (still extant).

From 1848 to 1850 Barye was Director and Curator of the Gallery of Plaster Casts in the Museum of the Louvre. Toward 1850 or 1851 he briefly taught zoological drawing at Versailles. He was appointed Master of Zoological Drawing in the Museum of Natural History of Paris in 1854, an important post he retained until his death. At the Universal Exposition of 1855, Barye exhibited a group of his small bronzes in the "*section industrielle*," which publicly affirmed his commitment to limited mass production, and for which he received a grand gold medal. Later in 1855 he was awarded the Officer's Cross of the Legion of Honor.

Barye abandoned work on a projected equestrian bronze of *Napoleon I,* for Grenoble, a design of 1862. Possibly this was due to political subterfuge, or to the heavy demands of Barye's other monumental commissions of that period. In 1865 he completed a major bronze equestrian of *Napoleon I in Roman Garb,* for the Bonaparte family monument at Ajaccio, Corsica. The superb plaster model at one-third scale is displayed in the Louvre. Two very late commissions restated themes long established in his art, the *Walking Lion* of 1865, a silver cast used as a horse-racing trophy, and the

four stone *Animal Combats* of 1869, for the entry of the Palais de Longchamp at Marseilles.

Bayre at last was made a member of the Académie, l'Institut de France, on May 30, 1868, by unanimous election. His health began to fail in January of 1874, according to the records of the interruptions of his teaching duties at the Museum of Natural History. He died in 1875 and was buried in Père Lachaise, with full honors befitting an Officer of the Legion of Honor.

Technical Practices

With the decline of the Orléanist monarchy of King Louis-Philippe in the late 1840s, the patronage Barye had earlier enjoyed came to an end. His last Orléanist commission was the monumental bronze *Seated Lion*, cast in 1846.

In 1845 Barye entered into a legal partnership with the entrepreneur Émile Martin, to form *Barye and Company*. Under the terms of their agreement (Pivar, *The Barye Bronzes*, unnumbered pp. between pp. 20 and 21), Barye was concerned only with his art, and Martin acted solely as a business manager and legal partner. They renewed their initial contract once, in 1851. Barye, however, ended the partnership in 1857, at the close of the second, conventional contractual period of six years. His success in the Exposition Universelle of 1855, together with the remuneration he received for his work for the New Louvre between 1854 and 1857, no doubt led Barye to seek financial independence after some twelve years of partnership with Martin. All of the extant printed sales catalogues of Barye bronzes reflect the *Barye and Company* enterprise but one, the very last one, dated 1865, and issued from the address Quai des Célestins, 4, Paris.

The date 1847–1848 on the masthead of the first of Barye's sales catalogues of bronzes is significant. A note in this catalogue states that the small bronzes of the "second series" listed would serve as decorations in business offices or sitting rooms, while those of the generally larger "third series" would be most appropriate for salons. A second note assures the prospective buyer that each bronze carries a proof number and the artist's signature. Thus the sculptor who once had worked for royalty turned to the middle class for patronage.

Previously, in the tradition of the master goldsmiths of the past, a single exemplar for an aristocratic patron had been the full extent of an edition. As Barye ventured into commercialism, quantities of small bronzes after his models were created for the myriad middle-class interiors of Paris. His sales catalogue offered groups of related designs as tempting ensembles for the collector. And, of course, small bronze versions of Barye's famous monumental works for the state were available as well—the *Tiger Devouring a Gavial*, the *Lion Crushing a Serpent*, and the *Seated Lion*. The richness and balance of Barye's catalogue of 1847 may testify to the years of experience the sculptor had gained in the art market of Paris, through his unsuccessful but instructive attempt to operate a private foundry and sales outlet, from about 1839 onward.

Documentary evidence of Barye's involvement with a variety of artisans and founders is contained in a journal, an original account book, maintained during the 1850s by Émile Martin, the business partner of Barye. This journal sheds considerable light on the sculptor's involvement with mass production and the identification of his bronze founders, sales outlets, and artisans. The original ledger was first acquired in Paris from Mme Martin-Zédée, a daughter of Émile Martin. It was purchased from M. C. Ross by

the Walters Art Gallery in November 1949. Of the ledger's 312 pages, 243 carry Émile Martin's handwritten entries. A small label on the binding is inscribed "Journal Barye 1850." A label on the front cover is inscribed as follows:

[illegible] . . . personnel 32
Affaire de Barye
Journal
du
31. Juillet 1850
au
30. Avril 1858.

An inscription on the front endpaper, written large in Martin's hand, reads as follows:

Journal
Contenans les Operations
de Barye
Commence le 31 Juillet 1850.

Biographies of Barye typically treat these years as a period when Barye was forced to consent to the reproduction of his sculptures in order to repay his creditor, Émile Martin. According to this theory, Martin had backed Barye's unsuccessful foundry and sales depot, and was intent upon recovering his losses. Possibly this was true. Yet there is no proof in the journal that Barye was coerced, and it seems more likely that Martin acted as a skillful business manager and marketing agent, rather than as an exploiter of Barye. Furthermore, Barye's aristocratic patrons had never been overgenerous, and the arrangement with Martin was probably a necessity in the effort to sell to a democratically large audience. As for the sheer quantity of Barye's artistic production during these years, one is reminded of the comparable financial situation of Barye's contemporary Honoré Daumier (1808–1879), who earned his livelihood by the production of no fewer than four thousand different lithographs for newspapers. The increased technical facility of Parisian bronze founders also opened larger markets to the sculptor, as Luc-Benoist has pointed out.

The most frequently entered name in the Martin journal of a founder is that of Ferdinand Barbe-dienne (1810–1892), whose Parisian casting establishment mass-produced a great variety of high quality, low-priced reductions of famous masterworks, as well as bronze proofs of Barye's models. At its peak, Barbedienne's foundry employed some three hundred artisans and produced roughly twelve hundred bronzes per year. Small wonder that the touch of Barye's own hand is virtually nowhere to be seen in most of the extant proofs.

A typical itemized entry in the journal, dated September 30, 1850, lists forty-two proofs of twenty-one different sculptor's models as those cast and sold by Barbedienne and Company, for which payment was received by Émile Martin.

Barbedienne et Co.	
5 Lapins sur terrasse	17.50f
4 Lapins sur terrasse oreilles Levées	14.00
1 Cigogne seul	5.00
4 ″ sur tortue	40.00
1 Biche couchée	15.00
1 Panthère Couchée	18.00
1 Gazelle	18.00
1 faisan	14.00
2 perrucher sur Arbre	50.00
3 Chien epagneul	60.00
1 Cerf debout	30.00
1 Cerf jambe levée	30.00
1 Jaguar et Agouti	30.00
1 Lion et Guib	60.00
1 Brule parfum	20.00
3 paire flambeaux renaissance	60.00
2 ″ ″ à vigner	50.00
1 groupe 2 chiens et faisan	75.00
1 paire couper Enfanti Levequet	130.00
4 Lapins sans terrasse	10.00
3 ″ Oreilles Levées	7.50

Émile Martin evidently leased the rights of reproduction to the founder, and exacted a fee for his services as intermediary.

Probably the cost charged by Barbedienne for the fabrication of each proof is represented in the difference between the higher prices stated in Barye's printed catalogues of 1847–1848 and 1855 and the prices paid in the Émile Martin journal in 1850. A typical sampling follows:

Proof Title	Barye Catalogue 1847–1848	E. Martin Journal 1850	Barye Catalogue 1855
Lapin sur terrasse	6.00f	3.50f	6.00f
Cigogne	8.00	5.00	8.00
Panthère couchée	20.00	18.00	20.00

The price difference was not a fixed percentage, but evidently increased where the design of a particular work demanded lengthier or more delicate attention from the artisan. An easily cast "*panthère couchée*," for example, merited only 10 per cent to the founder, whereas the more delicate "*cigogne*," with its fragile, spindly legs and very tiny size, required 37.5 per cent. The equally tiny "*lapin sur terrasse*" commanded 41 per cent.

Striking evidence of Barye's involvement with a variety of founders is provided by an entry in the Martin journal for May 31, 1851, where no fewer than five different casters are recorded as paid for the execution of proofs of the same decorative work, a pair of slightly different groups of *Three Cavorting Putti* supporting large gilt clamshells as saltcellars, designs patterned after a prototype by Clodion.

The entry is as follows:

Bronzes		31 May 1851	
3 paye Lévèque			
1 paire Enfants Barbedienne		30	20.00f
1 " Raingo		3 Dbre	20.00
1 groupe " Barbedienne		15 Febrier	10.00
1 paire " Lévèque		13 Mars	20.00
1 " Roussel		13 "	20.00
2 " "		3 Mai	40.00
			———
			130f

That Barbedienne was paid 10f for a single "*groupe*" and the other casters were paid 20f per "*paire*" corroborates the fact that the two matching compositions differ slightly in design, and were taken from separate models.

Of the many named bronze casters and artisans with whom Barye dealt, most can be further documented in sources other than the Émile Martin journal. A list of these firms and men attests to the emphasis on mass production in Barye's opera-

tions. Since most of the names are mentioned repeatedly in the journal, only the first citation of each is indicated here, unless later citations render identification more certain. Bronze casters and sculptors cited in the Émile Martin journal are as follows:

1. Barbedienne et Cie, September 30, 1850 (p. 4).
2. Bastide, *fondeur*, August 31, 1850 (p. 2).
3. Bastide et Trevon, January 31, 1851 (p. 14).
4. Boyeve, September 30, 1851, is paid for the reproduction of several of Barye's sculptor's models from which molds would be taken:
 1 *modèle terrasse sur cire petite famille* (de Cerf).
 1 *terrasse moufflon modèle.*
 1 " *chien à l'oise modèle.*
 1 *petit gazelle cire* (p. 40).
5. Bressan, *fondeur*, November 30, 1855 (p. 154).
6. Eck et Durand, August 31, 1850 (p. 2). August 31, 1851, paid for an expense of July 23, called "*5 terrasses per petites animaux*" (p. 36).
7. Fauconnier, July 31, 1851 (p. 36). August 31, 1851, entry cites "*4 bas reliefs fauconnier*" (p. 37).
8. Gayrard, November 30, 1850 (p. 10). June 30, 1851, paid for "*Ochar de modèles et épreuves*" (p. 32).
9. Gervais, *sculpteur*, December 31, 1854 (p. 129).
10. Grandvarler, September 30, 1851, paid for
 1 *modèle de la famille de Cerfs.*
 1 " *Moufflon.*
 1 " *d'un chien à l'oise* (p. 41).
11. Grigault, Alfred, October 31, 1851, paid for "*1 modèle du Chien à l'oise*" (p. 44).
12. Lecompte, October 31, 1851, paid for
 1 *modèle de petit cerf*
 1 *modèle de gazelle* (p. 44).
 On May 31, 1852, paid for "*1 modèle tête de mascaron*" (p. 67).
13. Lévèque, September 30, 1850 (p. 5). See also March 31, 1851 (p. 24).
14. Liènard, *sculpteur*, December 31, 1854 (p. 130).
15. Pressange, *fondeur*, September 30, 1857 (p. 229).
16. Richard, *fondeur*, March 31, 1851 (p. 21).

Bronze casters and sculptors were paid for a variety of tasks ranging from sophisticated reproduction of the sculptor's models, occasionally even in wax, to the more usual casting of bronze

proofs, to the less demanding casting of bases. Although the word *modèle* is ambiguous enough to describe a sculptor's model or a proof, the distinction made between *modèles* and *épreuves* in an entry dated June 30, 1851 is assumed to be a meaningful record of a distinction in usage maintained in Barye's circle. Thus it is fairly certain that even the sculptor's own models of his designs were reproduced by paid artisans, and not always touched by Barye himself.

A list of thirty-two artisans and suppliers also cited in the Émile Martin journal is as follows:

1. Bailly, September 30, 1854, paid "*sur le animaux bas reliefs Monter par Eck et Dur*" (p. 124).
2. Barbedienne, "*. . . sur la dorure des Flambeaux . . .*," March 31, 1851 (p. 24). August 31, 1851, paid to "*Réparé 1 Cigogne en tortue*" and to "*Reciselé 1 paire flambeaux renaissance de l'argent*" (p. 37).
3. Barré, "*note de Monture*," February 28, 1853 (p. 85).
4. Bernard, *monteur*, March 31, 1857 (p. 214).
5. Bertolin, *Société Marbrière*, September 30, 1857 (p. 233).
6. Boulonnois, September 30, 1854, paid for "*Monture et Bronzage*" (p. 123).
7. Boyer, September 30, 1854, paid for "*Galvanisation de 4 Bas reliefs*" (p. 124).
8. Chasseur, *ciseleur*, July 31, 1857 (p. 225); also *dorure*," November 30, 1857 (p. 239).
9. Chauvin, *émailleur*, December 31, 1857 (p. 241).
10. Cheret, *ciseleur*, July 31, 1850 (p. 1).
11. Claude, *marbrier*, January 31, 1851 (p. 15).
12. Couve, *bronzeur*, August 31, 1855 (p. 143).
13. Dethy, *marbrier* (p. 34).
14. Detouche, *ciseleur*, October 31, 1856 (p. 191).
15. Dotin, *émailleur*, April 30, 1857 (p. 219); spelled "Dottin" in entry December 31, 1857 (p. 241).
16. Decreux, *ciseleur*, January 31, 1857 (p. 208).
17. Duménil, *tourneur*, August 31, 1855 (p. 146).
18. Dupin, *papetier*, September 30, 1856 (p. 190).
19. Eck & Durand, September 30, 1854, mentioned in a payment to Bailly "*sur le animaux bas reliefs Monter par Eck & Dur*" (p. 124).
20. Faure, April 30, 1857, paid for "*Émaillage à froid reparation de 30 pièces*" (p. 220).
21. Gaday, *monture*, December 31, 1857 (p. 240).
22. Gallimard, July 31, 1854, paid for "*monture de la Bas reliefs . . .*" (p. 120).
23. Gauthier, *bijoutier*, March 31, 1857 (p. 214); also, Gauthier, *emballeur*, November 30, 1855 (p. 154).
24. Gautier, *galvaniseur*, December 31, 1856 (p. 199).
25. Ghislain, *marbrier*, December 31, 1853 (p. 102).
26. Hardeler, January 31, 1854, paid for "*Monture de le Bas reliefs*" (p. 105). [*sic*]
27. Lecompte, *ciseleur*, July 31, 1850 (p. 1); also, Lecompte, "*dorure et bronze de 2 groupes Enfants Lévèque,*" March 31, 1851 (p. 24).
28. Leroy, *ciseleur*, November 30, 1856 (p. 195).
29. Picard, *doreur*, July 1, 1856 (p. 185).
30. Rochet, "*note de Ciselure,*" February 28, 1853 (p. 85).
31. Sullen, "*note de Ciselure,*" February 28, 1853 (p. 85).
32. Voisin, *tourneur*, July 31, 1850 (p. 1).

Barye even seems to have employed one of his sons as an assistant, since a payment of 4f is recorded to "Barye," July 1, 1856 (p. 183), and a "Barye *fils*" is cited, July 31, 1856 (p. 186).

Artisans performed a number of functions in the production and repair of Barye's sculpture. They were paid for mounting works in-the-round, framing reliefs, chasing the proofs, turning bases on lathes, gilding, plating by means of electrolysis, and finally enameling the proofs. Suppliers provided sketch paper, packing material, marble, and bronze.

The journal makes it clear that numbered proofs were deliberately not recorded as such in the Émile Martin journal, with one intriguing exception. The single entry recording proof numbers in the entire eight years refers not to works sold in Paris, but to a dealer from Nancy. Possibly this extraordinary effort to record numbered casts as such was necessitated by the dealer's (and his customers') distance from Barye himself, who might easily have authenticated a questionable proof for a Parisian customer, just as Corot occasionally did with his often-copied paintings. The entry listing numbered proofs, dated October 31, 1850, is as follows:

Daubrée de Nancy
1 Cerf qui marche 41e Épreuve 35.00f

1 Chien et Lapin	14e	36.00
1 Epagneul	15e	18.00
1 Panthère	27e	18.00
1 Faon couché	39e	12.00
1 Lapin oreilles couchées	87e	3.50
1 " Droites	78e	3.50
1 " couchées	95e	2.50
1 " Droites	49e	2.50
1 Tortue sur plinthe	1ere Épreuve	4.00
1 Bougeoir	18e	5.00
2 pairer flambeaux renaissance	91e et 92e	36.00
1 cheval turc	7e	85.00

261f

This unique entry is followed by a typical list of twenty-four unnumbered bronzes cast by Barbedienne. Documented information is not yet extensive enough to allow a clarification of when and why Barye or his casters numbered proofs and when they ceased to do so. Forgery of such numbers is easily possible, as is true of Barye's typical block-letter signature. Perhaps the ease of forgery is in part responsible for the sculptor's rather relaxed attitude toward the problem. The absence of proof numbers would also serve to minimize any stigma attached to the notion of large editions of a given design.

The unusually high proof numbers of the candelabra sold to Daubrée of Nancy at this time, the ninety-first and ninety-second exemplars, give an accurate idea of the quantities generated by Barye's limited mass production operations. They also testify to unexpected financial success in the realm of functional decorative objects. The tiny rabbits also numbered in the nineties by 1850, but these might be expected to enjoy great popularity.

Prices of proofs and models remained the same throughout the eight-year period. No dramatic increase or reduction occurred.

Barye's involvement with artisans had a discernible impact on his work. These collaborations cannot be viewed merely as the result of financial necessity. Rather, this mode of operation reflected Barye's evolving attitude toward the nature of his art and the changing character of his patrons and audience.

The finest of the artisan casts of Barye's designs are of high quality. Often they are technically, if not expressively, superior to casts made by Barye himself, especially in regard to lightness, fine grain, lack of porosity, uniformity of wall thickness, and quality of patination—if not in crispness of detail. Indeed, precisely such technical perfection is almost always the sign of artisan work rather than autograph. "A light cast is a late cast" is a useful axiom, at least for designs of the 1830s and 1840s. Intrinsic quality of these pieces is not the fundamental question. What becomes elusive as a result of this practice is the sign of the autograph touch of Barye.

Visual evidence which illuminates the documented relationship between Barye and the founder, Barbedienne, can be seen in a comparison of a Barye autograph and a Barbedienne cast of Barye's *Python Killing a Gnu* (both in the collection of The Walters Art Gallery, Baltimore, Maryland). In this particular case, the possible negative results of such team operations become evident in that the autograph cast was literally redesigned—with a considerable loss of expressive quality—in the process of translation for mass production.

The autograph of *Python Killing a Gnu* (fig. 2) is a unique, heavy bronze, perhaps cast directly from a wax model. Earliest documentation places it in the collection of the Duchess of Orléans, until it was sold in Paris in January of 1853. This strongly suggests that the bronze was originally a part of the table-decoration ensemble of nine groups created for the Duke of Orléans between 1834 and 1838.

The bronze in figure 2 exhibits such fine details as the incised diamond pattern of the snake's scales. Even the burr left in the wax model by the incising tool is faithfully captured in the bronze. A spontaneous quality is evident in Barye's decision to omit the diamond pattern completely from the lower part of the serpent, held between the gnu's forelegs.

The base of the proof has a similar improvised quality. The original integrally cast base was cut down in size, no doubt to correct a flawed casting. Additional flat plates of bronze have been riveted

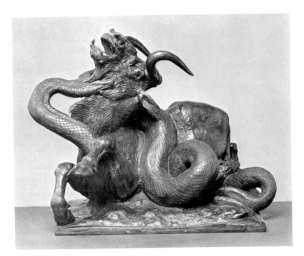

2. PYTHON KILLING A GNU
Bronze; H. *c.* 21.5 cm.
Markings
 BARYE

The Walters Art Gallery, Baltimore, Maryland (27.152)

Unique autograph cast

(not in exhibition)

3. PYTHON KILLING A GNU
Bronze; H. *c.* 21.5 cm.
Markings
 on base, proper left: F. BARBEDIENNE. FONDEUR.
 on base: BARYE

The Walters Art Gallery, Baltimore, Maryland (27.451)

Barbedienne artisan proof (see fig. 2)

(not in exhibition)

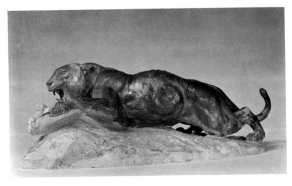

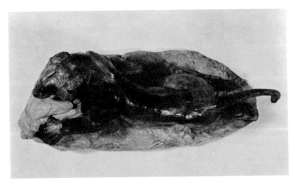

4. TIGER ATTACKING A PEACOCK
Plaster and wax; H. *c.* 17 cm.; L. *c.* 45 cm.
Markings
 on base: BARYE

Fogg Art Museum, Harvard University, Cambridge,
Massachusetts (1943.1023)
Bequest of Grenville L. Winthrop

Model used for making a sand-cast master bronze
Tiger portion adapted from *Tiger Hunt* (see fig. 5)

4a. Top view of fig. 4

and soldered along all four sides of the trimmed plinth, apparently in order to dress it into a stricter rectangle. The seam has opened along much of this repair. The base appears to be slightly undersized for the animal group upon it, with the effect that the animals seem to be bursting out of their allotted space. The small base also emphasizes the focal moment of the struggle, the backwards contortion of the embattled gnu. The unique surfaces and expressive force of this cast make it a touchstone for problems of Barye scholarship and analysis.

The Barbedienne artisan proof (fig. 3) uses a large, lozenge-shaped symbolic rock as a base, rather than the thin, plate-like plinth of the original. The recomposition required to unify the animal group with the new base has succeeded in losing completely the savage violence and intensity of the original. The gnu is not arched backwards so sharply, nor do the animals seem to explode into space so dramatically—both consequences of the elongation given the entire group, specifically for the new base. Fortunately, most instances of the artisan reproduction of Barye's models were considerably more respectful of the originals.

Finished three-dimensional models of Barye's compositions from which foundry molds would be taken are extant in several media and varied states of preservation in American and French collections. Most typical for Barye were models of plaster touched with wax. Also of interest are a number of models of bronze, cast plaster, and wax.

Barye apparently preferred plaster as the basic medium for his models for bronzes. Either he applied the plaster directly to an internal armature of wire or of wood, to build up the form he desired, or he used a cast-plaster positive taken from another model as a starting point for his further refinements of form and surface. He also combined both cast and directly-built passages and elements within a single model. Barye not only modeled, carved, and incised the plaster, but treated the wax-covered areas of his plaster models in these ways as well, contrasting the crisp, resistant quality of plaster with the fluidity of the

wax for expressive effect. A coating of wax on the plaster model allowed the sculptor to create a smoother, less porous surface, for an infinitely finer record of surface detail than could be possible with plaster alone. This mixture of media, and the wide spectrum of its possible qualities of surface and texture, marks a technical procedure apparently unusual for its time.

Barye was also unusual in his willingness to submit a delicate model directly to the sand-molder at the foundry. A more customary procedure at the time was to send to the foundry a cast-plaster positive, made indirectly from the original model, in order to assure that the sculptor's model remained undamaged. This intermediate reproductive step, however, intrudes between the autograph model and the mold made from it for a bronze cast, obliterating certain subtleties of the artist's touch. Barye sought to preserve the crisp autograph quality of his original models by eliminating the cast-plaster reproduction and by having the mold for a master bronze taken directly from his original model. Typically, the bronze proof cast in such a sand mold would be used, in turn, as the model for further sand mold–making. Successive bronze casts of the design would reproduce the bronze master, rather than Barye's relatively fragile original model of plaster touched with wax.

The model of a *Tiger Attacking a Peacock* (Fogg Art Museum) (figs. 4, 4a) illustrates the technical procedure just mentioned. Traces of fresh French sand inside the base have confirmed that this model was used to make a sand mold. Key measurements indicate that this tiger is essentially the same size as the serpentine tiger which scrambles up the right side of the elephant in the *Tiger Hunt* group (Walters Art Gallery) (fig. 5), a design cast in 1836 as the centerpiece of the table decoration ensemble for the Duke of Orléans. Barye apparently retained this one element of the rather complicated *Tiger Hunt* design and reused it with slight modifications as the basis of quite another image, the feline predator seizing its prey.

Some significant differences can be noted between the tiger of the *Tiger Hunt* group and that of the *Tiger Attacking a Peacock*. In the later

5. TIGER HUNT (detail of tiger and elephant)
Bronze; H. *c.* 70.4 cm.
Markings
 on base: BARYE
 1836
 inscribed: BRONZE D'UN JET SANS CISELURE
 FONDU A L'HOTEL D'ANGEVILLIERS
 PAR HONORE GONON ET SES DEUX FILS

The Walters Art Gallery, Baltimore, Maryland (27.176)

(not in exhibition)

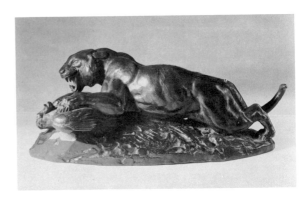

6. TIGER ATTACKING A PEACOCK
Bronze; H. *c.* 15.5 cm.; L. 43.1 cm.
Markings
 on side of base: BARYE

Fine Arts Museums of San Francisco, San Francisco,
California (1967.10)

Bronze cast related to plaster and wax model (see fig. 4)

(not in exhibition)

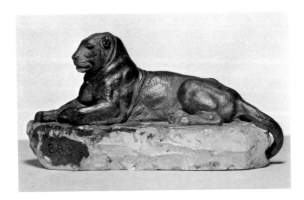

7. PANTHER OF TUNIS
Plaster and wax model; H. *c.* 10 cm.

The Walters Art Gallery, Baltimore, Maryland (27.46)

Model used for making a sand-cast master bronze

(not in exhibition)

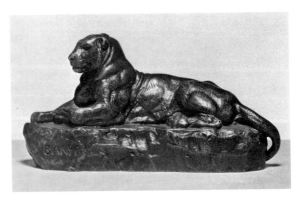

8. PANTHER OF TUNIS
Bronze; H. *c.* 10 cm.

Walters Art Gallery, Baltimore, Maryland (27.44)

Bronze cast related to plaster and wax model (see fig. 7)

(not in exhibition)

work, both the fore- and hind legs have been lengthened; by comparison, the legs of the hunt group tiger are unrealistically short. Barye seems to be correcting an unpleasant compromise with the animal's real proportions, perhaps necessitated by his original complex composition. In the *Tiger and Peacock* model, the major plane of the side of the tiger's left haunch is pressed inward toward the tiger's body; its head is rotated on its axis toward the left, and a wedge of plaster has been inserted into the top or nape of the neck, which brings the tiger's head close to the peacock.

The base of this model is of cast plaster, and it includes the integral form of the peacock, with the exception of the projecting left wing, which is now missing. Because of the elaborately worked surface of the tiger, irregularly touched with wax and coated with shellac, it is difficult to determine whether it is cast or a directly built element. The coat of wax on the tiger varies in its thickness. The heavy layers of wax at the shoulders and haunches are expressive focal points in the design of the animal. Spontaneity and brio mark the final, autograph modeling of such passages. Other areas of the model have a very thin layer of wax, barely deep enough to record the intaglio shapes of the tiger's stripes. Incised stripe-contours have been cut with a stylus directly into the plaster of the tiger's back, and the cruder, grainier quality of these stripes contrasts with the smoother, more fluid incisions in the wax, for an impressive range of textural qualities.

With these changes in form and detail complete, the reworked and separated tiger image was used directly as a model in sand-casting a bronze master. However, a comparison of the model with a related bronze cast in the collection of the Fine Arts Museums of San Francisco (fig. 6) reveals further differences in gesture. Close examination of the plaster-and-wax model shows that it was once cut into sections, probably to facilitate sand molding for casting the master bronze. It would appear that in the process of reassembling the model, independent elements were shifted. Typically, such reassembled models may betray a slight axial rotation of the elements being joined, or a slight alteration of the angles of their junc-

tures. These changes were not expressly conceived, but were merely mechanical incidents which render the models noticeably different from their respective bronze proofs.

A second example of Barye's working methods is illustrated by the model of the *Panther of Tunis* (Walters Art Gallery) (fig. 7). This model has a generally heavier layer of wax than the *Tiger Attacking a Peacock*. This wax layer is just thick enough to record expressive pattern. The wax is very thin over the ears, as the chipped right ear reveals, but thicker in certain passages such as the lobes at the top of the skull, the muscles of the left forepaw and haunch, and the projecting hipbones. The base is entirely of plaster, without wax except for the small area that records Barye's inscribed signature. Figure 8 is a bronze indirectly (?) cast from the model of *Panther of Tunis*.

Certain selected entries in the February 1876 catalogue of the posthumous sale of Barye's studio effects at the Hôtel Drouot further illuminate the spectrum of Barye's technical procedures.

A group of bronzes—evidently *surmoulage* casts—are termed proofs, "*épreuves*" (nos. 258–427). The title of a work is followed by the number of proofs available. For example, no. 258, "*Deux jeunes ours se battant. Cinq épreuves*" (*Two Bears Wrestling*, five proofs).

A group of sixteen works (nos. 428–443) are described as bronzes cast from plaster original models—"*bronzes fondus sur le plâtre ayant servi de modèle.*" One cast in lead, taken from a plaster original of the *Sleeping Jaguar* (now in the Louvre), is identified as no. 441, "*Épreuve en plomb, fondu sur le plâtre.*" Two electrolytic casts in this group are each termed "*épreuve en galvano*"—nos. 442 and 443, the *Panther of India* and the *Panther of Tunis*.

Five sculptures apparently not yet offered in editions of *surmoulage* casts are termed "*bronzes inédits.*" The entry for such an unedited bronze is immediately followed by an entry for its plaster model, as with the *Medieval Knight*:

no. 444. *Cavalier du moyen-âge.* Bronze inédit.
no. 445. " " " . Modèle en plâtre.

The other unedited plaster models are *Python Killing a Gnu, Tiger Devouring an Antelope, Horse Attacked by a Tiger,* and *Deer Brought Down by Three Algerian Hounds*—with the last offered without a related bronze cast. Twelve more designs complete this particular group, and all evidently were bronzes offered without related plaster models, for no other medium is cited.

Many of Barye's original plaster models, created at reduced scale for his major state commissions, were also listed—the *St. Clotilde*, the equestrians, and the decorations for the New Louvre. However, the relation of their size to the final work is not always accurately cited. *Strength (Force)*, for example, is listed as "*demi grandeur*," although the official contract called for a model at one-third full scale: "*au tiers au moins de la grandeur d'exécution.*" This particular kind of inaccuracy, of course, raises questions of accuracy for the other characterizations in the catalogue. Some caution is advised in the use of this information.

Design 497, *Charles VI Frightened in the Forest of Mans*, is described as a work "*fondu à cire perdue pour S.A. la princesse Marie d'Orléans. Plâtre doré.*" Thus a wax positive was made for a *cire-perdue* bronze, from the sculptor's original model of plaster touched with wax. The plaster model is now in the Louvre. Original plaster models for the *Bull Hunt* and *Lion Hunt* groups for the Duke of Orléans (nos. 520, 521), listed with a group termed plaster sketches, "*esquisses plâtre*,"

were also initially used for the making of *cire-perdue* wax models for those hunts.

"*Esquisses cires*" is the rubric used for a group of directly modeled waxes mounted on armatures (nos. 524–553). These wax models no doubt represent a very late, and thus rather special alternative to Barye's usual preference for a plaster model touched with wax. In fact, three entries in this particular group are further characterized as plaster touched with wax: *Hercules Killing a Lion* (542); *Tiger Seizing a Pelican* (547); and *Tiger Attacking a Peacock* (548). The last is without question the model in the collection of the Fogg Art Museum, Cambridge, Massachusetts.

More than two dozen terra-cotta sketches, "*esquisse terre cuite*," are offered as nos. 554–575, a surprisingly large number.

Seventy plaster casts of portions of real animals were listed in one lot as item 576, "*moulages environ sur nature (animaux).*" Such plaster casts of zoological specimens were shown in the Louvre Barye exhibition of 1956–1957. They are cited in the catalogue as "*plâtre moulé sur nature*" (nos. 121–123): *Right Forepaw of a Lion, Snout (?) of a Panther,* and *Flayed Cat*, from the collection of the École Nationale Supérieure des Beaux-Arts.

Bronze models, "*modèles en bronze*," are offered as nos. 577–730, and most of these design listings are accompanied by the phrase "*modèle en bronze avec son plâtre*" (bronze model with its plaster).

Lion Crushing a Serpent

The meaning of the *Lion Crushing a Serpent* can be interpreted on several levels. The primary purpose of the sculpture, flattery of the July Monarchy, was no doubt dictated to Barye by the Orléanist circle, with which he was intimately involved by 1832. The climate in France of widespread discontent with life under the regime at that time apparently prompted the supporters of Louis-Philippe to promote Barye's unusual sculptural imagery which could be understood as a flattery of the government. The royal lion, a symbol of strength, courage, and fortitude, could connote only positive traits.

Most specifically, the strongest link between Barye's sculpture and the July Revolution of 1830 (and thus with Louis-Philippe's accession to the throne of France) occurs in astrology and astronomy. The Revolutionary days—the 27th, 28th, and 29th of July—came under the adjacent constellations of Leo and Hydra, the lion and the serpent. Barye's innovative handling of the rather colorless image of two adjacent constellations, as they appear in the star charts, was its transformation into a romantically stirring combat of wild animals.

Barye's *Lion Crushing a Serpent* (fig. 9) was purchased from the Salon of 1833, cast in bronze at the King's request, and re-exhibited as a bronze in the Salon of 1836. It was one of few works given the carnet citation, "[M.d.R.] *les commandes ordonnés par le Roi*." Purchase of this piece by the Crown, its casting in bronze, and subsequent conspicuous placement on a terrace of the garden of the Tuileries Palace were fateful events in Barye's career. They apparently symbolized an official acceptance of animal sculpture as a major artistic mode. This in turn angered academically oriented critics, provoked the jealousy of Barye's artistic competitors, and even provided a target for the barbs of Louis-Philippe's political opponents. Barye's notoriety in the Parisian art world was established by the bitter criticism leveled at the *Lion Crushing a Serpent*. Gustave Planche asked sarcastically, "How is it possible that the Tuileries has been transformed into a zoo?" An anonymous writer declared, "Only the cage is missing!" Victor Schoelcher noted a distinct "odor of the menagerie." But the most vicious—and mindless—thrust of all came from a safely anonymous carp who proclaimed that "Barye's type of [animal] sculpture had developed because it was so easy and so popular." More observant, if negative, was the critic Charles Lenormant, who objected to an "overworked impression" in the *Lion Crushing a Serpent*, and said that while he admired the artist's laborious attention to "all the details of the hide and fur," he nonetheless found himself "continuously distracted by minutiae."

On the positive side, Alfred de Musset exclaimed:

What vigor and verism! The lion roars, the serpent hisses. What rage is in that snarling mask, in that sideward gaze, in the bristling fur of its back! What delicacy in that paw set upon the prey! . . . Where could Barye pose such models? Is his studio a desert of Africa or a forest of Hindustan?

Several original drawings related to this work are extant. A page of studies for a "Seated Lion," in the collection of the Walters Art Gallery (fig. 10), is basic to the monumental composition of the *Lion Crushing a Serpent*. The pose of the lion at bottom center is a mirror-reversal of the lion's pose in the bronze, with its head lowered slightly, and the paw of the weight-bearing foreleg placed just ahead of the hind paw. The nearly vertical frontal plane of the lion's head and the rolling, arabesque-like contours of the tail, haunches, back and shoulder are also similar to the bronze. Even the raised hackles on the shoulder are indicated in the drawing. At the right of the page, a slightly smaller drawing of a seated "Toying Lion" contains a second motif of significance for the monumental design, the sideward tilt of the lion's head. This brings the plane of the animal's left side into a nearly vertical line, repeating the verticality of the front of the head, exactly as on the bronze. The direct relation of this page of drawings to the monumental group and to two small bronze versions—which I will call the "Reduction No. 1" and the "Sketch," with the serpent pinned beneath the lion's forepaw and beneath a hind paw, respectively—documents their intimate

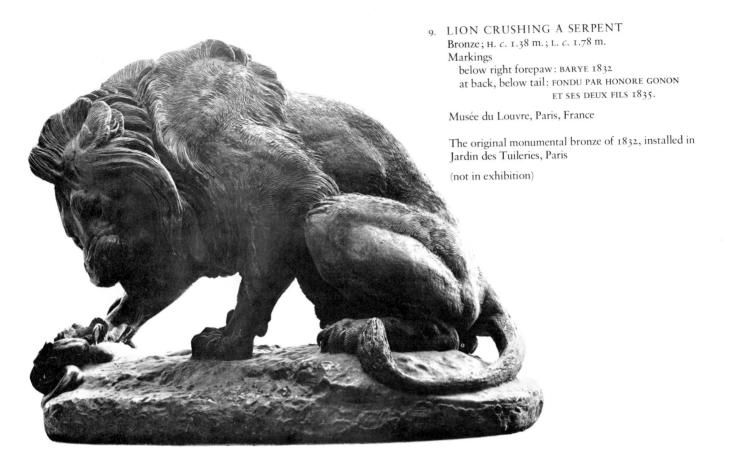

9. LION CRUSHING A SERPENT
Bronze; H. *c.* 1.38 m.; L. *c.* 1.78 m.
Markings
 below right forepaw: BARYE 1832
 at back, below tail: FONDU PAR HONORE GONON
 ET SES DEUX FILS 1835.

Musée du Louvre, Paris, France

The original monumental bronze of 1832, installed in Jardin des Tuileries, Paris

(not in exhibition)

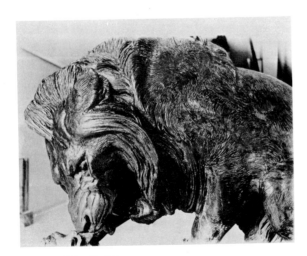

9a. Head detail of fig. 9

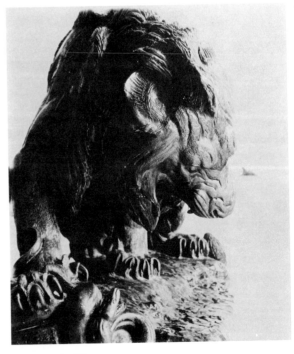

9b. Detail of fig. 9

conceptual connection. The great difference in scale seems to have been a conceptual irrelevancy to the sculptor at this moment in Barye's artistic development. The drawings affirm the interdependence of his miniature and monumental designs.

The inscription, "lionne du cabinet," which appears on an exquisite, measured contour study of the "Skeleton of a Lioness" in the Walters Art Gallery (fig. 11), indicates that Barye studied in the Cabinet d'anatomie comparée, established in Paris in the late eighteenth century by Baron Georges Cuvier. The suite of Barye's dissection drawings of the lioness also may be related to the monumental bronze.

Two measured drawings of a "Snake's Head" in the Walters Art Gallery (fig. 12) record lateral and dorsal views directly connected with the serpent in the original sculpture. In the lateral view, several aspects are reproduced in the monumental bronze: the angle of the opened jaws; the triangular web of tissue at the hinge of the jaw; the undulant line of the tongue; the number and spacing of the teeth; and the size, placement, and contour of the eye. The dorsal view shows the long ridges linking the eyes and nostrils, the narrowing of the throat behind the hinge of the jaw, and the tapered shape of the head.

In a preparatory terra-cotta sketch of the *Lion Crushing a Serpent* (figs. 13, 13a), the crouching lion is wholly involved with its adversary. Its head, drawn backward somewhat, is very close to the pinned serpent, ready to tear at it with its teeth. Dramatic emphasis is on the tension of the right forepaw pinning the snake, the lion's challenging mask, and the rhythmically repeated arches of the contours of its mane, neck, back, hindquarters, and tail.

The extreme closeness of the lion and serpent in the terra cotta presents a subtly different moment from that depicted in the monumental bronze. In the bronze, greater distance between the protagonists adds to the sense of the lion's caution before the fangs of the menacing serpent, underscoring the lion's almost human vulnerability.

This terra-cotta lion, crouching very low, appears to exert great strength in pinning the serpent, as though struggling with a much larger and stronger creature. The monumental lion, however, is in a slightly more open position, pinning the serpent with a gesture of repugnance.

Similar in the terra cotta and the monumental design are the arrangement of the hind legs, the curve of the tail, and the arched line of the back. Less well resolved in the small study are the articulation of the lion's shoulders, the relation of the neck to the head and shoulders, and the structure of the lion's face, as seen in the puffy forehead and rather short snout. A view of the terra cotta from the right rear reveals an emphasis upon the parallel, arched contours above and below the lion's body. The triangulation of that view is still indistinct and awaits the clarification of the monumental version.

In another more finished "Sketch" in bronze of the *Lion Crushing a Serpent* (fig. 14), a seated, snarling lion bats at the serpent with its left forepaw, while pinning it to the earth with its left hind paw. The snake is coiled and its jaws are open in challenge, ready to strike. Detail in the lion's claws is vividly articulated: the claws on the left front and rear paws are unsheathed, to hold and slash the serpent, while those on the right paws are withdrawn. The combination of psychological drama and physical action of the lion as it pins and slashes at the serpent is rich indeed. The domical modeling with graphic accents in the lion's snarling face, and the billowing tufts of its mane, are exquisitely realized passages, among Barye's finest of this period.

Barye's drawing of a "Toying Lion" (see fig. 10) at the right side of the page shows frontal and lateral views of a lion batting at something with its left forepaw. Even the tail of the lion curves upward as in the bronze sketch (see fig. 14). Different in the drawing, however, are the nearly vertical planes of the front and left sides of the lion's face—motifs Barye used on the monumental form. In the small bronze, the lion's face is lower, roughly a forty-five-degree angle to the horizontal. The lion's raised forepaw is lifted nearly to the height of its eye in the bronze, with elbow touching the knee of the hind leg. The

11. Drawing "Skeleton of a Lioness"

 Walters Art Gallery, Baltimore, Maryland (37.2167)

One of Barye's dissection drawings, possibly related to monumental bronze

(not in exhibition)

10. SKETCHES OF LION
 Graphite on paper; H. *c.* 10.7 cm.; L. *c.* 15.7 cm.
 Walters Art Gallery, Baltimore, Maryland (37.2248)

 Drawn sketches relating to *Lion Crushing a Serpent*

 (not in exhibition)

12. Drawing "Snake's Head"

 Walters Art Gallery, Baltimore, Maryland (37.2125B)

 Measured drawing of lateral and dorsal views related to serpent in Barye's *Lion and Serpent*

 (not in exhibition)

drawing, however, shows the forepaw lifted only half as high, and the elbow placed at some distance ahead of the knee. The frontal view of the "Toying Lion" is very like the small bronze sketch in the hesitant, sideways leaning attitude of the lion.

Barye used at least two different models for bronze editions, the first of which I shall call "Variation No. 1." The model (see figs. 14, 14a) for this variation is nearly solid bronze with very sharp detail directly cast from a wax positive. It may even be a direct cast. It appears to have been cut into five elements which could be reassembled to facilitate the making of sand molds: (1) the lion's body; (2) the lion's right foreleg and paw; (3) the lion's tail; (4) the serpent's head; (5) the plinth.

An unusual inscription in letters $c.$ 3 mm. high is cold-stamped beside the lion's left haunch: o BARYE 12. Do the numerical prefix and suffix identify an artisan, a founder, or was this proof the master for a particular edition of surmoulage casts? Unfortunately, our present knowledge does not provide an answer. The term MODÈLE does appear in either ink or paint inside, on the bottom (fig. 14b). A bronze made from this model (fig. 15) is in the collection of the Metropolitan Museum of Art, New York.

What I have designated "Variation No. 2" of the Lion Crushing a Serpent originates with a model of cast plaster touched with wax in the collection of the Musée des arts décoratifs, Paris (fig. 16). Since laboratory comparisons have not been made, it is unclear whether this model was itself molded from the Walters Art Gallery bronze (see fig. 14) or from some other predecessor to them both. In any case, a new motif of wax-pellet rocks, at the front of the base between the serpent and the lion's braced forepaw, marks the most obvious change from "Variation No. 1." The tufting of the mane, and the stance and gestures of this lion, also appear to differ slightly from those of the Walters Art Gallery bronze model.

This plaster-and-wax model was undoubtedly used to make a bronze master, which then became the foundry model for the bronzes of "Variation No. 2." An example of a bronze cast from the un-

located bronze model is in the collection of the Museum of Fine Arts, Boston, Massachusetts (figs. 17, 17a).

Compared with the monumental bronze, the small bronze "Sketch" and the terra-cotta compositional study reveal Barye's exploration of two extremes of silhouette-type in the small versions, both of which were assimilated into the final monumental sculpture. There is an essentially triangular silhouette in the bronze "Sketch," unlike that composed mainly of two great, arched lines in the terra-cotta version. A trangular silhouette remains the dominant impression of the monumental bronze when viewed from the lion's left front or right rear; whereas in the terra cotta, flowing, arabesque contours dominate a second principal view, from the lion's right front and left rear. Accents of arabesque contours serve to relieve the strict triangularity of the bronze "Sketch" in the play of the downward flowing contour of the lion's neck and face, opposing the upward curve of the tail—movements echoed in the tufts of the lion's mane, and in the roiling lines of the serpent. Similarly, rectilinear accents occur in the braced forelegs of the terra-cotta version, setting off the preponderance of flowing curves in the lines of that design.

The principal element retained for the monumental group from the bronze "Sketch" is the dramatic distance between the faces of the lion and serpent—an interval which establishes the emotionally charged relation between the two. Barye apparently regarded as too physical a motif the lion batting at the head of the serpent with its raised forepaw, while holding it fast with the claws of its hind paw. The final form of the design vividly restrains the action, and stresses instead the psychological tension of the encounter, for a great gain in dramatic effect. There is also a change in the posture of the lion of the bronze "Sketch," as viewed from the front. The small lion leans to the side—away from the serpent—creating an aura of hesitancy and fear, recoiling from the serpent. In contrast, the more upright stance of the monumental lion conveys a distinctly positive mood.

The rich surface texture on Honoré Gonon's

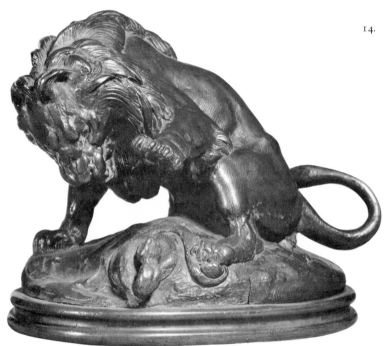

14. **LION CRUSHING A SERPENT**
Bronze; H. *c.* 13 cm.
Markings
 beside left haunch: O BARYE 12
 inside on bottom (either in ink or paint): "modele"

The Walters Art Gallery, Baltimore, Maryland (27.81)

A nearly solid bronze master model for "Variation No. 1" cut into five sections which could be reassembled to facilitate making sand molds

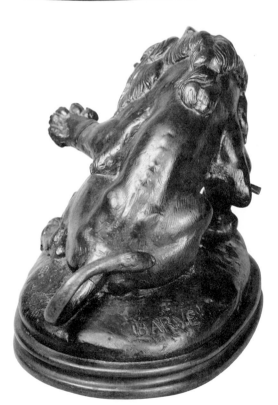

14a. Back view of fig. 14 14b. Bottom view of fig. 14

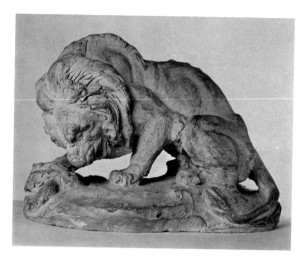

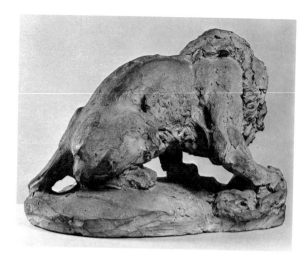

13. LION CRUSHING A SERPENT
Terra Cotta; H. *c.* 22 cm.; L. *c.* 31.5 cm.
No markings

Walters Art Gallery, Baltimore, Maryland (27.548)

Preparatory terra-cotta sketch

13a. Rear view of fig. 13

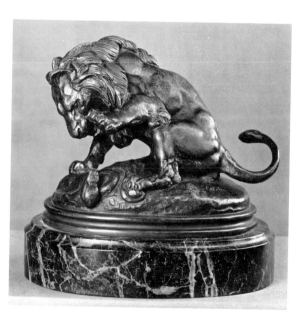

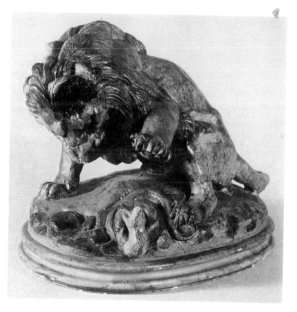

15. LION CRUSHING A SERPENT
Bronze; H. *c.* 13 cm.
Markings
 BARYE

The Metropolitan Museum of Art, New York, New York (39.65.57 A, B)
Bequest of Jacob Ruppert, 1939

An example of a bronze group which used fig. 19 as a model

(not in exhibition)

16. LION CRUSHING A SERPENT
Wax and plaster; H. *c.* 13.7 cm.; L. *c.* 16.7 cm.
No markings

Musée des arts décoratifs, Paris, France

Model for "Variation No. 2" of cast plaster touched with wax, used to make master bronze

(not in exhibition)

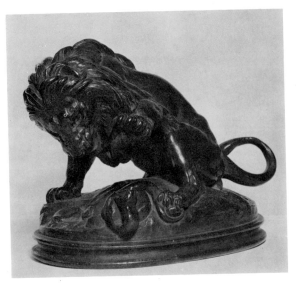

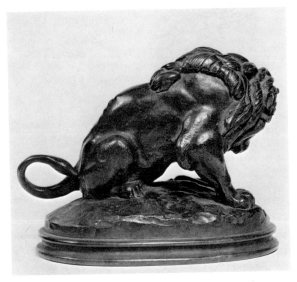

17. LION STRIKING A SERPENT
Bronze: H. *c.* 13.3 cm.
Markings
 on ground below proper right haunch: BARYE

Museum of Fine Arts, Boston, Massachusetts
(Res. 27.12)

17a. Back view of fig. 17

An example from a group of bronze casts of
"Variation No. 2" which indirectly used fig. 16 as a
model

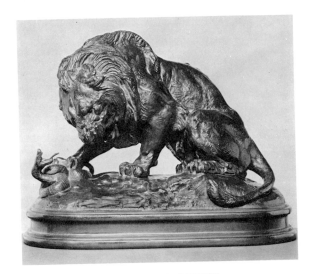

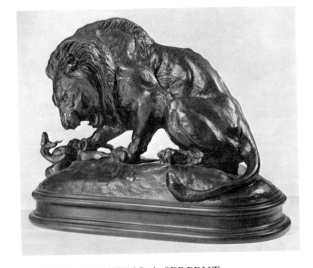

18. LION CRUSHING A SERPENT
Bronze; H. *c.* 26 cm.; L. *c.* 36 cm.
Markings
 BARYE
 behind right haunch, cold-stamped: VP under a
 crown (founder's mark)

The Walters Art Gallery, Baltimore, Maryland (27.157)

Master bronze for edition of "Reduction No. 1" (non-
mechanical)

19. LION CRUSHING A SERPENT
Bronze; H. *c.* 21 cm.; L. *c.* 35 cm.
Markings
 on ground below proper right haunch: BARYE

Philadelphia Museum of Art, Philadelphia,
Pennsylvania (W'93–1–162)

An example of a bronze group which used fig. 18 as a
model

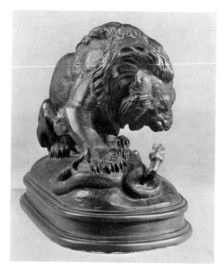

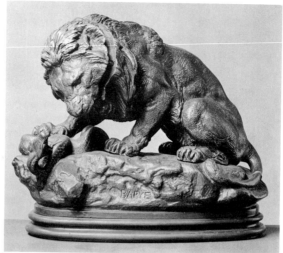

20. LION CRUSHING A SERPENT
Bronze; H. *c.* 26 cm.; L. *c.* 35.5 cm.
Markings
 on ground: BARYE

The Denver Art Museum, Denver, Colorado
Dr. T. Edward and Tullah Hanley Collection
(E.-1308)

An example of a bronze group which used fig. 18 as a model

21. LION CRUSHING A SERPENT
Bronze; H. *c.* 20 cm.
Markings
 on rocky base below left forepaw: BARYE
 on rock, below lion's face, cold-stamped:
 VP under a crown (founder's mark)
 right rear of base: S (tilted to left)

The Walters Art Gallery, Baltimore, Maryland (27.92)

Master model bronze for "Reduction No. 2" of four reassembled elements

21a. Exploded view of fig. 21

97

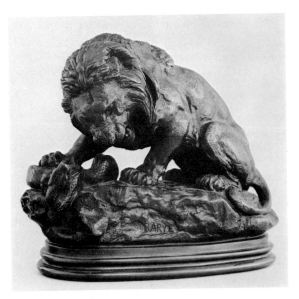

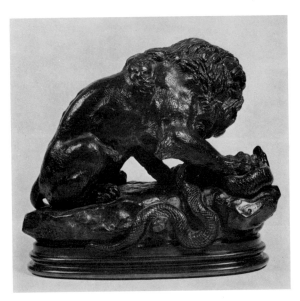

22. LION CRUSHING A SERPENT
Bronze; H. *c.* 20 cm.
Markings
 below left forepaw: BARYE
 inscribed inside by George A. Lucas: MODERN

The George A. Lucas Collection on indefinite loan to
the Baltimore Museum of Art from the Maryland
Institute, College of Art (64.15.5)

22a. Rear view of fig. 22

An example of a bronze group which used fig. 21 as a
model

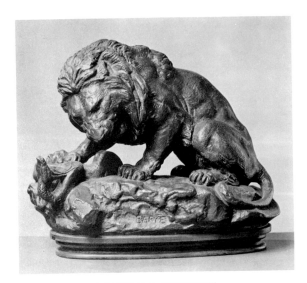

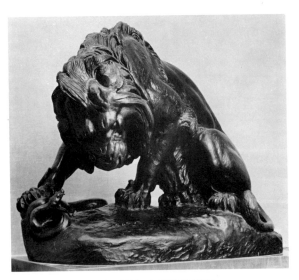

23. LION CRUSHING A SERPENT
Bronze; H. *c.* 16.25 cm.; L. *c.* 20.2 cm.
Markings
 below proper left forepaw, on side of ground:
 BARYE
 inside cast, in white paint: <u>LUCAS</u>

The Walters Art Gallery, Baltimore, Maryland (27.113)

An example of a bronze group which used fig. 21 as a
model, with base variation

24. LION CRUSHING A SERPENT
Bronze; H. *c.* 57 cm.; L. *c.* 73 cm.
Markings
 on ground between left forepaw and serpent: BARYE

The Baltimore Museum of Art, Baltimore, Maryland
(51.125)
Bequest of Jacob Epstein

An example, assembled of six separate elements, of the
largest free version, of the *Lion Crushing a Serpent*

bronze cast of the monumental *Lion Crushing a Serpent* is essentially linear (figs. 9a, 9b). Transitions from intaglio or graphic combing to the positive, projecting form of the ridges and tufts of the pelt are very subtle. Large whorls enliven the simple planes of the left shoulder and the lower mid-back of the lion: On the base where surface texture is more fluid and knobby, line is used as an occasional accent and does not predominate.

Barye's early interest in organizing designs by means of regular geometrical units is apparent in his use of two perfectly vertical planes for the front and left sides of the focal lion's head, and also in the strictly triangular form of the sculpture's silhouette when seen from the left front or right rear.

Non-Mechanical Small Versions

Barye freely invented miniature variations of his famous monumental design of 1832 in three different sizes—18, 26, and 56 cm. high—according to the entries in his own sales catalogues of the period 1847–1855. A fourth version, the smallest of them all, 15 cm. high, he called a "sketch of the same subject." This latter type was the preliminary design for "Variation No. 1" and "Variation No. 2," which included motifs omitted from the monumental form of the lion slapping at the serpent with a forepaw and pinning it with a hind paw. As has been pointed out, Barye regarded his variously scaled small bronzes as suited to an array of middle-class interiors. Business offices, parlors or salons, and sleeping rooms were the settings he named in his catalogue of 1847–1848. The following list, a collation of the three sizes of this design offered in Barye's catalogues (see Bibliography for complete catalogue designation), also includes a fourth size (40 cm. high), available in the undated but probably late (*c.* 1890s) Leblanc-Barbedienne catalogue. A capital letter in parentheses follows each catalogue citation of a distinct version, and a reference is given as well to an extant example of the type. Slight variations in measurements are due to the rounding off of dimensions to the nearest centimeter in the catalogues, to differences of base configuration, or to the alteration of such variable details as the projecting lion's tail.

CRB47 & CRSA:
No. 66. *Le lion des Tuileries* (réduction) 26 cm. × 35 cm. 10 $^1/_4$ × 13 $^3/_4$ inches. (A). [Cf. fig. 18, Walters Art Gallery, a master bronze.]

CQCI:
No. 44. *Lion au serpent. Jardin des Tuileries. Réduction No. 1.* 26 cm. × 35 cm. 10 $^1/_4$ × 13 $^3/_4$. (A).
No. 45. *Lion au serpent. Jardin des Tuileries. Réduction No. 2.* 18 cm. × 21 cm. 7 $^1/_8$ × 8 $^1/_4$. (B). [Cf. fig. 21, Walters Art Gallery, a master bronze.]
No. 46. *Lion au serpent. Jardin des Tuileries. Esquisse du même sujet.* 15 cm. × 16 cm. 6 × 6 $^3/_8$. Also cited in CQCII, No. 43, as #3 (*esquisse*). [This title has been rendered as *Lion Crushing a Serpent,* "*Sketch*" in the present study. Cf. fig. 14, Walters Art Gallery, a master bronze; and fig. 16, Musée des arts décoratifs, a plaster-and-wax model.]

CRF55:
No. 36. *Lion au serpent. Jardin des Tuileries.* 56 cm. × 73 cm. 22 × 28 $^3/_4$. (C). [Cf. fig. 24, Baltimore Museum of Art.]

CFBLB, page 9: *Lion au serpent (Tuileries).*
No. 1. 40 cm. × 52 cm. 15 $^3/_4$ × 20 $^1/_2$. (D).
No. 2. 27 cm. × 36 cm. 10 $^5/_8$ × 14 $^1/_8$. (A?).
No. 3. 13 cm. × 17 cm. 5 $^1/_8$ × 6 $^3/_4$. [Cf. fig. 28, Private collection, New York; H. 13 cm., L. 18.3 cm., a bronze mechanical reduction, rather than a freely invented small version.]

Reduction No. 1 (Non-Mechanical)

As previously discussed, Barye's desire to preserve the autograph quality of his original as fully as possible often led him to send his own sculptor's model—rather than a cast-plaster reproduction of it—directly to the founder, for the making of a sand mold. In such a primary sand mold a superbly detailed bronze would be cast, which would serve, in turn, as a long-lasting model for the making of successive sand molds and *surmoulage* casts of the design. This process was used for a master bronze *Lion Crushing a Serpent* (fig. 18) in the Walters Art Gallery, and for the group of eight successive *surmoulage* casts studied here. Two examples of these casts are in the collections of the Philadelphia Museum of Art (fig. 19) and the Denver Art Museum (fig. 20).

Traces of French sand inside the base of the Walters Art Gallery bronze confirm its function as a bronze model for the making of sand molds. The founder's mark, VP under a crown, is cold-stamped onto the base behind the lion's right haunch, and the gradual loss of that clearly recognizable detail of the master bronze is apparent on the successive casts.

The principal view of "Reduction No. 1," from left front (see fig. 20), is strikingly similar in emphases to the preliminary terra-cotta study (see fig. 13). The small bronze places the lion's head twice as high above the surface of the base—a larger interval also used in the monumental version. Different too is the somewhat more vertical plane of the lion's face—again a change echoed in the monumental form. On the lion's right side, the side away from its focal mask, a steely, spring-like muscular tension is well articulated. Raw power is conveyed in the large, domical compartments of muscle, relieved with deep grooves. The bronze repeats the short snout of the terra-cotta lion's face, although the planes and modeling of the head are clearer.

In consequence of the somewhat indistinct modeling of the lion's head in "Reduction No. 1," the animal loses some of its dramatic importance. Correspondingly, there is greater emphasis upon the serpent than is true in the monumental bronze: Its coils are more freely piled; its head is held high in the air, almost in a striking position. In the large version, the serpent in a nearly human attitude, appears to cower just beyond the slightly protective edge of the rock, and to weigh the risks of striking at the lion.

A comparison of the lion's head and mane in "Reduction No. 1" (see fig. 18) with those of the small bronze "Sketch" (see fig. 14) is instructive. Barye's use of positive, tufted forms in the mane, and of clearly defined domical forms in the mask of the "Sketch," is here replaced with graphic handling of the mane and a less distinct mask structure. The main tendency of the mask in the "Reduction No. 1" is toward a decoratively shimmering, almost impressionistic fragmentation of the larger, simple planes, with a somewhat confused final effect.

The finish of the animal in this master bronze cast is slightly more matte than the glossier base. Within the rich development of surface, there is a conscious avoidance of the regularity and parallelism of hachure evident in the pelt of the monumental version of 1832. The more economical surface accents are freer, flickering, sparkling, and intimately related to the interplay of flattened, planar surfaces and domical, mounded passages. The exuberant effect is altogether different from the more soberly zoological surfaces of the monumental group. The lion's face, built up of small mounds or pellets of wax, is given a richer, interrupted rhythm. Nonetheless, anatomical mastery is still forceful, as in the delineation of the claws, claw sheaths, and knuckles of the focal, serpent-pinning forepaw. The base shows a sharp ridge that creates a long line leading the eye directly from the serpent to the lion's left hind paw, a motif retained from the monumental original. There are all the marks of Barye's mature style, which suggest a date for this model in the mid-forties, probably just prior to the appearance of Barye's first printed sales catalogue of 1847.

Surface quality is waxy over the entire proof. The serpent's scales vary in size, but are regularly incised. The lion is a separate cast, attached to the base with bronze pins, screws, and solder. The major part of the serpent is integrally cast with the base, except for the projecting head, which is bolted and soldered to the base.

Reduction No. 2 (Non-Mechanical)

Often, to facilitate the very difficult process of fabrication of a sand-piece-mold, a bronze model would be cut into several segments which could be slipped together or pulled apart for this purpose. *Lion Crushing a Serpent* in the Walters Art Gallery (figs. 21, 21a) is an excellent example of this type of master model. It can be compared with related casts in the collection of the Baltimore Museum of Art (figs. 22, 22a) and the Walters Art Gallery (fig. 23). The Walters master model is cold-stamped with the founder's mark, VP under a crown, on the focal side, below the lion's face. The letter s, tilted toward the left at a forty-five-

degree angle, is inscribed at the right rear of the rocky base, possibly the mark of an artisan.

Several pieces of this model are held in place by sliding pins and by integrally cast "keying" ridges and sockets (see fig. 21a). (1) The lowest piece includes the plinth with its integral molding. A keying notch has been cut into the left side matching a similar notch in the section above. (2) The next element is the rocky base, with the integrally cast serpent and the end-portion of the lion's tail; this includes a reserved ridge of metal around the end to be butt-jointed, and peened over the seam. Two pins are mounted at the extreme ends of this section, which mate with holes in the plinth below. Four holes are bored in the top surface for the attachment of the pegs integrally cast with the lion's paws. (3) The third segment is the lion's body, with the stump of its tail. On the upper, machined surface, which mates with the last, lid-like segment, are three integrally cast tits joined by vertical ridges of metal, like tiny walls connecting corner towers of a fort. This triangular "key" fits into a socket cast on the underside of the uppermost element of the model and locates the two mating surfaces perfectly. (4) The top of the lion's head is the final segment. Interestingly, a subsidiary locating system of three long pegs of bronze has been soldered inside this element of the model. Pegs fit into tubular sockets soldered onto the interior walls of the lion's body, and their length suggests that they were added to allow the uppermost element to be drawn away from the lion's body, perhaps one-half centimeter. They are functionally redundant with respect to the disassembly needed for mold-making. Traces both of fresh and fired French sand are visible in the interior, evidence of both the casting of this model itself and of its use as a master for sand molds.

Proof of the relationship of this model to the Baltimore Museum of Art bronze (see fig. 22) can be seen in the presence of cold-work chasing marks in the mane of the Baltimore Museum lion, exactly at the separation line for the lid-like top of the lion's head in the bronze model from Walters Art Gallery.

A further note of technical interest can be observed in a cast in the Walters Art Gallery collection with an unusually small base section (see fig. 23). The point of union is located in the same position as found in the bronze model for this edition (see fig. 21a).

By comparison with the monumental original of 1832, the much deeper rocky base of "Reduction No. 2" is decoratively elaborated, with a wrinkled surface on the signature side, and a projecting crag jutting out directly below the serpent's head. The lion's mane is treated as a denser mass than in either the small "Sketch" or "Reduction No. 1." Its hair is more wiry and does not fall into the same sort of soft, blade-like tufts. On the back side, a new element of emphasis appears in the very long, undulant form of the snake, which leads the eye to the cursive contours of the lion's haunch. This treatment of the serpent goes far beyond the very subtle, abstract interest in the negative form between the animal and base of the monumental original. Now the serpent is shown as far larger, more active, and much more threatening.

The Largest Free Version

The largest bronze free version of *Lion Crushing a Serpent* is in the collection of the Baltimore Museum of Art (fig. 24). In comparison with the monumental original, this free variation reveals a greater emphasis upon the serpent, both by the exaggerated size of its head and its dramatic elevation above the base, similar to "Reduction No. 2." Subtler alterations are also apparent in the finer and more intricate treatment of the tufts of mane behind the lion's ears; the shorter appearance of its left haunch, which does not touch the elbow of the foreleg, as in the monumental design; and the flatter look of the lion's snarling mask.

The six assembled elements of the cast are (1) the base, including two-thirds of the lion's tail; (2) the serpent's head and a *c.* 5 cm. section of its projecting neck; (3) the lion's body with the stump of the tail; (4) the left paw and foreleg to a height of *c.* 8 cm. above the base; (5) the right paw and foreleg, to a height of *c.* 12 cm.; and (6) the lion's snout, its nose, upper jaw, and teeth.

The Mechanical Reductions

Barye exhibited a group of his small bronzes in the "*section industrielle*" of the Exposition Universelle of 1855. The term "*industrielle*" implies not only the idea of limited mass production, but also of mechanically produced reductions and enlargements of his designs of the sort possible with the then recently invented Collas machine or similar devices. Hence the group of mechanical reductions of the *Lion Crushing a Serpent* could date from as early as Barye's period of work preparatory to the 1855 exposition. The date 1852, inscribed on the plaster *Lion's Head* in the collection of the Louvre, Paris (fig. 25), indicates a perfect example of this type. This *Lion's Head* is a mechanically produced reduction of the head of the monumental lion of 1832, with an integrally cast signature and date, "Barye 1852." The plaster is sealed with a uniformly thin coating of wax. Tokens of the casting process by which this posi-

tive was made are the mold separation lines across the forehead, just above the eyes, and along the ridge of the central coxcomb of the mane.

The size of this plaster *Lion's Head* coincides perfectly with the freely invented "Reduction No. 1," and more importantly with the similar size of "proof no. 2" in the late Leblanc-Barbedienne catalogue, which appears to list only mechanical reductions. One glaring difference, however, between the free variation and this mechanical copy, which underscores the departure of the free variation from the original, is in the size of the lion's opened mouth: 2 cm. for the "Reduction No. 1," and 3.8 cm. for the mechanical proof. It is as though Barye had intended to display the two side by side at the 1855 exhibition to stress the distinctions between the invented and mechanical reductions. Strangely, no bronze proof made from this type of model has come to light in an American or Parisian collection.

It is clear that the *Lion Crushing a Serpent* in the collection of the Chrysler Museum at Norfolk, Norfolk, Virginia (figs. 26, 26a) is also a mechanical reduction of the original of 1832, and that it is not related to the freely invented variation of about 1855 (see fig. 24). One notes its general "soft" quality and the accurate duplication of its essential form as well as many major details, such as the intricacies of the plinth and the composition of the serpent. However, the configuration of the lion's mane departs very slightly from the original in its rhythmical system and its tufting pattern. The lion's mask is observably shorter in this reduction from the coxcomb of mane to the tip of the nose, and the lozenge-like folds about the nostrils are raised higher in relief. Some of these alterations may have an expressive function (the reworking of the mane and the more plastic treatment of the snout), but others seem merely mechanical, perhaps reflecting difficulties with mold structure or alignment, as in the lion's shortened mask.

It is interesting to note that the artisans who created these mechanical reductions at several scales felt it necessary to alter focal passages of the lion's mane for the sake of expression.

The *Lion Crushing a Serpent* in the Newark

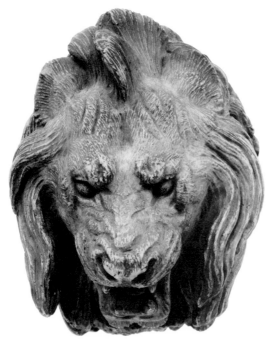

25. LION'S HEAD
Plaster; H. *c.* 14 cm.
Markings
back of head, bottom: BARYE
1852

Musée du Louvre, Paris, France (R.F.1569)

Cast plaster related to the mechanical reductions of the monumental bronze

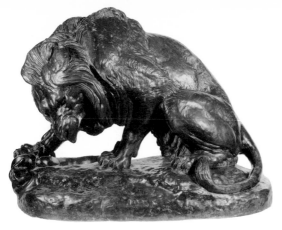

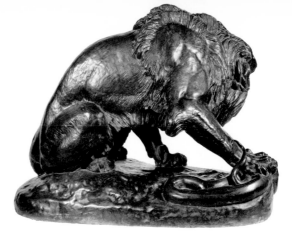

26. LION CRUSHING A SERPENT
Bronze; H. *c.* 50 cm.; L. *c.* 60.6 cm.
Markings
 edge of ground below right forepaw: BARYE
 1837

Chrysler Museum at Norfolk, Norfolk, Virginia
Gift of Walter P. Chrysler, Jr.

26a. Back view of fig. 26

 Largest example of group of bronzes which were made
from a mechanically reduced model

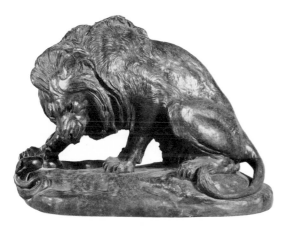

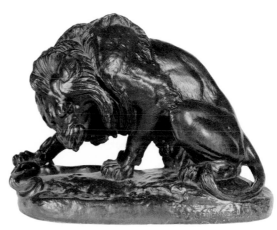

27. LION CRUSHING A SERPENT
Bronze; H. *c.* 19 cm.
Markings
 on ground below proper right forepaw: BARYE
 at edge of rear ground, in red paint: F.14.763

Collection of the Newark Museum, Newark, New
Jersey (14.763)

Mid-size example of a group of bronzes which were
made from a mechanically reduced model

28. LION CRUSHING A SERPENT
Bronze; H. *c.* 13 cm.
Markings
 beneath right forepaw: BARYE
 inscribed below left haunch: F. BARBEDIENNE
 FONDEUR
 inside the cast, inscribed: 43
 stamped: A

Private collection, New York

An example of a small mechanical reduction

[left]
29. LION CRUSHING A SERPENT
Bronze; H. *c.* 12 cm.
Markings
 on ground below proper right forepaw: BARYE

Indianapolis Museum of Art, Indianapolis, Indiana
(25.127)
Bequest of Delavan Smith

An example of the smallest mechanical reduction

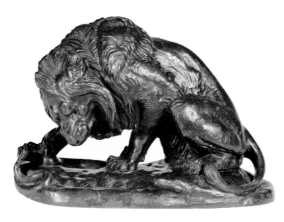

Art Museum, Newark, New Jersey (fig. 27) is a two-piece cast with a Roman sleeve joint at the insertion of the lion's right forepaw into the base, and a butt joint at the juncture of the two segments of the tail.

Many details of the design confirm that it is also a mechanically produced copy of the monumental original of 1832. In comparison with the original, the decorative development of the bristling ridges of the mane around the top of the lion's shoulder have an ineffectual, rather lifeless, quality of flatness. In the freely invented variation (see fig. 22), by contrast, these very focal passages are emphatically reworked and are given a measure of plastic vigor and impact sensitively adjusted to their actual scale.

In the still smaller mechanical reduction in a private collection, New York (fig. 28), we see that these bristling passages of the lion's mane are deliberately reworked—with a dramatic improvement in the liveliness and freshness of the design. This alteration so transforms the work that at first glance, the question arises as to whether it is not, after all, a freely invented version. Although the general form was reproduced mechanically, in this cast the lion's mane is more subtly varied. Expressively dissimilar degrees of relief are apparent behind the left ear and in the long tufts at either side of the neck, which are clearer and more pronouncedly blade-like. In view of the corresponding dimensions of this mechanical reduction with "no. 3" of the Leblanc-Barbedienne catalogue, it is possible that all three sizes offered therein refer to mechanical copies.

A lateral cut taken across the base, just ahead of the hind paws, separates the lion's body segment from the front portion of the plinth. This mode of assembly differs from that of the larger reductions in the collections of the Joslyn Art Museum, Omaha, Nebraska and Newark Art Museum, Newark, New Jersey.

Another bronze mechanical reduction in the collection of the Indianapolis Museum of Art, Indianapolis, Indiana (fig. 29) indicates a slight difference in size from the cast in the New York private collection. This size differential is too great to be the result of a *surmoulage* cast produced in materials with even a high degree of shrinkage. It appears to be the result of another "setting" of the Collas machine.

One apparent element of the final quality of this reduction, especially when it is seen directly beside the slightly larger Barbedienne cast (see fig. 28), is that the artisan used exactly the same size of burin or modeling point, the more deeply to incise the swirling patterns of the lion's mane and the tuft of its tail. The point was clearly too large for this tiny sculpture, and the incised channels are too wide and too regular in quality. Thus, although the mass and volume of the animal are reduced uniformly and proportionately, the surface intaglio is of a completely inappropriate scale.

A posthumous, state-sanctioned effort to issue copies—if not reductions or enlargements—of Barye's *Lion Crushing a Serpent* and *Lion of the Zodiac Relief* coincided with the Exposition Universelle of 1889. This campaign would have yielded molds and positives well suited to making mechanical reductions. The 1889 reproduction work coincides perfectly with the purchase of the fine Barbedienne cast of the *Lion Crushing a Serpent* for Philadelphia's Rittenhouse Square. A second cast of the *Lion Crushing a Serpent*, made in this same period, was installed atop the American-sponsored *Monument* to Barye, designed by Stanislas Bernier and unveiled in 1894 on the Ile Saint-Louis, at the Pont Sully–Boulevard Henri IV, Paris.

The largest reduction of the *Lion Crushing a Serpent* may be referred to in the Hôtel Drouot Barye sales catalogue of 1876, under "*sculpture plâtre*," no. 493, a "*Lion au serpent . . .* Jardin des Tuileries. *demi grandeur.*" Descriptions of size in this catalogue are demonstrably vague.

Even a proof in the size of the monumental original was obtainable for 5,000 francs, which means that an accurate full-size model, suitable for the making of reductions of any size, was available in the Leblanc-Barbedienne shop.

Selected Bibliography

MANUSCRIPTS:

Baltimore, Walters Art Gallery. Émile Martin. *Journal Contenans les operations de Barye, 31 July 1850 – 30 April 1858.*

Baltimore, Walters Art Gallery. George A. Lucas. *Agenda Book* (excerpts).

Baltimore, Walters Art Gallery. George A. Lucas. *Diary* (excerpts).

CATALOGUES:

I. Barye's Bronze Catalogues

CMBRT:
Bronzes Barye. Maison Brame, 31 Rue Taihout, Paris, n.d.

CRSA:
Bronzes de Barye, en vente dans ses magasins. Rue Saint-Anastase, 10, à Paris (Marais). (113 works.)

CRB47:
Catalogue des bronzes de Barye. Rue de Boulogne, No. 6 (Chaussée d'Antin), Paris, Années 1847–1848. September 1, 1847. (107 works.)

CRC:
Catalogue des bronzes de Barye. 12, Rue Chaptal (Chaussée d'Antin), Paris. (113 works.)

CQCI:
Catalogue des bronzes de Barye, Statuaire, Exposition Universelle, 1855 La Grande Médaille d'Honneur. Quai des Celestins, 10, Paris. (197 works.)

CQCII:
Catalogue des bronzes de A.-L. Barye, Statuaire, Exposition Universelle, 1865. La Grande Médaille d'Honneur. Quai des Celestins, 4, à Paris. (230 works.)

CRF55:
Catalogue des bronzes de Barye, Statuaire, Exposition Universelle de 1855, Medaille d'Honneur. Rue des Fosses-Saint-Victor, 13, Paris. (152 works.)

II. Sales and Exhibition Catalogues

Baltimore, Maryland Institute. *Exhibition of Paintings, Bronzes and Porcelains from the George A. Lucas Collection.* 1911.

Baltimore Museum of Art. *The George A. Lucas Collection of the Maryland Institute, Exhibition, October 12 – November 21, 1965.* 1965.

CEBLB:
Barbedienne, F., ed. *Oeuvres de A. L. Barye.* Paris, n.d.

New York, Alan Gallery. *Barye Bronzes.* 20 October – 16 November 1963. Catalogue with essays by George Heard Hamilton and Jacques de Caso.

New York, American Art Galleries. *Catalogue of the Works of Antoine-Louis Barye.* 1889.

New York, Fine Arts Society Building. *Catalogue of Bronzes in the A. L. Barye Loan Exhibition.* February 1893.

New York, Grolier Club. *Exhibition of Bronzes and Paintings by Antoine-Louis Barye.* March 11 – 27, 1909.

New York, Parke-Bernet Galleries, Inc. *The Mrs. Henry Walters Art Collection,* April 30 – May 1, 2, 3, 1941, pp. 252–254.

Paris, École national des Beaux-Arts. *Catalogue des oeuvres de Antoine-Louis Barye, membre de l'institut.* 1875.

Paris, École national des Beaux-Arts. *Catalogue des oeuvres de Antoine-Louis Barye, membre de l'institut.* April 1889.

Paris, Hôtel Drouot. *Catalogue des bronzes de Barye. Épreuves de choix groupes, statuettes, bas reliefs, etc. Modèles, tableaux et dessins par Barye. Composant la collection de M. Auguste Sichel.* February 27, 1876. Preface, "Un Mot," par Edmond de Goncourt.

Paris, Hôtel Drouot. *Catalogue des bronzes de Barye (modèles) dont la vente aura lieu a Paris.* April 24, 1884.

Paris, Musée national du Louvre. *Barye, sculptures, peintures, aquarelles des collections publiques françaises.* October 1956 – February 1957, with essays by Gerard Hubert, Maurice Serullay, Jacqueline Bouchot-Saupique.

BOOKS:

Alexandre, Arsène. *Antoine-Louis Barye.* Paris: Libraire de l'art, 1889.

Ballu, Roger. *L'Oeuvre de Barye.* Paris: Maison Quantin, 1890.

Benge, Glenn F. *The Sculptures of Antoine-Louis Barye in the American Collections, with a Catalogue Raisonné.* 2 vols. Unpublished Ph.D. dissertation, University of Iowa, Iowa City, 1969.

Blanc, Charles. *Les Artistes de mon temps.* Paris: Fermin-Didot and Co., 1876.

Claretie, Jules. *Peintres et sculpteurs contemporains.* 1er serie, 6e livraison, Paris: Libraire des bibliophiles, 1882.

Clement, Charles. *Artistes anciens et modernes.* Paris: Didier, 1876.

DeKay, Charles. *Barye, Life and Works.* New York: The Barye Monument Association, 1889.

Delaborde, Henri. *Discours prononcé aux funerailles de Barye, 28 Juin 1875.* Paris, 1875.

——, and Guillaume, J. J. *Discours prononcés à l'inauguration du monument élevé à la memoire de Barye, à Paris, sur le terre-plein du pont de Sully, le lundi 18 Juin, 1894.* Paris, 1894.

Delteil, Loys. *Barye. Le Peintre-graveur illustrée* VI. Paris, 1851.

Lengyel, Alfonz. *Life and Art of Antoine Louis Barye.* Dubuque, Iowa: Brown, 1963.

Luc-Benoist. *La Sculpture romantique.* Paris: Renaissance du livre, 1928.

Pivar, Stuart. *The Barye Bronzes.* Woodbridge, Suffolk: Baron Publishing Co., 1974.

Saunier, Charles. *Barye.* Paris: F. Rieder and Co., 1925.

Silvestre, Theophile. *Histoire des artistes vivantes, français et étrangers, études d'après nature.* Paris: E. Blanchard, 2ᵉᵐᵉ ed., 1886.

Smith, Charles Sprague. *Barbizon Days: Millet, Corot, Rousseau, Barye.* New York: A. Wessels Co., 1902.

Zieseniss, Charles Otto. *Les Aquarelles de Barye, Étude critique et catalogue raisonné.* Paris: C. Massin, 1956.

ARTICLES:

"Antoine-Louis Barye." *Archives de l'art français, recueil de documents inédits* IV (1910), pp. 180–181.

"Baltimore: Animal Bronzes by Barye." *Art News,* XXXIV (August 1937), 21.

Benge, Glenn F. "Barye's Uses of Some Gericault Drawings." *Walters Art Gallery Journal,* XXXI, XXXII (1968–1969, 1971), 13–27 and notes.

——. "The Bronzes of Barye." Essay for an exhibition catalogue, the Sladmore Gallery, London, England, 1972.

——. "Lion Crushing a Serpent." In *Sculpture of a City: Philadelphia's Treasures in Bronze and Stone,* edited by Nicholas B. Wainwright, pp. 30–35. Walker Publishing Co., 1974.

Chancellor, E. B. "A Pre-eminent Sculptor: Antoine-Louis Barye." *Architectural Review,* LV (1922), 32–35.

Crombie, T. "French Animal Bronzes of the Nineteenth Century." *The Connoisseur,* CLI (December 1962), 245–247.

Eckford, Henry. "Antoine-Louis Barye." *The Century Magazine,* XXXI, new series IX (1885–1886), 483–500.

Gautier, Theophile. "Barye." *L'Illustration, Journal Universelle,* XLVIII (May 19, 1866), 315.

Guillaume, J. J. "Exposition des oeuvres de Barye à l'École des Beaux-Arts." *Nouvelles Archives de l'art française,* 3ᵉᵐᵉ serie, V (1889), 178–181.

Hamilton, George Heard. "The Origin of Barye's Tiger Hunt." *Art Bulletin,* XVIII (1936), 250.

d'Henriet, Charles. "L'Art Contemporain. Barye et son oeuvre." *Revue des Deux Mondes,* XXV (February 1, 1860), 758–778.

Hubert, Gerard. "Barye et la critique de son temps." *Revue des Arts,* VI (1956), 223–230.

"One Hundred Sculptures by Barye, Who Mirrored the Struggle for Survival in Bronze." *Art Digest,* XI (1937), 12.

Johnson, L. "Delacroix, Barye and the Tower Menagerie, an English Influence on French Romantic Animal Pictures." *Burlington Magazine,* CVI (September 1964), 416–417.

Lamé, Émile. "Les Sculpteurs d'animaux. M. Barye." *Revue de Paris,* XXX (February 15, 1856), 204–219.

Mantz, Paul. "Artistes contemporains, M. Barye." *Gazette des Beaux-Arts,* 2ᵉᵐᵉ serie, I (1867), 107–126.

Musset, Alfred de. "Salon de 1836." *Revue des Deux Mondes,* VI (1836), 144–176.

Planche, Gustave. "Exposition des Beaux-Arts." *Revue des Deux Mondes,* XI (1855), 1160–1161.

——. "Barye." *Revue des Deux Mondes,* XI (July 1, 1851), 47–75.

Raynor, V. "Barye Exhibition at Alan Gallery." *Arts,* XXXVIII (December 1963), 64.

Reboussin, R. "Barye peintre." *L'Art et les artistes,* XVI (1913), 195–210.

Remington, Preston. "Lion About to Strike a Serpent Given to the Metropolitan." *Bulletin of the Metropolitan Museum of Art,* XXXV (1940), 58.

——. "Sculptures by Barye; Recent Acquisitions." *Bulletin of the Metropolitan Museum of Art,* XXXV (1940), 34–36.

Saunier, Charles. "Les aquarelles de Barye." *La Renaissance de l'Art francais* (1925), pp. 142–148.

Vitry, Paul. "La salle Barye au Musée du Louvre." *Les Musées de France,* No. 6 (1912), pp. 93–96 and figs.

——. "Les accroissements de la salle Barye." *Bulletin des Musées de France,* III (1931), 65–66 and figs.

——. "Modèles de Barye." *Bulletin des Musées de France,* V (1933), 73–74.

——. "Une Nouvelle donation d'oeuvres de Barye au Musée du Louvre." *Les Musées de France,* No. 2 (1914), pp. 17–18 and figs.

Checklist of the Exhibition

4. TIGER ATTACKING A PEACOCK
Plaster and wax; H. *c.* 17 cm.; L. *c.* 45 cm.
Fogg Art Museum, Harvard University, Cambridge,
Massachusetts

13. LION CRUSHING A SERPENT
Terra Cotta: H. *c.* 22 cm.; L. *c.* 31.5 cm.
The Walters Art Gallery, Baltimore, Maryland

14. LION CRUSHING A SERPENT
Bronze; H. *c.* 13 cm.
The Walters Art Gallery, Baltimore, Maryland

17. LION CRUSHING A SERPENT
Bronze; H. *c.* 13.3 cm.
Museum of Fine Arts, Boston, Massachusetts

18. LION CRUSHING A SERPENT
Bronze; H. *c.* 36 cm.
The Walters Art Gallery, Baltimore, Maryland

19. LION CRUSHING A SERPENT
Bronze; H. *c.* 28 cm.; L. *c.* 34 cm.
Philadelphia Museum of Art, Philadelphia,
Pennsylvania

20. LION CRUSHING A SERPENT
Bronze; H. *c.* 26 cm.; L. *c.* 35.5 cm.
Denver Art Museum, Denver, Colorado

21. LION CRUSHING A SERPENT
Bronze; H. *c.* 20 cm.
The Walters Art Gallery, Baltimore, Maryland

22. LION CRUSHING A SERPENT
Bronze; H. *c.* 20 cm.
The Baltimore Museum of Art, Baltimore, Maryland

23. LION CRUSHING A SERPENT
Bronze; H. 16.25 cm.; L. *c.* 20.2 cm.
The Walters Art Gallery, Baltimore, Maryland

24. LION CRUSHING A SERPENT
Bronze; H. *c.* 57 cm.; L. *c.* 73 cm.
The Baltimore Museum of Art, Baltimore, Maryland

25. LION'S HEAD
Plaster; H. *c.* 14 cm.
Musée du Louvre, Paris, France

26. LION CRUSHING A SERPENT
Bronze; H. *c.* 50 cm.; L. *c.* 60.6 cm.
Chrysler Museum at Norfolk, Norfolk, Virginia

27. LION CRUSHING A SERPENT
Bronze; H. *c.* 19 cm.
The Newark Museum, Newark, New Jersey

28. LION CRUSHING A SERPENT
Bronze; H. *c.* 13 cm.
Private Collection, New York

29. LION CRUSHING A SERPENT
Bronze; H. *c.* 12 cm.; L. *c.* 16.5 cm.
Indianapolis Museum of Art, Indianapolis, Indiana

30. LION CRUSHING A SERPENT
Bronze; H. *c.* 26 cm.; L. *c.* 35.5 cm.
Markings
 incised right rear corner: BARYE
The George A. Lucas Collection on indefinite loan to
the Baltimore Museum of Art from the Maryland
Institute, College of Art

31. LION CRUSHING A SERPENT
Bronze; H. *c.* 26 cm.; L. *c.* 35.5 cm.
Markings
 inscribed on base at rear: BARYE
Corcoran Gallery of Art, Washington, D.C.

32. LION CRUSHING A SERPENT
Bronze; H. *c.* 26 cm.; L. *c.* 35.5 cm.
Markings
 top of base: BARYE
Fogg Art Museum, Harvard University, Cambridge,
Massachusetts
Gift of Mrs. Henry Dexter Sharpe (Henry Dexter
Sharpe Collection)

33. LION CRUSHING A SERPENT
Bronze; H. *c.* 22.5 cm.; L. *c.* 34 cm.
Markings
 stamped: BARYE 36
The Metropolitan Museum of Art, New York, New
York
Rogers Fund, 1910

34. LION CRUSHING A SERPENT
Bronze; H. *c.* 26 cm.; L. *c.* 35.5 cm.
Markings
 on base behind tail: BARYE
New Orleans Museum of Art, New Orleans, Louisiana
Gift of the Samuel Weis Estate, New Orleans,
Louisiana

35. LION CRUSHING A SERPENT
Bronze; H. *c.* 26 cm.; L. *c.* 35.5 cm.
Markings
 incised near right haunch: BARYE
 inscription on base: "AMBULANCE ST. LOUIS—1871"
Stanford University Museum of Art, Stanford,
California
Gift of the Committee for Art at Stanford

36. STAG ATTACKED BY A LYNX
Bronze; H. *c.* 20.6 cm.
Markings
 cast in raised letters on both sides of base:
 A. L. BARYE 1836,
 CERF ATTAQUE PAR UN LYNX
 at each end of base: founder's inscribed monogram
 (Honoré Gonon and two sons)
The Walters Art Gallery, Baltimore, Maryland

37. Set of eight sculpture tools
The Walters Art Gallery, Baltimore, Maryland

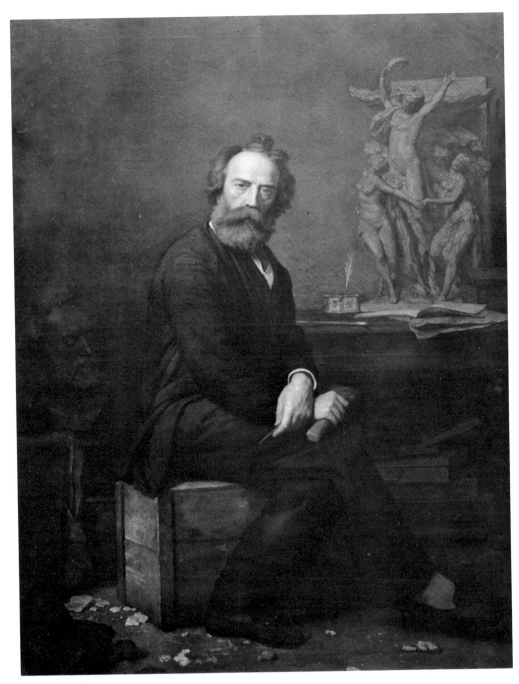

1. Bruno Chérier
 *J. B. Carpeaux dans l'atelier de Chérier, bd
 Saint Jacques, Paris*, 1875
 Oil on canvas; 161 × 121 cm.

 Musée des Beaux-Arts, Valenciennes, France

ANNIE BRAUNWALD
ANNE MIDDLETON WAGNER

Jean-Baptiste Carpeaux (1827–1875)

Born in Valenciennes in 1827, Jean-Baptiste Carpeaux was the son of a stonemason and a lacemaker (fig. 1).[1] He received his early instruction at local academies where the doctrine of the theorist Jacotot—intellectual advancement through self-education—held sway. Although he moved to Paris with his parents in 1838, Carpeaux never forgot his birthplace and returned to its friendly shelter throughout his life. The city and its people were sources of commissions and admiring support until his death in 1875.

In Paris, Carpeaux's entrance into the École Gratuite de dessin et de mathématique (called the Petite École) was arranged by a cousin, Victor Liet. The school's unorthodox curriculum combined instruction in drawing from nature and ornamental decorations with training in the technical skills of sculpture. Instruction was free to impoverished young students like Charles Garnier, Albert Carrier-Belleuse, and Carpeaux. In 1854, Jules Dalou and Auguste Rodin were Carpeaux's students when he became an instructor there.

After two years at the Petite École, Carpeaux won admission to the École des Beaux-Arts and embarked on a succession of attempts to win the Prix de Rome. The next decade of his life was shaped by his search for recognition. When he transferred in 1853 from the studio of François Rude (which he had entered that same year) to the atelier of Françisque-Joseph Duret, Carpeaux was motivated simply by the fact that Rude's students did not win prizes, while those attached to Duret did. In 1854 he achieved his goal.

Carpeaux's departure was delayed until 1856 by two official projects, the marble of his relief *L'Empereur reçoit Abd-el-Kader à Saint-Cloud* and the *Génie de la Marine* commissioned by the architect Lefuel for the Louvre decorations. Once in Rome, Carpeaux was overwhelmed by the life of the city as well as by its art. He sketched constantly, filling numerous notebooks with his impressions. His frequent companion, the engraver Joseph Soumy, taught him to paint and to engrave and introduced him to the work of Dante. Passionately attracted to his new environment—and distracted by it—Carpeaux nonetheless completed his first-year *envoi, Le Jeune pêcheur à la coquille*. In this tribute to his teacher Rude, Carpeaux gave form for the first time to his intense observation of nature. Beginning in 1857, the sculptor was occupied with the composition of his great *Ugolin et ses enfants*.

While in Rome, Carpeaux also began to develop his talent for portraiture, which he would exercise throughout his career. In the French colony at Rome and later in the high society of Paris, he found commissions for busts. These allowed him to manipulate historic portrait styles, from neo-classic to baroque, and to combine them with realistic representations of his sitters' features. His portrait of the Prince Impérial, commissioned in 1865 (plaster, Salon of 1866; marble, 1867), marked his mastery of a totally contemporary portrait style.

After his return to Paris in 1862, Carpeaux's success with the French imperial family was accompanied by growing public recognition of his talents as a sculptor. He received many commissions: a monument to Watteau from his native city (1860), the architectural decoration of the Pavillon de Flore at the Louvre (1863, finished 1866), *La Danse* (1865, installed 1869), the *Fontaine de l'Observatoire* (1867), maquette (approved 1873, unveiled 1874). At the end of this period, in 1869, he was married to Amélie de Montfort.

Despite his successes and accomplishments, Carpeaux continued to be plagued with numerous financial and personal problems. When both creditors and his own family demanded payment of his debts, Carpeaux's studio in Auteuil began to turn out editions of his work under the direction of his father and his brother. The sculptor's

health was failing; he was periodically estranged from his wife.

In his last years, Carpeaux traveled sporadically —to London in 1871 and 1873, to the home of his friend Bruno Chérier, and finally to Nice. In Nice he was the guest of the Prince Stirbey, to whom he gave many of his drawings. Carpeaux died on October 12, 1875.

Carpeaux was survived by his wife and three children. The young widow immediately fought to regain control of the Auteuil atelier from her husband's family. She succeeded, and continued to manage its business affairs until her death, when these responsibilities were assumed by her daughter, Louise Clément-Carpeaux.

Carpeaux's early experience and education gave him a thorough grounding in reproductive techniques. The instruction he received in Valenciennes in the classes of the architect J. B. Bernard introduced him to the rudiments of his craft; he was later apprenticed to a plasterer, Debaisieux.

In Paris, Carpeaux learned the techniques of casting in plaster from Charles Laurent-Daragon, head of the casting studio at the École des Beaux-Arts. As in Valenciennes, Carpeaux put his talents to commercial use and supported himself by selling models to the manufacturers of *objets d'art* in bronze and porcelain. A letter of December 1851 reveals his difficulties in these early commercial ventures:

... since my return, I've made a few little objects which I've not yet disposed of because the manufacturers are not risking new expenses for models, added to which the selling season is too close to use to undertake new manufactures. I'm waiting, and I hope to sell what I've made.[2]

In this same letter, Carpeaux frankly asserts his increasing skill and growing independence:

you know, my dear Louis, that I'm not too clumsy to make a portrait, because I made one for M. Duret which he just signed.[3]

Besides providing works for Duret's signature, Carpeaux also assisted him in the decoration of the Salle des Sept Cheminées at the Louvre (1851).[4]

The responsibility which the older man shared with his young assistant gave Carpeaux the valuable basic experience on which he was to build his career.

Carpeaux also emulated François Rude. Numerous sketches on paper of Rude's sculptures survive as evidence of his artistic influence on the young sculptor. Interestingly enough, this influence extended to practical matters as well. In 1855, as he was about to depart for Rome, Carpeaux needed a *praticien* to complete the marble version of his relief *Abd-el-Kader*. He employed Charles-Romain Capellaro, who had worked both for Rude and Duret.[5] Later, in 1862, after returning from Rome, Carpeaux established himself in the studio at 25 rue d'Enfer, which had once belonged to Rude.

Carpeaux's own method of creating a sculpture, moreover, was not radically different from that used by other academically trained artists. Basic to that method was the modeling process. From an initial clay sketch with rough, broad surface treatment, Carpeaux would refine and modify a final version. Only in its final stage, if then, would it receive the smooth surface finish deemed necessary by academic canons.

Carpeaux was an inveterate modeler and a tireless draughtsman. All of his major sculptures, whether architectural decorations or Salon pieces, portraits or monuments, were preceded by drawings. The sculptor studied attitude, gesture, and movement to prepare works like *La Danse* or his portrait of the *Prince Impérial*. For other portraits, he concentrated on capturing the line of a neck or an angle of the chin.

Drawing was essential to Carpeaux, because it provided him with the means to work out novel ideas, to examine a multitude of natural phenomena, and to experiment with variations in composition without the tiresome and lengthy process required to change a sculpture. However, not all of the thousands of drawings by Carpeaux need be connected directly with executed sculptures. They demand consideration apart from his sculpted oeuvre for their own sake, both as aesthetic objects and as the enduring documents of a visually creative mind.

Those drawings which can be connected directly to sculptures, however, like those relating to the *Ugolin* and *La Danse*, reveal a certain patterned approach to the specific problems which any one sculpture presents. Carpeaux seems to have been consistently interested in accurately interpreting and depicting physical realities. Thus for *La Danse*, he sketched the fleeting poses of dancers at the Opéra.[6] The group of the *Quatre parties du monde* for the *Fontaine de l'Observatoire* was preceded by studies of Negro and Oriental models dressed in exotic costumes. Such studies contributed to the sculptor's understanding of the people he was to incorporate into his piece, even if no specific pose from the drawings would be used in the final work.

Carpeaux also used drawings to develop individual figures and their place in the composition of a complicated sculpture. Thus for the *Ugolin* various possibilities for the poses of the three sons were tried out in a series of drawings from live models. Most of these are careful, anatomically accurate studies, executed in a pen-and-ink hatching which creates a forceful illusion of a three dimensional body in space. Carpeaux's meticulous attention to anatomical detail, characteristic of these drawings, is transferred to the finished work.

Drawings for *La Danse*, however, are slightly different in character. In these sketches, Carpeaux most often considered the ensemble of figures in the complex *ronde* which he was trying to weave together. He studied the entire group in a series of sketches that trace the development of a solution in which each element plays a complementary part. Like the *Ugolin* sketches, these studies for *La Danse* were essential to the artist because they gave him an opportunity for creative trial and error.[7]

In the *Ugolin*, *La Danse*, and the full-length *Prince Impérial*, as in the majority of his full-length and figural compositions, Carpeaux began with a small-scale model which he expanded to the size of the finished work. The sculptor seems to have preferred manipulating clay at a hand-sized scale; most of his clay sketches are no more than a foot high. Even his architectural pieces were planned on a relatively small scale.[8]

This practice must be contrasted with his working method for the many portrait busts he executed. Almost without exception, these were modeled life-size in clay, and then cast by means of the waste-mold process. These resulting unique plasters served as models for further versions in plaster, bronze, or, most often, marble. It was at this stage that large editions of individual busts, such as *Gérôme* or *Garnier*, were made.

2. Stamp of the Carpeaux atelier with Carpeaux's signature from the base of terra-cotta cast of *Les Trois Graces*, Art Gallery of Ontario, Toronto, Canada (see fig. 31)

(not in exhibition)

3. Stamp of the Carpeaux atelier on the base of terra-cotta *Les Trois Graces*, Art Gallery of Ontario (see fig. 31)

(not in exhibition)

Early in his career, Carpeaux began to have his work cast in bronze by professional founders. The Maison Thiébaut, which had a reputation for fine quality work, executed the bronze versions of his *Jeune pêcheur à la coquille* (exhibited Salon of 1859)[9] and the *Ugolin* (exhibited Salon of 1863). As Mme Braunwald has pointed out, between 1859 and 1869 Thiébaut began to produce reductions of the *Pêcheur*, as well as of busts. Carpeaux was eventually to go into debt to this firm, so that at his death, Thiébaut confiscated a bronze of the *Prince Impérial* in payment of his account. The Barbedienne foundry was also employed by Carpeaux to reduce certain busts, among them that of the *Prince Impérial*. These were issued, with the aid of the Collas process, at sizes of one-fifth, one-third, one-half, and three-fifths of the original size.[10] As early as 1855, in fact, Carpeaux had consigned his sculpture *La Tendresse maternelle* to Barbedienne; however, the extent of the edition is not given by Mme Clément-Carpeaux. That same year, as a contract testifies, he entrusted his group *L'Impératrice protégeant les orphelins et les arts* to M. Paillard for an edition. Carpeaux's model had a rough, sketch-like surface; the academic and lifeless finish was added by Paillard.[11]

Like other nineteenth-century sculptors, Carpeaux employed *praticiens* to advance the works carved in his own workshop through the many stages necessary for their completion. Capellaro, the marble cutter who had worked for Duret and Rude, was his first recorded helper. He was soon followed by others, although their history is not complete. Nonetheless, there are records of the names of some of the technicians who helped the sculptor and the tasks they performed for him. His two chief marble workers were the Belgian Bernard Bernaërts, who worked on the *Prince Impérial*, *La Danse*, and the *Ugolin*, and Victor Bernard, who was Carpeaux's friend as well as his employee. Another carver, Armand, also worked on *La Danse*. The brothers Matifat must be mentioned as marble workers, with the carver Narcisse Jacques, who finished the marbles left in Carpeaux's studio at his death. Skilled in the processes of casting were the founder Ridan, the molder Cajani, and a certain Arnoult, expert in delicate work. Men named Costamier and Jacques Bernard were also involved in bronze production. Mme Clément-Carpeaux links the names of two workers, Pascal and Lacave, to the production of terra cottas.[12]

Carpeaux's brother Émile and his father, Joseph, played important roles in the control and organization of Carpeaux's studios. Émile was the first to be linked by contract to Jean-Baptiste,[13] when in 1866 he became the director of Carpeaux's studio operations. The two brothers undertook the edition of the reduction of the *Prince Impérial* on which the sculptor's fortunes rested; Émile was charged with the distribution and sale of the piece.

In 1868, Carpeaux purchased the property for a new, expanded studio in the Paris suburb of Auteuil, and tried to discharge his debt to his father from the sculptor's student days. Joseph was made the director of this new studio and advertised its products:

BRONZE D'ART
DEPOT DE BRONZE
71, Rue Boileau
AUTEUIL-PARIS
Station du Point du Jour

REPRODUCTION ARTISTIQUE
DES OEUVRES DE
J.-B^te CARPEAUX
SCULPTEUR

MARBRE – BRONZE
TERRE-CUITE
GALVANOPLASTIE
ALUMINIUM

Editées par Joseph CARPEAUX, Père

Émile continued his association with the new atelier, and under his direction the father issued reproductions of fifteen of his son's works.[14] In the early years of the seventies, there were further large editions of terra cottas, bronzes, and plasters. These can bear one or both of the two stamps *Atelier Carpeaux* and *Propriété Carpeaux*, and sometimes an eagle cachet or a number (figs. 2, 3). Sales of these reproductions were organized. In 1873 in London, Paris, and Brussels there were a total of 179 sculptures by Carpeaux on the market.[15]

According to Mme Braunwald, the reproductions and sales were a last resort. Carpeaux needed to recoup the financial losses caused by the great expense of completing *La Danse* and the dissolution of his Auteuil operation during the Franco-Prussian War. Carpeaux himself was probably not directly involved in the majority of these proceedings, since he traveled extensively during this period. His failing health and conflict in his marriage further divorced him from studio operations.

Thus he did not attend to his brother Émile's mismanagement of the studio until 1873. In that year, while Émil was still nominal director of the workshop, Carpeaux hired Emille Meynier to supplant his brother in his supervisory position. Meynier had invented a mechanical method of cutting marbles which was adopted by Carpeaux and his *praticiens*, a method which replaced the Collas process which they had previously used. Both busts and groups were submitted to this process—among them the *Génie de la Danse* and the *Ugolin*.[16] Meynier remained at the studio until December 1874.

With the aid of the sculptor Lacave, Carpeaux personally developed a new method for the fabrication of terra cottas. It involved the use of a clay which was not only pigmented to simulate flesh tones but which was mixed according to a formula which reduced shrinkage and facilitated baking.[17] This material was reportedly used for the large terra-cotta *La Danse* made in 1873 (see fig. 17).

Carpeaux seems to have taken an active interest in studio matters when they involved technical procedures. Still, most changes initiated in studio practice seem to have been motivated by the desire to reap the most lucrative possible financial harvest.

One of the most interesting documents associated with the Auteuil studio is a partial list of studio regulations, compiled in 1873, the year of its reorganization under Meynier.[18] Eight of its seventeen articles were published by Mme Clément-Carpeaux; she states that the list was posted in permanent view of the workers. The regulations deal primarily with the hours, responsibilities, and payment of each employee. Great stress is given to employment practices on the job, which would seem to indicate that new employees entered the operation frequently.

Ugolin et ses Enfants

Conceived and executed while Carpeaux was a *pensionnaire* at the French Academy in Rome, the *Ugolin et ses enfants* was undertaken as his fourth-year-student project, to be displayed in Paris as evidence of its author's progress. Appropriated by the state as payment for the young artist's education, all *envois* like the *Ugolin* were expected to observe rules of composition established by the Academy, which limited the piece to one or two figures. Carpeaux ignored this dictum in choosing to illustrate the Ugolino theme, a subject which occupied French artists throughout the nineteenth century. The political, social, and moral implications of this story from Dante's *Divine Comedy*, of the imprisoned, starving Count Ugolino who devoured the bodies of his dead children, appealed to artists. To them, the symbolism of the theme of the child-eating father was the allegorical anti-

thesis to that of the nourishing mother.[19] Like most romantic artists before him, Carpeaux turned to the story as a vehicle for his artistic and philosophical vision.

The long history of Dantesque themes in French art, and specifically the interpretations of Ugolino, indicate that this subject was not offensive to the public. Nonetheless, Carpeaux's plan to interpret it was opposed from its inception by Jean-Victor Schnetz, the director of the Villa Medici, the Academy's quarters in Rome.[20] He urged Carpeaux to render a subject from the Bible, classical mythology, or national history, and urged him to take up other themes, as possible replacements for his offensive *Ugolin*. The two battled for months, Schnetz refusing to approve a subject that violated the compositional rules of the Academy. Finally, Carpeaux won out over all Schnetz's objections, and the sculptor returned to the *Ugolin* with relief and eagerness. The time he had lost through illness and the arguments with Schnetz required a trip to Paris to seek the prolongation of his *pension* to complete the work. A terra-cotta sketch is preserved from that trip (see fig. 9). According to Mme Clément-Carpeaux, it was modeled to show the authorities the character of the sculpture he wished them to subsidize.[21]

Carpeaux's devotion to the Ugolino theme can

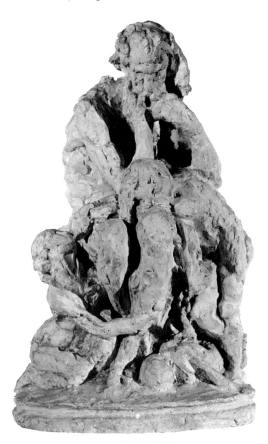

4. UGOLIN ET SES ENFANTS
Plaster; H. *c.* 54 cm.

Académie de France à Rome, Villa Medici, Rome

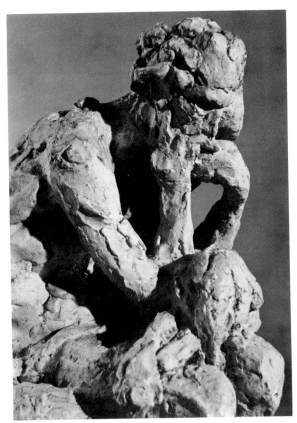

4a. Detail of fig. 4

Possibly cast from a waste mold, this plaster may have served as the original model from which subsequent piece molds and gelatin molds were taken.

(not in exhibition)

best be understood in terms of the range of expression possible in the group. The brutality and pathos of the story attracted the young sculptor, and the combination of noble youth and tortured age appealed to his interest in the human figure. Most of the drawings for the piece study the characters in a variety of postures and attitudes and reveal the fascination they held for the sculptor and the importance he attached to defining them exactly.

Crucial to his choice, however, was the story's potential as a vehicle for intense examination of Michelangelo's principles of sculpture. The French student pursued the Italian master's concentration on the muscularity of the male body. He translated these forms into an agonized realism of straining muscles and clawing fingers. The sculpture portends an iconoclasm which challenges the tradition of the ideal, which was the hallmark of nineteenth-century French sculpture.

Despite its implications for a new and powerful realism, the composition of the *Ugolin* is halting and slightly labored. The gradual unification of the piece into a tight pyramidal form took years to accomplish. The greatest difficulty for Carpeaux was the accommodation of the four accessory figures, Ugolino's sons and grandsons, to each other and to the central figure. He attempted these interrelationships again and again.

In fact, in the early stages of the *Ugolin*'s evolution, the piece was composed of only four figures instead of the five in the final version. In a letter of December 19, 1857 Carpeaux wrote:

... but there is something even better yet, that I am about to arrive at in my composition for the final year, it's a group of four figures. . . . The subject is dramatic to the last degree, there is a great likeness to the Laocoön.[22]

This initial composition with only four figures is preserved in a variety of casts—plasters, bronzes, and dry clay—apparently taken from a plaster model preserved at the Villa Medici, Rome. Today there still exists a plaster at the Villa Medici (figs. 4, 4a) as well as a bronze cast. It must be emphasized that none of these various casts were ever issued in an official edition, either during

Carpeaux's lifetime or after his death. On the contrary, the Villa Medici plaster, itself a cast of an unknown original, served as the model from which molds were made and casts produced by successive generations at the Academy. Some of these were made in plaster at the request of Mme Clément-Carpeaux, to be given by her to French museums. Clément-Carpeaux herself stated in a letter that she knew of no example of the piece in bronze which had been cast during her father's lifetime.[23] Thus, ever since Carpeaux's departure from Rome, some version of the Villa Medici sketch has been available for unlimited reproductions. Posthumous reproductions indirectly related to the Villa Medici model have been achieved by several molding campaigns and techniques. Detailed photographs have revealed that the plaster currently in the Villa Medici is without easily discernable mold lines (see fig. 4a). Although it would be tempting to say that it must be the original waste-molded plaster, a full technical comparative examination must be conducted before reaching such an important conclusion.

In conjunction with this study, technical examination of seven casts of the Villa Medici maquette yielded information about some of these various casting campaigns and techniques which produced them. Four different types could be distinguished by the casting technique or medium employed, and more importantly by their individual physical characteristics, such as mold lines, dimensions, etc.

In the first group, which we shall designate as "type A," are three plasters and a bronze, which appear to be made directly or indirectly from the same plaster piece mold. An example from this group is in the collection of Dr. Barnet Fine (fig. 5 —also see Carpeaux checklist of the exhibition). Technical evidence suggests that two of the type A plasters have since served as models for gelatin molds. Although most of the piece mold lines were removed in the wax model for the bronze example, enough corresponding lines appear to place this cast in group A.

The Villa Medici plaster apparently served as the model for other piece-molded versions as exemplified by a lost-wax bronze cast in the collec-

tion of the Walker Art Center, Minneapolis, Minnesota (fig. 6). This "type B" has a crisp, detailed surface covered with a fine network of piece-mold lines. No attempt was made to remove these lines in the wax model before the piece was cast, as was done on the type A bronze. Although the Walker bronze was also produced indirectly from a piece mold, the mold used can be distinguished from the type A mold. Individual piece mold subdivisions are in different locations and of different configurations.

A third type (C) is here represented by a plaster from the Detroit Institute of Arts (fig. 7). This piece was produced by the gelatin-mold process. It has no mold lines other than the large sectional divisions of the gelatin mold, suggesting that this work was modeled on the Villa Medici plaster.

An unbaked clay cast in the collection of the Museum of Fine Arts, Boston (fig. 8) is a fourth version, "type D," of the Villa Medici sketch. Probably cast from a third plaster piece mold, the piece does not preserve much of the detail of the Villa Medici original. Its small size, twelve per cent smaller than the plasters (see fig. 5), may likely be attributed to the shrinkage of the clay as it dried. Considering that the clay apparently has

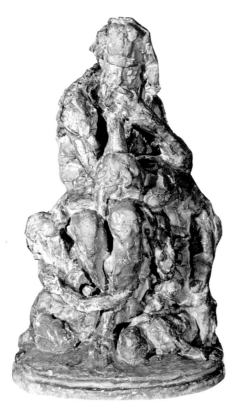

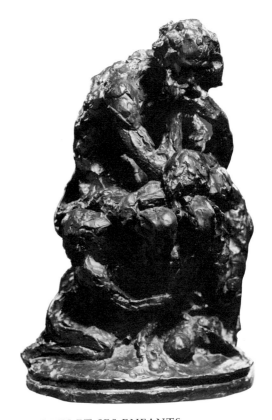

5. UGOLIN ET SES ENFANTS
Plaster; H. c. 53.5 cm.
Markings
 incised signature on proper right rear: B. Carpeaux

Barnet Fine, M.D., New York, New York

This "type A" plaster was made from the same piece mold which produced at least four other casts.

6. UGOLIN ET SES ENFANTS
Bronze; H. c. 51.5 cm.
No markings

Walker Art Center, Minneapolis, Minnesota

A bronze lost-wax cast, "type B," made from a wax model associated with a piece mold different from fig. 5

not been fired, the twelve per cent figure is high. The explanation of the high shrinkage may be traced to the type of clay used in the cast.

Even though the Villa Medici reproductions were not issued by Carpeaux's own studio, they nonetheless remain more or less faithful to an early sketch by the sculptor, and thus provide visual evidence of the creative evolution of the *Ugolin*.

As previously mentioned, Carpeaux executed another sketch of the *Ugolin* in 1860 while visiting Paris to convince the authorities of the Ministère des Beaux-Arts to extend his stay in Rome. Ac-

cording to the sculptor's daughter, Carpeaux executed this sketch from memory. The work is now in the collection of the Louvre (fig. 9). Its rough surface offers a good demonstration of Carpeaux's modeling technique, adding pellets of clay and flattening them with a tool.

A further step in that development of *Ugolin* is revealed by a unique plaster, retouched with wax, in the collection of Fabius Frères, Paris (fig. 10).[24] Probably produced from a waste mold, this plaster was the basis for additions and corrections easily achieved with the malleable wax. This sculpture marks Carpeaux's arrival at the final composition

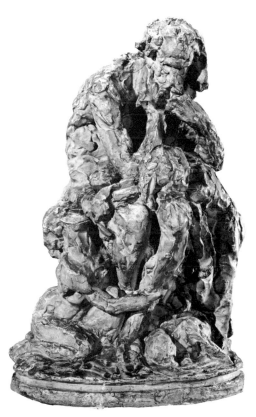

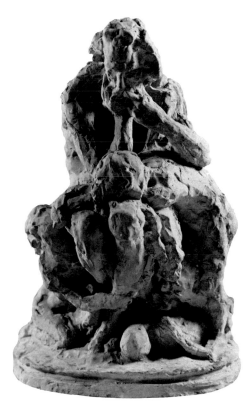

7. UGOLIN ET SES ENFANTS
Plaster; H. *c.* 52.5 cm.
Markings
 incised at lower rear: 5

Detroit Institute of Arts, Detroit, Michigan
Founders Society Purchase from the Miscellaneous
Gifts Fund

This "type C" cast was taken from a gelatin mold that was made from a model free of mold lines.

8. UGOLIN ET SES ENFANTS
Cast unbaked clay; H. *c.* 48.5 cm.
No markings

Museum of Fine Arts, Boston, Massachusetts
The H. E. Belles Fund

This piece, "type D," was cast from a different piece mold from previous types.

of his piece. The figure of a fourth youth, standing with his head buried in Ugolino's lap, has been worked into the composition. This change has been dated to the summer of 1860. Hints of this arrangement can be seen in the sketch of the piece Carpeaux modeled in Paris (see fig. 9).

After Carpeaux had accomplished this final composition, he had only to refine the handling of forms and surface before the piece was enlarged. The full-size version was exhibited in the sculptor's Villa Medici atelier in June 1861, and received great acclaim. Six months later he returned

to Paris with the work, which he exhibited at the École des Beaux-Arts. To his surprise, Carpeaux was severely criticized for a lack of elevated sentiment and sculptural clarity. Official disapproval made itself felt emphatically. The Commission des Beaux-Arts refused to purchase the marble version of the offending sculpture, as was its practice. Instead, only a bronze was commissioned from Carpeaux. For it, he was to be paid 30,000 francs over the period from 1862 to 1864.

In February 1863, the Maison Thiébaut cast the bronze version of the sculpture. Exhibited in the

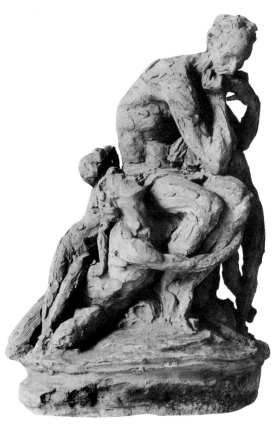

9. UGOLIN ET SES ENFANTS
Terra Cotta; H. c. 56 cm.
No markings

Musée du Louvre, Paris, France

A unique sketch probably executed in Paris in 1860

(not in exhibition)

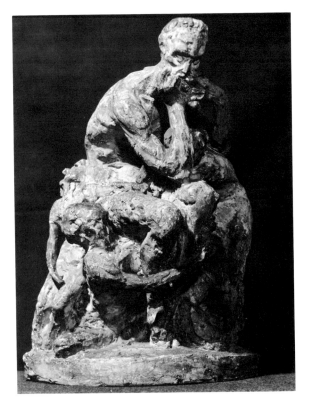

10. UGOLIN ET SES ENFANTS
Plaster, retouched with wax; H. c. 63 cm.
Markings
 on base: J Bte Carpeaux
 on rear: Rome JBC

Fabius Frères, Paris, France

This unique work was probably cast from a waste mold.

(not in exhibition)

Salon that year, the *Ugolin* took the first prize for sculpture. In December, it was placed in the gardens of the Tuileries as a pendant to a copy of the *Laocoön*. It remained there until 1904, when it was moved to the Louvre. That same year, *surmoulage* casts commissioned by the Comtesse de Maille and the Baron Empaille of Brussels were then taken from the piece. These are now in the Musée des Monuments francais, Paris, and the Musée de Cinquantenaire, Brussels.[25]

A plaster version of the piece, now in the Musée du Petit Palais, Paris and considered by Mme Braunwald to be the original plaster, was exhibited in Brussels in 1863. Carpeaux gave a second plaster version, which he called a "first proof," to the city of Valenciennes, where it is in the Musée des Beaux-Arts. Ten years later, in 1873, a full-scale terra-cotta version was produced by the sculptor in his Auteuil studio. It was exhibited in Vienna in 1873, since Carpeaux had no other version, marble or bronze, which he could show. The terra cotta is now at the Ny Carlsberg Glyptotek, Copenhagen (fig. 11).

In 1873, there did exist a marble version of the *Ugolin* which Carpeaux could not exhibit. A third full-size plaster now at Compiègne had served as the model for the carved version of the monumental group. In 1865, Carpeaux approached M. Cyr-Adolphe Dervillé, the head of the firm MM Dervillé et Cie, which controlled the marble quarries at Saint-Béat. Dervillé had been looking for a suitably notorious sculpture to execute in the marble he sold. He meant to show it at the Exposition Universelle as an advertisement of the qualities his stone offered a sculptor. Carpeaux's *Ugolin* suited his needs perfectly. A contract was drawn up between the two parties and signed on December 23, 1865.[26]

The liaison between Carpeaux and the Maison Dervillé was fraught with seemingly endless difficulties. Despite the problems, however, Carpeaux

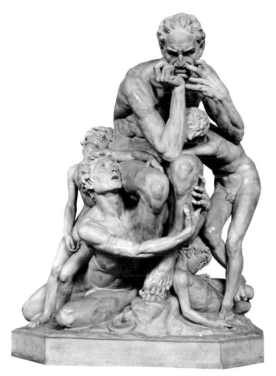

11. UGOLIN ET SES ENFANTS
Terra Cotta; H. *c.* 180 cm.
Markings
 incised on left oblique face of base: J. B^te Carpeaux
 1873

Ny Carlsberg Glyptotek, Copenhagen, Denmark

Exhibited in Vienna in 1873, the year it was executed

(not in exhibition)

overleaf:

12. UGOLIN ET SES ENFANTS
Marble; H. *c.* 196 cm.
Markings
 cut in marble, oblique proper left front of base:
 B^te Carpeaux
 Rome 1860

The Metropolitan Museum of Art, New York, New York
Funds given by Josephine Bay Paul and C. Michael Paul Foundation, Inc., and the Charles Ulrick and Josephine Bay Foundation, Inc., and the Fletcher Fund, 1967

(not in exhibition)

12a. Proper right view of fig. 12

119

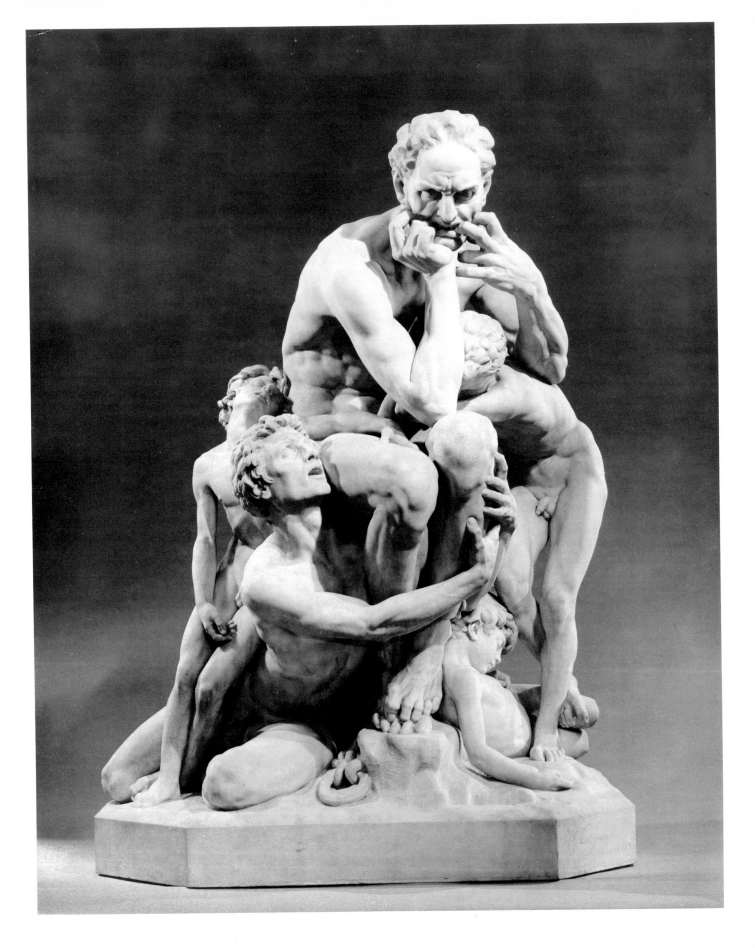

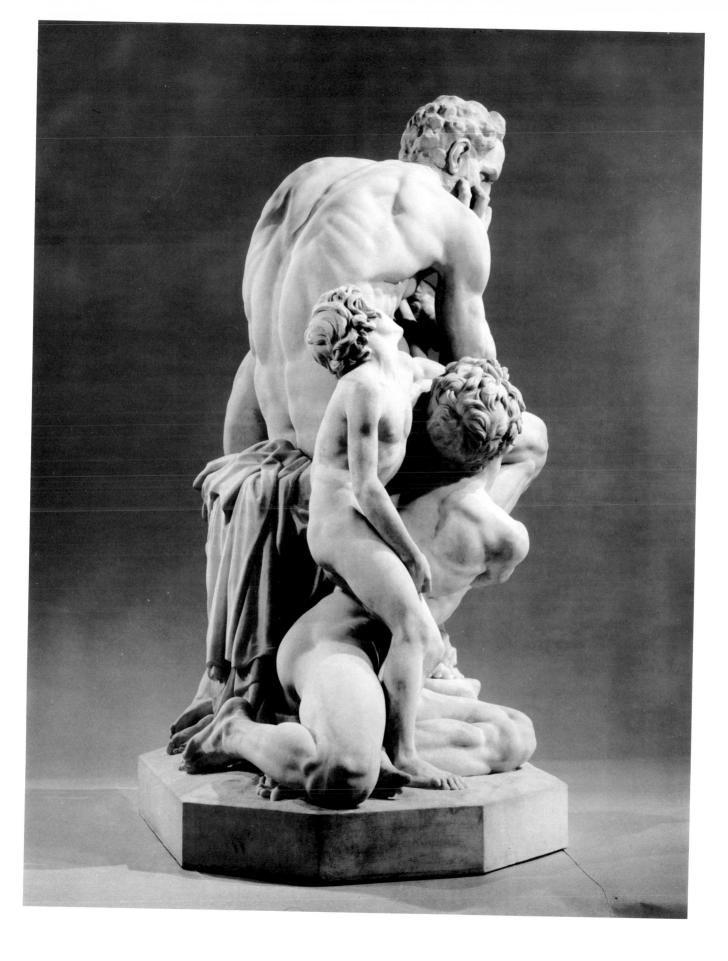

was able to fulfill his part of the bargain and deliver the group in time for the opening of the Exposition Universelle. The Maison Dervillé, however, did not keep its promise to release the sculpture for public sale within twelve months of the exhibition. Years of dispute followed. In 1870, Carpeaux took back his sculpture, ostensibly for safekeeping, and deposited it at the home of his friend Bruno Chérier. In spite of the sculptor's efforts, the marble returned to the possession of the Dervillé family. The work is today in the collection of the Metropolitan Museum, New York (figs. 12, 12a).

The documents and accounts connected with the Carpeaux-Dervillé dispute demonstrate the kinds of obligations undertaken by the nineteenth-century sculptor in promising goods to a client, as well as the relationship among the sculptor, the *praticien*, and the client. These negotiations take place long after the creative process is at an end.

In 1867, according to Mme Braunwald, Carpeaux planned to issue a reduction of the *Ugolin*. He proposed his idea to Christofle, who replied that it would be too expensive to reproduce the sculpture in *galvanoplastie* (electrotype). The fol-

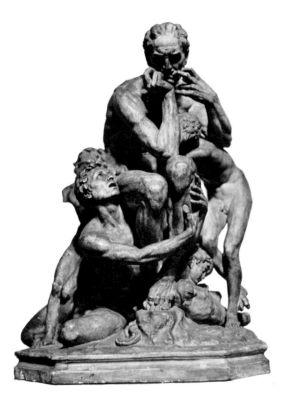

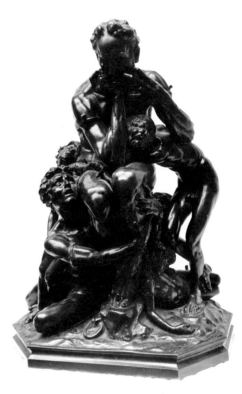

13. UGOLIN ET SES ENFANTS
 Plaster; H. *c.* 50 cm.
 Markings
 on base at right: J B^te Carpeaux Roma 1860

 Musée du Petit Palais, Paris, France

 This reduction, made by means of the Collas process, may have served as the model for the bronze reductions (see fig. 15).

 (not in exhibition)

14. UGOLIN ET SES ENFANTS
 Bronze; H. *c.* 50 cm.
 No markings

 Private Collection, France

 A founder's model for sand-casting with sections pinned together for disassembly

 (not in exhibition)

lowing year Christofle quoted a price for the model of a reduction, 2,000 francs, and for each proof, 1,000 francs. The first bronze reduction appeared in London in December 1871, and another, called a first proof, was sold in Paris on March 21, 1872. These small bronzes were all based on a mold taken from a plaster model, now in the Musée du Petit Palais, Paris (fig. 13), which may, in fact, be the model for a reduction mentioned in the inventory of the Auteuil studio taken at Carpeaux's death. From such a model the bronze founder's model would have been cast

(fig. 14) and used to make reductions such as the one in the collection of the Chrysler Museum at Norfolk, Norfolk, Virginia (figs. 15, 15a).

Other editions of reductions of the *Ugolin* have been made.[27] During Carpeaux's lifetime, terra-cotta reductions appeared in sales catalogues as early as 1872. As Mme Braunwald has indicated, a terra-cotta proof from the Auteuil studio, bearing the two atelier stamps and numbered 234, can be traced to 1876. After Carpeaux's death, both terra-cotta and bronze reductions were issued by Susse Frères, Paris, under the terms of a contract from 1909.

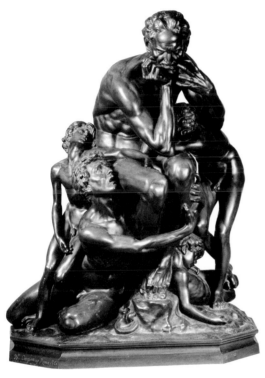

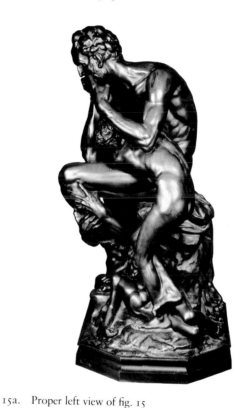

15. UGOLIN ET SES ENFANTS
Bronze; H. *c.* 48 cm.
Markings
 incised on front, oblique proper right face of base
 B^te Carpeaux Roma 1860
 traces of partially removed signature on upper
 surface of base

Chrysler Museum at Norfolk, Norfolk, Virginia
Gift of Walter P. Chrysler, Jr.

15a. Proper left view of fig. 15

The piece probably came from the bronze founder's model (see fig. 14). The signature is close to that on the plaster model (see fig. 13).

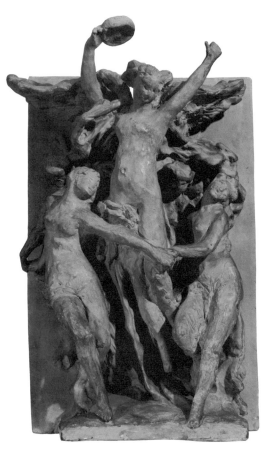

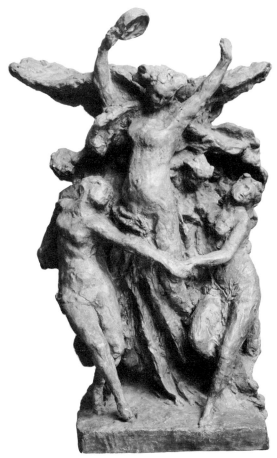

16. LA DANSE
 Cast terra cotta; H. *c.* 50 cm.
 Markings
 oval stamp on proper right top of base:
 PROPRIÉTÉ CARPEAUX
 stamped on vertical proper left face of base: 987
 oval stamp on proper left top of base:
 ATELIER ET DEPOT 71 RUE BOILEAU AUTEUIL PARIS
 at front top of base proper left corner:
 B^te Carpeaux

Yale University Art Gallery, New Haven, Connecticut

Cast terra cotta related to an original plaster maquette
in the Louvre. The two stamps and the engraved
number (with three figures) correspond to one of the
first editions.

17. LA DANSE
 Terra Cotta; H. *c.* 52.5 cm.
 Markings
 on proper left side of base:
 B^te Carpeaux 186 (?)
 stamped on proper left side of base:
 PROPRIÉTÉ CARPEAUX

Ny Carlsberg Glyptotek, Copenhagen, Denmark

Unlike the Yale piece (see fig. 16) and the Louvre
plaster, this version of the maquette has no back-
ground. It is more closely related to terra cottas in the
Petit Palais, the Musée des Beaux-Arts, Valenciennes,
and to one in the collection of Fabius Frères, Paris.

(not in exhibition)

La Danse

On Christmas Day, 1863, Carpeaux wrote to a friend that he might be asked to contribute to the elaborate decoration being planned for the new Paris Opéra.[28] The architect, Charles Garnier, whom Carpeaux had known as a student at the Petite École, had suggested that the sculptor execute one of the monumental groups which were to adorn the building's chief facade—or, as Carpeaux eloquently described it, to fill one of the most beautiful pages of the Opéra.[29]

The official commission, dated August 17, 1865, mentioned only the proposed size, placement, and material of the sculpture, and the payment Carpeaux would receive for the group. Its subject was left open. Only after several months of work did Carpeaux arrive at his final theme for his group. His earliest idea, a leaden and brooding composition recorded in both drawings and plaster maquettes, was called *La Comédie et le Drame*. Garnier rejected that first plan at once, advising Carpeaux to visit the studios of the other sculptors employed to create the three groups pendant to Carpeaux's own.

Garnier objected not to the theme Carpeaux had chosen, but to the form which he had given it. As the designer and supervisor of the entire project, he had definite ideas of the role which sculpture would play in his overall concept of the Opéra —a building that would be the summation of the style for an entire epoch in French culture. Garnier demanded that each work adhere to a specific pattern. Moreover, he conveyed his wishes to each sculptor in the clearest manner possible, giving the artist an outline drawing indicating contour, silhouette, and dimensions of a group composed of one central and two accessory figures.[30]

According to his own account, Garnier was so overwhelmed by Carpeaux's sketches for the final group that he had no heart to check the sculptor, even though the design for *La Danse* broke with the preestablished program. The free rein granted the sculptor is surprising, since Garnier had exerted such efforts to insure the conformity of the sculptures to his plans. All the façade pieces were to be symmetrical, in both form and content —an extension of academic symmetrical planning

into the realm of sculpture, making the plastic medium the true servant of architecture.

While the silhouette of *La Danse* conforms loosely to Garnier's outline drawing and the other three parallel groups, its means of expression was at odds with traditional expectations. In conventional allegorical sculpture—and in the other Opéra groups—figures literally represent activities or ideas. Personification is made explicit by sculptured thematic elements and accessory figures which identify the work of art almost as surely as printed labels. Carpeaux's approach, however, is not nominative, but evocative. His statue does not "name" dance, but evokes it by the representation of its essential and universal qualities.

Carpeaux's approach to this problem of representation was wide ranging. He sought information and ideas everywhere. Like his contemporary Edgar Degas, whom the sculptor had met while both were students in Italy, he sketched endless studies of dancers at the Opéra, capturing fleeting movement and recording the postures of the young ballerinas as they exercised. He drew from his knowledge of the old masters as well. The figure of the *Génie* incorporates both the fine features of Raphael's *St. Michael* and the electrifying posture of Michelangelo's *Risen Christ*, both of which he had copied.[31] Contemporary art also found its way into the work, although it is less specifically identifiable. Carpeaux's work seems conversant with the sculpture of his day—from works like Bartholdi's *Génie dans les griffes de la Misère* (Salon of 1859)[32] to the many Clodion-inspired Greek dancers whose carved images graced every yearly exhibition. He also used live models.[33]

Several sculpted studies modeled at hand size must have preceded the final full-size composition. It is surprising that only one of the sculpted studies for the group exists today, a maquette which does not show the final form of the group but rather illustrates an early stage in its development. Initially, the central *Génie* figure was feminine, and only four figures danced around it.

Two versions of this maquette, distinguished by the presence or absence of a background repre-

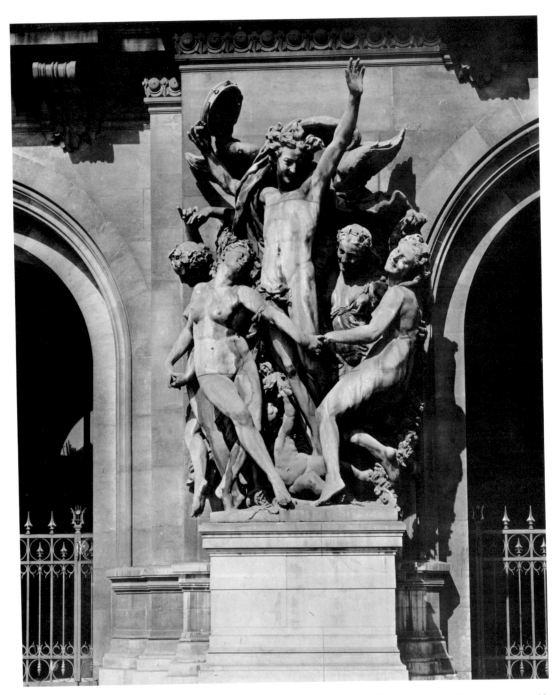

18. LA DANSE
 Echaillon stone; H. *c.* 450 cm.

 L'Opéra, Paris, France

 (not in exhibition)

Carving indirectly in stone, Carpeaux executed his
full-scale decorative group with the aid of two
praticiens, Armand and Bernaërts. The original group
was removed to the Louvre and replaced by a copy in
1964.

senting the Opéra façade, are known. During Carpeaux's lifetime, on March 23, 1874, a terra cotta of the sketch was sold. This transaction is important to any chronology of editions of the piece. It was the first cast in plaster; the original plaster is in the Louvre. Like both a cast terra cotta at Yale (fig. 16) and a plaster sold in December 1913, it was made with a background. Apparently, the Yale cast was made from a piece mold using the Louvre plaster as a model. This terra cotta would be an example from one of the earlier editions of the piece. The same mold, however, could have been used to produce the versions of the piece without backgrounds which are found at the Ny Carlsberg Glyptotek, Copenhagen (fig. 17); the Musée du Petit Palais, Paris; the Musée des Beaux-Arts, Valenciennes; and with Fabius Frères, Paris. Like the Yale terra cotta, these terra cottas all measure c. 50 cm. in height; the 5 cm. variation in height between these and the Louvre plaster (H. c. 55 cm.) can be explained by the shrinkage of ten per cent in the clay as it dried and was fired.

As Carpeaux developed this early sketch away from Garnier's ideal pattern he moved from allegory to realism. Rather than illustrating "The Dance," he created dance—a circle of naked women whirling around their rhythm-striking inspiration (fig. 18). Carpeaux sets stone into motion. His illusion is totally convincing. Its success was achieved by Carpeaux's ability to confound the flatness of relief and its concomitant uni-directional reading. He suggested additional figures which are understood as bodies occupying space behind the Génie; in fact they are simply fragmentary heads projecting from the background plane. The figures of the faun and the putto waving a jester's wand are late additions to the composition. They function as attributes suggesting the bacchic, abandoned nature of the dance, and contribute the legibility sought by the nineteenth century in a work of sculpture.

Once Carpeaux finally won Garnier's approval of his group, in 1868, the sculptor turned to the difficult task of translating the plaster model into the rather coarse, hard stone prescribed for the façade group. The plaster, c. 232 cm. high, had to be doubled in size. Carpeaux went to work in the Auteuil studio where he had recently established his operation. He wrote to his wife about the labor: "My studio makes progress; several men are staggering from fatigue. Armand especially and Bernaërts are put to the test."[34]

In fact, difficulties with praticiens like Bernaërts and Armand proved one of the greatest obstacles to the successful completion of the group. As Garnier described the situation:

Where his fellow sculptors paid twelve or fifteen thousand francs for execution, he [Carpeaux] paid at least double . . . no praticien wished to engage himself to produce a group so movemented, so open and offering so many difficulties in pointing. Thus the days passed and the praticiens made slow progress although Carpeaux was always in their midst, working himself with compass and chisel. His resources exhausted themselves and the artist had already received the total payments for a group which was not yet close to being finished.[35]

Most of the necessary funds were provided by Carpeaux's wife, but the sculptor also borrowed from friends and from Garnier himself. The total cost of the group was 90,000 francs; Carpeaux's original contract had guaranteed him only 30,-000.[36] Ironically enough, once the group was revealed to the public it was criticized as unfinished. Moreover, it was censured for its indecent realism, a moral threat to the nation. The public was outraged and the critics dismayed.[37]

Despite the cacophony of protest which greeted La Danse, it was allowed to remain on the façade in full view of the crowd which gathered around it daily and clamored for its removal. The furor culminated in an anonymous midnight assault with a bottle of ink. Soon after, however, the Franco-Prussian War became a more pressing issue for public concern, the Opéra was taken over as a hospital, and the controversy—though not the sculpture—dropped from sight. La Danse remained in position on the Opéra façade until 1964.

In 1873, still beset with financial troubles, Carpeaux decided to undertake the production of a terra-cotta version of La Danse (fig. 19). An "exact reproduction of the Louvre plaster" in the words of Mme Clément-Carpeaux, it was doubtless cast

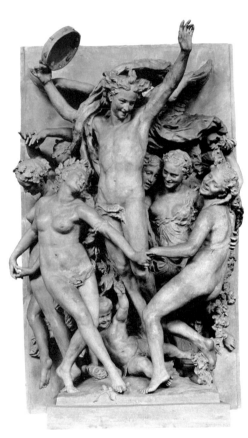

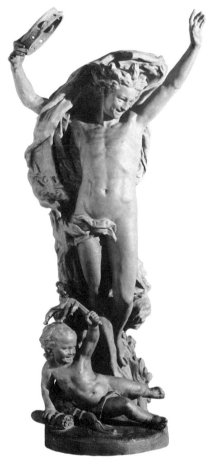

19. LA DANSE
Terra Cotta; H. *c.* 224 cm.
Markings
 inscribed: J B^te Carpeaux 1873

Ny Carlsberg Glyptotek, Copenhagen, Denmark

This terra cotta, like the Glyptotek *Ugolin* (see fig. 11),
was executed by Carpeaux in 1873 with the aid of his
pupil-assistant Etcheto. Garlands and drapery were
added to this version.

(not in exhibition)

20. LE GÉNIE DE LA DANSE
Cast terra cotta with light brown surface coating;
H. *c.* 99.5 cm.
Markings
 stamped at proper left of base: ATELIER DEPOT
 AUTEUIL PARIS
 stamped at proper right rear of base:
 PROPIÉTÉ CARPEAUX
 numbered between stamps: 2426

Philip Pearlstein, New York, New York

(not in exhibition)

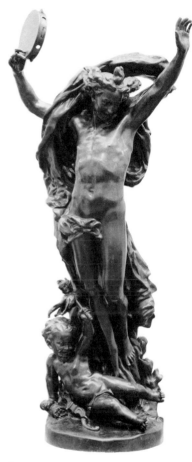 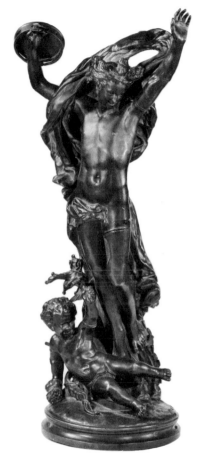

21. LE GÉNIE DE LA DANSE
Bronze; H. *c.* 106 cm.
Markings
 incised on proper left top of base: Carpeaux

Museum of Art, Carnegie Institute, Pittsburgh,
Pennsylvania

(not in exhibition)

22. LE GÉNIE DE LA DANSE
Bronze; H. *c.* 57.7 cm.
Markings
 incised on proper left top of base: J Bᵗᵉ Carpeaux
 1872

Metropolitan Museum of Art, New York, New York
Rogers Fund, 1970

This bronze founder's model which can be disassembled
into several parts, probably corresponds to that sold
May 31, 1844, with reproduction rights, and bought
back by the Carpeaux atelier.

(not in exhibition)

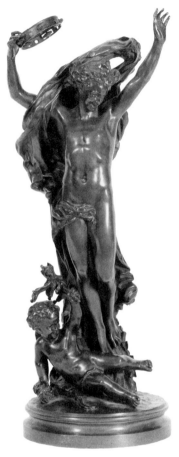

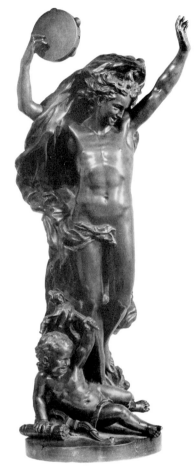

23. LE GÉNIE DE LA DANSE
Bronze; H. *c.* 55.2 cm.
Markings
 incised at proper left top of base: Carpeaux
 stamped at rear of base on face of tree trunk:
 PROPRIÉTÉ CARPEAUX
 Eagle cachet

J. B. Speed Art Museum, Louisville, Kentucky

This bronze must have been cast from a different
founder's model than the one from the Metropolitan
Museum (see fig. 22).

24. LE GÉNIE DE LA DANSE
Bronze; H. *c.* 85.1 cm.
Markings
 proper left of base: Carpeaux
 stamped on rear of statue, on tree trunk:
 PROPRIÉTÉ CARPEAUX
 Eagle cachet
 engraved on front of base:
 à Monsieur Edmond BESSE
 PRÉSIDENT DU TRIBUNAL
 DE COMMERCE
 1895 à 1898
 SES COLLÈGUES ET AMIS
 MM ED. GLOTIN F. PETIT G. BASSIE G. ADET
 M. LANNELUC SANSON G LAGARDE L. DESPAX A. DENIS
 F. BALARESQUE J. WINTER J. BEGOUEN G. LAFON
 J. FORSANS P. MAUREL

H. Peter Findlay, Inc., New York, New York

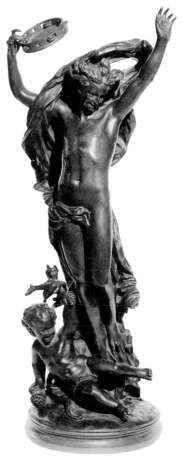

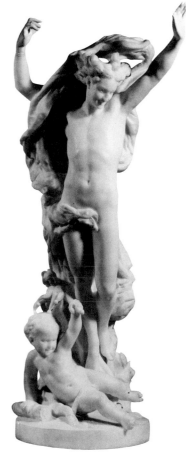

25. LE GÉNIE DE LA DANSE
Bronze; H. *c.* 54.6 cm.
Markings
 on proper left edge of base: B^te Carpeaux
 incised on proper right rear of sculpture, near base:
 Susse Fr^es, Ed^es
 stamped with the circular cachet of Susse Frères at
 mid-rear of base

William Rockhill Nelson Art Gallery, Atkins Museum
of Fine Arts, Kansas City, Missouri

This sand cast was issued by Susse Frères, Paris, about
1925 as the round cachet indicates. Although the piece
was produced from a model like the one at the
Metropolitan Museum (fig. 22), the actual model for
the piece remains unknown.

26. LE GÉNIE DE LA DANSE
Marble; H. *c.* 82.6 cm.
Markings
 incised on top of base: J B Carpeaux

H. Peter Findlay, Inc., New York, New York

This marble is probably one of those produced by the
process of M. Meynier from full-size versions and
finished by Narcisse Jacques, after the death of
Bernaërts, the *praticien* who first undertook them.

from the same mold. When it was removed from the piece mold and still wet, Carpeaux reworked its surface and, with the help of his pupil Etcheto, added the garlands and drapery (and modesty) the original lacked. Some changes were perhaps legally necessary, as Carpeaux was kept from reproducing the work exactly because it was the property of the French state.

Removed from the mold, the group was dried and then fired. In order to fit in the Auteuil ovens, it was sawed into three pieces and later rejoined. The parts were held together with the aid of iron clamps attached on the interior with tinted plaster. A light patination was added to cover the join lines.

The year before Carpeaux undertook this complicated process, he returned to *La Danse*, mining it to produce a series of decorative sculptures. He dissected the complicated composition, extracting from it nine separate works. Three of these, *Bacchante aux yeux baissés*, *Bacchante criant*, and *Faune*, were not then reproduced in editions but rather in single plasters. Later there was a limited lost-wax edition by Hébrard.

The other sculptures were more widely published in terra cottas and marbles which could be turned out by Carpeaux's own atelier. Three different *Bacchante* busts—*aux lauriers*, *aux roses*, and *aux vignes*—were taken from the heads of the individual dancers in the full-sized sculpture; they were identified as their titles indicate, by the introduction of different garlands in their hair.

The *Génie de la Danse* was liberated without change from the original plaster. Although a drawing dated 1873 exists which is a study of the *Génie* group alone, it does not seem that Carpeaux reworked the composition.[38] Rather, it was translated directly from the Louvre plaster, perhaps cast from the original mold. The full-sized piece, measuring *c.* 210 cm., was then reduced by a mechanical process for editions of various sizes. The atelier inventory of 1875 lists three dimensions of plaster models with their molds. Two of these, measuring *c.* 210 and 105 cm., are now known.[39]

In a similar inventory of terra-cotta *Génies*, a third size of 58 cm. appears; examples of it were exhibited and sold in 1873. Another size in terra cotta was mentioned in the listing, but its dimensions are unknown. Both terra cottas and plasters could be cast at any time, since the molds remained in the possession of the Carpeaux inheritors. A terra-cotta cast is in the collection of Philip Pearlstein, New York (fig. 20). The slight difference between this piece (H. *c.* 99.5 cm.) and the 105 cm. plaster and mold mentioned above is probably the result of material shrinkage. According to Mme Braunwald, the Pearlstein cast must correspond to a terra cotta which was sold in 1894.

The atelier inventory of 1875 makes no mention of a *Génie* in bronze. In the sale of May 31, 1894, however, two dimensions of bronzes appeared (H. *c.* 105 cm. and *c.* 58 cm.)—apparently posthumous casts. The larger of the two dimensions may be represented by a piece in the collection of the Carnegie Institute, Pittsburgh (fig. 21).

A founder's model in the smaller size is in the collection of the Metropolitan Museum of Art, New York (fig. 22). Its parts were probably cast by the lost-wax process. Then, as a disassembled model, it was used to produce a sand-cast bronze edition. A piece of similar size but of different base design is in the collection of the J. B. Speed Art Museum, Louisville, Kentucky (fig. 23). Unlike the Metropolitan piece, which has a simple oval base with little detailing on its surface, the Speed *Génie* has a round base, with a more complicated edge molding and a more elaborate treatment of its surface, which creates a greater illusion of a landscape setting, and gives the piece a more finished appearance. The difference between the two bases is sufficient to allow us to distinguish the two pieces as separate variations of the *Génie* at this scale, and to hypothesize that the Speed bronze was produced by a model other than the Metropolitan piece.

Despite the difference in size, the Speed bronze bears a close resemblance to a bronze in the collection of H. Peter Findlay, Inc., New York (fig. 24). Both have round bases, both have the name "Carpeaux" incised on the proper left front surface of the base, and, furthermore, both bear stamps of the Carpeaux atelier on the top surface of the tree trunk at the rear of the piece. The re-

semblance between the two pieces in these details is striking and significant. In spite of the markings, we cannot conclude that they are the products of the Auteuil atelier. The configuration of the inscription, the placement of the stamps on the base, and the shape of the base itself differ conclusively from the other pieces which seem to have been issued by the Auteuil shop. Furthermore, bronzes at the scale of *c.* 85 cm. (the size of the Findlay bronze) were not listed in the 1875 inventory or included in the 1894 sale. On the basis of this information, Mme Braunwald questions their provenance from the Carpeaux atelier and suggests that they might have been cast by the Maison Collin. According to one of the last representatives of that foundry, the company was at one time in possession of Carpeaux stamps and models which were eventually returned to the Carpeaux heirs.

Other editions of the *Génie de la Danse* were cast by the foundry Susse Frères, Paris, under the terms of a 1909 contract between Susse and Carpeaux's heirs. Since the models for the editions issued by Susse were supplied from the Auteuil workshop, it is not surprising that the bases of all the *Génie*s produced by Susse are oval and simple, like those of the Metropolitan model and the Carnegie cast. The foundry issued three sizes of the work, *c.* 103 cm., *c.* 84 cm., and *c.* 56 cm. They were priced at 1,600 francs, 1,125 francs, and 450 francs. A cast at the William Rockhill Nelson Gallery, Kansas City, illustrates the smallest dimension (fig. 25). These casts often have a fluid, almost slippery quality in the drapery, which flows around the *Génie*'s body. This is quite different from the crisper realism of the earlier editions, apparently the product of the taste of the later period in which they were produced.

It is known that marble versions of the *Génie* were produced during Carpeaux's lifetime, often transferred from a plaster model to the stone by means of the mechanical process invented by Meynier. According to Mme Braunwald, some marbles were left unfinished at the death of the *praticien* Bernaërts and were finished by Narcisse Jacques. It is probable that the marble now in the possession of Peter Findlay is one of these (fig. 26). However, the frequent uniformity of execution

and lack of markings of many marbles makes it difficult to be absolutely certain about the history of a piece if the provenance is not complete.

The *Génie* figure was enormously popular. One proof of its attraction lies in the numbers of unofficial editions which followed its appearance. Among these must be counted the busts of the *Génie*, which were issued without stamps or founder's marks (fig. 27). Although one of these

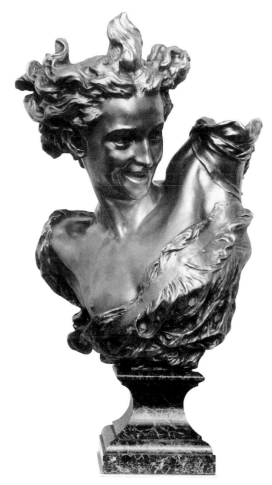

27. BUST OF GÉNIE DE LA DANSE
Bronze, with gold patination; H. *c.* 53 cm.
No markings

H. Peter Findlay, Inc., New York, New York

Although a bust of the *Génie* appeared in a sale of December 20, 1873, this particular size of the model was unknown during Carpeaux's lifetime.

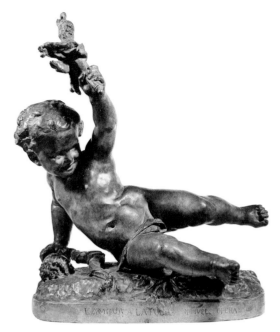

28. L'AMOUR A LA FOLIE
 Cast terra cotta; H. c. 73.7 cm.
 Markings
 incised at front of base: L'AMOUR A LA FOLIE
 NOUVEL OPERA
 proper right of base: oval Auteuil atelier stamp
 proper left of base: oval Propriété Carpeaux stamp
 incised at proper right side of base: B Carpeaux 1869

 Private Collection, New York, New York

appeared in the sale of December 20, 1873, its re-
lationship is closer to the portrait bust of Hélène
de Racowitza, the model for the features of the
Génie, than to the sculpture. It is not possible to
trace bronze versions of the *Génie* to sales or
inventories within Carpeaux's lifetime.

The popularity of decorative sculptures taken
from *La Danse* is further documented by the pro-
duction of the *Amour à la folie* as a separate work
(fig. 28). Although the plump putto maintains his
original posture, with raised hand playfully wav-
ing a jester's wand, he is separated entirely from
his original placement at the *Génie*'s feet. In the
atelier inventory taken at Carpeaux's death, both
a plaster and a mold for the *Amour* were listed. A
terra cotta, doubtless produced from this mold,
was sold March 11, 1874. A bronze version of the
laughing cupid was the only other bronze figure
from *La Danse* recorded in the inventory from
1875. One of these, bearing the two oval atelier

stamps, is now in the collection of the Musée du
Petit Palais, Paris.

Of the individual decorative sculptures which
Carpeaux took from *La Danse* for editions in
1872–1873, the group called *Les Trois Graces*
seems to have required the most attention from
the sculptor to transform it into an independent
piece. The connection between *Les Trois Graces*
and the dancers in the circle around the *Génie* in
his Opéra group is clear; but while the original is
in high relief, *Les Trois Graces* is fully in the
round. Carpeaux studied the modifications de-
manded by this new format in a small, unique,
terra-cotta sketch (fig. 29). His intention, which
he fully realized, was to charge his sculpture with
life and movement. As the viewer moves around
it, the inanimate substance of the piece quickens
with a vitality which is the product of continual
variation. From every angle, the group presents an
entirely different aspect, individual, yet unified
within the whole.

Unlike the *Génie de la Danse*, *Les Trois Graces*
seems to have been issued at only one scale, c. 80
cm., although a terra cotta listed as H. c. 50 cm.
did pass in the sale of December 23, 1873. The
models which exist for the series indicate that the
production of this group was similar to that of the
other pieces which issued from Carpeaux's studio.
A plaster model, now in the Ny Carlsberg Glypto-
tek, Copenhagen (fig. 30), is marked with hun-
dreds of "point" locations presumably used as a
model for one or more marbles whose present lo-
cations are unknown. The mold for the Glyptotek
plaster was also used to cast terra cottas, such as
the one at the Art Gallery of Toronto, signed by
Carpeaux and dated 1874 (fig. 31). No bronze
version of *Les Trois Graces* was listed in the atelier
inventory of 1875. The bronze founder's model
which appeared in the sale of 1894 has been linked
by Mme Braunwald to the founder's model at the
Sterling and Francine Clark Art Institute, Wil-
liamstown (fig. 32). According to her, the last au-
thorized proof was sold June 27, 1924. A later
edition of *Les Trois Graces* was issued after 1909
by Susse Frères, Paris. One of these is in the collec-
tion of the Chrysler Museum at Norfolk, Virginia
(fig. 33).

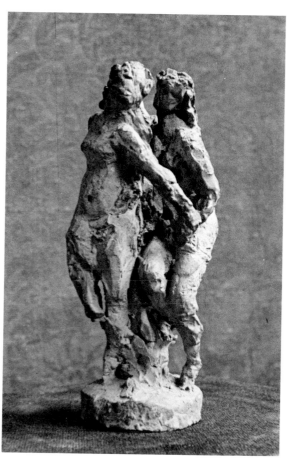

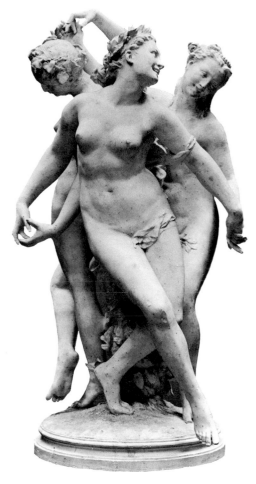

29. LES TROIS GRACES
 Terra Cotta; H. *c.* 15 cm.
 Markings
 wax cachet

 Musée du Petit Palais, Paris, France

 Unique sketch, probably dating from *c.* 1872,
 executed in Carpeaux's favored working scale

 (not in exhibition)

30. LES TROIS GRACES
 Plaster, with metal points; H. *c.* 83 cm.
 No markings

 Ny Carlsberg Glyptotek, Copenhagen, Denmark

 This plaster is marked with "points" to serve as a
 model for a marble, whose present location is unknown.

 (not in exhibition)

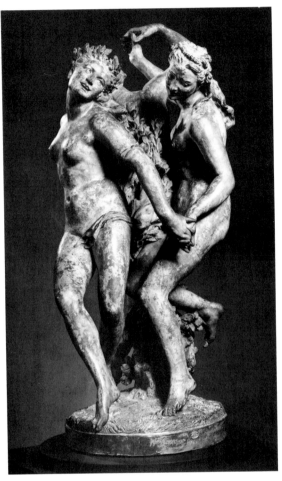

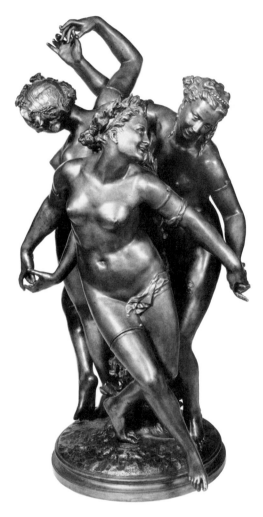

31. LES TROIS GRACES
 Cast terra cotta; H. *c.* 79.7 cm.
 Markings
 on front of base: B^te Carpeaux 1874
 stamped on front of base: PROPRIÉTÉ CARPEAUX
 stamped on proper left side of base:
 ATELIER DEPOT
 71 RUE BOILEAU
 AUTEUIL PARIS

The Art Gallery of Toronto, Toronto, Canada
Gift from the Junior Women's Committee Fund, 1958

A cast terra cotta probably made from the same mold
which produced the Glyptotek plaster (see fig. 30)

(not in exhibition)

32. LES TROIS GRACES
 Bronze; H. *c.* 84 cm.
 Markings
 on top front of base: J. B. Carpeaux

Sterling and Francine Clark Art Institute,
Williamstown, Massachusetts

This founder's model which disassembles was included
in the first Carpeaux atelier sale, May 30, 1913.

136

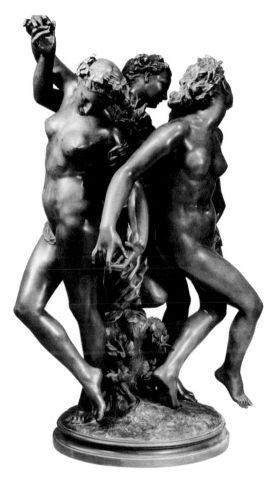

33. LES TROIS GRACES
Bronze; H. *c.* 80 cm.
Markings
 incised at front on upper edge of base: JB Carpeaux
 stamped at rear at edge of base: round Susse Frères
 stamp
 at rear: Susse Fr^es Ed^t B

Chrysler Museum at Norfolk, Norfolk, Virginia
Gift of Walter F. Chrysler, Jr.

Notes

1. Any study of the life and works of J. B. Carpeaux must make use of the biography, *La Verité sur l'oeuvre et la vie de J.-B. Carpeaux (1827–1875)*, 2 vols. (Paris: Doucet et Bigerelle, 1934), by Louise Clément-Carpeaux. Also essential are A. Mabille de Poncheville, *Carpeaux Inconnu ou la tradition recueillie* (Paris and Brussels: G. Van Oest, 1921). The most recent contribution to Carpeaux studies is the major exhibition catalogue *Carpeaux*, Paris, Grand Palais, 1975. Hereafter Carpeaux is referred to as JBC and Louise Clément-Carpeaux's biography as LCC.

2. JBC to Louis Dutoquet, December 27, 1851, quoted in Mabille de Poncheville, p. 91.

3. *Ibid.*

4. *LCC*, I, 21.

5. *LCC*, I, 41.

6. A group of the drawings are at the Louvre. See the *Inventaire général des dessins du Musée du Louvre, et du Musée de Versaille*, École Française, III, nos. 2007, 2141–2149.

7. The reader is referred to the catalogue *Carpeaux*, 1975, for illustrations of studies for the *Ugolin* and *La Danse*. See especially nos. 66–71 and 300–304.

8. *Carpeaux*, 1975, no. 174.

9. *LCC*, I, 96, mentions the difficulties presented by the production of this cast and points out in footnote 96 that replicas from the first editions of the casts can be distinguished because they lack a small "filet" on the legs, later added for the sake of modesty.

10. Written communication from Mme Annie Braunwald to the Fogg Art Museum, June 1975.

11. Information on the histories of Carpeaux's dealings with foundries for the production of these statues is found in *LCC*, I, 57–59.

12. *LCC*, I, *passim.*

13. *LCC*, I, 213ff., 222ff., 347ff. A later contract between the two dated April 12, 1872 is also published, pp. 411–412.

14. *LCC*, I, 221–222. These models produced by Joseph Carpeaux were: *La Toilette*, *La Tendresse maternelle*, *L'Impératrice protégeant les orphelins et les arts*, *Boudeur*, *La Palombella*, *Espeigle*, *Rieuse napolitaine*, *Rieur napolitan*, *Rieur aux pampres*, *Jeune fille à la coquille*, *Prince Impérial* (statuette and bust), *Candeur Espérance*, *La Negresse*.

15. These statistics are given in detail in *LCC*, I, 374, as follows: London, March 10, 1873—fifteen works; Paris, April 29, 1873—fifty-three works (seventeen marbles, six bronzes, thirty terra cottas); Brussels, June 3, 1873—thirty works (four marbles, six bronzes, twenty terra cottas); Paris, December 20, 1873—eighty-three works (thirteen marbles, twenty-three bronzes, forty-two terra cottas).

16. *LCC*, I, 373. The works produced by the Meynier process were: (busts) *La Palombella*, *Beauvois*, *Garnier*, *Marquise de la Valette*, *M. Chardon*, *Mme Chardon*, *Lagache*, *Napoléon III*, *Rieur napolitain*, *Le Chinois*, *La Négresse*; (groups) *Le Génie de la Danse*, *Le Jeune pêcheur à la coquille*, *Ugolin*.

17. Written communication from Mme Braunwald.

18. *LCC*, I, 413.

19. Frances A. Yates discusses this history in "Transformation of Dante's Ugolino," *Journal of the Warburg and Courtauld Institutes*, XIV (1951), 92–117.

20. For this long history see Gaston Varenne, "Carpeaux à l'École de Rome et la genèse d'*Ugolin*," *Le Mercure de France* (1908), pp. 579–593, and the correspondence of Schnetz in Henri Lapauze, *Histoire de l'Académie de France à Rome*, II (Paris: Plon-Nourrit et cie, 1924), 320–344.

21. *Carpeaux*, 1975, no. 77.

22. JBC to Charles Laurent-Daragon, cited in *Carpeaux*, 1975 (unpaginated).

23. In a letter of May 18, 1954. Examples of the Medici sketch were given by Clément-Carpeaux to the Musée du Petit Palais, Paris and to the museums in Nice and Valenciennes.

24. First published and reproduced in *Carpeaux*, 1975, no. 79.

25. *LCC*, I, 134ff.

26. *LCC*, I, 187ff., 394–410.

27. Communication from Mme Braunwald.

28. JBC to Louis Dutouquet, in Mabille de Poncheville, p. 208.

29. *Ibid.*

30. Garnier's own publication, *Le Nouvel Opéra de Paris*, Librairie Général de l'architecture et des travaux publics, 2 vols. (Paris: Ducher, 1878–1881), offers an interesting account not simply of the history of the building but also of his approach to architecture and of his dealings with the sculptors in his employ. The outline drawings he gave Carpeaux are published in *Carpeaux*, 1975, nos. 285, 286 (Musée du Louvre, R.F. 8643, 8644). Another account of the evolution of *La Danse* is L. Clément-Carpeaux, "La genèse du groupe de *la Danse*," *Revue de l'Art*, I (1927), 285–300.

31. For a copy of the head of Raphael's St. Michael, see *Carpeaux*, 1975, no. 311 (mistitled). The existence of

Carpeaux copies after the Risen Christ was confirmed to me by Gerhard Fries.—A.M.W.

32. See "Sculpture, Salon of 1857," *L'Illustration*, XXXIV, no. 2, pp. 116.

33. As is well known, Carpeaux modeled the head of the *Génie* on the features of Hélène de Racowitza while the torso was based on that of Sébastien Visat.

34. *LCC*, I, 270.

35. Quoted in *LCC*, I, 278.

36. *LCC*, I, 278–280.

37. The criticism of *La Danse* is extremely interesting. Seldom in the nineteenth century did a work of art meet with the vociferous reaction which greeted Carpeaux's piece as a composition without precedent and compared its realism to that of Courbet. See Charles Blanc, *Le Temps*, August 11, 1869; Arthur DuParc, "*La Danse* par M. Carpeaux," *Le Correspondant*, n.s. XLIII (79), September 16, 1869, 949–953; Charles d'Henriet, "L'Art contemporain. Les sculptures de M. Carpeaux," *Revue des deux mondes*, LXXXIII (1869), 477–490; René Menard, "Les Groupes du Nouvel Opéra," *Gazette des Beaux-Arts*, II, 2ème per. (1869), 264–269.

38. See *Carpeaux*, 1975, no. 322, Musée du Louvre, R.F. 2920.

39. Information on atelier inventories from written communication of Mme Braunwald.

Further Observations on Carpeaux by Mme Braunwald

The following notations are included here as they relate to the objects studied and discussed in the previous essay. Numbers refer to the figure numbers in the Carpeaux section.

Ugolin

4. *Le plâtre* La fille de Carpeaux, Madame Clément-Carpeaux fit faire des tirages par des Prix de Rome de Sculpture sur la maquette de la Villa Médicis, pour en donner aux musées: Valenciennes, Petit Palais, Nice, etc. . . .

Le bronze A une demande, concernant l'authenticité d'un bronze, Mme Clément-Carpeaux répond . . . Je ne connais pas d'oeuvre . . . tirée du temps de mon père (lettre du 18/5/1954).

Un bronze est fait par la maison Susse.

Une terre cuite établie d'après le moulage d'une esquisse appartenant à Mme Clément-Carpeaux, "qui n'a jamais été éditée" (lettre de Susse du 30/3/1922).

Ière maquette *épreuve en plâtre*. Au Petit Palais, à Nice, à Valenciennes, à Montargis, dons de Mme Clément-Carpeaux.

13, 14, 15. En 1867 (?) Carpeaux a l'idée d'une réduction de l'Ugolin, et s'adresse à Christofle qui estime qu'il n'y a pas d'économie à le tirer en galvanoplastie. En 1868, Christofle donne comme prix d'établissement du modèle: 2.800F; et l'épreuve: 1.000F.

Bronze La réduction paraît pour la première fois à Londres en Décembre 1871. A Paris, la Vente du 21 mars 1872 fait mention d'une première épreuve.

Des bronzes de 45, 46, 49 cm. passent dans des ventes en 1873 et 1874.

Un bronze dédicacé à Diaz en 1875, passe dans la Vente Arnold Seligmann en 1935. 4–5 juin. repr.

L'inventaire à la mort de Carpeaux mentionne *"Ugolin br. réduction modèle."*

Le plâtre modèle pour le bronze Signé: JB^te

Carpeaux Rome. 1860 sur le pan coupé de la base à droite. Don Mme Clément-Carpeaux au Petit Palais 1938.

Une *terre cuite* parait à la vente du 7 mai 1872, de 1872 à 1874 les prix varient entre 245F; et 280F.

En 1876 une *épreuve en terre cuite* signée J. B. Carpeaux porte les cachets "atelier" et "propriété" avec le n° 234 gravé.

Après la mort de Carpeaux:
Vente de 1894 un *modèle bronze* de 50 cm. (pour être le n° 82 de l'Ex. de Paris de 1975).

Autres bronzes:
Un bronze (ancienne coll. Bellanger).
Un bronze édité par Susse après 1909.
Une terre cuite Vente du 13/4/1973 avec cachet (des S entrelacés) cachet rectangulaire: Susse Frères Paris (après 1909).

15. La signature est bonne, la gravure soignée. L'inscription est très proche de celle du plâtre modèle du Petit Palais, la différence est peut-être due aux matériaux: bronze et plâtre. Les traces de signature sur la terrasse sont intéressantes.

La Danse

La maquette, *plâtre original* au Musée du Louvre, 55 cm. épreuve en plâtre, très proche de celle du Louvre, V^te Déc. 1913, 71. repr.

Carpeaux tire une *terre cuite* de cette esquisse en 1874. terre cuite, "1ère esquisse du sujet: 54 cm. —"Vte du 23 Mars 1974."

Une terre cuite (sans fond), signée B^te Carpeaux 1869, 50 cm., un seul timbre; "propriété Carpeaux." Don L. Clément-Carpeaux au Petit Palais en 1938.

Une terre cuite, signée JB^t Carpeaux 1869, cachet "propriété Carpeaux," 50 cm. Achat de la Ville de Valenciennes V^te du 27 juin 1924 n° 114; 4.600f (sans fond).

Une terre cuite: coll. Fabius-Paris (sans fond).

16. La terre cuite est très semblable à l'épreuve en plâtre de la vente de décembre 1912, de 50 cm., avec fond, qui a du être établie d'après la maquette originale du Louvre de 54,5 cm. (beaucoup plus fine). Les deux timbres et le n° gravé (à 3 chiffres) correspondent à un des premiers tirages.

Bronzé à cire perdue: édition Hébrard en 1927 limitée à 15 épreuves; une épreuve n° 1 vendue en 1927—13.200F.

Le modèle bronze sur plâtre aux héritiers Hebrard.
Achevée en terre en janvier 68, en mars moulage, plâtre original 2,32 × 1,48 m agrandie au double par le praticiens et terminée en 1869.

Le Génie de la Danse

Le plâtre modèle: un inventaire, en 1875 indique 3 dimensions de modèles en plâtre avec leurs moules. Sont connus: les n^os 1: 2,10 m (env.) Vte 1913 repr. Coll. Rothchild; le n° 2: 1,05 Vte 1913 Coll. part.

La terre cuite: un état des terres cuites mentionne:

> un n° 1?
> un n° 2: 58 cm.
> un n° 2: 58 cm.; Exp. mars 1873
> 58 cm.; Vte du 29 avril 1873

Le bronze: l'inventaire de 1875 ne mentionne pas de bronzes du Génie dans l'atelier. La vente du 31 mai 1894 donne deux dimensions: n° 1: 105 cm.; n° 2: 58 cm. (la dimension de 85 cm. ne se trouve pas en 1894).

21. La terre cuite doit correspondre à la terre cuite n° 1 de la vente de 1894 Haut. 1,05 m.

22. Doit correspondre au n° 2 de la *Vente de Modèles en bronze*.

N° 535 du 31 mai 1894 racheté par les héritiers le n° 1 de 105 cm., 534 de 1894; Vte 1913 n° 15, 6.680F. Coll. part.

Un modèle bronze de 77 cm. (sans le tambourin) signé JB^te Carpeaux, don Mme Clément-Carpeaux au Petit Palais, en 1938.

Le tambourin est mal remonté, les autres modèles 77 et 105 cm. n'ont pas de tambourin.

24. La date extrême de 1898 prouve une épreuve postérieure à Carpeaux. Les timbres ont donc été utilisés par les héritiers. L'épreuve est très proche du modèle bronze du Petit Palais de 77 cm. (approximativement)—sans le tambourin.

La dimension de 88 ou 85 cm. ne se trouve ni en 1875 ni en 1894. Les deux bronzes ont peut-être été fondus par la maison Collin qui d'après un des derniers représentants de la maison avait les cachets et modèles repris par les héritiers.

En 1909; contrat entre le Maison Susse et les heritiers Carpeaux.

 3 dimensions : n° 1 : 103 cm. = 1.600F
 n° 2 : 84 cm. = 1.125F
 n° 3 : 56 cm. = 450F

L'amour a la Folie

28. Un bronze dans l'inventaire de 1875.

Un bronze, timbres "propriété Carpeaux" et "petit aigle" don L. Clément-Carpeaux au Petit Palais en 1938.

Une terre cuite vendue le 21 déc. 1943.

Autre épreuve de terre cuite 39 cm. chez Susse 3.III–67.

Les Trois Graces

31. *Autres terres cuites* :
Terre cuite vendue à l'avoué Chéramy en 1875.

Terre cuite épreuve, Vte 1894, 320F.

Terre cuite, h. 77 cm., signé : Carpeaux 1874. Cachet Propriété Carpeaux, don de Mme L. Clément-Carpeaux au Petit Palais en 1938.

Terre cuite, Vte 6 nov. 1957, signée et datée : 1875. Vte 30–31 mai 1927, coll. de M.G; U. (Urion).

Terre cuite, n° 105, h. 80 ; l. 31 cm., signée JBte

Carpeaux 1874. Estampillée "propriété Carpeaux," vendue 86.000F à Mr. T.

32. Le bronze n'est pas mentionné à l'inventaire de 1875. Modèle bronze, statuette, 85 cm., Vte 1894.

33. Le timbre rond serait une médaille frappée et daterait de 1925. Le B = initiale de l'ouvrier ciseleur.

Selected Bibliography

SALES AND EXHIBITION CATALOGUES:

Brussels. Galerie Saint Luc. *Catalogue de trente-deux oeuvres de J.-B. Carpeaux: marbres, bronzes, terres cuites.* 1873.

Paris, École National des Beaux-Arts. *Exposition des oeuvres originales et inédites de J. B. Carpeaux.* Preface by Maurice Guillermot. May 20–28, 1894.

Paris, Galerie Manzi-Joyant. *Atelier J. B. Carpeaux. Catalogue des sculptures originales, terres cuites, plâtres, bronzes, par Jean-Baptiste Carpeaux. . . .* May 30 (first sale); December 8, 9 (second sale), 1913.

Paris, Galeries Nationales, Grand Palais. *Catalogue Exposition sur les traces de Carpeaux.* March 12 – May 5, 1975.

Paris, Hôtel Drouot. *Atelier J. B. Carpeaux. Tableaux, dessins, esquisses, croquis, études, carnets de poche, terre cuites.* Preface by Maurice Guillermot. December 14, 1906.

Paris, Hôtel Drouot. *Catalogue de vente des tableaux, dessins, esquisses et marbres par Carpeaux et des modèles en bronze vendus avec droits de reproduction en bronze et marbre composant l'atelier Carpeaux.* May 31 and June 1–2, 1894.

Paris, Petit Palais. *Catalogue Exposition J. B. Carpeaux, 1827–1875.* 1955–1956.

Paris, Salle du Jeu de Paume. *Exposition des oeuvres de Carpeaux et de Ricard.* May 13 – June 15, 1912.

Paris, Salon des Artistes Français, Grand Palais. *Exposition retrospective Carpeaux (Centenaire de sa naissance).* 1927.

Valenciennes, Musée de Valenciennes. *Catalogue de l'Exposition du Centenaire de Carpeaux.* (Biography by Louise Clément-Carpeaux.) 1927.

BOOKS AND ARTICLES:

Bouyer, Raymond. "L'atelier de J. B. Carpeaux avant sa dispersion." *Revue de l'Art ancien et moderne,* May 1913.

Braunwald, Annie-Marvaud. "Les sculptures de J. B. Carpeaux au Petit Palais." (Unpublished dissertation, École du Louvre, 1971.)

de Caso, Jacques. "Jean-Baptiste Carpeaux." *Médecine de France,* 161 (April 1965), 17–32.

Chesneau, Ernest. *Le Statuaire J.-B. Carpeaux, sa vie et son oeuvre.* Paris, 1880.

Clarétie, Jules. *J.-B. Carpeaux, 1827–1875.* Paris, 1875.

Clément-Carpeaux, Louise. "La genèse du groupe de *la Danse.*" *Revue de l'Art,* 1 (1927), 285–300.

———. *La Vérité sur l'oeuvre et la vie de J.-B. Carpeaux, 1827–1875.* 2 vols. Paris: Doucet et Bigerelle, 1934–1935.

Duclaux, Lise. "La Sculpture monumentale dans l'oeuvre dessiné de Carpeaux." (Unpublished dissertation, École du Louvre, 1962.)

Garnier, Charles. *Le nouvel Opéra de Paris.* Librairie générale de l'architecture et des travaux publics. 2 vols. Paris: Ducher, 1878–1881.

Guillermot, Maurice. "Le plâtre original du groupe de *la Danse* au Musée du Louvre." *La Patrie,* November 7, 1889.

Lami, Stanislas. *Dictionnaire des sculpteurs de l'École française au XIXe siècle.* 4 vols. Paris: Éditions Champion, 1914.

Lapauze, Henri. *Histoire de l'Académie de France à Rome.* 2 vols. Paris: Plon-Nourrit et cie, 1924.

Mabille de Poncheville, André. *Carpeaux Inconnu ou la tradition recueillie.* Paris and Brussels: G. Van Oest, 1921.

Salelles, M. C. A. de. *Le groupe de la Danse de M. Carpeaux jugé au point de vue de la morale, ou essai sur la façade du nouvel Opéra.* Paris: Dentu, 1869.

Terrier, Max. "Carpeaux à Compiègne." *Bulletin de la Société historique de Compiègne,* XXV (1960), 199–208.

Theunissen, Corneille. "Les terres cuites de Carpeaux." *La Grand Revue,* June 25, 1912, pp. 827–830.

Varenne, Gaston. "Carpeaux à l'École de Rome et la genèse d'*Ugolin.*" *Le Mercure de France,* 1908, pp. 579–593.

Vitry, Paul. *La Danse de Carpeaux.* Paris: Alpina, 1939.

Yates, Frances A. "Transformation of Dante's Ugolino." *Journal of the Warburg and Courtauld Institutes,* XIV (1951), 92–117.

Checklist of the Exhibition

UGOLIN ET SES ENFANTS

5. Plaster; H. *c.* 53.5 cm.
 Barnet Fine, M.D., New York, New York

5a. Plaster, painted black over gilt and shellacked, some touches of green paint; H. *c.* 53.5 cm.
 No markings
 The Metropolitan Museum of Art, New York, New York. Anonymous Gift.

 A plaster cast from the same piece mold (type A) which produced, directly or indirectly, figs. 5, 5b, and 5c. The patination given the piece was probably meant to simulate the surface of a bronze.

5b. Plaster, painted black; H. *c.* 53.5 cm.
 No markings
 Mr. and Mrs. Joseph M. Tanenbaum, Toronto, Canada

 Cast from the same plaster piece mold (type A) which produced figs. 5, 5a, and 5c. Mold key marks on the under surface of the base suggest this plaster was used as a model for a gelatin mold.

5c. Bronze; H. *c.* 51.5 cm.
 No markings
 Chrysler Museum of Art at Norfolk, Norfolk, Virginia

 A lost-wax cast of type A.

6. Bronze; H. *c.* 51.5 cm.
 Walker Art Center, Minneapolis, Minnesota

7. Plaster; H. *c.* 52.5 cm.
 Detroit Institute of Arts, Detroit, Michigan

8. Cast unbaked clay; H. *c.* 48.5 cm.
 Museum of Fine Arts, Boston, Massachusetts

15. Bronze; H. *c.* 48.5 cm.
 Chrysler Museum of Art at Norfolk, Norfolk, Virginia

LA DANSE

Maquette
16. Cast terra cotta; H. *c.* 50 cm.
 Yale University Art Gallery, New Haven, Connecticut

Le Génie de la Danse
23. Bronze; H. *c.* 55.2 cm.
 J. B. Speed Art Museum, Louisville, Kentucky

24. Bronze; H. *c.* 85.1 cm.
 H. Peter Findlay, Inc., New York, New York

25. Bronze; H. *c.* 54.6 cm.
 William Rockhill Nelson Gallery of Arts
 Atkins Museum of Fine Arts, Kansas City, Missouri

25a. Bronze; H. *c.* 101.5 cm.
 Markings
 incised on front of base: B Carpeaux JC pt
 incised on upper left side of base: Fondu sur la modele original en 1912
 incised on rear of base: Susse Fres Edrs Paris
 stamped on rear with round Susse cachet
 Chrysler Museum of Art at Norfolk, Norfolk, Virginia
 Gift of Walter P. Chrysler, Jr.

26. Marble; H. *c.* 82.6 cm.
 H. Peter Findlay, Inc., New York, New York

Bust of Génie de la Danse
27. Bronze with gold patination; H. *c.* 53 cm.
 H. Peter Findlay, Inc., New York, New York

27a. Bronze; H. *c.* 39.5 cm.
 Markings
 incised on proper left of base: B. Carpeaux
 H. Peter Findlay, Inc., New York, New York

 A reduction of fig. 27.

L'Amour à la folie
28. Cast terra cotta; H. *c.* 73.7 cm.
 Private Collection, New York, New York

Les Trois Graces
32. Bronze; H. *c.* 84 cm.
 Sterling and Francine Clark Art Institute, Williamstown, Massachusetts

33. Bronze; H. *c.* 80 cm.
 Chrysler Museum of Art at Norfolk, Norfolk, Virginia

1. Rodin in his studio at the Hotel Biron. From *Rodin the Man and his Art*, by Judith Cladel [New York: The Century Co., 1917], p. 43.

Auguste Rodin
(1840–1917)

Born in 1840 of a modest Parisian family, Rodin (fig. 1) began his artistic career at fourteen when he entered the École Impériale Spéciale de Dessin et de Mathématiques (the "Petite École"). He hoped to study sculpture at the more prestigious École des Beaux-Arts, but was repeatedly turned down. Hampered by this rejection for almost the next twenty years of his career, he did decorative sculpture and worked as an assistant to conventional sculptors like Carrier-Belleuse. Still he continued to seek his own personal expression, producing a number of remarkable early works such as *The Man with the Broken Nose* and the portrait of his lifelong companion, Rose Beuret, as *Mignon*. Following the Franco-Prussian War of 1870, he departed for Belgium where for seven years he worked primarily as a sculptor of public monuments and architectural decorations.

After a memorable trip to Italy in 1875, Rodin finished the sculpture that brought him at last to public attention. *The Age of Bronze* was exhibited at the Salon of 1877, where some said it had been cast from life. Nevertheless, this carefully worked sculpture presaged his initial artistic acceptance; official patronage was soon to follow. His famous *Gates of Hell* was commissioned by the French government in 1880. Never installed in the museum for which it was intended, it became a lifelong preoccupation for the sculptor and the starting point for many of his most famous works: *The Kiss, The Thinker, Eve, The Prodigal Son.*

With his growing reputation, Rodin received commissions for a series of public monuments in the 1880s and 1890s, including *The Burghers of Calais* (1884) and the *Balzac* (1891). Both of these took years to complete and are now considered two of his most significant works. The aggressive expressiveness of the *Balzac* raised a storm of protest and a counter-barrage in its defense when it was shown at the 1898 Salon. Rodin's reputation as the most progressive sculptor of his time was cemented. With a highly successful one-man show held at the time of the Paris International Exposition of 1900, his considerable international fame was spread even further.

The late years of the artist were distinguished by innumerable drawings of the human figure and a series of remarkable portraits, increasingly in demand by the political, social, and cultural leaders of the world, including such notables as George Bernard Shaw, Joseph Pulitzer, Gustave Mahler, and Georges Clemenceau. Increasingly aware of his public and artistic position in these years, Rodin wrote or collaborated on a series of essays, which included his views on art (*L'Art*, 1911) and his thoughts on the French cathedrals (*Les Cathédrales de France*, 1914). After a long campaign by his friends, the sculptor's gift to the nation of his own works and the art that he had collected was finally accepted by France in 1916, to be housed after his death in what is now the Musée Rodin in Paris.

For many years the archives of the Musée Rodin, which reportedly houses an extensive collection of documents, have been effectively closed to scholars. One hopes that this condition will change in the near future; but in the meantime the reconstruction of Rodin's studio practices involves piecing together bits of information from eyewitness accounts, the artist's correspondence, old photographs, and the multitude of sculptures existing in collections around the world. Still, many technical aspects and procedures necessarily remain imperfectly defined.

The general working method and preferred media seem to have been established early in his career. Although his technique varied somewhat from one type of sculpture to another, acute observation of the living model was fundamental to all his work. Rodin's study of the human figure was continuous. Models often roamed freely around his studio until they unintentionally assumed a posture the sculptor liked. Then he seized

a bit of clay and quickly modeled a little figure.[1] As the studies developed into more advanced groups, he frequently had several plaster casts made. Some of these would be cut up so that he could further experiment with the arrangement of the figures, or later use the components as starting points for new compositions.[2]

In making his larger figures he would usually begin with a carefully executed sketch one-third or one-half the desired size. This was then enlarged and reworked to adjust it to its new scale.[3] Modeling the figure in clay again required the very intense study of the subject, whom the sculptor continually compared with the sketch. Rodin called this method the study of profiles, and described it in 1913:

When I begin a figure, I first look at the front, the back, the right and left profiles, that is the profiles at right angles; then, with the clay, I locate as exactly as possible the large mass as I see it. I next make the intermediaries, that is the profiles as seen in three-quarters; then, turning my clay and my model successively, I compare and refine them.[4]

This had been his technique for many years. It was the method employed in making *The Man with the Broken Nose*.[5] As with the small studies, he would sometimes have multiple plaster casts made of his half life-size sketches, which could then be reemployed in a variety of experiments.[6]

In making portraits, Rodin followed a similar painstaking procedure. First he studied the sitter for characteristic movements and expressions. "I am seeking always the distinguishing trait that makes this man or woman an individual different from the rest of his kind," he said.[7] When he was ready to begin modeling, he roughed in the main masses and then proceeded to refine the head, again through the careful study and measurement of profiles.[8] George Bernard Shaw, who was portrayed by Rodin in 1906, revealed some of the peculiarities of the sculptor's technique:

He plodded along exactly as if he were a river god doing a job of wall-building in a garden for three or four francs a day. When he was in doubt he measured me with an old iron dividers, and then measured the bust. If the bust's nose was too long, he sliced a bit out of it, and jammed the tip of it up to close the gap, with no more emotion or affectation than a glazier putting in a window pane. If the ear was in the wrong place, he cut it off and slapped it into its right place, excusing these cold-blooded mutilations to my wife (who half expected to see the already terribly animate clay bleed) by remarking that it was shorter than to make a new ear.[9]

Unusual too was his habit of having casts made of a bust at various stages of development, like a printer making proofs of various states. Malvina Hoffman, who worked with Rodin periodically between 1910 and 1914, explained his rationale for this custom:

Sometimes he would make six or seven different studies of the same person—varying slightly the pose of the head or the expression of the face. Frequently I knew him to start a portrait, and after a few sittings, to call in a plaster-caster and have a mould made as a record; then he would make a "squeeze" [*estampage*], that is, the fresh clay would be pressed into the negative of the piece-mould and with this stage of the portrait safely registered, he would feel more free to make bold changes or experiments, without the fear of losing what had been achieved up to that point. The first plaster was a guide to which he could always refer if he felt himself in doubt during the subsequent sittings.[10]

Only after progressing through these laborious steps was a bust, a figure, or a group finally ready to be rendered in its final medium—usually bronze, often marble, and occasionally less common materials like wax, silver, ceramic, and glass.

The reproduction of the original clay model into a more permanent medium usually required the assistance of specialists. Actually, from a very early date, Rodin's sculptural production involved others. The studio assistants and specialists became a larger and larger community as the sculptor prospered in the 1890s and the early twentieth century. Visitors to his studios described the workshop-like atmosphere of the austere rooms bespattered with plaster, with workers, students, plaster casters, and marble carvers bustling about. Characteristic jobs given to young pupils who

wanted to "study" with the master were those he himself had performed in his youth: constructing armatures, preparing scaffolding for large works, creating the first rough massing of the clay on a larger scale from small sketches, sometimes modeling the less important parts of the final clay under Rodin's direction, and carving marbles after the sculptor's model. The names of a number of his collaborators have come down to us. Among them are Jules Desbois and Camille Claudel, both sculptors in their own right, who modeled portions of Rodin's sculptures.[11] There seems to be no doubt that the major portion of the modeling was done by Rodin.

As we have seen, the sculptor frequently had plaster casts of sketches and works in progress made. This work was done by his many *mouleurs*. Specialists in plaster casts and molds made *estampages* of work finished or in progress. Rodin had his *mouleurs* make record copies, in plaster, of marbles as they were finished; these would sometimes, in turn, be cast in bronze.[12] It seems that the sculptor frequently had the *mouleurs* make multiple casts which were stored in his studios; many of these were given to his friends. These were not necessarily of the quality required for models for bronze casts, and the sculptor expressed his concern around 1897 that the friends to whom he had presented plasters might have them cast in bronze.[13] Although he had several *mouleurs*, only the names of the Montagutellis and Guioché have come down to us. The two Montagutellis worked for Rodin from the 1890s into the twentieth century. However, in 1919 they were implicated in a lawsuit against a ring of counterfeiters who were making *surmoulages* (overcasts) from Rodin sculptures.[14] Guioché collaborated with the sculptor at least as early as 1906.[15]

The *réducteur*, who enlarged and reduced sculptures from their original size, was another important technician in Rodin's studio. Henri Le Bossé began working for the sculptor in the 1890s. He collaborated on such important works as *The Thinker*, the Victor Hugo monument, *The Three Shades*, the *Balzac* and the *Ugolino*.[16]

When the clay model had been cast by the

mouleur (and, if desired, enlarged or reduced), it was ready for the bronze founder. In 1889 Rodin's earliest biographer, T. H. Bartlett, wrote that bronze was the sculptor's preferred medium because it most faithfully reproduced the artist's original intention, without the interference of the marble carver. He mentioned that lost-wax (*cire-perdue*) was his favored casting technique at the time.[17] In 1881 Rodin had called *cire-perdue* the only method suitable for rendering his *Gates of Hell*.[18] Only a few founders in the late nineteenth and early twentieth century used this technique; these included Eugène Gonon, C. Bingen, Thiébaut Frères, and A. A. Hébrard, all of whom the sculptor employed at one time or another between the early 1880s and the early years of the twentieth century. Gonon cast the bronze busts of Jean-Paul Laurens (Salon of 1882) and Victor Hugo (Salon of 1884).[19] Bingen reportedly worked for Rodin between 1884 and 1889.[20] The Thiébaut foundry, one of the most prominent in the nineteenth century, cast the first bronze *Age of Bronze* in 1880, and Rodin wanted them to cast *The Burghers of Calais*.[21] While working for the sculptor between 1903 and 1905, A. A. Hébrard cast the bust of Falguière, the monumental *Thinker*, and *The Fallen Caryatid Carrying Her Stone*.[22]

Another foundry employed by Rodin at an early date was Griffoul and Lorge, which produced bronze casts of his work between 1887 and 1895.[23] Somewhat later he had casts made by Auguste Griffoul (1895–1899) and P. Griffoul (1903). Between 1896 and 1901 the Léon Perzinka foundry cast a number of works for Rodin, including *Fugit Amor*, *Despair*, and *Victor Hugo Inspired by the Muses*.[24] A recently examined cast shows that this foundry used the sand-casting technique.

The sand-casting method was also used by the Barbedienne foundry, which began casting editions of two of Rodin's sculptures in 1898. By the turn of the century the sculptor relied on sand-casting almost exclusively. It was the technique followed by the Alexis Rudier firm and its successor, Georges Rudier. The history of the Alexis Rudier foundry has been somewhat confused in recent years, and bears restating here. Alexis Rudier, for whom the foundry is named, never

cast for Rodin; his son Eugène, who succeeded him at his death in 1897, was to become the sculptor's most trusted founder in the early twentieth century. Eugène had always been more interested in the bronze founding that had been practiced by his uncles, François and Victor Rudier, than the silver and gold bibelots, with an occasional small bronze, cast by his father.

Around 1899 Eugène began casting for Alexandre Charpentier who presented him to his friend Jules Desbois; Desbois in turn introduced him to Rodin.[25] Eugène Rudier later told how Rodin had handed him a bust by another artist in order to test him. Rodin was pleased with Rudier's results, and soon gave him major pieces to cast.[26] Although 1902 is the date usually given for the beginning of the Rodin-Rudier relationship, it probably began earlier, as the bust of Jules Dalou exhibited at the 1900 Paris Exposition Centennale is a Rudier cast.[27] Eugène Rudier continued to cast for the Musée Rodin until 1952. In 1954 he was succeeded by his nephew, Georges Rudier.

These founders are apparently only a few of those who cast for Rodin. About the others much less is known. Many of the early bronzes, for example, bear no founder's mark. Casts with the marks of Banjean (Paris), A. Gruet aîné, Henri Luppens and J. Petermann (Brussels) are known, but nothing has been uncovered about the relationships of these firms with the sculptor.

Rodin seems to have played a supervisory role in the production of his bronzes. In a letter of 1881 he described how the lost-wax founder would cast The Gates of Hell in five pieces, and how he himself would retouch the waxes as they were prepared by the founder.[28] He was obviously concerned about the quality of the casting; his cautious testing of Eugène Rudier has been mentioned. In 1900 Rodin wrote to Roger Marx about a new bronze cast of The Age of Bronze which he thought better than the first one done by the Thiébaut foundry.[29]

He was equally conscientious about the patination of the bronzes. The sculptor had his patinator, Jean Limet, redo the large version of The Walking Man three times before he considered it ready to send to the Salon de la Nationale of 1907.[30] On the other hand, he seems not to have liked the highly chased surfaces that his predecessors and many contemporaries admired. His casts typically retain traces of the mold seams and other accidents of casting that add visual interest to the pieces.

It seems that Rodin was not very happy with the results of casts made by commercial bronze founders, but from time to time he sold them the right to reproduce certain of his pieces. In 1872 he sold the copyright for two terra-cotta heads, Dosia and Suzon, for a very low price, around twenty-seven dollars by today's values, to the Compagnie des Bronzes in Brussels. They continued to produce a very sizeable edition until 1939.[31]

It was not until 1898, in the year of the Balzac affair and during the period of his expanded recognition, that he again approached a commercial founder. In that year four of his works began to be cast in large quantities. The largest editions were made by the big bronze firm of Leblanc-Barbedienne, which acquired the right to reproduce two of the sculptor's most popular groups celebrating the theme of love between man and woman: The Kiss and The Eternal Spring. Rodin retained the right to make sand casts of these in various sizes, but for these he was required to pay Barbedienne a 20 per cent fee.[32] He was not particularly pleased with the mechanically reduced replicas turned out in vast quantities by this firm.[33] In the twenty years between 1898 and 1918 it produced a total of 319 bronze casts of The Kiss and 231 of The Eternal Spring, both in four sizes.[34]

In the same year Rodin signed contracts with Fumière and Gavignot, successor to Thiébaut Frères, giving them the right to cast replicas of the 50 cm. model of Triumphant Youth and reductions of his St. John the Baptist for a period of ten years. In return, he was to receive a royalty of twenty per cent for each cast after the first five casts in each size, again no great bargain for the sculptor. He retained the right to reproduce the St. John in its original size, but metal casts had to be made with this foundry. In 1908 the foundry exercised its option to renew the contract for ten more years for the first piece, but relinquished it for the second.[35] Between 1898 and 1908 the Fumière firm produced at least twenty-one casts of the St. John

in varying sizes and at least thirty-nine casts of *Triumphant Youth*.[36]

If the commercial edition was not Rodin's usual production practice, neither was the limited edition or unique cast, although there were occasional exceptions. He sometimes sold a plaster with all rights of reproduction so that the size of the edition could necessarily be limited by the purchaser.[37] On rare occasions he sold unique bronze casts, breaking the plaster model as a guarantee that no more would be made.[38] Although he did not make it a consistent practice, he sometimes numbered his sculptures, but usually only through the first or second casting of a piece.

The dating of bronze casts of Rodin's sculpture is problematic. Without the foundry account books and other archival material in the Musée Rodin, it is difficult to reconstruct the exact casting sequence of the various pieces. A well-established provenance, preferably documented, and marks of early founders are indicators, but certainly not conclusive in and of themselves. Other markings on the bronzes are less reliable. The Alexis Rudier mark, as we have seen, appears on Rodin sculptures from about 1900 to 1952. Certain bronzes acquired during Rodin's lifetime are unmarked. This absence of markings cannot be taken as proof of early casting, particularly in light of the illicit casts made during Rodin's lifetime and since his death.

The presence or absence and style of Rodin's signature also vary. A sequence for the signature has never been determined by scholars; presumably signatures were often added by the founder rather than the sculptor anyway, which may account for some of the variation. The *cachet*, a stamp pressed into the negative sand mold so that the marking "A. Rodin" stands out in relief (usually on the inside of the bronze), does not, as it has been sometimes claimed, occur only on posthumous casts. Exactly when and why this began to appear is unknown, but a number of casts, dating approximately from the time of the sculptor's association with Eugène Rudier, bear this mark.[39] The Musée Rodin has continued to use this *cachet*.

The continued production of bronze casts by the Musée Rodin since the sculptor's death raises ethical as well as aesthetic questions. The Museum claims that in his will, which to date has not been made public, the artist gave them the right to cast twelve bronzes for each sculpture. The order of the various casts within the edition of twelve, at least in recent years, has been communicated by a *certificat d'origine* signed by the director of the Museum, although occasionally the cast number is inscribed on the bronze itself. Although the former director of the Musée Rodin, Cécile Goldscheider, claims that casts produced by the Museum are always marked with the copyright and the date of casting, this practice began only in the 1950s.[40] Prior to that time posthumous casts were not distinguished on the bronzes themselves. Since the 1950s, Musée Rodin casts are usually marked with the copyright and with the name of the founder employed by the Museum. Georges Rudier cast most of these for nearly twenty years, but of late the Musée Rodin has increasingly employed the firms of Susse and Godard.

Although bronze casts are in greater favor today, many of Rodin's works were produced in marble. At latest count almost 400 marbles are known to have come from his studios.[41] Such a large number, in addition to his other output, obviously required the employment of professional marble carvers (*praticiens*), a common practice at the end of the nineteenth century. The sculptor's personal role in the marble work is debatable. Some say that he did no carving at all, others that he carved the work in its final stages. The practice followed in Rodin's studio was "indirect carving," which meant the initial carving was done with the assistance of a mechanical pointing device from the plaster model, rather than directly on the block of stone.

The increased demand for his marbles at the turn of the century meant that Rodin required more and more marble carvers. The names of many of these have come down to us today. They include Jules Desbois, Jean Baffier, Antoine Bourdelle, Jean Turcan, Jean Escoula, Alfred Halou, Victor Peter, Louis Mathet, Charles Despiau, to name only a few.[42] Rodin supervised their work, giving them instructions by making pencil or chalk

markings which showed them where and how much to cut.[43]

In marketing his bronzes and marbles, usually produced to order, Rodin seems to have distrusted dealers. Usually he preferred to represent himself or be represented by his friends in these transactions. The bronzes produced and sold by founders in large editions are obviously exceptions. Rodin liked to show his finished works in his studios and a number of letters detail his negotiations with many purchasers.[44] Not infrequently he enjoined the assistance of friends. In the 1870s the Belgians Julien Dillens and Amédée Bourson tried without success to find a buyer for *The Man with the Broken Nose*.[45] Later in 1902 and 1903 Jelka Rosen Delius, painter and wife of the composer, negotiated the sale of three sculptures to Karl-Ernst Osthaus, then director of the Folkwang Museum in Hagen.[46] The sculptor Ivan Meštrović, who had formerly worked with Rodin, helped to arrange the sale of *The Walking Man* to a Viennese industrialist in 1911.[47]

Only occasionally did Rodin entrust his work to art dealers. In the 1860s and 1870s he displayed little terra-cotta heads and figures in shops in Paris and Brussels, but had little luck in selling them. William Rothenstein, who was associated with the new Carfax Gallery, proposed in 1898 that Rodin exhibit some drawings and sculptures there, and the sculptor accepted.[48] On behalf of the gallery, Rothenstein negotiated the sale of the second marble version of *The Kiss* to Edward Perry Warren in 1900 for the sum of 25,000 francs (5,000 for the block of marble and 20,000 for Rodin).[49]

While low by today's market, the 20,000 francs (equivalent to the purchasing power of $15,444 in 1967)[50] received for this piece was a vast improvement over prices paid for Rodin's works some twenty years earlier. Around 1880 one of Rodin's Belgian friends, Gustave Biot, wrote to him about a man who was interested in purchasing a bronze cast of *The Man with the Broken Nose*. Biot suggested that he charge a serious price (Rodin could not always "work for nothing") of 200 to 300 francs (about $133 to $200).[51] Considering that the sculptor's contemporary Monet received 1,000 to 1,500 francs for a painting in the

1870s, the prices Rodin was receiving in the same decade seem startlingly low. In 1872 he received 50 francs (about $27) apiece for the models of *Suzon* and *Dosia*.

During the 1860s and much of the 1870s, Rodin was relatively unknown and had found few buyers for his work. Shortly after his return to Paris in 1877, this state of affairs began to improve. The French government purchased several of his works and commissioned *The Gates of Hell* around 1880, but even so, with the high costs of production he was fortunate to come out ahead. In 1879 he received from the French State 300f (about $1,071 by 1967 standards) for his life-size *Age of Bronze*, on which he had labored eighteen months, paying the model $200.[52] Although these government commissions may not have increased his income substantially, they did give him the official recognition he needed. From this time he exhibited more and more, and began to attract private collectors. In the mid-1880s, French patrons such as Alphonse de Rothschild and Antony Roux began to purchase his work at higher prices; in 1887 Roux bought *Deux femmes bacchantes* for 2,000 francs (about $1,428).[53]

During the 1880s Rodin exhibited with other artists several times at the Georges Petit Gallery in Paris, but it is not known whether any sales were realized. At the same gallery he had his first extensive showing of sculpture in 1889; thirty-six pieces were exhibited along with paintings by Claude Monet. Works in plaster, wax, bronze, silver, and marble shown in the 1880s demonstrate a willingness to exhibit both sketches and finished pieces in a variety of media.

Commissions for monuments continued during the 1880s and 1890s so that Rodin's name was frequently before the public. The great scandal over the *Balzac* in 1898 may have been an upsetting experience for the sculptor, but from this time sales and commissions multiplied.[54] Important exhibitions of his work around the turn of the century—one-man shows in Belgium and Holland in 1899, in Paris in 1900, and in Prague in 1902 as well as the exhibition of sixty sculptures at Düsseldorf in 1904—established his international reputation and appeal more firmly than ever. At

his 1900 exhibition, he made a total of 200,000 francs (approximately $154,440) in sales of his work, which more than covered expenses and expanded his future market greatly.[55]

This was the first marked increase in prices paid for his work. A large bronze *St. John the Baptist*, for which the French government paid only 2,200 francs (about $1,465) in 1880, just enough to cover the cost of casting,[56] was bought by a 1902 subscription in London for almost three times that amount, £260 (about $4,874). *The Man with the Broken Nose*, which was offered so cheaply *c.* 1880, was going for 1,250 francs (about $893) in 1906.[57] Three years later the same work was offered at 2,000 francs ($1,428.57).[58]

After Rodin's death the prices received for his sculpture dropped substantially. A bronze *Man with the Broken Nose* brought 5,300 francs in 1925 (then worth only about $545 due to inflation) at a Georges Petit sale. The market has long since recovered, and this piece sold at Kornfeld and Klipstein for $11,960 in 1972.

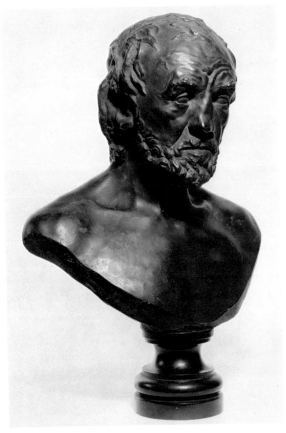

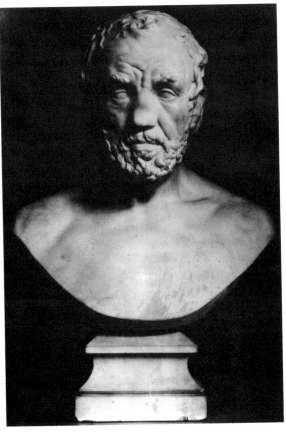

2. THE MAN WITH THE BROKEN NOSE, Bust
 Plaster, painted terra-cotta, then black; H. *c.* 56.5 cm.
 Markings
 center back: Rodin
 front, proper left: RO . . . (rest of signature painted
 over)

 University Art Museum, University of Texas, Austin,
 Texas

 Said to be from the collection of sculptor Louis Dubois,
 whom Rodin knew in Brussels. Possibly cast after bust
 of 1872

3. THE MAN WITH THE BROKEN NOSE, Bust
 Marble; H. *c.* 58 cm.
 Markings
 right side of base: A^TE RODIN/1875
 Musée Rodin, Paris, France

 Marble bust exhibited in Salon of 1875

 (not in exhibition)

152

The Man with the Broken Nose

Created at the very outset of his career, *The Man with the Broken Nose* is Rodin's earliest masterpiece and an exemplary work against which he measured his future sculpture. He remarked on it in the late 1880s:

That mask determined all my future work. It is the first good piece of modeling I ever did. From that time I sought to look all around my work, to draw it well in every respect. I have kept that mask before my mind in everything I have done. . . . In fact, I have never succeeded in making a figure as good as "The Broken Nose."[59]

It was begun in late 1862 or early 1863, but it took him over a year to complete.[60] Rodin evidently chose his subject with the Salon jury, and its classical bias, in mind. Besides, the young sculptor shared their enthusiasm for artists such as Ingres and Pradier who worked in this tradition.[61] He deliberately selected his model, an odd-job man named Bibi, who reminded him of ancient Greek and Roman sculptures.[62] To reinforce this image he added a simulated Greek hairstyle and fillet.

Rodin's contemporaries, no doubt with occasional prompting from the sculptor, saw and commented upon these associations. It was called "an inevitable reminder of early antique sculpture";[63] there is even a story that cannot be verified about how Jules Desbois represented a cast as an antique to friends at the École des Beaux-Arts in 1878.[64] Rodin believed that with this sculpture, hailed as "a revival of the best Greek realism,"[65] he had rediscovered the ancient practice of modeling by profiles.

Despite months of work and careful choice of a model, the mask cast in plaster was refused when he sent it to the Salon in the spring of 1864. Rodin's proponents saw this as one more failure to recognize artistic genius. The sculptor and some biographers reasoned that the piece was too "realistic," an argument that reflects a central issue in art theory and criticism at the time. Rather, Rodin seems to bridge the gap between the "realists" and the "école grec" in selecting a common man as a model, representing him faithfully, and then transforming him into a reminder of a Greek

philosopher portrait. Considering the large number of sculptures submitted to the Salon jury each year, it is more likely that lacking an influential sponsor such as students at the École des Beaux-Arts had, Rodin was quickly passed over as an unknown. He did not submit a sculpture to the Salon again until 1875, when a marble version of the same piece (called *Portrait de M. B . . .*) was accepted.

A plaster version of the bust had been exhibited in 1872 at the Brussels Salon.[66] That bust has been described as a reconstitution of the original clay, which some say froze and cracked, leaving only the mask intact.[67] However it came about, the first version of this work does seem to have been a mask, a less typical form of portrait sculpture in the 1860s. Rodin carefully preserved the mold of this work, and probably used it to model a new clay bust from which the plaster of 1872 would have been made.[68] The plaster was probably the model for the 1875 marble.

A plaster cast of the bust is today in the University of Texas Art Museum in Austin (fig. 2). Differences in modeling, which in the face is richer and more subtle, and in the rest of the bust is dryer and more generalized, suggest that Rodin had indeed begun with an impression of the original mask and then added the back of the head and the shoulders to complete it. The Austin plaster, which was reportedly presented to one of Rodin's Belgian friends,[69] while similar in general shape, differs somewhat from the marble in the Musée Rodin (fig. 3). The marble carver changed the bust by stylizing the coiffure, beard, and eyebrows, which in the plaster are left much less distinct. The folds of the skin in the marble are also much more defined than in the Austin bust.

Although Rodin always felt a fondness for the mask of *The Man with the Broken Nose*, he did not seem to be so attached to the bust.[70] This is probably why it is mentioned so briefly and so infrequently in Rodin literature.

The mask itself was cast in bronze and finally accepted at the Salon of 1878, where, though badly placed, it was discovered and admired by a number of students from the École des Beaux-Arts, who sought out the sculptor and were allowed to

make impressions of the work.[71] Demonstrating its continued value to Rodin, the mask was exhibited a number of times over the next few years. Its first official recognition came in Nice where it won a gold medal in 1880. In 1882, a year after Rodin's visit to England (where through the painter Alphonse Legros he met such eminent men as Robert Browning, Sir Frederick Leighton, Lord Lytton, W. E. Henley, Robert Louis Stevenson, and the young American sculptor Gustave Natorp), the bronze mask was shown in London at the Grosvenor Gallery as *Etude de Tête*. It was exhibited under the same title in 1883 at the Dudley Gallery (Egyptian Hall). His English friends responded enthusiastically and several of them bought casts of the mask. As of 1889 there were no less than ten bronze casts in England, while none had been sold in France.[72]

The piece was exhibited at the progressive Salon des XX in Brussels in 1887 and also included two years later as *Masque d'Homme* in the retrospective centennial exhibition at the 1889 international exposition in Paris. About this time people began to call it by its present title, *The Man with the Broken Nose* ("L'Homme au nez cassé"). Although he had originally created it thirty-six years before, it was considered worthy to stand beside works of the sculptor's maturity at Rodin's 1900 exhibition.

Casts of the mask of *The Man with the Broken Nose* in modern collections are of two basic types. One shows the neck extending downward to just below the sternum (Group I); this type probably corresponds most closely to the original conception since such casts are known from the 1880s. A second group (Group II) consists of masks with a much shorter neck, which seem to date from a later time.

Within Group I, we can identify casts that are based on three slightly different plaster models. Since we know that Rodin often made several plaster casts from the same clay, it is difficult to place the versions in exact chronological sequence although there are clues to the first castings.

One version (Type A) is quite similar to the head of the 1872 bust in the modeling and treatment of the hair, although the back, of course, is

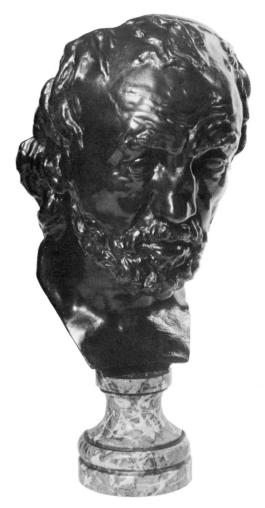

4. THE MAN WITH THE BROKEN NOSE, Mask
Bronze; H. *c.* 39.4 cm.
No markings

Mead Art Building, Amherst College, Amherst, Massachusetts

Said to be gift from the sculptor to the Belgian engraver, Gustave Biot (1833–1905). This cast belongs to Group I, Type A, which has a long neck and shows the hair on the center forehead and on the proper right, probably as originally modeled.

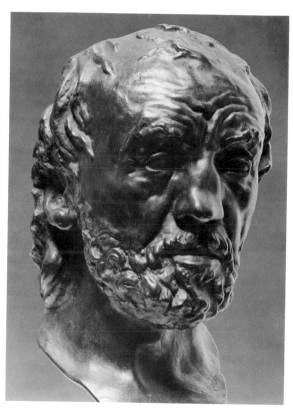

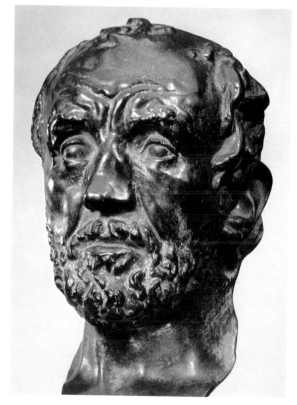

5. THE MAN WITH THE BROKEN NOSE, Mask
Bronze; H. *c.* 31.7 cm.
Markings
 front of neck, proper left: A. Rodin
 inside, lower right: ALEXIS RUDIER/FONDEUR
 PARIS
 stamped in relief, inside, lower right: A. Rodin
The Fine Arts Museums of San Francisco, San
Francisco, California

Gift of Mrs. Alma de Bretteville Spreckels

This cast belongs to Group I, Type A, but has less hair
on side of head, proper right, than the Amherst cast.

6. THE MAN WITH THE BROKEN NOSE, Mask
Bronze; H. *c.* 31 cm.
No markings

The Metropolitan Museum of Art, New York,
New York
Bequest of Mrs. Stephen C. Clark, 1967

This cast belongs to Group I, Type A, with a slightly
different rear termination.

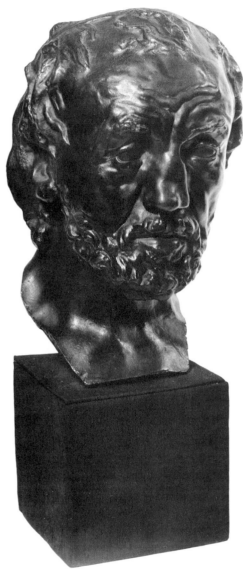

7. THE MAN WITH THE BROKEN NOSE, Mask
Bronze; H. *c.* 31.5 cm.
No markings

Museum of Art, Rhode Island School of Design,
Providence, Rhode Island
Gift of Mrs. Gustav Radeke

Said to have been in collection of Constantine Ionides,
Brighton, England. This is a Group I, Type B cast with
large repaired area at back, proper right.

7a. Detail of fig. 7. Proper right side; showing tool marks
on area of repair

left open. Type A casts do differ somewhat from one another in the rear termination and in the mounting. The bronze from Amherst College (fig. 4), a very fine sand-casting, has a larger amount of hair on the proper right side of the head than another cast from this same group belonging to the Fine Arts Museums of San Francisco (fig. 5). The two casts are also mounted at different angles, the San Francisco mask being upright and the Amherst bronze tilted forward. Variation in the attitude of the mask is a characteristic feature of casts of *The Man with the Broken Nose* as a group, and shows the subtle psychological and aesthetic differences that result from such a minor variation. While this practice may have been in part the decision of the founder—the variety of mounting tabs suggests the work of different foundries—it is a known fact that Rodin experimented with different kinds of mountings for the same piece.

Differing points of termination at the back of the masks is another constant in the various versions of this work: the amount of hair and bits of fillet change from cast to cast. In the Amherst and San Francisco casts, only a bit of the fillet is visible at the top of the head, while another cast that belongs to this group in the Metropolitan Museum of Art in New York (fig. 6) has none at all. These three casts, like others within Group I, differ slightly in the silhouette of the lower termination, on both front and side edges.

Four Type A bronzes, all sand cast, are known at the present time. The Amherst bronze was presented by Rodin to Gustave Biot, who tried to help the sculptor sell a cast of this work in about 1880, which may suggest an early dating for this particular cast. The existence of a plaster of the same type, formerly in the collection of Antony Roux and now in the Musée Rodin, also indicates that Type A casts were in production early, since this collector purchased a number of the artist's works in the 1880s and early 1890s. The Amherst and Metropolitan masks have no inscriptions, but the San Francisco bronze was cast by Alexis Rudier, indicating that it is a twentieth-century casting. Examples of Type B casts are bronzes from the Rhode Island School of Design and the Fogg Art Museum (figs. 7, 8). These differ most notably

from the Type A group in the evidence of a large area of repair on the proper right side of the head (and a smaller area on the left). Possibly the model was broken and then reworked in these places. The tool marks suggest that this was done in a soft medium, such as wax, clay, or wet plaster (fig. 7a). Compared with the Type A casts, there is little attempt to suggest locks of hair. The Type B bronzes also differ in the presence of the fillet on the head's upper right side, which is cut out in Type A casts. In the Rhode Island and Fogg examples there are again minor variations in mounting and finishing. The Fogg bronze is tilted further forward and the corner at the proper left of the Rhode Island cast is cut off.

The locations of four Type B casts are known, and all of these lack markings. Three have origins that indicate that they were part of a series of bronzes sold or given to collectors in England in the 1880s. The cast in the Ashmolean Museum at Oxford comes from the collection of Alphonse Legros, an important link between Rodin and England in the 1880s, as we have seen. A photograph of a cast very similar to this one was reproduced by Bartlett in 1889. Gustave Natorp, who studied with the sculptor in Paris from 1881 to 1883, was the original owner of the bronze today in the Fogg Collection (fig. 8). A label once attached to the base of this piece distinguishes it as the first of an edition of six casts. The Rhode Island mask was formerly owned by the prominent English collector Constantine A. Ionides, who knew Legros and was apparently one of Rodin's early patrons. Finally, the bronze formerly in the Robert Barrett Browning collection (sold at Sotheby, Wilkinson and Hodge, London, May 1–8, 1913, no. 1274) seems to belong to this group and is probably the cast acquired by his father, the poet, by the early 1880s.[73] Other casts owned by Rodin's English friends, W. E. Henley and Sir Frederick Leighton, have not been located, so it is uncertain whether or not they belong to this series.[74]

A third group (Type C), represented by the sand-cast bronzes in the Smith College Museum of Art and the Museum of Fine Arts in Boston (figs. 9, 10), is distinguished by a casting flaw that

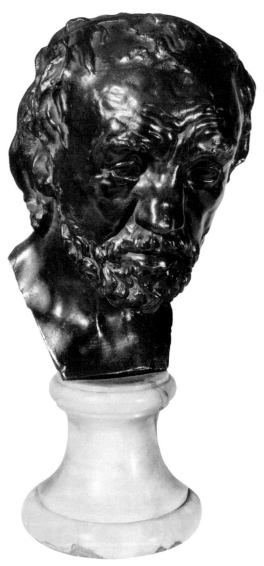

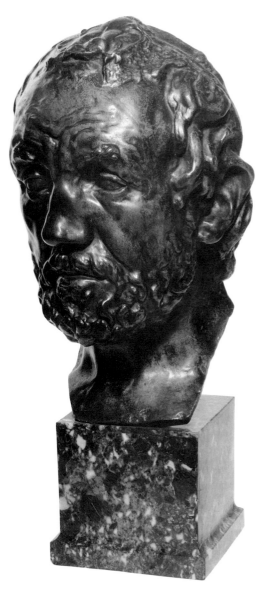

8. THE MAN WITH THE BROKEN NOSE, Mask
Bronze; H. *c.* 30.5 cm.
No markings

Fogg Art Museum, Harvard University, Cambridge,
Massachusetts
Grenville L. Winthrop Bequest

Said to be from former collection of Gustave Natorp.
Group I, Type B cast, with minor variations from
Rhode Island School of Design cast

9. THE MAN WITH THE BROKEN NOSE, Mask
Bronze; H. *c.* 31 cm.
Markings
 side of neck termination, proper right: A. Rodin
 inside in relief, lower left side: A. Rodin

Smith College Museum of Art, Northampton,
 Massachusetts

Said to have been acquired from Rodin by Mrs. Emil
Hesslein, sister of William Rothenstein. Group I, Type
C cast, which has a casting flaw to the proper left side
of the center of the forehead. Upper right ear is cut off.

158

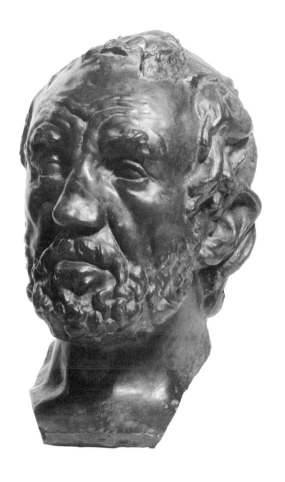

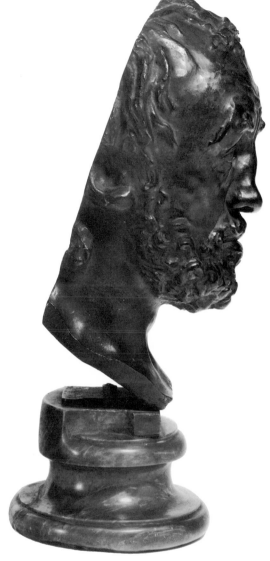

10. THE MAN WITH THE BROKEN NOSE,
Mask
Bronze; H. *c*. 31 cm.
Markings
 back edge of neck, proper left: Rodin 8 (?)

Museum of Fine Arts, Boston, Massachusetts

Group I, Type C cast, with variation in mounting
from Smith cast

11. THE MAN WITH THE BROKEN NOSE,
Mask
Bronze; H. *c*. 31 cm.
Markings
 back of proper left edge: Rodin

Collection Musée d'art et d'histoire, Geneva,
Switzerland

Gift of the artist to the city of Geneva in 1896.
Group I, Type C cast, similar to Boston cast in
mounting

(not in exhibition)

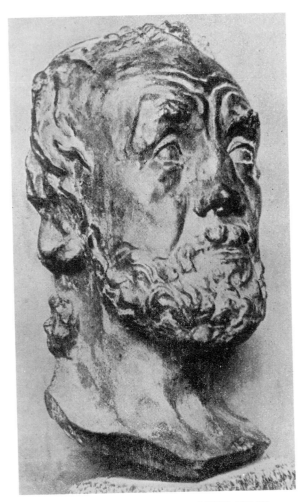

12. THE MAN WITH THE BROKEN NOSE,
Mask
Photograph from 1900 edition of *La Plume* (p. 3)
showing Group I, Type C cast. Photograph by
E. Druet

caused a loss of detail in the hair at the center left of the forehead. Because of the damage, which was probably done in the molding process, this area appears irregular and sketchy compared to surrounding areas. It also differs in the back termination where the upper part of the right ear is missing. The Boston bronze, like the one in the Musée d'art et d'histoire in Geneva (fig. 11), leans slightly to the right, while the lower front edge, which is thick in the other two, has been filed down at the proper right corner. The mounting tab of the Smith cast has been twisted to straighten the axis of the head.

The available evidence places the Type C casts around the turn of the century. The Geneva bronze was presented to that city in 1896 and a photograph of a similar one by E. Druet (fig. 12) appeared in the literary magazine *La Plume* in 1900 (p. 3). Five casts of this type are known and all except the one in the University of Notre Dame at South Bend bear Rodin's signature. The Smith and Notre Dame bronzes have the Rodin *cachet* inside, which may indicate twentieth-century castings. Only the Notre Dame bronze has a founder's mark, that of the Alexis Rudier firm.

In his 1906 biography of the sculptor, Frederick Lawton refers to an "exact facsimile" that had been made to replace the original model of *The Man with the Broken Nose* which had "disappeared in the continued process of reproduction."[75] He may have been referring either to one of the long-necked versions or to the newer short-necked one (Group II). It is uncertain exactly when Rodin began producing the Group II versions, although photographs of one example began appearing in publications around 1910.[76] There is no indication that Group II casts were made in the nineteenth century. Most of the bronzes are Alexis or Georges Rudier casts, and only the Sterling and Francine Clark Art Institute bronze has a provenance evidencing acquisition during Rodin's lifetime.

Casts in this group exist in a variety of sizes, formats, and media, but all seem to be based on a single model which closely resembles the 1872 plaster bust. They differ from Group I casts in the loop of hair in the center of the forehead. Unlike

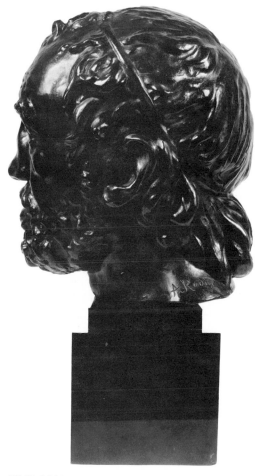

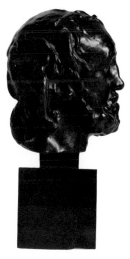

13. THE MAN WITH THE BROKEN NOSE,
Head
Bronze; H. *c.* 28 cm.
Markings
 edge of neck, proper left: A. Rodin
 inside in relief: A. Rodin
 back, left edge: © by musée Rodin. 1967
 back, right edge: .Georges Rudier./.Fondeur. Paris.

B. G. Cantor Collections, Beverly Hills, California

Group II, Type D cast showing back of head restored.
This is cast no. 8.

14. THE MAN WITH THE BROKEN NOSE,
Head
Bronze; H. *c.* 9.5 cm.
Markings
 edge of neck, proper left: A. Rodin n⁰ 6

Los Angeles County Museum of Art, Los Angeles,
California
Gift of Mrs. Leona Cantor

Reduction of Group II, Type D head

161

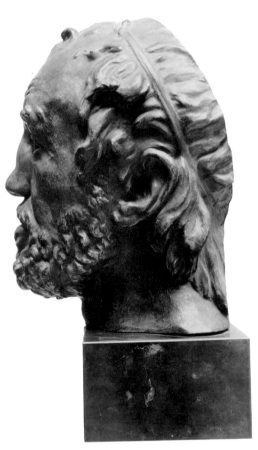

15. THE MAN WITH THE BROKEN NOSE,
Mask
Terra cotta (proper left profile); H. *c.* 23 cm.
Markings
 inside: RODIN nº 5

Koninklijk Museum voor Schone Kunsten, Antwerp,
Belgium

Gift of the Musée Rodin, Paris, 1924. One of a series
of terra-cotta casts (Group II, Type E)

(not in exhibition)

15a. Back view of fig. 15

16. THE MAN WITH THE BROKEN NOSE, Mask

16a. Back view of fig. 16

Bronze; H. *c.* 24 cm.
Markings
 edge of neck, proper left side toward back: A. Rodin
 back edge of neck at right: Alexis. Rudier/Fondeur.
 Paris

Sterling and Francine Clark Art Institute, Williams-
town, Massachusetts

Purchased by R. S. Clark in 1916. Group II, Type F
cast with head open above fillet and joined at neck

17. THE MAN WITH THE BROKEN NOSE,
Mask
Bronze; H. *c*. 26.7 cm.
Markings
 edge of neck, proper left: A. Rodin
 at end of fillet, proper right:
 ALEXIS RUDIER (printed) /
 Fondeur Paris. (script)

Museum of Art, Carnegie Institute, Pittsburgh,
Pennsylvania

Group II, Type G cast showing back of head entirely
open

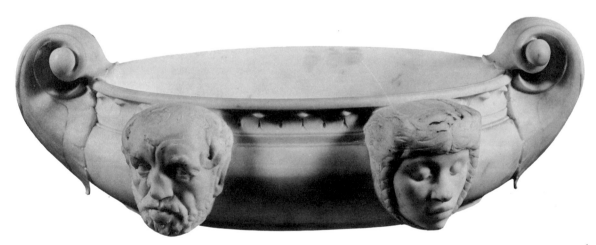

18. JARDINIERE
Marble; H. *c*. 16 cm.
Markings
 back of bowl on left: Rodin

Museum of Fine Arts, Boston, Massachusetts.
Gift of Julia Isham (Mrs. Henry Osborn) Taylor,
Estate of Samual Isham

The Man with the Broken Nose was carved as one of
two heads ornamenting bowl commissioned by
Samual Isham, *c*. 1900.

Group I, which seems to consist only of masks, Group II casts include both complete heads and masks. For many casts classed within Group II it has not been possible to identify specific versions. In general there is about a 4 cm. difference between Group I masks and the large Group II heads and masks, the former being approximately 30.5 cm. high, the latter about 26 cm. (Measurements obviously vary according to the different mountings.)

A fourth type of bronze cast of the head in the B. G. Cantor Collections (Type D; fig. 13) shows the back of the head intact. Similar treatment of the hair in the 1872 bust suggests that it was the model for this piece. The date of the first casting is not known, but this bronze is marked as cast no. 8.

At some point—again specific information is lacking—a reduced head (9.5 cm. high) was made. The bronze in the Los Angeles County Museum of Art (fig. 14) is cast no. 6, indicating at least that many existing bronzes.

There is an unusual series of at least five numbered terra-cotta casts (Type E) about which very little is known. Cast no. 5 in the Koninklijk Museum in Antwerp (figs. 15, 15a), a gift of the Musée Rodin in 1924, shows the back entirely open, except for a supporting cross piece. The hair extends beyond the fillet a short distance.

Another group (Type F), represented by the bronze, purchased in 1916, in the Sterling and Francine Clark Art Institute (figs. 16, 16a), differs from the terra cottas in that the hair stops at the fillet and the back of the neck is joined. The joined portion, which includes the hair that falls on the neck, is similar to the head. Three other bronzes of this type are known; all four are Alexis Rudier casts.

Still another version (Type G) is represented by the bronze in the Carnegie Institute in Pittsburgh (fig. 17). This Alexis Rudier cast differs from the Type F series in the elimination of the joining at the neck. No other examples of this type have yet been identified.

Probably around 1900, Rodin was commissioned to create a marble *jardinière* by Samual Isham. For this planter, today in the collection of the Museum of Fine Arts, Boston, Rodin had *The Man with the Broken Nose* reworked as a horned satyr (figs. 18, 18a). Undoubtedly carved by one of his assistants, this shows a reduced and stylized version of the familiar head.

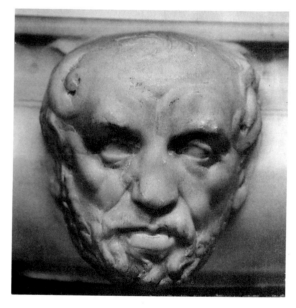

18a. Detail of fig. 18 showing carved version of *The Man with the Broken Nose*

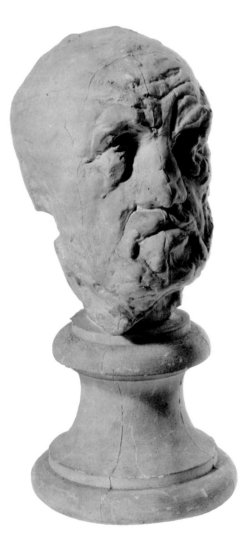

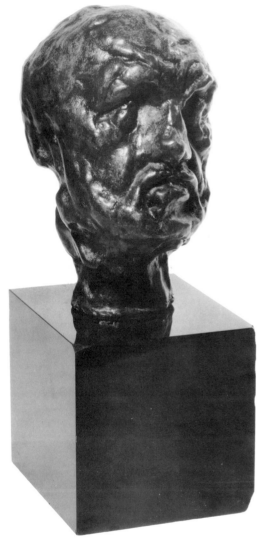

19. LITTLE MAN WITH THE BROKEN NOSE
Plaster; H. *c.* 19.2 cm.
No markings

Maryhill Museum of Fine Arts, Maryhill,
Washington

Said to have been given by Rodin to Theodore Spicer-
Simpson (1871–1959). Later reworking of *The Man
with the Broken Nose*

20. LITTLE MAN WITH THE BROKEN NOSE
Bronze; H. *c.* 12.7 cm.
Markings
 side of neck, proper left: A. Rodin
 side of neck, proper left, at bottom:
 Georges Rudier./
 .Fondeur. PARIS.
Stanford University Art Museum, Stanford,
California

The Little Man with the Broken Nose

Some twenty years after creating the original mask, Rodin reworked this early piece as a small head, *Little Man with the Broken Nose* (figs. 19, 20). The sketchy modeling and fluid surfaces of this later work make this version more tragic than the first. All allusions to antique prototypes are dropped.

The plaster in the collection of the Maryhill Museum of Fine Arts, Washington (fig. 19), is thought to have been cast during the sculptor's lifetime, one of several casts made by the piece-molding process.[77] At least three of these plasters were reused in other works. Two casts were added to *The Gates of Hell*, one in the tympanum to the right of *The Thinker*, and one in the row of heads just above. Another was added to a headless cast of *The Earth*, to create a strangely contorted image, half male, half female.

The entire projected edition of twelve bronzes has been cast for this piece; casts by both Alexis and Georges Rudier are known.[78] Both seem to have experimented with *cire-perdue* castings of these pieces, an unusual practice for both foundries. A bronze example from the Stanford University Art Museum is a hollow lost-wax cast by Georges Rudier (fig. 20). A bronze from the Collection of the Los Angeles County Museum of Art is apparently a sand cast made by Alexis Rudier. An addition beneath the neck in both of these extends and changes the axis of the head from its position in the Maryhill cast.

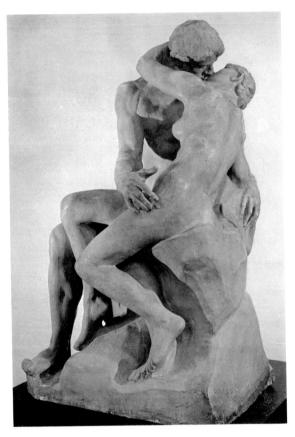

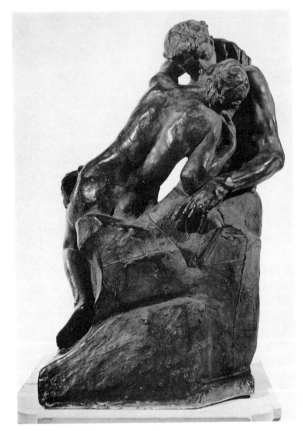

21. THE KISS
 Plaster; H. *c.* 86.5 cm.
 No markings

 Milwaukee Art Center, Milwaukee, Wisconsin

 Said to have been given by the artist to the Belgian
 sculptor Paul de Vigne in 1887. This is probably the
 first plaster cast after the original clay group.

 (not in exhibition)

22. THE KISS
 Identified by Museum as terra cotta, but may be
 painted plaster; H. *c.* 78 cm.

 Museo Nacional de Bellas Artes, Buenos Aires,
 Argentina

 Said to have been formerly in the collection of Rodin's
 friend the painter Albert Besnard. This cast is based on
 the original clay model.

 (not in exhibition)

The Kiss

When Rodin's recently finished marble *Kiss* and his revolutionary *Balzac* stood opposite each other at the 1898 Salon, the sculptor began to have doubts about *The Kiss*. He saw that "it looked slack, that it did not hold its place beside" the other work.[79] Contrasting it with the statue of the French author, Rodin said that:

... without doubt the interlacing of "The Kiss" is pretty, but in this group I did not find anything. It is a theme treated according to the tradition of the School: a subject complete in itself and artificially isolated from the world which surrounds it. . . .[80]

The theme was indeed a traditional one, although Rodin had changed it in a way that shocked some of his contemporaries. The public was prepared for embracing men and women, whether in modern dress or in classical nudity, but this pairing of an obviously contemporary man and woman in a state of undress, without any mythological justification, was another matter. The frank eroticism of the group was shockingly evident to Rodin's contemporaries—and less shocking but still evident to us today.

Despite its sexual explicitness, or more likely because of it, *The Kiss* was an immediate success at the Salon. While controversy raged around the *Balzac*, *The Kiss* was almost universally praised. Probably this immediate popularity persuaded Rodin to contract in the same year with the large Barbedienne firm for a commercial edition of this piece. The fame of *The Kiss* has continued, as the present-day abundance of modern, inexpensive reproductions attests.

Despite the contemporary appearance of the figures, the group was inspired by the medieval tale of Paolo and Francesca, one of the most salient themes from Dante's *Inferno*, which attracted Rodin at the time of *The Gates of Hell* commission in 1880. The sculptor continued to be deeply fascinated by this story, which became for him almost a synonym for heterosexual love, and he later explored its possibilities further in a series of works. Studies for the two lovers appear among his first meditations for the monumental portal.[81] Again and again he modeled the group that was to become *The Kiss*, finally detaching it from *The Gates* and reconstituting it as a separate sculpture.[82] Plaster and bronze casts of the over half life-size piece were exhibited in 1887, although it probably existed as an independent work by the early 1880s, when one writer described a group of Paolo and Francesca from *The Gates of Hell* already existing in the round.[83] In the final formulation of *The Kiss*, the exact moment in the tale of Paolo and Francesca is evident. The man's left hand rests on the book they have just dropped as their lips meet in that first kiss, the prelude to their death and damnation.

A number of casts in both plaster and bronze of this first version of *The Kiss* were made during Rodin's lifetime, while bronzes continue to be produced today by the Musée Rodin. We have located two plasters, one possible terra cotta, and eight bronzes of the slightly over half life-size group (figs. 21, 22, 23). Although the quality of the casts differs, most show marks left by the tools and covering cloth on the moist clay. The book is also clearer in this version.

In 1887 or 1888, Rodin was commissioned by the French government to make an enlarged version of *The Kiss* in marble. Departing from his usual practice, it is said that he made no intermediary enlargement before beginning the marble. Instead he had his *praticien*, Jean Turcan, make the enlargement with the use of a compass directly on the marble block from the small model.[84] This explanation leaves unaccounted for the enlargement of the first version of *The Kiss*, cast in bronze by the Musée Rodin only after the sculptor's death.[85] Did Rodin, then, have second thoughts about an enlargement after the French government's marble was begun? Or was it enlarged later, perhaps as a model for one of the other marbles? Or was this done on the initiative of the Musée Rodin? For the moment the questions must remain unanswered.

Rodin claimed insufficient time as the reason for not making an enlarged version in clay and yet the marble was only ready for the 1898 Salon. It was then placed in the old Musée du Luxembourg and is today in the Musée Rodin (fig. 24). The marble differs from the original version not only in size and surface finishing, but in significant de-

tail. In the earlier version the thumb of the man's right hand is raised, while in the marble it rests on the woman's thigh, perhaps signifying the difference between the touch and the caress.

Two other marbles were carved during Rodin's lifetime. Comparisons show that these differ from the first marble primarily in the size and shape of the base. Edward Perry Warren commissioned the marble *Kiss* now in the Tate Gallery in 1900 (fig. 25). The original contract for this piece includes the unusual stipulation that the man's genitals, absent in the previous versions, be included.[86] For this marble Rodin employed the *praticien* Rigaud. It was completed by 1904, when it was shown at the Düsseldorf exhibition. Less is known about the marble in the Ny Carlsberg Glyptotek except that it was carved by Dolivet in 1902 and presented to the museum by Carl Jacobsen the following year (fig. 26). A fourth marble in the Rodin Museum in Philadelphia was carved after the sculptor's death by H. Gréber.

When Rodin contracted with the Barbedienne foundry for a series of reductions after *The Kiss*, the marble which had just been completed for the Salon, and not the original clay version of the 1880s, was used as the model. This is evident particularly in the texture of the base, which repeats the tool marks made on the carved marble rather than those made on the clay, and the more generalized treatment of the figures (fig. 27). These bronze reductions, made first by Barbedienne and later by founders for the Musée Rodin, constitute a second and distinct group of casts.

The peculiar practice of making bronze casts after the marbles was not unusual with Rodin, and he certainly approved of it.[87] However, his attitude toward the casts produced in such large quantities by Barbedienne was equivocal at best. He wrote to William Rothenstein that he did not value these reductions.[88] On the other hand, the 24 cm. version in the National Gallery of Art in Washington, D.C., bears a dedication to Mrs. Kate Simpson, the donor of the piece, which is an implicit statement of approval.[89]

The examples from the Barbedienne edition examined for this study (Library of Congress, Washington, D.C., 71.1 cm.; Newark Museum, 59.6 cm.; B. G. Cantor Collections, 39.5 cm.; National Gallery of Art, Washington, D.C., 24.7 cm.; and Stanford University Art Museum, 25 cm.) show that the group was sand-cast in two pieces which were then joined and finished. These casts bear one of the typical markings of the foundry, "F. BARBEDIENNE. Fondeur" incised into the metal. The National Gallery cast also has a seal which identifies it as having been indirectly made by the mechanical process invented by Achille Collas in 1836 and used by the Barbedienne firm since its establishment. The metal seal which is inset into this cast shows the right profile of the inventor in the center with the inscription in relief "RÉDUCTION MÉCANIQUE" at the top and "A.COLLAS/BREVETE" at the bottom. The gilt bronze from Stanford exemplifies a less common and more expensive type of finish, found only occasionally among Rodin bronzes.

Since Barbedienne held the exclusive rights for the reductions of *The Kiss* between 1898 and 1918, Rodin could only have replicas the size of the marble model made without paying the founder a fee. Besides the London and Copenhagen marbles, at least three plasters and two bronzes have been made in this size. He presented a plaster to the Museo Nacional de Bellas Artes in Buenos Aires in 1908; the bronze now in the National Museum of Wales in Cardiff was purchased from Georges Petit in 1912. Both of these appear from photographs to have been cast after the Musée Rodin marble.

Besides the reduced versions in four sizes (72.5, 61, 38, and 24 cm. high) produced by Barbedienne, there is a fifth size (86.5 cm.) based on the marble model. Very few of these have been located, but since the Georges Rudier bronze in the collection of Mrs. B. Gerald Cantor, Beverly Hills, is identified as cast no. 10, there are presumably at least this many in existence.[90]

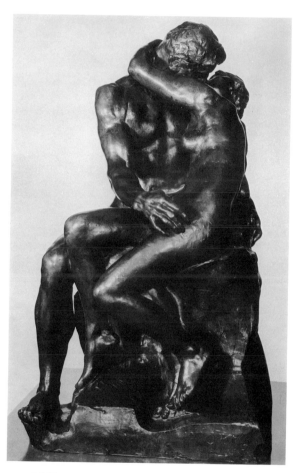

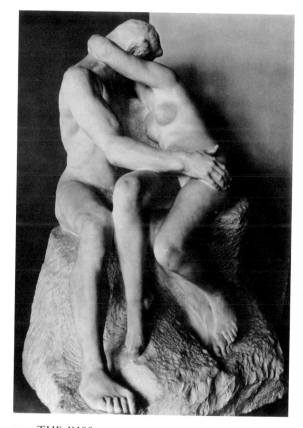

23. THE KISS
Bronze; H. *c.* 85.7 cm.
Markings
 on base at rear: Rodin

The Baltimore Museum of Art, Baltimore, Maryland
Bequest of Jacob Epstein

One of eight known bronzes cast on the scale of the
original clay model

(not in exhibition)

24. THE KISS
Marble; H. *c.* 190 cm.

Musée Rodin, Paris, France

The first marble version of *The Kiss*, carved for the
French government between *c.* 1886 and 1895 by Jean
Turcan, and exhibited at the Salon of 1898. This was
the model used for most of the subsequent bronze
casts.

(not in exhibition)

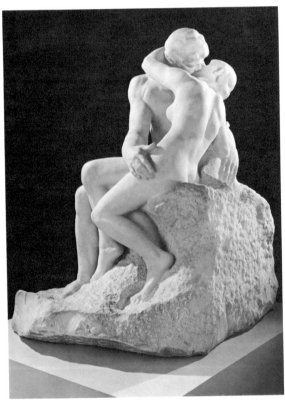

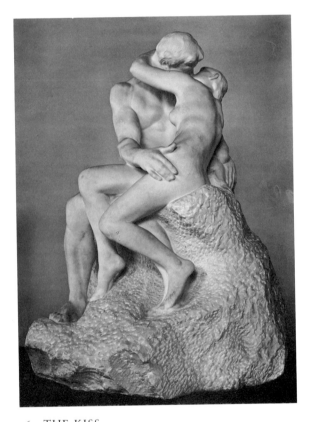

25. THE KISS
 Marble; H. *c.* 182 cm.
 Markings
 proper left of female figure, on rock: A. Rodin

The Tate Gallery, London, England

Commissioned in 1900 by Edward Perry Warren and completed in 1904. Differs from Musée Rodin marble in size and shape of base

(not in exhibition)

26. THE KISS
 Marble; H. *c.* 196 cm.
 Markings
 proper left of female figure on rock: A. Rodin

Ny Carlsberg Glyptotek, Copenhagen, Denmark

Carved by Doliver in 1902. This marble differs from the one in the Musée Rodin in size and shape of base.

(not in exhibition)

Notes

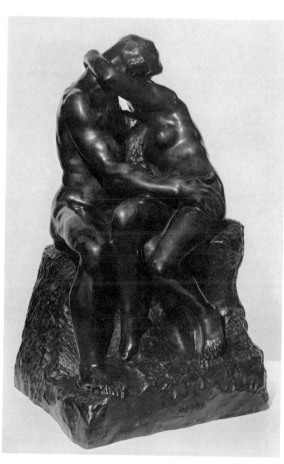

27. THE KISS
Bronze; H. *c.* 71.1 cm.
Markings
 proper right side of male figure on rock: Rodin
 proper left side of female figure on rock:
 F. BARBEDIENNE, FONDEUR

Gertrude Clark Whittall Foundation Collection in the Library of Congress, Washington, D.C.

This is one of a large edition of bronze reductions cast after the Musée Rodin marble (fig. 24).

1. Auguste Rodin, *L'Art. Entretien réunis par Paul Gsell* (Paris: Bernard Grasset, 1911), pp. 24–25.

2. Malvina Hoffman, *Heads and Tales* (New York: W. W. Norton and Co., 1966), p. 43; William Rothenstein, *Men and Memories: Recollections of William Rothenstein*, 3 vols. (London: Faber and Faber, 1931), I, 320.

3. Judith Cladel, *Rodin, Sa vie glorieuse, sa vie inconnue*, definitive edition (Paris: Bernard Grasset, 1950), p. 133.

4. "Lorsque je commence une figure, je regarde d'abord la face, le dos, les deux profils dans les quatre angles; puis, avec la terre, je mets en place la grosse masse telle que je la vois et le plus exactement possible. Je fais ensuite les intermédiaires, ce qui donne les profils vus des trois quarts; puis, tournant successivement ma terre et mon modèle, je les compare entre eux et les épure." François Dujardin-Beaumetz, *Entretiens avec Rodin* (Paris: P. Dupont, 1913), p. 11.

5. *Ibid.*, p. 10.

6. Mathias Morhardt, for one, described seeing six similar plaster casts of the half life-size study of *Balzac* in Rodin's studio in the 1890s. "La Bataille du 'Balzac,'" *Mercure de France*, CCLVII, 879 (December 15, 1934), 467.

7. Marie van Vorst, "Rodin the Sculptor," *Pall Mall Magazine*, XXIII, 93 (January 1901), 23.

8. Judith Cladel, *Auguste Rodin pris sur la vie*, first edition (Paris: Éditions de la Plume, 1903), p. 40.

9. "Rodin," *The Nation*, XII, 6 (November 9, 1913), 259.

10. Hoffman, *Heads and Tales*, p. 43.

11. Cladel, *Rodin, Sa vie glorieuse*, pp. 132, 230.

12. Several letters in the former Ernst Durig collection, now in the Musée Rodin archives, refer to his *mouleur* Guioché taking impressions (*estampages*) from marbles; e.g., letter from Rodin to Guioché of December 31, 1914. I am grateful to Kirk Varnedoe who allowed me to examine photocopies of these letters.

13. Rothenstein, *Men and Memories*, I, 223–224.

14. "Rodin Counterfeits," *London Times*, May 10, 1919. Several bronze casts by the Montagutellis can be identified in modern collections by their stamp, "MONTA-GUTELLI/FRES/PARIS/CIRE PERDUE" within an oval. The problem of isolating *surmoulages* from possible casts approved by the sculptor remains to be studied.

15. Several letters in the former Ernst Durig collection relate to Guioché. A letter signed by Rodin and dated April 17, 1906 mentions the plaster caster, while several letters written to Guioché giving him instructions are dated between 1911 and 1914.

16. Stanislas Lami, *Dictionnaire des sculpteurs de l'école*

française au XIXe siècle, IV (Paris: Editions Champion, 1921), 162–163.

17. T. H. Bartlett, "Auguste Rodin, Sculptor," *American Architect and Building News*, XXV, 700 (May 25, 1889), 250.

18. Letter of December 11, 1881 to the Beaux-Arts committee, quoted in translation in Albert E. Elsen, *Rodin's Gates of Hell* (Minneapolis: University of Minnesota Press, 1960), p. 70; original in French National Archives.

19. Bartlett, "Auguste Rodin," 689 (March 9, 1889), 113.

20. These and other dates for Rodin's affiliations with his various founders are given in Ionel Jianou and Cécile Goldscheider, *Rodin* (Paris: Arted, Editions d'Art, 1967), p. 82.

21. The negotiations for the monumental group are discussed in a letter from Rodin to Mayor Dewavrin, July 5, 1889. Typescript from original in the Archives of the City of Calais. Rodin, *Letters, Essays, Criticisms*, Philadelphia Museum of Art Library, Philadelphia, Pennsylvania.

22. Casts by this foundry are marked with a rectangular stamp containing the inscription CIRE / PERDUE / A. A. HEBRARD.

23. The cast of Rodin's *La Defense* in the National Gallery of Scotland in Edinburgh is marked "Griffoul et Lorge, Fondeurs à Paris."

24. This foundry marked its bronzes "L. Persinka Fondeur Versailles."

25. This account of the Rudier family and Eugène's relationship with Rodin is given by Paul Moreau-Vauthier, "Le Maître Fondeur Eugène Rudier," *L'Art et les artistes*, N.S. 32 (March 1936), 205–207.

26. "The Last Master," *Time*, LIX (May 5, 1952), 82.

27. This bust is today in the Detroit Art Institute; it still bears the label of the exhibition and is stamped "Rudier".

28. Elsen, *Gates*, p. 70.

29. Letter dated 10 [. . .] 1900, former Ernst Durig Papers.

30. Cladel, *Rodin, Sa vie glorieuse*, p. 280.

31. Ruth Butler Mirolli, "The Early Work of Rodin and its Background" (unpublished Ph.D. dissertation, New York University, 1966), p. 131. Frederick Lawton said that these were cast in three sizes and were sold by the thousands in Belgium; *The Life and Works of Auguste Rodin* (London: T. Fischer Unwin, 1906), pp. 37–38. Today locations of only a few casts are known. Bronzes by this foundry are marked "Cie des bronzes/Bruxelles" and bear the signature "A RODIN", with the cross-bar of the "A" formed by an open V-shape.

32. In an undated letter to William Rothenstein [probably written *c.* 1902] the sculptor mentions this obligation to Barbedienne. Correspondence of Rodin and Rothenstein, Harvard University Library, the Houghton Library, Harvard University, Cambridge, Massachusetts.

33. In a letter of May 9, 1955 from René Chéruy to the Director of the Tate Gallery, Rodin's former secretary mentioned that the quality of the Barbedienne bronzes was very poor, that the plaster models were never repaired. Distrustful of this firm, for years the sculptor would not collect the royalties they owed him. Tate Gallery archives.

34. Of *The Kiss*, this foundry made 50 casts of the 72.5 cm.-high version, 69 of the 61 cm. version, 105 of the 38 cm. version and 95 of the 24 cm. version. Jianou and Goldscheider, *Rodin*, p. 100. For *The Eternal Spring* they made 50 casts of the 64 cm.-high version, 32 of the 52.5 cm. version, 80 of the 40 cm. version, and 69 of the 23 cm. version. *Ibid.*, p. 96. Both pieces are inscribed "Rodin" and "F. BARBEDIENNE. Fondeur."

35. A draft on a printed form and a copy of the contract of October 24, 1898 for *Triumphant Youth* and a copy of the contract for the *St. John* are among the Ernst Durig Papers. The renewal of the contract for the *Triumphant Youth* was acknowledged in a letter from Rodin to Mssrs. Thiébaut Frères of February 18, 1908. The non-renewal of the other piece is discussed in letters from Rodin to Fumière and Gavignot of October 5, 1907 and April 27, 1908. Ernst Durig Papers.

36. There is some confusion about the exact number and sizes of these two pieces. It is reported by Jianou and Goldscheider that nineteen casts of *Triumphant Youth* were made. *Rodin*, p. 106. The Durban Museum and Art Gallery, however, has a Fumière cast inscribed "39 Epreuve". There is a discrepancy in the number of sizes indicated for the *St. John* by Jianou and Goldscheider. On p. 82 they indicate that casts were made in four sizes, but on p. 86 they list casts by Barbedienne in only three. According to this source there were four casts made of the 20 cm.-high version, twelve of the 58 cm. version, five of the 79 cm. version. The cast of *Triumphant Youth* in the Cleveland Museum of Art is inscribed "A. Rodin" and "FUMIERE/THIEBAUT FRES/PARIS/ET CIE SUCRS" within a circle and "24me Epreuve." The 79 cm. cast formerly in the Huntington-Hartford collection, New York, is inscribed "A. Rodin" and stamped with the Thiébaut stamp ("THIEBAUT FRERES/FONDEURS/PARIS" within a circle), beneath which is inscribed "Fumière & Gavignot. Srs."

37. Several plasters with these rights were purchased by Antony Roux in the late 1880s and early 1890s. Rodin explained the conditions applying to his *La Baigneuse* in a letter of September 24, 1888: "Reçu de M. Antony Roux

la somme de . . . pour une petite figure 'Jeune Fille au bain.' Je la livre comme original, m'interdisant la reproduction. Deux ou trois épreuves ont été données en plâtre antérieurement à des amis." Galerie Georges Petit, *La Collection Antony Roux*, Sale, May 19 and 20, 1914 (Paris: G. Petit, 1914), p. 102.

38. A bronze cast of *L'Idylle* was sold to Antony Roux under these conditions, which Rodin described in a letter of July 20, 1891: "Ce modèle est unique et ne pourra jamais être reproduit en aucune matière. Je m'engage à briser le modèle en plâtre qui a servi à la fonte en bronze aucun autre n'existant." *Ibid.*, p. 93.

39. The earliest example located so far is the *Frère et Soeur* given by Rodin to Robert Tweed in 1902. Sold at Sotheby's, December 2, 1970, no. 5.

40. In an interview with Sabine Marchand, she said: "L'oeuvre est toujours délivrée marquée du 'copyright,' de la signature du fondeur et de la date d'exécution de la fonte"; "Rénovation du Musée Rodin," *Le Figaro*, March 7, 1968.

41. Albert E. Elsen, "Rodin Bronzes at Stanford—A Prodigious Production," *San Francisco Sunday Examiner and Chronicle*, July 21, 1974 ("This World" section, p. 27).

42. These and other assistants are listed by Cladel, in *Rodin, Sa vie glorieuse*, p. 230. On Baffier see Frederick Lawton, *Life and Work*, pp. 63-64. For a general discussion of Rodin's marbles see Albert E. Elsen, *Rodin* (New York: Museum of Modern Art, 1963), pp. 133-139.

43. Sculptures in progress showing these markings are sometimes reproduced in old publications. Examples are the *Pygmalion and Galatea* illustrated in Gustave Kahn, *Auguste Rodin* (London/Leipzig: T. Fisher Unwin, 1909), plate opposite p. 35; and the *Christ and Magdalene* reproduced in *World's Work*, 1904, p. 6827.

44. For example the letters from Rodin to Gustav Pauli from March 26, 1905 to April 12, 1911 in the Kunsthalle, Bremen; and the letters from Rodin to Walter Butterworth from November 5, 1911 to December 17, 1912 in the Princeton University Library, Princeton, New Jersey.

45. Cladel, *Rodin, Sa vie glorieuse*, p. 108.

46. Lionel Carley, "Jelka Rosen Delius: Artist, Admirer and Friend of Rodin. The Correspondence 1900-1914," *Nottingham French Studies*, IX, 2 (October 1970), 88-93.

47. Vesna Barbić, "Lettres d'Ivan Meštrović à Auguste Rodin," *Annales de l'Institut Français de Zagreb*, 2nd ser, 22-23 (1970-1971), 17.

48. William Rothenstein to Rodin, December 12, 1898. Typescript in Correspondence of Rodin and Rothenstein; original in Musée Rodin.

49. This marble is today in the Tate Gallery, London. The terms of the contract for this piece are quoted in Osbert Burdett and E. H. Goddard, *Edward Perry Warren* (London: Christopher's, 1941), p. 259.

50. Equivalent values, which will be given in terms of purchasing power of the 1967 base dollar, are based on the rates of exchange as given by R. L. Bidwell, *Currency Conversion Tables. A Hundred Years of Change* (London: Rex Collings Ltd., 1970), and on the value of the dollar per 1967 dollar tabulated in *Standard and Poor's Trade and Securities Statistics: Price Indexes* (New York, February 1972), p. 76.

51. Undated letter from Gustave Biot to Rodin, copy in Rodin *Letters, Essays, Criticisms*, pp. 125-126.

52. Bartlett, "Auguste Rodin," 688 (March 2, 1889), 100.

53. Bartlett tells us that Rodin's first well-paid commission came from the Baron Alphonse de Rothschild. *Ibid.*, 696 (April 27, 1889), 199. The letter of purchase from Rodin to Roux dated September 17, 1887 is today in the Musée de Meudon.

54. Cladel, *Rodin, Sa vie glorieuse*, p. 241.

55. *Ibid.*, p. 254.

56. *Ibid.*, p. 120.

57. In Rodin to William Rothenstein, May 13, 1906 (Correspondence of Rodin and Rothenstein), Rodin acknowledged receipt of the check for this piece.

58. Rodin to Pauli, December 1, 1909. Letters from Rodin to Pauli.

59. Bartlett, "Auguste Rodin," 682 (January 19, 1889), 28.

60. Bartlett says that Rodin finished it in about eighteen months. *Ibid.* He also states that Rodin made the work at age 22. *Ibid.*, 700 (May 25, 1889), 249. Although this is a clear indication that it was begun at the end of 1862, Cladel tells us that at this time he was in a monastery; *Rodin, Sa vie glorieuse*, p. 84.

61. Bartlett, "Auguste Rodin," 682 (January 19, 1889), 28.

62. Judith Cladel and S. K. Star, "Rodin and the Beaux-Arts," *Century*, XCII (September 1916), 738.

63. Bartlett, "Auguste Rodin," 700 (May 25, 1889), 249.

64. Cladel, *Rodin, Sa vie glorieuse*, p. 91. This story is suspiciously similar to the one told about Michelangelo's marble *Sleeping Cupid* which was said to have been sold as an antique.

65. Lawton, *Life and Work*, p. 25.

66. This is usually referred to as a marble, but Mirolli points out that the catalogue lists it as a plaster; "Early Work," p. 130.

67. Cladel is the source of this often repeated story. *Rodin, Sa vie glorieuse*, p. 90. Bartlett, the earliest to record the history of the piece, does not mention this. He does refer to clay sketches and finished models drying and falling to pieces, but not *The Man with the Broken Nose*. "Auguste Rodin," 682 (January 19, 1889), 28. Cladel's romantic story is reminiscent of the story about the sculptor Louis Brian, who froze to death one night after wrapping his clay Mercury in his only blanket. Bartlett repeats this story and tells us about Rodin's admiration for the fatal figure, for which Brian was posthumously awarded the Medal of Honor at the Salon of 1864. "Auguste Rodin," 701 (June 1, 1889), 262. One wonders about the reliability of Cladel's story and whether it is a confusion of the events recorded by Bartlett. Certainly there is no reason to believe that Rodin did not plan this piece as a mask from the first.

68. In 1871 Rodin wrote to Rose Beuret reminding her to take care of his "moule de Bibi." Cladel, *Rodin, Sa vie glorieuse*, p. 100.

69. This work was for sale in the Robert Schoelkopf Gallery in New York in 1964, when it was described as having belonged at one time to Louis Dubois of Brussels. "Notable Works of Art Now on the Market," *Burlington Magazine*, CVI, 735 (June 1964), p. XIX.

70. Lawton wrote in 1906 that at that time he had nothing to say in its favor. *Life and Work*, p. 37.

71. Bartlett, "Auguste Rodin," 689 (March 9, 1889), 113.

72. *Ibid.*, 701 (June 1, 1889), 261.

73. Browning alludes to the copy owned by his father in a letter of 1882. Lawton, *Life and Work*, p. 243.

74. W. E. Henley mentioned the cast he owned in a letter to Rodin of 1881. *Ibid.*, p. 239. Lawton mentions that Leighton (d. 1896) purchased a cast, but does not say when. *Life and Work*, p. 26.

75. *Ibid.*

76. For example, Otto Grautoff, "Auguste Rodin," *Die Kunst*, XXIII (October 15, 1910), 29.

77. According to former director of the Maryhill Museum, C. R. Dolph, this plaster was originally a gift from Rodin to the medalist, Theodore Spicer-Simpson (1871–1959).

78. Cast no. 12 is in the collection of Mrs. B. Gerald Cantor, Beverly Hills.

79. Camille Mauclair, *Auguste Rodin: The Man—His Ideas —His Works*, trans. Clementina Black (London: Duckworth, 1905), p. 73.

80. *La Revue*, November 1, 1907, p. 105; quoted in translation in Elsen, *Gates*, p. 88.

81. See for example, Elsen, *Gates*, pp. 21 and 43.

82. Lawton, *Life and Work*, p. 110.

83. "Current Art," *Magazine of Art*, VI (1883), 176. An undated letter from Rodin to William Rothenstein informs us that the *"modèle primitif"* of *The Kiss* was half the size of the large marble (190 cm. high). Correspondence of Rodin and Rothenstein. The plaster exhibited in Brussels in 1887 was presented to Rodin's Belgian friend, Paul de Vigne, in the same year; it is today in the Milwaukee Art Center.

84. Edmond and Jules de Goncourt, *Journal des Goncourt: mémoires de la vie littéraire . . .*, XV (Monaco: Académie Goncourt, 1956), entry for February 26, 1888, p. 86; Lami, *Dictionnaire*, IV, 171.

85. This cast is illustrated and posthumously identified as the first cast of the piece, in *Mostra di Auguste Rodin*, Exhibition Catalogue, Accademia di Francia, Villa Medici, Rome, May 26 to June 30, 1967, p. 27, no. 33, figs. 14–17.

86. Burdett and Goddard, *Edward Perry Warren*, p. 259.

87. For more on Rodin's practice of making casts from marbles see Athena Tacha Spear, "A Note on Rodin's *Prodigal Son* and on the Relationship of Rodin's Marbles and Bronzes," *Allen Memorial Art Museum Bulletin* (Oberlin College), XXVII, 1 (Fall, 1969), 25–36, and Athena Tacha Spear, "*The Prodigal Son*: Some New Aspects of Rodin's Sculpture," *ibid.*, XXII, 1 (Fall, 1964), 30, 33.

88. Undated letter [*c.* 1902], Correspondence of Rodin and Rothenstein.

89. The dedication reads: "Hommage à Madame / Kate Simpson en / souvenir des heures / d'atelier, Sept. 1902. / A. Rodin."

90. A number of reductions after the marble of the 72.5, 61 and 38 cm. sizes either have no founder's marks or it has not been possible to verify them. For *The Kiss*, as for *The Man with the Broken Nose*, we have not attempted in this exhibition to list or identify the versions of all the existing casts, since information is not sufficient to do this at the present time.

Selected Bibliography

ARCHIVAL COLLECTIONS:

Correspondence of Auguste Rodin and William Rothenstein, Harvard University Library, the Houghton Library, Harvard University, Cambridge, Massachusetts.

Ernst Durig Papers, Musée Rodin, Paris.

Letters of René Chéruy to the Director, Tate Gallery, London.

Letters from Auguste Rodin to Walter Butterworth, Princeton University Library, Princeton, New Jersey.

Letters from Auguste Rodin to Omer Dewavrin (typescripts from originals in Archives of City of Calais), Philadelphia Museum of Art Library (bound with Rodin *Letters, Essays, Criticisms*, pp. 46–101).

Letters from Auguste Rodin to Gustav Pauli, Kunsthalle, Bremen.

Bartlett, T. H. "Auguste Rodin, Sculptor." *American Architect and Building News*, XXV, 682–703 (January 19 and 26, February 9, March 2 and 9, April 27, May 11 and 25, June 1 and 15, 1889), 27–29, 44–45, 65–66, 99–101, 112–114, 198–200, 223–225, 249–251, 260–263, 283–285.

Burdett, Osbert and E. H. Goddard. *Edward Perry Warren.* London: Christopher's, 1941. (Ch. 13: "Rodin and Le Baiser.")

Cladel, Judith. *Auguste Rodin pris sur la vie.* First ed. Paris: Editions de la Plume, 1903.

——. *Rodin, Sa vie glorieuse, sa vie inconnue.* Definitive ed. Paris: Bernard Grasset, 1950.

Galerie Georges Petit. *La Collection Antony Roux*, sale, May 19 and 20, 1914. Paris: G. Petit, 1914.

Grappe, Georges. *Catalogue du Musée Rodin.* Paris, 1944.

Hoffman, Malvina. *Heads and Tales.* New York: W. W. Norton and Co., 1936.

Jianou, Ionel, and Goldscheider, Cécile. *Rodin.* Paris: Arted, Editions d'Art, 1967.

Lami, Stanislas. *Dictionnaire des sculpteurs de l'École française au XIXe siècle.* 4 vols. Paris: Editions Champion, 1921.

Lawton, Frederick. *The Life and Work of Auguste Rodin.* London: T. Fischer Unwin, 1906.

Marchand, Sabine. "Rénovation du Musée Rodin." *Le Figaro*, March 7, 1968.

Moreau-Vauthier, Paul. "Le maître fondeur Eugène Rudier." *L'Art et les artistes*, N.S. 32 (March 1936), 203–209.

Rodin, Auguste. *L'Art. Entretiens réunis par Paul Gsell.* Paris: Bernard Grasset, 1911.

Rothenstein, William. *Men and Memories: Recollections of William Rothenstein.* 3 vols. London: Faber and Faber, 1931.

177

Checklist of the Exhibition

THE MAN WITH THE BROKEN NOSE

2. Plaster; H. *c.* 56.5 cm.
 University Art Museum, University of Texas, Austin, Texas

4. Bronze; H. *c.* 39.4 cm.
 Mead Art Building, Amherst College, Amherst, Massachusetts

5. Bronze; H. *c.* 31.7 cm.
 The Fine Arts Museums of San Francisco, San Francisco, California

7. Bronze; H. *c.* 31.5 cm.
 Museum of Art, Rhode Island School of Design, Providence, Rhode Island

8. Bronze; H. *c.* 30.5 cm.
 Fogg Art Museum, Harvard University, Cambridge, Massachusetts

9. Bronze; H. *c.* 31 cm.
 Smith College Museum of Art, Northampton, Massachusetts

10. Bronze; H. *c.* 31 cm.
 Museum of Fine Arts, Boston, Massachusetts

13. Bronze; H. *c.* 28 cm.
 B. G. Cantor Collections, Beverly Hills, California

14. Bronze; H. *c.* 9.5 cm.
 Los Angeles County Museum of Art, Los Angeles, California

16. Bronze; H. *c.* 24 cm.
 Sterling and Francine Clark Art Institute, Williamstown, Massachusetts

16b. Bronze; H. *c.* 26 cm.
 Markings
 proper left: A. Rodin
 inside (cachet): A. Rodin
 proper right of neck, back: Alexis RUDiER / Fondeur. PARiS.
 Philadelphia Museum of Art, Rodin Museum, Philadelphia, Pennsylvania
 Type F Cast

17. Bronze; H. *c.* 26.7 cm.
 Museum of Art, Carnegie Institute, Pittsburgh, Pennsylvania

JARDINIÈRE

18. Marble; H. *c.* 16 cm.
 Museum of Fine Arts, Boston, Massachusetts

LITTLE MAN WITH THE BROKEN NOSE

19. Plaster; H. *c.* 19.2 cm. (*c.* 11.7 cm. without base)
 Maryhill Museum of Fine Arts, Maryhill, Washington

20. Bronze; H. *c.* 12.7 cm.
 Stanford University Art Museum, Stanford, California

20a. Bronze; H. *c.* 12.4 cm.
 Markings
 proper right side of neck: A. Rodin
 proper left side, neck extension: ALEXiS RUDIER / Fondeur PARiS
 The Baltimore Museum of Art, Cone Collection, Baltimore, Maryland

THE KISS

23a. Bronze; H. *c.* 84.5 cm.
 Markings
 proper left of female figure, lower part of rock:
 A. Rodin
 proper left side, back, lower edge: © by musée rodin.
 1958.
 back, lower edge: Georges Rudier.
 Fondeur. Paris.
 B. G. Cantor Collections, Beverly Hills, California
 Cast after original clay model

27. Bronze; H. *c.* 71.1 cm.
 Library of Congress, Washington, D.C.

27a. Bronze; H. *c.* 59.6 cm.
 Markings
 front top of rock: Rodin
 proper left of male on edge of base:
 F. BARBEDiENNE. Fondeur.
 Collection of the Newark Museum, Newark, New
 Jersey
 This is one of a large edition of bronze reductions cast
 after the Musée Rodin marble.

27b. Bronze; H. *c.* 39.5 cm.
 Markings
 front top of rock: Rodin
 bottom front, proper right side: F. Barbedienne.
 Fondeur
 B. G. Cantor Collections, Beverly Hills, California
 Bronze reduction cast after Musée Rodin marble.

27c. Bronze; H. *c.* 25 cm.
 Markings
 proper left side, back, on rock: Rodin
 proper right, bottom edge: F. BARBEDIENNE.
 FONDEUR.
 Stanford University Museum of Art, Stanford,
 California
 Smallest bronze reduction, gilded. Cast after Musée
 Rodin marble.

27d. Bronze; H. *c.* 24.7 cm.
 Markings
 proper left side, on rock: hommage à Madame /
 Kate Simpson / en
 souvenir des heures /
 d'atelier Sept 1902 /
 A. Rodin
 below inscription: (Collas metal inset)
 front top of rock: RODIN
 proper right, bottom edge: F. BARBEDIENNE,
 Fondeur
 National Gallery of Art, Washington, D.C.
 Gift of Mrs. John W. Simpson, 1942
 Smallest bronze reduction, cast after Musée Rodin
 marble.

1. AUGUSTUS SAINT-GAUDENS
1848–1907

Augustus Saint-Gaudens (1848–1907)

Augustus Saint-Gaudens (fig. 1) was born in Dublin in 1848, the son of Bernard Saint-Gaudens, a shoemaker, and Mary McGuiness. The family came to New York when Augustus was six months old. The boy was apprenticed to a cameo cutter at the age of thirteen, and soon after began his studies in the Cooper Union night drawing classes. About 1864 he started sculpture modeling at the National Academy of Design.

In 1867 Saint-Gaudens enrolled in the preparatory school of the École des Beaux Arts, Paris, where he began regular study a year later. Three years later he left Paris and went to Rome where he set up a studio and began modeling the *Hiawatha* and the first commissioned portraits, all in marble. In 1877, shortly after his return to New York, he married Augusta Homer of Boston. Immediately the couple returned to Paris, where Saint-Gaudens established a studio for three years, where he completed the *Farragut Monument* and began the series of portraits in bas-relief which are among some of his most significant works. He made over ninety of these portraits, which comprise more than three-fourths of his oeuvre.

Following the unveiling of the *Farragut* in New York in 1881, Saint-Gaudens was acclaimed as a master of new realism, bringing renewed vitality to an art form which had grown progressively more pedantic and stilted in the nineteenth century. He created nearly thirty monuments, of which the most noteworthy are the *Adams Memorial* (1891), *Puritan* (1887), *Lincoln: The Man* (1887), *Shaw Memorial* (1897), *Sherman* (1905), and *Lincoln: The Head of State* (1906). His thirty or more portrait busts and heads, many of them preliminary statements for the monumental pieces, are representative of this period, the age of portraiture. The sculptor often rued the fact that he had not more opportunity to execute the ideal works he longed to do, such as the *Amor Caritas*, *Diana*, and *Victory*. Thus many of the monu-mental works combine elements of both portraiture and allegory.

The infrequent commissions for medals culminated in the designs for the *United States Coinage of 1907*. Here Saint-Gaudens' masterwork developed early, in the cameos and bas-reliefs, which have never been rivaled.

Saint-Gaudens is also recalled as a teacher. Beginning in 1888 he taught classes at the Art Students' League in New York, and throughout his productive lifetime he supervised many pupils in his studios in New York, Paris, and Cornish, New Hampshire. A number of these students became noted sculptors: James E. Fraser, Frederick W. MacMonnies, Henry Hering, John Flanagan, Mary Lawrence Tonetti, the artist's brother Louis Saint-Gaudens, and Philip Martiny. Saint-Gaudens was a major force in the movement to establish the American Academy in Rome as well as in securing prizes and commissions for promising young sculptors. Through his work on the redesigning of the nation's Capitol and in the creation of the National Arts Commission under President Theodore Roosevelt, he was also instrumental in the development of city planning efforts in the early twentieth century.

The laurels of a gifted and strenuous career came late in life. Saint-Gaudens was made a correspondent of the Institut de France in 1889, the third American to be so named. He was awarded the Legion of Honor by the French Government in 1901, followed by honorary degrees from Harvard, Yale, and Princeton. He was elected to the National Academy of Design, the American Academy of Arts and Letters, and the Royal Academy in London. After his death in 1907, his family and friends established the Saint-Gaudens Memorial at his former home and studio in Cornish, New Hampshire, which is now maintained by the United States Government as a National Historic Site. A major retrospective exhibition of his works was mounted the year after his death by the Met-

ropolitan Museum of Art, New York City, and traveled to Washington, D.C., Indianapolis, Pittsburgh, Chicago, St. Louis, and Detroit. In Washington it combined with the annual meeting of the American Institute of Architects where President Theodore Roosevelt and the cultural leaders of the era paid tribute to the man and his art.

This brief career of fifty-nine years witnessed and participated in a total renaissance in American art.

As a student of the Beaux Arts, Saint-Gaudens was early guided by the established art practices of drawing from antique casts, studies of anatomy, life models, and concentration on costume. His sketches for sculpture, preserved in photographs, contrast with the earlier and infrequent drawings, such as the portrait of a child in the collection of the Saint-Gaudens National Historic Site at Cornish, New Hampshire (hereafter referred to as the Cornish collection). This portrait, *Fanny Whittelsey*, was done in 1870 while he was in Paris. The later sketches are mere notations, refinements of ideas, designs for placement of decorative details.

There are volumes of photographs, however, of the clay and plaster sketches. These show a gradual and laborious development of selected pieces. The refinement of the model also occupied a great deal of his time and attention. Very few of the preliminary sketches in plaster have been preserved, such as the *Shaw Memorial* and *Boston Library Groups*. Although made from life, the models, sketches for the black heads in the *Shaw Memorial*, are developed only in three-quarters round, as they were to be used in the finished monument.

There is ample evidence in the *Stevenson* relief molds to show that Saint-Gaudens used the plaster to advantage, cutting out a section here, reworking it there, and inserting the changes in the finished model for the foundry. At other times he destroyed successive models, leaving the commission for long periods of time, sometimes years (as in the *Shaw Memorial*, on which he worked fourteen years). During the production of the *Shaw*, according to his son Homer in his *Remi-niscences of Augustus Saint-Gaudens*, he . . . struggled with difficulty after difficulty, both technical and artistic . . . the constant wetting of the clay and covering of the *Shaw* with damp rags became such a nuisance that he began to look about for a substitute. French plastoline in the quantities he needed was quite out of the question because of the expense. So he talked the matter over with Mr. Philip Martiny, who had been working for him, with the result that there was evolved the present American plastoline now in common use. (*Reminiscences*, v. 1, p. 342)

In a note to his nephew Homer, Louis Saint-Gaudens told of another adversity that had a creative solution. Robert Treat Paine solved the problem of mechanical enlargement by fitting six stovepipes together, and pointed the Sherman horse in the New York 36th Street studio, at the rate of 400 points a day. Previously Saint-Gaudens had to remodel the *Standing Lincoln* and the *Peter Cooper* entirely freehand because the old pointing systems were ineffective (manuscript for *Reminiscences*, Dartmouth College Library).

Saint-Gaudens changed formats frequently. A work such as the *Garfield Monument* for Fairmount Park, Philadelphia, was originally commissioned as a full-standing figure, for which models were developed, but in reworking the commission over an eleven-year period, Saint-Gaudens finally produced a bust on a high plinth. In the reliefs, he experimented with the rectangular and the circular, preferring the rectangular, as he thought the circular format too easy. Yet in the case of the *Stevenson*, for instance, he modeled it first in the rectangular, but soon saw it best in a circular relief. In the commission for the *St. Giles Memorial*, several years later, he returned to the simple rectangular, after attempting the more traditional upright rectangular entablature with the circular bas-relief set in. The plaster of the *Shaw Memorial* displayed in Paris in the 1900 Exposition had been changed from the bronze in Boston Common and was changed again for the 1901 Pan American Exhibition in Buffalo. This last version is preserved in the Cornish collection. Saint-Gaudens was so dissatisfied with the model for the Boston bronze after the many changes, that he had it buried beside the studio.

Saint-Gaudens' reasons for returning to Paris in 1877 were not simply financial, but also were related to the improved techniques of the Paris foundries. He created his work for bronze; the infrequent requests for marble were made from a model in the Piccirilli studio in New York. So many foundries were used throughout his lifetime it is difficult to present a complete listing. The *Farragut* was cast in 1880 by Gruet, in Paris. Seemingly, Saint-Gaudens developed a gold-colored patina with the assistance of a Paris founder, during the casting of the *Montgomery Relief* for the Church of the Incarnation in New York. (The normal color at the time was a dark brown.) The sculptor's regard for color may be seen in the patinas for many of the later bronzes, especially the *Stevenson*s and *Diana*s, which range from brown to silver, gold, green, and blue-gray. Bureau Brothers in Philadelphia, one of the founders used by Saint-Gaudens, cast the *Puritan* (1886) and possibly the *Adams* (1891). Henry Bonnard in New York seemed to be a favorite of the artist, perhaps because of the chief founder or superintendent, Eugene Aucaigne, whom Saint-Gaudens often referred to as "Aucaigne the Tragic." Bonnard cast the early large-size *Stevenson*s, as well as the *Chapin Relief* (1888), the *Governor Flower Monument* (1901), the *Hanna Monument* (1907), the *Garfield* (1895), and the *Logan* equestrian (1897).

Saint-Gaudens had no regular contract with any one founder. As in the case of the *Flower Monument*, he received bids from three firms, John Williams in New York, Roman Bronze in Brooklyn, and Bonnard, who submitted the lowest bid. Other major commissions were cast by Gorham in Providence, Rhode Island: the *Shaw Memorial* (1896), *Brooks Monument* (1907), and the *Daly Monument* for Montana (1905). The bas-reliefs of *Mrs. Charles Beaman*, *Charles Billings*, and *Jacob Rogers* were all cast by John Williams in New York, and that firm may have also cast some of the *Stevenson*s after Saint-Gaudens' return to the United States in 1900. Aubry Brothers, another New York firm, cast the *Cooper Monument* (1897) and the early reductions of the *Diana*s.

Thiébaut Brothers in Paris cast the heroic equestrian *Sherman* with the Victory figure. The bronze was shipped to Cornish where it was set up in an adjacent field and Saint-Gaudens incorporated some of the changes he had made in the model after his departure from the Paris studio. After coating it with gold leaf at an extra cost of $3,000, he sent it to New York for the unveiling. The New York committee refused to pay the additional expense. Saint-Gaudens thought of doing the same thing to the *Garfield Monument* in Philadelphia, but the commissioners of Fairmount Park would have nothing to do with the idea. The sculptor said that he had a fear that his sculpture would end up looking like old stovepipes.

All of these activities and the constant changes required the services of a great number of extra hands; at one time there were fifteen employees in the Cornish studios. A good plaster molder was crucial and he had working for him such a man, Gaetan Ardison. French by birth, Ardison was working in a New York clock factory when Saint-Gaudens first found him.

In a newspaper article in 1909 Ardison claimed that he had been with the sculptor for twenty-three years. We know that he worked with him prior to 1896, since there is extensive correspondence between the sculptor and the caster. Letters were exchanged frequently whenever they were separated, such as when Saint-Gaudens was in Paris and Ardison was closing the New York studios. After Saint-Gaudens' return to Cornish in 1900, Ardison remained in Paris until about 1903. He was especially helpful in carrying out all of the orders for reproductions of bronzes by the Paris founders, such as Gruet, the Liards, Chartier, Barbedienne, Siot-Decauville, Soulant, and Poirrot. Ardison also assisted in modeling some of the decorative details, preparing reductions, finishing the changes in the models, patination, and framing. At other times Saint-Gaudens used the Contini family of plaster molders; John H. A. Walthausen, another New York caster; and a Czechoslovakian named Bill ("Boho" Bohuntsky?) mentioned in Malvina Hoffman's *Sculpture Inside and Out* (pp. 100–101).

The question of Saint-Gaudens' personal involvement in the production of each piece arises

in connection with the bronze reproductions or editions. In a letter of November 14, 1899, written from Paris and addressed to Doll & Richards in Boston, one of the galleries selling his work, Saint-Gaudens remarked that "Tiffany and Co. seemed to think that the fact that I work over each bronze myself should be generally known." That the sculptor did not always trust the work of the founders and patinators is reflected in his letter of February 17, 1903, to his friend and student James E. Fraser in New York: "The Wolcott medallion has arrived and the patina is admirable. It is a bad cast however and when the good ones that I am expecting come I will ask you to give them the same color" (Syracuse University Library, James E. Fraser collection). This may have been just a convenient excuse to get Fraser to come up to Cornish; although it was still winter, Saint-Gaudens enjoyed his company, especially on the golf course. An earlier letter to Ardison written from Paris on November 9, 1897, concerns the *Stevenson* casts: ". . . If the patina is nice, leave it, if not, make it green like the one that was so good. As for the frames it would be better if you do it yourself. . . ." On other occasions the galleries complained about the bronzes, as in a letter from Wunderlich in New York dated October 16, 1902: "We find that the Stevenson bronzes now with us are too gray to be saleable. Is it possible to have the colour changed? . . . Those in the greenish tint are what we have been most successful in selling."

Saint-Gaudens tended to use one foundry for a specific edition once assured of quality work and low prices. Bonnard cast the large version of the *Stevenson* before 1900. The large *Diana* was cast by Aubry Brothers. However, once he was in Paris, Saint-Gaudens used Gruet to cast the small *Diana*. There were other editions such as the *Amor Caritas*, cast by Chartier, which were not entirely successful. Aubry Brothers and John Williams were used for the *Stevenson*s on his return to the United States and both Tiffany and Gorham cast and sold bronzes for Mrs. Saint-Gaudens after her husband's death.

The first subjects to be issued in bronze editions were the *Diana* and the *Stevenson*. The reductions of the *Puritan* were begun in Paris in 1898. The sculptor may have been encouraged by the popularity of the early sales of the *Stevenson* and *Diana*, as well as the recognized success of contemporary French sculptors. In a letter written from Paris to his brother Louis in Ohio, on July 2, 1899, he says:

I have quite a little income now from the Stevensons and the Diana and now I have sold two small Puritans and a small Angel with the Tablet. MacMonnies sells more of his "Boy playing on the reeds" than anything else, and if I were you I would model again a figure like the one you made for Barney [*Piping Pan*]. I would make it as near like that as you can remember. I would have reductions made over here and you surely would sell three or four at least every year with a profit of $100 each. . . . I have not had the Homer reduced yet [bas-relief of the artist's son as a baby]. . . . It seems that bronzes sell very little at first and then when they commence the sale goes on increasing if the work is attractive. People see the bronze in friends homes and that suggests their purchase to them. Mercier's David and Dubois' Chanteur Florentine did not sell at all at first and now their sale is enormous. Go ahead.

All of his sculpture was marked with signature and date in the bronze. After 1901 there was special concern for the copyright. He had Ardison model a small stamp, or plug, which was sometimes cast separately and inset into the finished bronze and at other times cast with the model. Thus all of the *Stevenson* casts after 1901 have the small round stamp in the lower right hand corner, and the *Diana*s have it on the base. Prior to this time, if a piece was to be copyrighted, the mark was incised into the bronze by hand.

There is an amusing exchange in the correspondence with Ardison concerning the placement of the signature or copyright on the *Sherman* monument. Ardison, in New York, thought of placing it on the hoof of the horse, but Saint-Gaudens retorted on May 9, 1903, from Cornish:

. . . incised in the shoe of the horse, that would only be seen by someone who looked at it with a lorgnon . . . it must be on the work for the next thousand years, when the archaeologists examine the statue with their spectacles after having fished it out of the Hudson, or an enraged population . . . when they notice that the

work is by the illustrious idiot St. Gaudens. It doesn't have to be big. . . .

Copyrights were taken out as early as 1889 for the Washington Inaugural Centennial medal. One for the *Diana* is listed in the records for January 1895 and another for a relief of *Stevenson* the following September. The *Stevenson* listed for January 15, 1904, is probably the Edinburgh relief. The reduction of the bust of *Diana* was copyrighted on October 21, 1907, as well as the bronze head of *Diana* in January 1908 by Saint-Gaudens' wife, after his death.

In a letter to Mr. J. L. P. Hill, in Washington, whose mother had commissioned a portrait bust of her husband, David J. Hill, and wished to have copies made on her own from the plaster model, Saint-Gaudens wrote on May 9, 1902:

. . . Mr. C. C. Beaman years ago was allowed to do just what Mrs. Hill wants to do with the result that there are several bad bronze casts scattered about, and to protect myself I have to attend to them. . . . I cannot allow anyone but myself to have the casts made. Mr. S. G. Ward made the same request when I was in Europe and I had to refuse it. A copy of a work of mine would bear my name and you will understand what I would feel about it as you would feel about a distorted publication of your writings.

In another letter written the same day to Hill, Saint-Gaudens reiterated his position. "I make it a rule to dispose of the work but not of the copyright with my name on it." In his will he made a specific bequest to his wife, giving her the right to reproduce his works with the copyrights.

The question of the numbering of editions arose more importantly in the marketing of Saint-Gaudens' works, especially in the *Stevenson*s, as noted in a letter from the sculptor in Paris to his wife who had returned to Cornish, dated July 26, 1899:

Cable has paid me $1200 for the big bronze [*Stevenson*, D. c. 91.5 cm.]. . . . I think I remember how you told me at the time that you told him $1000 and of course in that event that is what he must pay only I have told him that in any case he must say that they cost $1200 as this is what I ask and what Armour paid.

He said you also said that the sale was limited to 5 of the big ones at 1000 each and 100 of small ones at 100 each. I told him I was surprised at that but if you told him so you were mistaken that there was no limit to either but that each large bronze was unique in itself.

An earlier letter, dated December 13, 1897, from Saint-Gaudens to Ardison in New York, stated:

I answered in response to your last letter at the request of Harrey [or Harvey, possibly his student Henry Hering, who went to Paris at this time] if I shouldn't "limit" the number of Stevensons? That there were people who refused to buy them if they were "unlimited" that I "did not want to limit them." I thought of this since Harrey would be able to tell the dealers that I will make a change in the arrangement of the drapery of those I will send after that, which will make of those already in New York, 29—and one I will make to make the count around 30—it will be an edition of 30 *only* the model no longer in existence (because I am changing the drapery in the model itself)—it will be a unique edition. The next edition of 20 or 30 or 40, according to the advice the dealers give Harrey, will be a different arrangement of drapery and they will also be unique—its raining!

The income account books preserved in the Saint-Gaudens collection at Dartmouth College Library, as well as the few letters from dealers and foundries, give some indication of the extent of the reproduction business, although these records only date from 1898. The dealers involved in the sales of the *Stevenson*s and *Diana*s were Wunderlich and Frederick Keppel, both in New York, and Bigelow-Kennard in Boston. Mrs. Saint-Gaudens also became involved in the sales management as reflected in her correspondence. On October 14, 1898, while she was still in Paris, she wrote their lawyer, Charles Brewster, in New York:

Before Christmas be on the lookout for bronze reductions of the Puritan. . . . Then there will be Dianas and Stevensons. So Saint-Gaudens seems to be going to set up as a statuette maker.

Her niece Rose Nichols, in Boston, was their liaison with private collectors and galleries as well. William Ellsworth, secretary of the Century Company, publishers in New York, assisted her. They

gave exclusive sales rights for the bronzes to Tiffany in New York and Doll & Richards in Boston; in return, the galleries took a twenty per cent commission. This turn of events did not sit well with other dealers, as reported by Ellsworth in a letter to Mrs. Saint-Gaudens, December 19, 1899, while he was gathering up the unsold inventories for delivery to Tiffany:

I cannot get any definite information from Wunderlich. . . . Mr. Kennedy is an extremely cross person who is generally in a disgruntled condition. He is now disgruntled over the fact that the bronze he had has been taken away from him, for he says that the making of the bronze was an original suggestion of his own.

The move was evidently a good one, for by January 1900 Tiffany had set up an exhibit on their second floor and had begun an advertising campaign in the newspapers. In June, Tiffany was selling the small *Stevenson* reduction (*c.* 30.5 cm.) for $85; it had sold the previous year for $64. The larger reduction was selling for $135. The *Diana*s were priced at $150 and $200, the smaller version being less expensive, while the cost of casting the two sizes was $30 and $60 respectively.

The exclusive representation by the two galleries did not last long, and soon Wunderlich and others were again selling the bronzes. By 1908 the smaller *Stevenson* was selling for $100 and the larger version for $150. The cost of the casting was $9 and $12. The *Diana*s were selling for about $300 in the larger size and $200 to $225 (depending on the type of base) in the smaller version. They cost $100 and $55 to $75 to cast.

Saint-Gaudens exhibited about fourteen of his bas-relief reductions in the 1900 Paris Exposition. These were also shown, along with other pieces, in the 1901 Buffalo Exhibition. A dealer in Buffalo wrote to Saint-Gaudens asking if they were for sale, and the artist replied that they were all for sale to museums, other than the portraits of the celebrities such as Stevenson and Bastien-Lepage. The dealer, George W. Benson, must have replied that he wished to sell them from his gallery. Saint-Gaudens accepted with the provision of a twenty per cent commission, and promised ". . . of all you

can have as many duplicates as you wish" (letter in the collection of the late Dr. Winthrop Wetherbee, Brookline, Massachusetts).

It is virtually impossible to compute the exact number of *Stevenson*s and *Diana*s sold during the sculptor's lifetime. One can only approximate a number from the information found in account books and letters, and the bronzes recorded in public and private collections. The *Stevenson*s were by far the most popular of the editions and sales were augmented by the production of the Edinburgh reduction and the reduction of the so-called first version, with Stevenson in bed, holding a cigarette. After her husband's death in 1907, Mrs. Saint-Gaudens had a number of new bronzes cast for sale through the galleries and for presentation as gifts. The list numbered twenty-five pieces and included reductions of the *Victory* from the Sherman group, the head of Diana, bust of Diana, and the heads of Farragut, Lincoln, and Shaw. The reductions of the monumental *Standing Lincoln* also became popular sales items. These continued to be sold through Doll & Richards, Tiffany, Ferargil in New York, and the studios in Cornish.

At the retrospective exhibition of Saint-Gaudens' works held at the Indianapolis Museum from 1909 to 1910, visitors were requested to write down which of the bronzes they would like to have for the Museum's collection. The majority chose the large *Stevenson*, which the Museum bought and still holds (Indianapolis *Star*, February 28, 1910). A number of the bronzes in the collection of the Metropolitan Museum of Art were cast at this time. Similar purchases were made by other museums—but perhaps not as democratically as in Indianapolis.

Mrs. Saint-Gaudens continued to exhibit her husband's work in the major annual exhibitions as well as at the Exposition in Rome in 1911 and the Pan-Pacific Exhibition in San Francisco in 1915. After 1919, the opening of the studios in Cornish as a memorial reflected the public's continuing interest in the sculptor and his work. In 1924 over 10,000 visitors signed the Cornish guest register.

Robert Louis Stevenson

In 1877 while Saint-Gaudens was working on the reredos for St. Thomas' Church, New York City, he shared a studio in Paris with Will H. Low, a close friend of Robert Louis Stevenson. The author came to visit Low several times that year, but Saint-Gaudens was always away and never saw him there. Ten years were to go by before they met and became friends. Low had drawn Saint-Gaudens' attention to Stevenson's work, however, and through Low's insistence the sculptor finally read *New Arabian Nights*. This "set him aflame as have few things in literature" and he enthusiastically told Low that "if Stevenson ever crossed to this side of the water, I should consider it an honor if he would allow me to make his portrait" (*Reminiscences*, v. 1, p. 373).

The first meeting took place in the autumn of 1887 when Stevenson came to America. Low arranged for the two to meet in Stevenson's rooms at the Hotel Albert on Eleventh Street in New York. Saint-Gaudens thought that Stevenson was "astonishingly young, not a bit like an invalid, and a bully fellow." Stevenson was equally impressed. To Low he said, "I like your sculptor, what a splendid straight-forward and simple fellow he is, and handsome as well." To Sidney Colvin, his friend and future biographer, he wrote, "I withdraw calling him handsome; he is not quite that, his eyes are too near together; he is only remarkable looking and like an Italian cinquecento medallion" (Colvin, *Letters*, v. 2, p. 37).

Stevenson accepted Saint-Gaudens' offer to make his portrait and the first five sittings took place at the Hotel Albert. While the sculptor worked, Stevenson lay in bed propped up by pillows and either read or was read to by Fanny Stevenson, his wife. Will Low also sat with them. During one of the discussions Saint-Gaudens complained that he never had had time to do a nude statue. Low quoted Emerson:

> The sinful painter drapes his goddess warm
> Because she still is naked, being dressed:
> The God-like sculptor will not so deform
> Beauty, which limbs and flesh enough invest.
> (Low, *Chronicles*, p. 394)

From that day on Stevenson referred to Saint-Gaudens as his "God-like Sculptor."

Stevenson had to go to Saranac for treatment of his tuberculosis before the bas-relief was finished, but by April of 1888 he was back in New York. He stayed this time at the St. Stevens Hotel, which his friends called the "St. Stevenson." Saint-Gaudens returned to modeling the relief, but before long Stevenson took a house in Manasquan, New Jersey, near his friend Low. Saint-Gaudens had nearly completed the bas-relief except for the hand, which he modeled from Mrs. Saint-Gaudens, because her slender fingers resembled Stevenson's. He asked for one more sitting so he could make some drawings and a cast. On the scheduled day he took along his son Homer, who was then eight. Saint-Gaudens had endeavored to instill in Homer an impression of the importance of the man he was meeting, but Homer, in a child's way, was far from enthusiastic. While he was posing, Stevenson wrote a letter to the boy which he sealed and stipulated should not be opened for "five or ten years, or when I am dead." The letter dated May 27, 1888 describes Homer and his "single-minded ambition to get back to play" on that day and continues:

. . . But you may perhaps like to know that the lean flushed man in bed, who interested you so little, was in a state of mind extremely mingled and unpleasant; troubled with difficulties to which you will in time succeed, and yet looking forward to no less a matter than a voyage to the South Seas and the visitation of savage and desert islands. (*Reminiscences*, v. 1, pp. 377–378)

Saint-Gaudens and Stevenson never saw each other again, but their friendship and correspondence continued. Stevenson moved to Samoa where he built "Vailima," a plantation high on a hill and accessible only by primitive track. There were many difficulties in getting the finished bronze relief to the author, but finally on July 8, 1894 he wrote to Saint-Gaudens:

We have it in a very good light which brings out the artistic merits of the god-like sculptor to great ad-

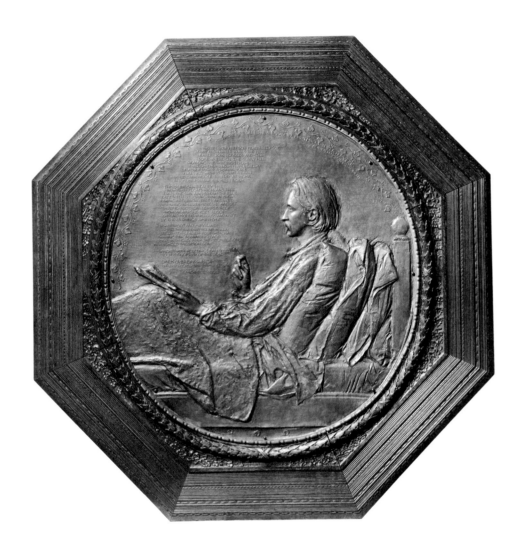

2. ROBERT LOUIS STEVENSON
 Bronze; D. *c*. 91.5 cm.
 Markings
 upper border: TO ROBERT LOUIS STEVENSON IN HIS
 THIRTY SEVENTH YEAR. AUGUSTUS
 SAINT GAUDENS
 below poem: MDCCCLXXXVII
 bottom of circle: REPLICA MADE FOR GEORGE
 ALLISON ARMOUR
 MDCCCLXXXX

bottom of circle (in script): CAST BY THE HENRY
 BONNARD BRONZE CO.
 NEW YORK 1890

Princeton University Library, Princeton, New Jersey

Earliest known cast. Hand carved oak frame designed
by Stanford White. Former collection of George
Armour.

vantage. As for my own opinion, I believe it to be a speaking likeness and not flattered at all possibly a little the reverse. The verses (curse the rhyme) look remarkably well. . . . (Colvin, *Letters*, v. 2, p. 407)

Saint-Gaudens was specially moved by his meetings with Stevenson and summarized his feelings in a letter to Low:

My episode with Stevenson has been one of the events of my life, and I can now understand the state of mind he gets in about people. I am in a beatific state. It makes me very happy. . . . (Low, *Chronicles*, p. 395)

The verses inscribed on the relief are from the "Underwoods" collection, dedicated to Low:

YOVTH · NOW · FLEES · ON · FEATHERED · FOOT
FAINT · AND · FAINTER · SOVNDS · THE · FLVTE
· RARER SONGS OF GOD AND STILL ·
· SOMEWHERE ON THE SVNNY HILL ·
· OR ALONG THE WINDING STREAM ·
· THROVGH · THE WILLOWS · FLITS · A DREAM
· FLITS · BVT SHOWS A · SMILING FACE ·
· FLEES · BVT WITH SO QVAINT A GRACE ·
· NONE · CAN CHOOSE · TO · STAY · AT HOME ·
· ALL · MVST · FOLLOW · ALL MVST ROAM ·

· THIS IS VNBORN BEAVTY · SHE
NOW IN AIR FLOATS HIGH AND FREE
TAKES · THE SVN AND BREAKS THE BLVE ·
LATE · WITH STOOPING PINION FLEW
· RAKING THE HEDGEROW TREES AND WET ·
HER WING IN SILVER · STREAMS AND · SET ·
· SHINING · FOOT · ON · TEMPLE ROOF ·
· NOW · AGAIN · SHE FLIES · ALOOF ·
· COASTING MOVNTAIN CLOVDS AND KISS'T ·
BY · THE · EVENING'S · AMETHYST ·

· IN WET-WOOD AND MIRY · LANE ·
· STILL WE PANT AND POVND IN VAIN
· STILL WITH LEADEN FOOT WE CHASE ·
· WANING PINION FAINTING FACE
· STILL · WITH GREY HAIR WE STVMBLE ON
· TILL BEHOLD THE VISION · GONE ·

WHERE HATH FLEETING BEAVTY · LED
· TO · THE · DOORWAY OF THE DEAD

· LIFE IS OVER · LIFE · WAS · GAY ·
WE HAVE · COME · THE · PRIMROSE · WAY

Underwoods; Book I: In English, xi
"To Will H. Low"

"Youth now flees on feathered foot . . . Life is over, life was gay, we have come the primrose way." Saint-Gaudens gave a plaster cast of the large circular relief, about 91.5 cm. in diameter, to Low, which Low had installed in his studio wall in Bronxville, New York.

Saint-Gaudens first modeled the relief as a long rectangular portrait, with the full bed and Stevenson smoking a cigarette. He soon found that this was too unwieldy. By inscribing a circle around the right half of the relief, he modeled the finished piece as a more intimate and immediate portrait, with the long inscription arranged as a sweep along the left side. He placed the dedication and signature above the portrait, along the edge of the relief, surrounding the upper edge with a decorative ivy border. The bedposts in these early casts had a ball finial.

The first bronze casting known to have been made was purchased by George Armour and is now at the Princeton University Library (fig. 2). This has the date 1890 cast in the bronze with the mark of Henry Bonnard, New York City, the founder. The cast sent to Stevenson is unlocated, but it was ordered in 1893, as was another for his friend Colvin. Colvin's version, as yet unlocated (fig. 3), differs in the arrangement of the poetry, which the sculptor broke up into two blocks, and has the special dedication to Colvin in the upper left quadrant. It has a squared-off bedpost, the pillows are arranged somewhat differently, as are the folds in the bed linen. Colvin received it just after Stevenson's death in Samoa in 1894. These changes would be the hallmarks in each of the very large circular versions made thereafter.

According to Saint-Gaudens' own statement in correspondence prior to 1900, there were only four bronze casts of the large circular version: one given to Stevenson, one in Colvin's possession, George Armour's cast, and one sold to Benjamin Cable, a United States Congressman from Rock Island, Illinois, who was also a director of the Rock Island Railroad (fig. 4). Not specifically inscribed to Cable, it has the familiar arrangement with the dedication, "To Robert Louis Stevenson," the signature of the artist on the right side,

and the squared bedpost. It is only in the bed drapery that the individualization occurs. With this change the sculptor intended to make each copy unique. Another bronze (fig. 5), in the collection of the Textile Museum in Washington, D.C., also has the Bonnard casting mark and the date 1893, as well as the date 1888 under the signature. In addition, the treatment of the bed linen is the same as that in the Colvin cast (see fig. 3). Therefore, except for the dedication and the signatures, these casts are the only two alike in this 91.5 cm. size. If the 1893 date on the Textile Museum bronze reflects accurately when it was cast, this might possibly be the bronze given to Stevenson.

Those 91.5 cm. reliefs cast after 1900 have

either the ball finial and the sweep of the inscription or the blocked inscription and the square bedpost. Most of these are specifically inscribed in the section above the bedpost: "Replica made for [etc.]" and the date. There is a bronze in the Cornish collection (fig. 6) which has a scroll top on the bedpost and another scroll in the right corner of the bed frame. These decorative details may also be observed in the reduction of the so-called first version, which is in the rectangular format.

There are at least two plaster casts extant in the largest circular size, one in the American Academy of Arts and Letters, from the estate of the sculptor Charles Henry Niehaus (fig. 7), and another in the Coffee House Club, New York City. The latter,

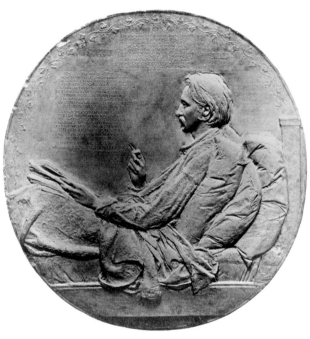

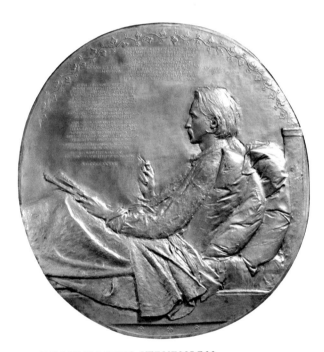

3. ROBERT LOUIS STEVENSON, from illustration in Talcott Williams, "Augustus Saint-Gaudens," *International Studio*, Vol. 33, February 1908, pp. CXXIII–CXXXVIII

The present location of this plaster is unknown. Visible on the illustration are the markings, upper left: TO SIDNEY COLVIN and at upper right: ROBERT LOUIS STEVENSON. The text of the poem appears in two sections for the first time.

4. ROBERT LOUIS STEVENSON
Bronze; gilt, D. *c.* 91.5 cm.
Markings
 upper left: TO ROBERT LOUIS STEVENSON
 upper right: AUGUSTUS SAINT GAUDENS
 below verse: MDCCCLXXXVII
 across bottom: COPYRIGHT BY A.SAINTGAUDENS
 MDCCC XCIV

Upland Country Day School, Kennett Square, Pennsylvania

One of four early bronze casts of large circular version according to Saint-Gaudens' correspondence. Frame after design by Stanford White. Former collection of Benjamin Cable

somewhat smaller in diameter, is a less detailed cast, perhaps even a surmoulage. These differ from the earlier work dedicated to Sidney Colvin (see fig. 3) in the dedication, the date beneath the poetry, and extensive changes in the bed linen beneath Stevenson's forearm.

The reductions in the 45.5 cm. size were in two editions, with one perhaps unique cast in the Nichols House Museum, Boston, Massachusetts (fig. 8). Even in the bronze cast one can see as deliberate changes the clear reworking of the bed linen (fig. 8a) and the dedication. To judge from Saint-Gaudens' correspondence with his plaster molder, the very early editions in the 45.5 cm. size and the 30.5 cm. size were evidently of the same model or version. The only similar pieces presently known in the two sizes are the 45.5 cm. cast in the Museum of Art, Carnegie Institute, Pittsburgh, Pennsylvania (fig. 9), the 45.5 cm. cast in the Art Institute of Chicago, Illinois, and the 30.5 cm. bronze in the Hopkins Center Art Galleries, Dartmouth College, Hanover, New Hampshire (fig. 10). It may be assumed that they represent that original edition of thirty, mentioned in the December 13, 1897 letter to Ardison referred to above.

All of the other 45.5 cm. bronzes and plasters represent editions which postdate 1898. Examples include one bronze from the Houghton Library, Harvard University, and a gilded version from the collection of Dr. J. M. Morganstern (fig. 11). Here again the only significant change is in the bed linen drapery.

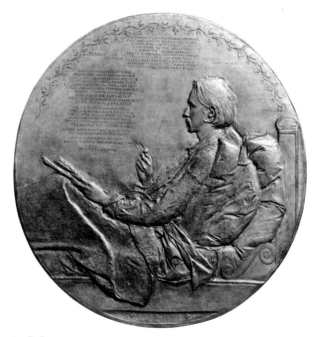

5. ROBERT LOUIS STEVENSON
Bronze; D. *c.* 91.5 cm.
Markings
 upper right top: TO ROBERT LOUIS STEVENSON
 AUGUSTUS SAINT-GAUDENS 1888
 bottom of circle: CAST BY HENRY-BONNARD BRONZE
 CO., NEW YORK. 1893 (in script)
 above castmark: COPYRIGHT BY AUGUSTUS
 SAINT-GAUDENS. 1892

Textile Museum, Washington, D.C.

Possibly the bronze from Stevenson's collection

(not in exhibition)

6. ROBERT LOUIS STEVENSON
Bronze (yellowish-gilt patina); D. *c.* 91.5 cm.
Markings
 upper left: TO ROBERT LOUIS STEVENSON
 below poem: MDCCCLXXXVII
 upper right: AUGUSTUS SAINT-GAUDENS
 bottom center: copyright stamp (cast from model)

Saint-Gaudens National Historic Site, Cornish, New Hampshire

This is from Saint-Gaudens' personal collection and is an apparently unique bronze version.

In the approximately 30.5 cm. size, we have already mentioned that the early edition is represented by the Dartmouth College cast (see fig. 10). In successive editions in this size there are minor variations in the arrangement of the bed linen and in the use of the decorative scroll in the bed details (fig. 12). Those with the scroll elements are the most numerous of the casts. Some of these do not have the copyright stamp; others which do may therefore be later, since we know that this stamp was used on the bronzes after 1901. Thus we may assume that except for an apparently unique cast in the collection of John Howell—Books, San Francisco (fig. 13), which does not have the scrolls, all the casts in this size are the same.

Not long after Stevenson's death in 1894, Saint-Gaudens was asked to create a memorial to the author for the St. Giles Cathedral in Edinburgh, Scotland. Lord Rosebery was chairman of the memorial committee and Sidney Colvin was the liaison with the sculptor. The committee had little money but Saint-Gaudens agreed to accept the commission at no profit for himself. The first mention of the memorial in available manuscript sources is in a letter addressed to Colvin, November 2, 1899. Saint-Gaudens describes his idea for the memorial, an upright rectangular entablature of stone, with the large bronze circular relief set in and an inscription above and below on the marble (fig. 14). He also made some pen and ink sketches (embellished with an ornate architectural frame)

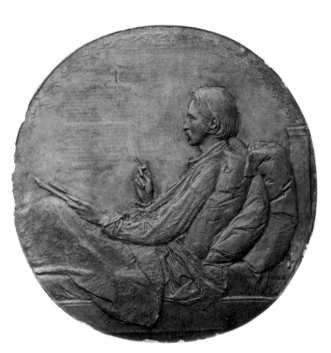

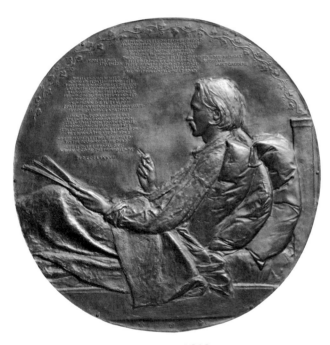

7. ROBERT LOUIS STEVENSON
Plaster; D. *c.* 91.5 cm.
Markings
 upper left: TO ROBERT LOUIS STEVENSON
 below poem: MDCCCLXXXVII
 upper right: AUGUSTUS SAINT-GAUDENS

American Academy of Arts and Letters, New York, New York

One of two extant plaster casts of large circular version with variations in bedpost and inscription

(not in exhibition)

8. ROBERT LOUIS STEVENSON
Bronze; H. *c.* 45.5 cm.
Markings
 upper right: TO ROSE NICHOLS
 below dedication: AUGUSTUS SAINT-GAUDENS
 below poem: MDCCCLXXXVII
 lower border: COPYRIGHT AUGUSTUS SAINT-GAUDENS

Nichols House Museum, Boston, Massachusetts

Perhaps a unique cast, with special dedication and obvious reworking of the drapery

which show his return in plan to the early rectangular first version (fig. 15).

Saint-Gaudens finished the model in Paris and sent it to the Barbedienne foundry, anticipating its installation in St. Giles in 1900. However, he soon learned that he had cancer and returned to the United States for an operation. After a convalescence in Cornish he evidently sent for the model. The founder had turned out a very poor cast, and there was the added problem of a misspelled word in the lower inscription tablet, in the line beginning, "Bright is the ring of word[s] . . ." (fig. 16).

Perhaps Saint-Gaudens was also annoyed by the fact that Barbedienne had included their foundry mark on the left side background, as large and obvious as his own signature on the right. He called that cast "attrocious" [sic] in a letter to Ardison on September 7, 1901. He also wrote to Colvin on November 10, 1901:

The casting did not satisfy me and I decided to have it done over again and as that was to be done I also decided on some changes that will improve it.

His changes were primarily in the inscription. As Homer Saint-Gaudens notes in the *Reminiscences*, the 1,052 letters of the inscriptions were modeled —not stamped—twelve consecutive times (vol. 2, p. 125). The inscriptions were Stevenson's "Prayer," followed by the epitaph, "Under the wide and starry sky / dig the grave and let me lie. . . ." In reworking the inscription he elimi-

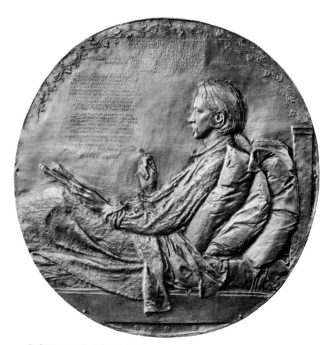

8a. Detail of fig. 8

9. ROBERT LOUIS STEVENSON
Bronze; D. *c.* 45.5 cm.
Markings
 upper left: TO ROBERT LOUIS STEVENSON
 below poem: MDCCCLXXXVII
 upper right: AUGUSTUS SAINT-GAUDENS

Museum of Art, Carnegie Institute, Pittsburgh, Pennsylvania

Possibly one of an edition of thirty including the *c.* 30.5 cm. size, cast prior to 1898

nated the epitaph, placing it in the tablet below the portrait. The "Prayer" was rearranged so that there was more space around the figure of Stevenson. Saint-Gaudens told Colvin that the shells, which appear in the early version, were an inspiration from an arrangement in the garden of the Musée de Cluny in Paris. There was also to be some allusion to Stevenson's forebears, who were marine engineers, especially lighthouse builders; they may be symbolized in the sailing ship in the lower right corner of the lower tablet. The first version of the memorial also had a decorative French empire sofa with swan heads. In rethinking the piece, Saint-Gaudens eliminated this and the shells, as he thought they might be considered inappropriate for a Scottish church memorial.

The cast of the second version was made by Gruet in Paris in 1902. This too proved to be unacceptable, especially in the casting of the head and hands. (Fig. 17 is a photograph, probably of that second relief, now on exhibit in the Cornish studio.) That final changes were made in the bronze cast itself seems to be substantiated in obscure references in some of the correspondence and other sources. New bronze casts of the head and hands were sent to Paris, after being cast in New York, and evidently inserted into the existing relief. Even in a photograph one can see a definite square silhouette in the bronze around the head (fig. 18). The memorial was set up in St. Giles in December and January 1903–1904, and the unveiling took place in June of 1904. This second

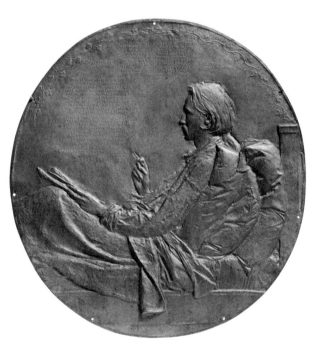

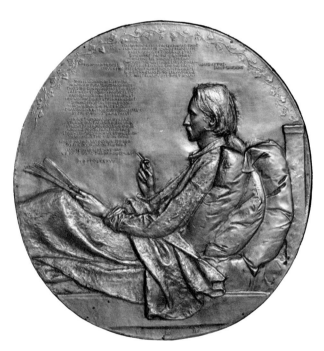

10. ROBERT LOUIS STEVENSON
Bronze; D. *c.* 50.5 cm.
Markings
 upper left: TO ROBERT LOUIS STEVENSON
 below poem: MDCCCLXXXVII
 upper right: AUGUSTUS SAINT-GAUDENS

Dartmouth College, Hopkins Center Art Galleries, Hanover, New Hampshire

Reduced version of fig. 9

11. ROBERT LOUIS STEVENSON
Bronze, with gilt patina; D. *c.* 45.5 cm.
Markings
 upper left: TO ROBERT LOUIS STEVENSON
 below poem: MDCCCLXXXVII
 upper right: AUGUSTUS SAINT-GAUDENS
 lower border: COPYRIGHT AUGUSTUS SAINT-GAUDENS

Jay M. Morganstern, Hartsdale, New York

This is one of a group given different patinas, this one with a gilt patina.

bronze was given a green patina, instead of the gold color of the Barbedienne cast, and surrounded with a narrow border of red marble. Casts in bronze and plaster of the head alone exist in the Cornish collection. The plaster is taken directly from the model for the first version (fig. 19). Later reworked, it appears as a 30.5 cm. bronze medallion (fig. 20).

Reductions were made from a model of the first version with a different poem inscribed in the upper field. In fact, the phrases that had been eliminated from the first St. Giles version, beginning "Bright is the Ring of Words . . . ," were used on the reductions. Ardison was directed to get estimates from Victor Janvier on the cost of reducing the *Stevenson* on February 22, 1901. Two

weeks later Saint-Gaudens wrote that the estimates in New York were better than those in Paris and that he wanted to order not only the bronze models of the large and small *Diana*s and *Angel with the Tablet*, but also the Edinburgh *Stevenson*.

The bronze casts of the Edinburgh reduction were put on sale beginning in 1902 (fig. 21). They are all marked with the round copyright seal, the date 1900, and the name of the artist. To judge from the number of casts known at present, this edition may have been limited to ten. There is a unique bronze and corresponding plaster model in the Cornish collection. The bronze was presented by the artist to Mrs. Dodge, bearing the earlier (1887) relief's inscription, "Youth now flees . . . ,"

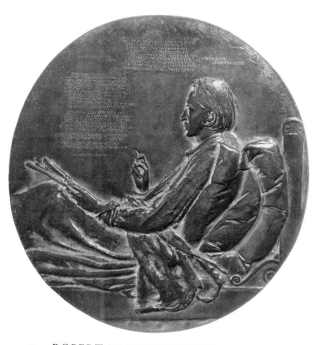

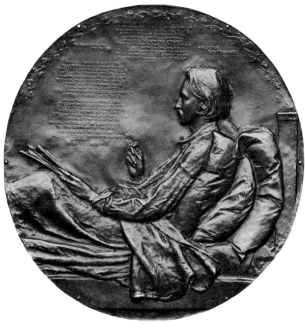

12. ROBERT LOUIS STEVENSON
Bronze; D. *c.* 30.5 cm.
Markings
 upper left: TO ROBERT LOUIS STEVENSON
 below poem: MDCCCLXXXVII
 upper right: AUGUSTUS SAINTGAUDENS

Yale University Art Gallery, New Haven, Connecticut

One of an edition in this size with decorative scroll in details of the bed

13. ROBERT LOUIS STEVENSON
Bronze; D. *c.* 45.5 cm.
Markings
 upper left: TO ROBERT LOUIS STEVENSON
 below poem: MDCCCLXXXVII
 upper right: AUGUSTUS SAINT-GAUDENS

John Howell—Books, San Francisco, California

Apparently unique cast in this size with different treatment of decorative detail

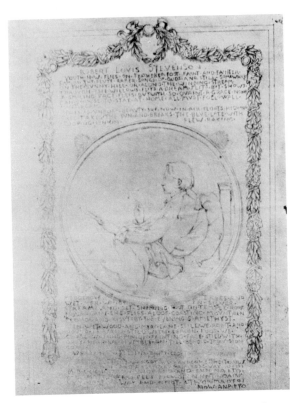

14. Preliminary drawings for the Stevenson Memorial in
St. Giles Cathedral, Edinburgh, Scotland

(not in exhibition)

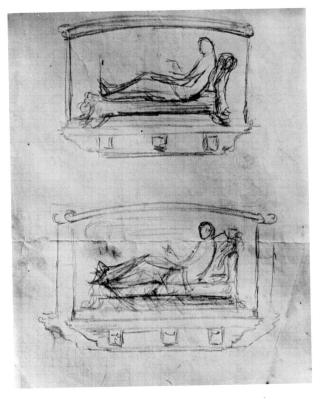

15. Preliminary drawings for the Stevenson Memorial in
St. Giles Cathedral, Edinburgh, Scotland

(not in exhibition)

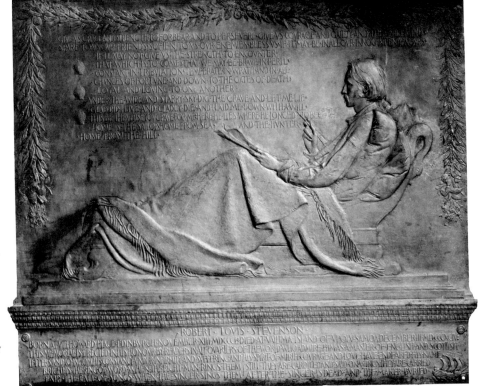

16. ROBERT LOUIS STEVENSON from a
photograph by deWitt Clinton Ward, c. 1900, print by
Peter Juley & Co., New York City

The photograph shows a bronze cast by the
Barbedienne foundry, Paris, of the first version of the
Stevenson Memorial for St. Giles Cathedral,
Edinburgh. This cast, no longer extant, has a word
misspelled in the lower inscription and was rejected by
Saint-Gaudens. Visible markings include at right,
platform level: AUGUSTUS SAINT-GAUDENS and
at left, platform level: PHILAM BARBEDIENNE.

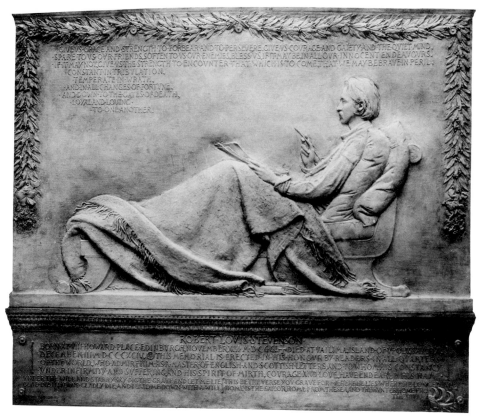

17. ROBERT LOUIS STEVENSON
Plaster; H. *c.* 172.7 cm.; w. *c.* 274.8 cm.
Markings
 lower left, lower tablet: AUGUSTUS SAINT-GAUDENS
 MDCCCLXXXVII · MDCCCCII

Saint-Gaudens National Historic Site, Cornish,
New Hampshire

Plaster exhibited at Buffalo, New York, Pan
American Exposition, 1902

(not in exhibition)

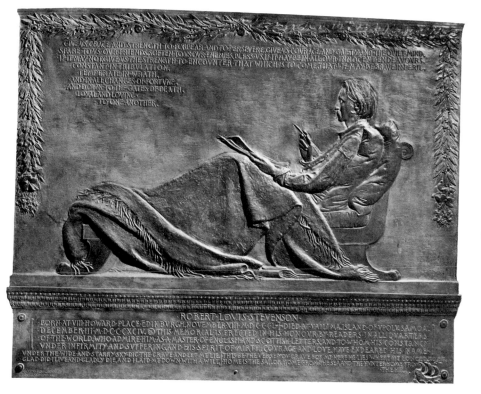

18. ROBERT LOUIS STEVENSON
Bronze; H. *c.* 172.7 cm.; L. *c.* 274.8 cm.
Markings
 lower left, lower tablet: AUGUSTUS SAINT-GAUDENS
 MDCCCLXXXVII · MDCCCCII

St. Giles Cathedral, Edinburgh, Scotland, *in situ*

Note final changes in head and hands have been
inserted into bronze.

(not in exhibition)

and the dedication to SARAH HOADLEY DODGE AND HER SON AND DAUGHTER CLEVELAND AND GRACE, MCMIV. There is also a plaster cast in the Beinecke Rare Book Library, Yale University, with a special dedication from Homer Saint-Gaudens to Jeanette Gilder, publisher of the literary magazine *Critic*, dated 1905.

Having come full circle, the so-called first version might more properly be listed last. An edition of reductions of the early design in the rectangular format were for sale simultaneously with the Edinburgh reduction in 1902. The latter had been made in Paris by Victor Janvier (as is noted on the back of a plaster model in the Cornish collection). The first mention of this reduction is in the correspondence with Ardison in which Saint-Gaudens spoke of a "galvano" or electrotype made of gilded copper (fig. 22). There is another electrotype in the former Luxembourg collection, Paris, which was one of fourteen such reductions of different subjects given to the French government by the artist following the 1900 Exposition, where they were all exhibited. An edition of bronzes was cast on the same scale as the electrotype and is identical in every way, except that it bears the

1899 copyright seal in the lower right hand corner. There exists at least one unique bronze of this type bearing the dedication across the top TO MARGARET AND ARTHUR FROM UNCLE AUGUSTUS, TWENTY-SEVENTH APRIL MC.M.V. (fig. 23).

In all the quite complicated sequences for this one subject it is obvious that no significant changes were made by the artist in the portrait itself. Changes do occur, however, in the decorative details, design, and style, adding new rhythm and color to the work. It is clear that most of these changes were a direct commercial technique for creating unique works or limited editions of a popular subject and conception. As the reliefs were made smaller, by reduction, they became almost illegible, and were heightened with patinas such as the oxidized silver, gold, and variegated greens, blues, and browns. The *Stevenson* in successive editions might be considered as a large medal, a symbol of an age when his poetry was so well known that there was no need for a truly legible inscription. The portrayal of a great writer, created with sensitivity by a famous sculptor, produced an image whose popularity virtually demanded multiplication.

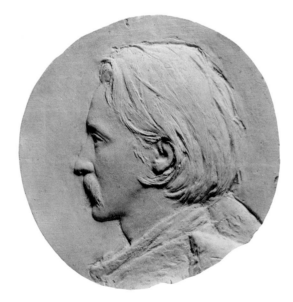

19. ROBERT LOUIS STEVENSON
Plaster; D. *c.* 26 cm.
No markings
Saint-Gaudens National Historic Site, Cornish, New Hampshire

Final model for head of Stevenson in St. Giles Memorial (compare with fig. 18)

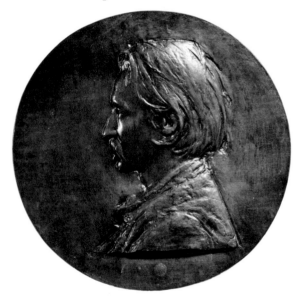

20. ROBERT LOUIS STEVENSON
Bronze; H. *c.* 30.5 cm.
Markings
 bottom center: copyright stamp with date
 MDCCCXCIX

Saint-Gaudens National Historic Site, Cornish, New Hampshire

Circular relief of head, reworked from final version of St. Giles Memorial

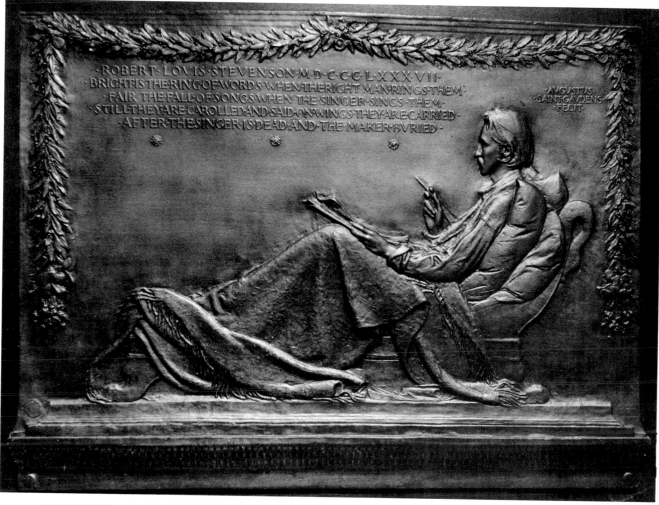

21. ROBERT LOUIS STEVENSON
Bronze; H. 43.2 cm.; L. 59.7 cm.
Markings
 across top, above poem: ROBERT LOUIS STEVENSON
 MDCCCLXXXVII
 upper right: AUGUSTUS SAINT-GAUDENS FECIT
 lower right: copyright seal with date MDCCCXCIX
 lower right: AUGUSTUS SAINT-GAUDENS

Harvard College Library, The Houghton Library,
Cambridge, Massachusetts

So-called Edinburgh reduction with copyright seal

· BRIGHT · IS · THE · RING · OF · WORDS · WHEN · THE ·
RIGHT · MAN · RINGS · THEM · / · FAIR · THE · FALL · OF ·
SONGS · WHEN · THE · SINGER · SINGS · THEM · /
· STILL · THEY · ARE · CAROLLED · AND · SAID · ON ·
 WINGS ·
THEY · ARE · CARRIED · / · AFTER · THE · SINGER ·
IS · DEAD · AND · THE · MAKER · BVRIED ·

 Robert Louis Stevenson, *Songs of Travel*, XV

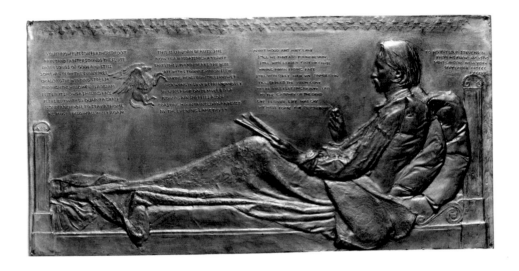

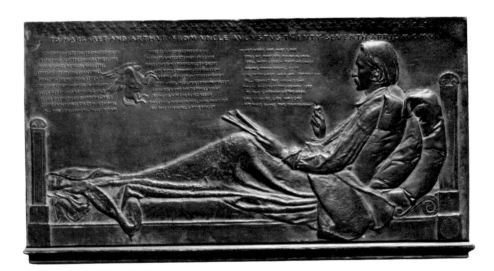

[Above]
22. ROBERT LOUIS STEVENSON
Gilded copper electrotype (galvano); H. *c.* 17.2 cm.;
L. *c.* 35 cm.
Markings
 upper right: TO ROBERT LOUIS STEVENSON FROM HIS
 FRIEND AUGUSTUS SAINT-GAUDENS NEW YORK
 SEPTEMBER MDCCCLXXXVII

Saint-Gaudens National Historic Site, Cornish,
New Hampshire

From an edition made in Paris by Victor Janvier from
the so-called first version design

[Below]
23. ROBERT LOUIS STEVENSON
Bronze; H. *c.* 16.8 cm.; L. *c.* 34.8 cm.
Markings
 across top: TO · MARGARET · AND · ARTHUR · FROM ·
 UNCLE AUGUSTUS · TWENTY · SEVENTH ·
 APRIL · MC · M · V
 lower right: copyright stamp with date
 MDCCCXCIX

Private Collection, Cambridge, Massachusetts

A unique bronze with special dedication

Diana

As early as 1893, the art critic Royal Cortissoz sought some understanding of the changes that take place in a sculptor's ideal over a lifetime, and presaged the goal of this study and exhibition. In an article entitled "The Metamorphosis of Diana" in *Harpers Weekly* (November 25, 1893), Cortissoz considered the only nude figure ever created by Augustus Saint-Gaudens.

With or without the sculptor's intention, the *Diana* quickly gained notoriety in New York from the day it was first installed atop the tower of Madison Square Garden. She became a symbol in the works of such writers as O. Henry and Willa Cather and the subject of many cartoons (fig. 24), editorial comment in the press, and public controversy. It is said that Ethel Barrymore was so enamored of her small bronze that she carried it with her on tour. *Diana* was an instant landmark, a happening, the first sculpture to be illuminated in modern times. And what is more, she turned in the wind.

Stanford White, one of the sculptor's closest friends, was the designer and chief proponent of the three-million-dollar Madison Square Garden which opened in 1891. The collaboration between sculptor and architect had begun as early as 1876, when Saint-Gaudens was working on several commissions for the architect Henry Hobson Richardson and White was a young draftsman in Richardson's office. One of their earliest projects together was the design for the *Farragut Monument* base, unveiled in 1881. White also designed a number of the frames for Saint-Gaudens' relief sculptures, including the one which surrounds the Princeton University Library *Stevenson*. Stanford White knew of Saint-Gaudens' desire to do ideal sculpture; and as the tower of Madison Square Garden was directly inspired by the tower of the Giralda in Seville, the architect quite understandably wanted his building also to have a revolving weathervane finial.

Although construction of the building did not begin until 1890, Saint-Gaudens had begun work in 1886 on his ideal image with the bust of his model and mistress Davida Clark. The bust is sometimes referred to as "Study for a Head" or "First Study for the Head of Diana" (fig. 25).

There is also a photograph of a clay sketch for a female figure, possibly a Diana, done about this time (fig. 26).

A photograph of an early plaster sketch model for the first figure of *Diana* (fig. 27) was enclosed by the architect Lionel Moses in a letter to Homer Saint-Gaudens dated March 5, 1909, when the latter was editing the *Reminiscences*. Moses commented:

. . . Your father himself, with the minutest care and most careful study, posed the little statue, spending a great deal of time in changing its position and moving

24. Anthony Comstock's and the League of Decency's objection to the nude *Diana* is reflected in the cover of the popular *Collier's* magazine by artist E. M. Kemble, August 25, 1906

201

25. STUDY FOR A HEAD
Marble; H. *c.* 27.7 cm.
No markings

Saint-Gaudens National Historic Site, Cornish,
New Hampshire

Possibly the first study for the head of *Diana*

26. Clay sketch, possibly for *Diana*
c. 1886
(no longer extant)

Photograph from Saint-Gaudens Collection, Dart-
mouth College, Hanover, New Hampshire

(not in exhibition)

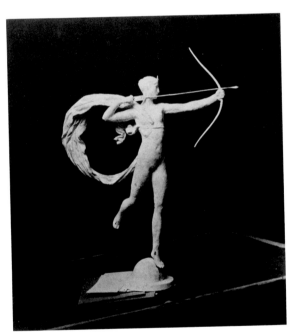

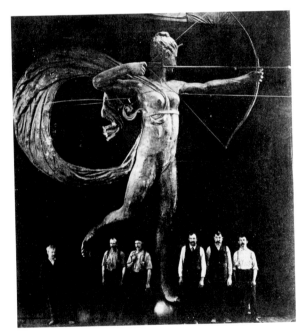

27. Early plaster model for the first figure of *Diana*, from
a photograph taken by Lionel Moses

(not in exhibition)

28. First version of *Diana*, H. *c.* 5.051 m. (18 ft.), prior to
installation on tower of old Madison Square Garden,
New York, in 1891. Constructed by the W. H. Mullins
Manufacturing Company, Salem, Ohio.

(not in exhibition)

it until it just suited his idea of how it should stand, and it was from this photograph, which I took and had enlarged, that the drawing was made by which the large statue on the tower was set.

The model was enlarged to 5.051 m. (18 ft.) and constructed of metal by the W. H. Mullins Manufacturing Company, Salem, Ohio (fig. 28). The figure weighed 1,800 pounds with its iron frame, armatures, and counterpoising. Made of 22-ounce copper, it was struck up in drop presses, using zinc male and female dies. The sections were then riveted together and brazed to make them weathertight. The piece was so designed that the drapery acted as a rudder with the bow and arrow as a pointer. Mounted on ball bearings, a wind pressure of one-quarter pound to the square foot was sufficient to move it (*Scientific American Architects and Builders Supplement*, XXXI [February 1892], 31). The figure had the additional device of a 3.655 m. (12 ft.) crescent below, containing sixty-six incandescent lamps. There were also four spotlights above the crescent. The complete figure was gilded to increase its visibility from the ground, 347 feet below.

The sculpture was not installed until October 1891. For this gala event, White made New York's first spectacular use of the Edison light, stringing 6,600 bulbs around the Garden's outer walls and lavishing 1,400 more on what the newspapers called his "pillar of fire." In addition, ten giant arc lights were trained on the weathervane (*New Yorker*, XLI (February 27, 1965), 63).

And yet the architect and sculptor were not satisfied with the results. Evidently an error in the disposition of the figure on the ball made it unbalanced. Moreover, as their painter friend Thomas W. Dewing predicted, the figure was too large, and *Diana* appeared to be out of proportion with the top of the tower. Another friend, architect George F. Babb, is quoted as saying:

Stan that was a beautiful pedestal you made for Saint-Gaudens' statue, but I thought he was going to make a finial for your tower. (Frederick P. Hill, *Charles F. McKim, the Man* [Francestown, New Hampshire, 1950])

On September 7, 1892, the sculpture was re-

moved from the tower. Because it was sent back to Ohio for correction of the problem, and since the firm of McKim, Mead and White was also designing one of the buildings for the World's Columbian Exposition in Chicago in 1893, they took the opportunity to install the repaired sculpture on the Agricultural Building at the Fair (fig. 29).

Saint-Gaudens began immediately to remodel a plaster for a new figure. The sketch, cast in bronze, now in the National Collection of Fine Arts in Washington, D.C. (fig. 30), differs from the earlier sketch in the position of the toe on the sphere and the elimination of the drapery. Both versions showed a crescent on the head of *Diana*. In retrospect, and in comparison to the later figure, the large, original *Diana* was uncomfortably awkward in pose—heavily proportioned and with an equally ungraceful swirl of drapery, which one critic thought resembled a teapot handle (see figs. 28, 31).

The new figure was to be 3.965 m. (13 ft.) in height and much lighter than the first version, perhaps weighing from 1,000 to 1,500 pounds. Remodeled, it was more graceful and lithe (fig. 31); the head was refined with a clearer rendering

29. Agricultural Building, World's Columbian Exposition, Chicago, Illinois, 1893, with original *Diana*, 5.051 m. (18 ft.)

(not in exhibition)

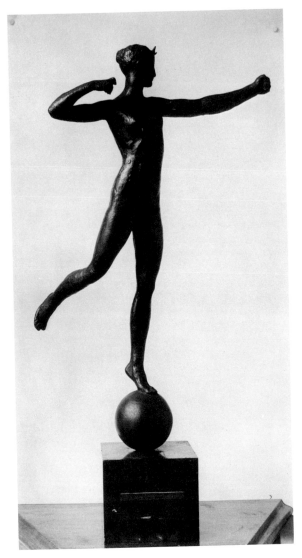

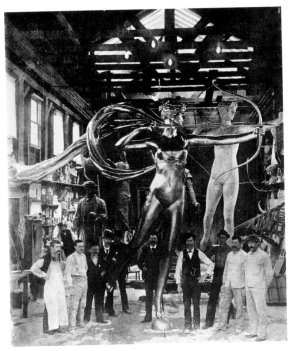

30. DIANA
Bronze; H. *c.* 51.2 cm. (top of head to toe)
No markings

National Collection of Fine Arts, Smithsonian
Institution, Washington, D.C.

Bronze, probably unique, cast from Saint-Gaudens'
first plaster sketch of the second 3.965 m. (13 ft.)
version of the weathervane. Purchased by John
Gellatly from the auction of the collection of Stanford
White, American Art Galleries, New York, November
27, 1907, no. 364.

31. Second version of *Diana*, sheet copper, H. *c.* 3.965 m.
(13 ft.), prior to installation on the tower of Madison
Square Garden, New York, 1891. W. H. Mullins
Manufacturing Co., Salem, Ohio

(not in exhibition)

204

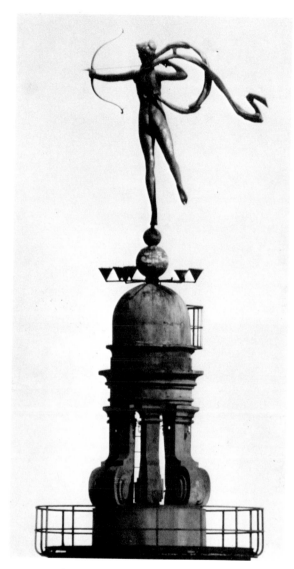

32. View of *Diana* (second version) installed on the tower
 of the old Madison Square Garden, New York

 First use of telephoto lens by deWitt Clinton Ward,
 photographer, New York, *c.* 1894

32a. Detail of fig. 32

205

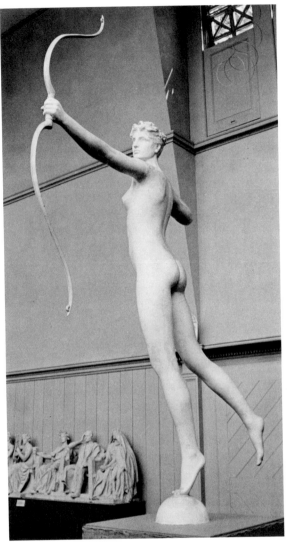

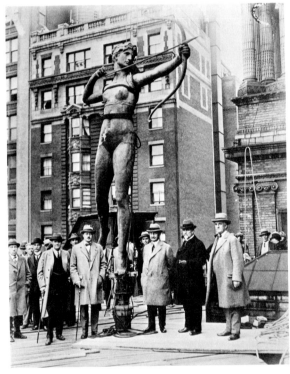

33. DIANA
Plaster; H. *c.* 1.830 m. (6 ft.) (top of head to toe)
No markings

Formerly *in situ*, Saint-Gaudens National Historic
Site, Cornish, New Hampshire

Half-size model for the second version of *Diana*

34. Second version of *Diana*, *c.* 3.965 m. (13 ft.), after
removal from the tower of Madison Square Garden,
New York, in 1925

(not in exhibition)

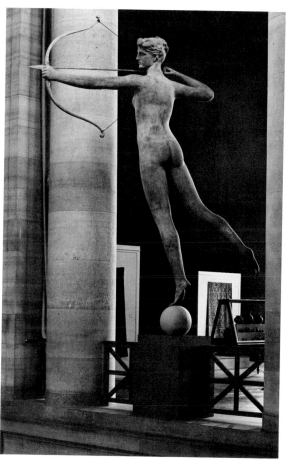

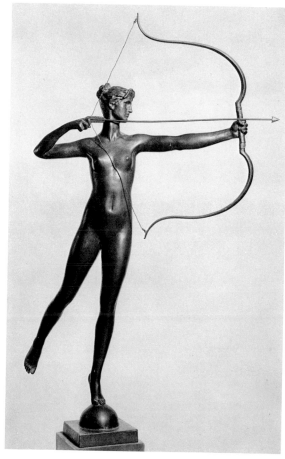

35. DIANA
 Sheet copper; H. *c.* 3.965 m. (13 ft.)

Philadelphia Museum of Art, Philadelphia,
Pennsylvania
Given by the New York Life Insurance Company

Removed from the tower in 1925, just before the
demolition of the old Madison Square Garden, this
Diana was given in 1932 by the New York Life
Insurance Company to the newly opened Philadelphia
Museum of Art.

(not in exhibition)

36. DIANA
 Bronze; H. *c.* 78.5 cm. (top of head to toe)
 Markings
 proper left side of half-sphere: C. A. SAINT GAUDENS
 (MDCCCXCV)

Chesterwood National Trust for Historic Preservation,
Stockbridge, Massachusetts

One of the first edition of reductions of the full figure.
Mentioned in later Saint-Gaudens correspondence as
the "large *Diana*"

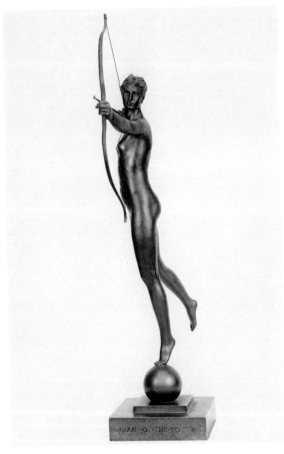

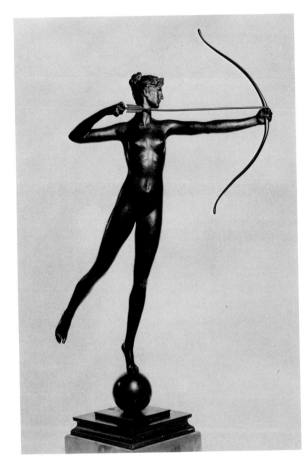

37. DIANA
 Bronze; H. *c.* 50.35 cm. (top of head to toe)
 Markings
 front of lower base: DIANA OF THE TOWER
 back of sphere: AUGUSTUS-SAINT-GAUDENS
 COPYRIGHT BY A. ST. GAUDENS 1899

Private Collection, Massachusetts

Note elaborate curve of bow, and the marble base
with bronze letters attached.

38. DIANA
 Bronze; H. *c.* 50.35 cm. (top of head to toe)
 Markings
 on base: AUGUSTUS SAINT-GAUDENS
 1894
 upper platform of base: Foundry Stamp, E. Gruet,
 Paris

Nichols House Museum, Boston, Massachusetts

Example of first type in the edition of "small *Diana*s."
Note shape of bow and arrow and two-tiered base
(see fig. 36)

of the hair, and the face was much thinner and more elegant. Instead of the balloon-like drapery, the sculptor introduced an elliptical, billowy, flowing train, tied casually at the breast. Altogether lighter and more willowy, this new *Diana* was installed on the tower November 18, 1893 (figs. 32, 32a).

An amusing account in the *New York Herald* of December 5, 1897, records the comments of a studio model, Julia (Dudie) Baird, who claimed to have posed for the second version. She said that Saint-Gaudens was in such a rush to finish the piece that plaster casts were actually taken directly from her body; and that as the figure was sent from Saint-Gaudens' studio, it was exactly her height, five feet, six inches! Although anything is possible, Miss Baird must have had to do some stretching, since the plaster from the Cornish collection (fig. 33) is the half-size model, and measures just over 1.830 m. (6 ft.) high. Another cast, made in cement, of this half-size model was presented to Stanford White by Saint-Gaudens in 1894. It was made by Walthausen, the New York plaster molder, and installed on the grounds of White's estate at St. James, Long Island.

The 3.965 m. (13 ft.) figure's drapery was lost in a heavy wind, and never replaced. In 1925, the figure was removed from the tower just before the building was demolished (fig. 34). In 1932 it was given to the newly opened Philadelphia Museum by the New York Life Insurance Company (fig. 35) after various attempts to reerect the tower and figure had failed.

It was in 1894, the same year that White received the cement cast, that Saint-Gaudens presented his wife, Augusta, with a Christmas present, "the little *Diana*, to do whatever you please with it." There is no photograph or description of the piece, nor has it been found in the collection at Cornish.

Saint-Gaudens took out a copyright on one *Diana* in January 1895, and although there is no photograph in the copyright files for this piece, it may be assumed to have been the first of the reductions of the full-standing figure. These bronzes were cast by Aubry Brothers in New York (fig. 36)

and measure 78.5 cm. in height, poised on a half-sphere. Figures this size in the collections of the Brooklyn Museum, Brooklyn, New York, and the Chesterwood National Trust for Historic Preservation in Stockbridge, Massachusetts, have the copyright of 1895 incised on the base. One bronze, formerly in the collection of McKim, Mead and White and now in the collection of Walker O. Cain, has the Aubry Brothers' name on the base. These were later referred to in Saint-Gaudens' correspondence with the dealers as the "large *Diana*." The cast from the sketch, like the one in the National Collection of Fine Arts, measures 51.2 cm. from the foot of the figure to the top of her head, and rests on top of a ball sphere. This is the same size as the so-called "small *Diana*."

On August 3, 1899, Saint-Gaudens wrote from Paris to his wife in Cornish. He mentioned the small *Diana*, for which he had just arranged a new pedestal and "remodeled the bow and hair carefully." In another letter from Paris to Doll & Richards, the Boston gallery, dated November 28, 1899, the sculptor wrote:

As you will see I have had a new pedestal for the small Dianas and an entirely new model. This had added a good deal to the expense of production and if you think it could be done I should like to have the price raised to $175.00.

Since the price they were quoting for the "small *Diana*" in August 1899 was $150, it is apparent that there was indeed an earlier edition of this figure. In the same letter of August 3, Saint-Gaudens told his wife that she should give her brother Tom Homer one of the earlier versions. He may have referred to the cast (fig. 37) now in a private collection in Massachusetts. As early as October 1898, he obtained estimates from Gruet in Paris for a "large *Diana*" with "pedestal and letters" and a "small *Diana*" without "pedestal and letters." Tom Homer's *Diana* has a marble base inscribed "Diana of the Tower" with attached bronze letters. An identical inscription appears on a tripod base used to mount another figure of the same size. The Nichols House Museum cast, by Gruet, has the 1894 copyright on the base, and may represent those earlier "small *Dianas*" with

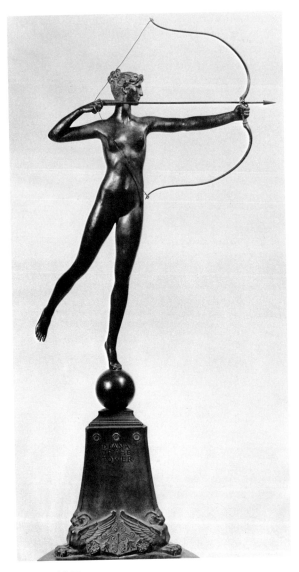

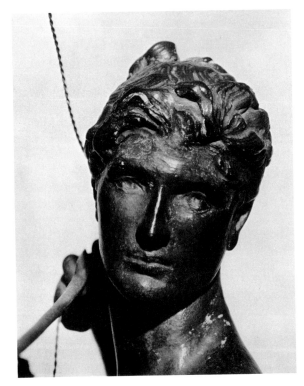

39a. Detail of fig. 39

39. DIANA
 Bronze; H. *c.* 50.35 cm. (top of head to toe)
 Markings
 front of tripod: DIANA OF THE TOWER
 top of lower base, proper right rear:
 AUGUSTUS SAINTGAUDENS
 MDCCCXCIX
 top of lower base, proper right: copyright stamp

 Private Collection, Cornish, New Hampshire

 Example of the edition of "small *Diana*," mounted
 on tripod base decorated with griffins.

quite different bow and arrow (fig. 38). However, the figures themselves are all apparently the same (viz. Nichols House Museum, Saint-Gaudens National Historic Site, Smith College, etc.). It is only in the bases and the bows and arrows that the changes occur (figs. 39, 39a). It is interesting to note, however, that the Smith College cast is fashioned with a gear-driven turning mechanism inside the tripod base to permit the figure to be rotated on the mount. A floral knob to initiate the motion is located on the proper left back face of the tripod base.

A fragmented plaster model (fig. 40) the same height as the "small *Diana*" was recently found in the studio of Louis Saint-Gaudens. It shows a very obvious change in the plaster itself; an alternative arrangement of the hair has been added to the older plaster model (fig. 40a). Perhaps it was this model to which the sculptor referred in the August 3, 1899, letter to his wife. In his November letter to Doll & Richards (quoted above) he was speaking of the model for the base which caused his extra expense and the rise in price for the "small *Diana*s." This new model with the change in the hair was used to cast the bronze that is now part of the collection of the National Gallery of Art in Washington, D.C. (fig. 41), and it, too, appears with the tripod base modeled in 1899. Another bronze from this model with the new hair style, formerly in the White family collection, was sold recently by the Davidson Gallery in New York.

To summarize, editions of the reductions of the *Diana* may be said to have come from three basic models: the large figure on a half-sphere, measuring approximately 78.5 cm. from toe to top of head; the smaller figure mounted on a whole sphere, 50.35 cm. (both dating from 1894 or 1895); and finally the last model, the same as the earlier "small *Diana*" except for the change in the hair style, dating from 1899. This last figure also measures 50.35 cm. in height.

All of these are hand-modeled reductions of the 3.965 m. (13 ft.) figure, and thus were not done mechanically as were some of the *Stevenson* reliefs.

After Saint-Gaudens' death in 1907, a small bust of *Diana* was cast in a bronze edition. Its model was the same plaster (with the new hair arrangement) as the last edition of "small *Diana*" figures, with the added modification of a small label-inscription, "Diana of the Tower," on its base (figs. 42, 42a). The copyright for the bust, issued to Mrs. Saint-Gaudens, was registered on October 21, 1907.

Also cast after the sculptor's death by his widow were bronze heads of the *Diana* (fig. 43), approximately life-size (24 cm. high), which were taken from the plaster half-size model for the full figure.

This plaster half-size model has been exhibited in the Cornish studios since 1916 (see fig. 33). A mold for it (and the one formerly in the Stanford White estate, St. James, Long Island, New York) was retained by the plaster molder Contini in New York and had been in the Contini studio as early as 1929 (Minutes of the Annual Meeting of the Trustees of the Saint-Gaudens Memorial, August 31, 1929). This mold was used to make a bronze for the Saint-Gaudens Memorial in Cornish. The bronze was cast in the Deprato Foundry, Pietrasanta, Italy, in 1973, and the mold has since been destroyed.

In 1928, the White family allowed the Metropolitan Museum of Art to make a bronze cast of the *Diana* from their half-size cement model. At the same time the family ordered a duplicate bronze for their own use. Both of these casts were made in Munich, Germany, by the Friessmann Baur Foundry.

The original 5.051 m. (18 ft.) figure, last exhibited at the Columbian Exposition in Chicago, was almost totally destroyed by successive fires in the deserted Fair buildings in 1894. Only a remnant, the top portion, was saved and exhibited as an uncatalogued item in the Saint-Gaudens retrospective exhibition held at the Art Institute of Chicago in 1909. Mrs. Saint-Gaudens' note to H. W. Kent, Secretary of the Metropolitan Museum of Art, dated September 9, 1909 (Metropolitan Museum Archives), mentions the exhibition of the remnant. It is apparently no longer in existence.

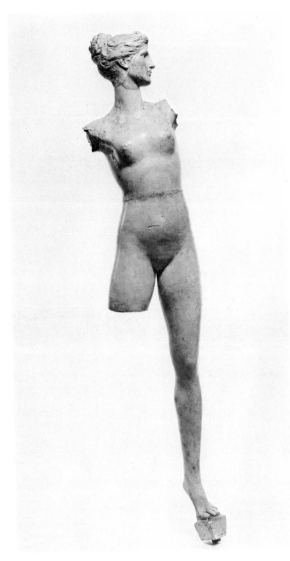

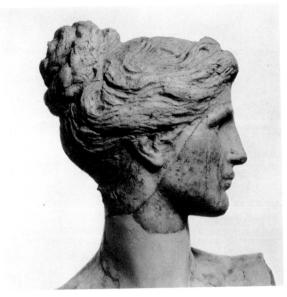

40a. Detail of fig. 40, showing cast plaster addition with change in treatment of hair

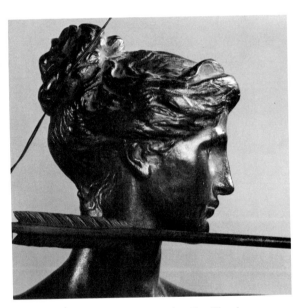

40. DIANA
 Plaster; H. *c.* 59 cm. (including mounting inset)
 No markings

 Saint-Gaudens National Historic Site, Cornish,
 New Hampshire

 Fragmented plaster model fashioned with separable
 parts (arms and proper right leg missing). A different
 color in the plaster shows where the hair has been
 remodeled. Evidently this model was used to cast an
 edition which includes the bronze *Diana* (fig. 41) now
 in the National Gallery of Art, Washington, D.C.

41. DIANA, detail of proper right side of head
 Bronze; H. (of full figure) *c.* 50.35 cm.
 Markings
 front of tripod base: DIANA OF THE TOWER
 top of lower base, proper right:
 AUGUSTUS SAINTGAUDENS MDCCCXCIX
 top of lower base, proper right rear: copyright stamp
 Foundry: E. GRUET JEUNE FONDEUR
 AVENUE DE CHATILLON
 PARIS

 National Gallery of Art, Washington, D.C.
 Former collection Jules Cambon

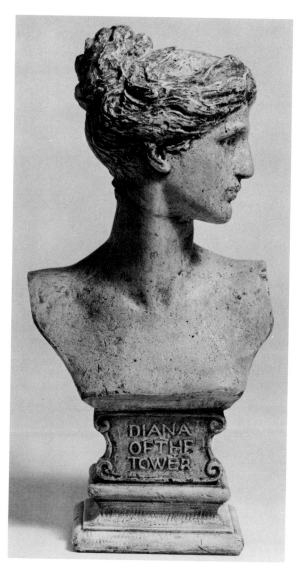

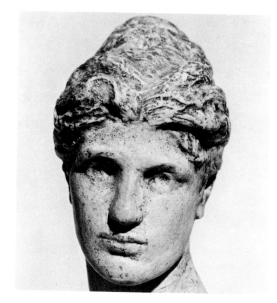

42a. Detail of fig. 42

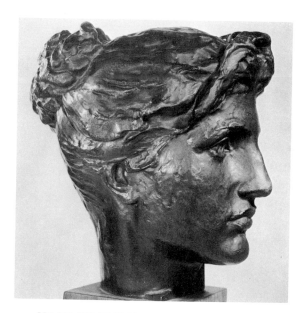

42. BUST OF DIANA
 Plaster; H. *c.* 19.05 cm. (including base)
 Markings
 front of base: DIANA OF THE TOWER
 proper left side of base: · A.SᵀG ·

 Saint-Gaudens National Historic Site, Cornish,
 New Hampshire

 Made from final version of small *Diana* (fig. 41)

43. HEAD OF DIANA
 Bronze; H. *c.* 24 cm.
 Markings
 proper left front of bronze support: ASᵗG monogram
 proper left of bronze support:
 COPYRIGHT MCMVIII BY
 A. H. SAINT-GAUDENS

 Fogg Art Museum, Harvard University, Cambridge,
 Massachusetts

 One of a posthumous edition of heads taken from the
 plaster half-size model for the second version of *Diana*

Selected Bibliography

In the section on Stevenson, I wish to thank Mr. Marvin Sadik for allowing us to use the material from the *Augustus Saint-Gaudens: The Portrait Reliefs* catalogue for the exhibition held at the National Portrait Gallery, Smithsonian Institution, November 1969, by John Dryfhout and Beverly Cox.

All quotations from letters in the text, unless otherwise noted, are in the Saint-Gaudens Family collection and the Records of the Trustees of the Saint-Gaudens Memorial, deposited with the Dartmouth College Library Special Collections Division, Hanover, New Hampshire.

James Earle Fraser Papers, Syracuse University Library, Syracuse, New York.

Daniel H. Burnham Papers, Ryerson Library, Art Institute, Chicago, Illinois.

Report of the General Manager, World's Columbian Exposition, Chicago, 1894, in the Ryerson Library, Art Institute, Chicago.

McKim, Mead & White Papers in the New-York Historical Society, New York City.

Royal Cortissoz Papers, Beinecke Library, Yale University, New Haven, Connecticut.

Saint-Gaudens Exhibition File, Metropolitan Museum of Art Archives, New York City.

Diana File, New York Life Insurance Company, Archives, New York City.

Manuscript letter, from Augustus Saint-Gaudens to George Benson, used by permission of the late Dr. Winthrop Wetherbee, Brookline, Massachusetts.

American Art Galleries. "Auction of the Collections of Stanford White," New York, November 27, 1907.

Blackmur, H. P. "The Virgin and the Dynamo." *Magazine of Art*, April 1952, pp. 147–153.

Cary, Edward. "Letters to the Editors, The Diana of the Tower." *Century Magazine*, XLVII, New Series v. XXV (January 1894), 477.

Colvin, Sidney (ed). *Letters of Robert Louis Stevenson to Friends and Relatives*. New York: Charles Scribner's Sons, 1899. 2 vols.

Cortissoz, Royal. "The Metamorphosis of Diana." *Harpers Weekly*, XXXVII (November 25, 1893), 1124.

Hill, Frederick P. *Charles F. McKim: The Man*. Francestown, New Hampshire, 1950.

Hoffman, Malvina. *Sculpture Inside and Out*. New York: W. W. Norton & Co., 1939.

Indianapolis Star, February 28, 1910 (Interview with Gaetan Ardison).

Logan, Andy. "That Was New York: The Palace of Delight." *New Yorker*, XLI (February 27, 1965), 63.

Low, Will H. *A Chronicle of Friendships, 1873–1900*. New York: Charles Scribner's Sons, 1908.

"Madison Square Garden Weather Vane." *Scientific American: Architects and Builders Supplement*, XIII (February 1892), 31.

Metropolitan Museum of Art, New York. *Catalogue of a Memorial Exhibition of the Works of Augustus Saint-Gaudens, March 3 – May 31, 1908*. Second edition printed by D. B. Updike, The Merrymount Press, Boston, 1908.

New York Herald, December 5, 1897 (Interview with Julia Baird).

Saint-Gaudens, Homer (ed). *Reminiscences of Augustus Saint-Gaudens*. New York: Century Company, 1913. 2 vols.

Checklist of the Exhibition

ROBERT LOUIS STEVENSON

2. Bronze; D. *c.* 91.5 cm.
 Princeton University Library, Princeton, New Jersey

4. Bronze; D. *c.* 91.5 cm.
 Upland Country Day School, Kennett Square, Pennsylvania
 There are three similar examples in bronze and three similar examples in plaster presently known.

6. Bronze; D. *c.* 91.5 cm.
 Saint-Gaudens National Historic Site, Cornish, New Hampshire

8. Bronze; D. *c.* 45.5 cm.
 Nichols House Museum, Boston, Massachusetts

9. Bronze; D. *c.* 45.5 cm.
 Museum of Art, Carnegie Institute, Pittsburgh,
 Pennsylvania

 There is one other example presently known.

10. Bronze; D. *c.* 30.5 cm.
 Dartmouth College, Hopkins Center Art Galleries,
 Hanover, New Hampshire

 There are two similar examples presently known.

10a. Bronze; D. *c.* 45.5 cm.
 Markings
 upper left: TO ROBERT LOUIS STEVENSON
 below poem: MDCCCLXXXVII
 upper right: AUGUSTUS SAINTGAUDENS
 lower border: COPYRIGHT AUGUSTUS
 SAINTGAUDENS
 Harvard College Library, The Houghton Library,
 Cambridge, Massachusetts

 From an edition made after 1898

11. Bronze, with gilt patina; D. *c.* 45.5 cm.
 J. M. Morganstern, Hartsdale, New York

 There are twenty-three similar examples presently
 known.

11a. Unsealed plaster mold, positive and negative;
 D. *c.* 46 cm.
 Markings
 negative reverse (incised in plaster): worn out mold
 positive reverse (in pencil): BEST MODEL FOR BRONZE
 below (incised in plaster): STEVENSON TO. MAKE –
 NEW. MOLD ONLY!
 Foundry instructions written left and right side of
 positive obverse in French
 Saint-Gaudens National Historic Site, Cornish,
 New Hampshire

 The hands, head, and areas of dedication are plaster
 insets.

11b. Plaster negative mold; D. *c.* 46.4 cm.
 Markings
 proper right side (inset plaster dedication):
 TO
 CONSTANCE. HOMER
 IN. LOVING. MEMORY
 OF. UNCLE. AUGUSTUS
 MAY. XVIII.M.C.M.XII
 on reverse (in pencil): STEVENSON
 Saint-Gaudens National Historic Site, Cornish,
 New Hampshire

 Unique negative mold used to make foundry positive
 plaster model with specific dedication

12. Bronze; D. *c.* 30.5 cm.
 Yale University Art Gallery, New Haven,
 Connecticut

There are ten similar examples with copyright stamp
added, and three similar plaster examples presently
known.

12a. Plaster cast positive; D. *c.* 30.5 cm.
 Markings
 upper left: TO ROBERT LOUIS STEVENSON
 below poem: MDCCCLXXXVII
 upper right: AUGUSTUS SAINT.GAUDENS
 Saint-Gaudens National Historic Site, Cornish, New
 Hampshire

 Plaster cast positive with plaster insets in areas of
 hands and head.

12b. Plaster cast positive model; D. *c.* 30.5 cm.
 Markings
 obverse side:
 upper left: TO ROBERT LOUIS STEVENSON
 below poem: MDCCCLXXXVII
 upper right: AUGUSTUS SAINT.GAUDENS
 reverse side: STEVENSON
 MODEL FOR BRONZE
 EDGE TO BE TRIMMED (in script)
 Saint-Gaudens National Historic Site, Cornish, New
 Hampshire

13. Bronze; D. *c.* 45.5 cm.
 John Howell—Books, San Francisco, California

19. Plaster (head only); D. *c.* 26 cm.
 Saint-Gaudens National Historic Site, Cornish, New
 Hampshire

20. Bronze (head only); D. *c.* 30.5 cm.
 Saint-Gaudens National Historic Site, Cornish, New
 Hampshire

21. Bronze; H. *c.* 43.2 cm.; L. *c.* 59.7 cm.
 Harvard College Library, The Houghton Library,
 Cambridge, Massachusetts

 There are four similar examples in bronze and two
 similar examples in plaster presently known.

21a. Eight positive sections in plaster, seven of which have
 corresponding negative molds, probably used as blanks
 in the reduction process. These plaster sections relate
 to the first version of the St. Giles Memorial relief.
 When assembled they would make up a unit of a
 dimension corresponding to the bronze cast reduction
 (fig. 21). Saint-Gaudens National Historic Site,
 Cornish, New Hampshire.

22. Gilded copper electrotype (galvano); H. *c.* 17.2 cm.;
 L. *c.* 35 cm.
 Saint-Gaudens National Historic Site, Cornish, New
 Hampshire

23. Bronze; H. *c.* 16.8 cm.; L. *c.* 34.8 cm.
 Private Collection, Cambridge, Massachusetts

23a. Plaster cast positive; H. *c.* 16.8 cm.; L. *c.* 34.8 cm.
Markings:
across top:
TO · MARGARET · AND · ARTHUR · FROM ·
UNCLE AUGUSTUS · TWENTY · SEVENTH · APRIL ·
MC · M · V.
lower right: copyright stamp with date MDCCCXCIX
Private Collection, Cambridge, Massachusetts
Possible trial proof held aside to make new negative
molds for electrotyping

23b. Plaster mold (negative); H. *c.* 16.8 cm.; L. *c.* 34.8 cm.
Markings
across top:
TO · MARGARET · AND · ARTHUR · FROM ·
UNCLE AUGUSTUS · TWENTY · SEVENTH · APRIL ·
MC · M · V.
lower right: copyright stamp with date MDCCCXCIX
Saint-Gaudens National Historic Site, Cornish, New
Hampshire
Negative corresponds to positive plaster model in 23a.
Dedication appears to have been incised in reverse in a
negative electrotype mold model similar to this mold.

23c. Plaster model (positive); H. *c.* 16.8 cm.; L. *c.* 34.8 cm.
Markings
on reverse (in black grease pencil):
STEVENSON
FIRST. MODEL. FROM JANVIER
on obverse:
lower right hand corner: circular copyright
copper or bronze inset
Saint-Gaudens National Historic Site, Cornish, New
Hampshire

DIANA

25. Marble (study for a head); H. *c.* 27.7 cm.
Saint-Gaudens National Historic Site, Cornish, New
Hampshire

30. Bronze; H. *c.* 51.2 cm.
National Collection of Fine Arts, Washington, D.C.

33. Plaster; H. *c.* 1.830 m. (6 ft.)
Saint-Gaudens National Historic Site, Cornish, New
Hampshire

36. Bronze; H. *c.* 78.5 cm.
Chesterwood National Trust for Historic Preservation,
Stockbridge, Massachusetts

36a. Bronze (gold patina); H. *c.* 78.5 cm.
Markings
on back of base: AUGUSTUS SAINT-GAUDENS 1895

The Brooklyn Museum, R. B. Woodward Memorial
Fund, Brooklyn, New York

36b. Plaster cast; H. *c.* 80 cm.
No markings
Saint-Gaudens National Historic Site, Cornish, New
Hampshire
Plaster cast made from plaster piece mold (see 36c)

36c. Plaster piece mold (ten pieces) of head section of 36b
No markings
Saint-Gaudens National Historic Site, Cornish, New
Hampshire

37. Bronze; H. *c.* 50.35 cm.
Private Collection, Massachusetts

38. Bronze; H. *c.* 50.35 cm.
Nichols House Museum, Boston, Massachusetts
There is one similar example known.

39. Bronze; H. *c.* 50.35 cm.
Private Collection, Cornish, New Hampshire
There are six similar examples presently known.

39b. Bronze; H. *c.* 50.35 cm.
Markings
front of tripod: DIANA OF THE TOWER
top of lower base, proper right rear:
AUGUSTUS SAINTGAUDENS
MDCCCXCIX
front top lower base proper left side: bronze or
copper circular copyright inset
top left back corner base platform:
stamped AUBRY BROS
FOUNDERS, N.Y.
Smith College Museum of Art, Northampton,
Massachusetts
There is a mechanism in tripod base for revolving
figure.

39c. Bronze; H. *c.* 50.35 cm.
Markings
front of tripod: DIANA OF THE TOWER
top of lower base, proper right rear:
AUGUSTUS SAINTGAUDENS
top of lower base, proper left side front:
copyright
A. SAINT-GAUDENS
MDCCCXCV
top of lower base, proper left side rear:
GRUET (Foundry stamp)
Collection of Mrs. Philip H. Faulkner, Dublin, New
Hampshire

40. Plaster; H. *c.* 59 cm.
Saint-Gaudens National Historic Site, Cornish, New
Hampshire

41. Bronze; H. *c.* 50.35 cm.

National Gallery of Art, Washington, D.C.

There is one other example presently known.

42. Plaster bust; H. *c.* 19.05 cm. (including base)
Saint-Gaudens National Historic Site, Cornish, New Hampshire

42b. Bronze bust (founder's model?) with rods extending from head and shoulders; H. *c.* 19.05 cm. (including base)
Markings
 front plinth: DIANA OF THE TOWER
 proper left: Artist's monogram A.S^t.G.
 back: COPYRIGHT BY
 A.H.SAINT-GAUDENS
 M.C.M.VIII
Saint-Gaudens National Historic Site, Cornish, New Hampshire

There are eight similar examples presently known.

42c. Plaster piece mold for bust; H. *c.* 19.05 cm.
Markings
 front plinth: DIANA OF THE TOWER
 proper left: artist's monogram A.S^t.G.
 back side (incised in reverse):
 TO. IDA.METZ.REED
 IN.AFFECTIONATE.
 APPRECIATION. FROM AUGUSTA.
 H. SAINT-GAUDENS
 CHRISTMAS. MC.M.VII
Saint-Gaudens National Historic Site, Cornish, New Hampshire

Plaster piece mold including mother mold.

43. Bronze (head); H. *c.* 24 cm.
Fogg Art Museum, Harvard University, Cambridge, Massachusetts

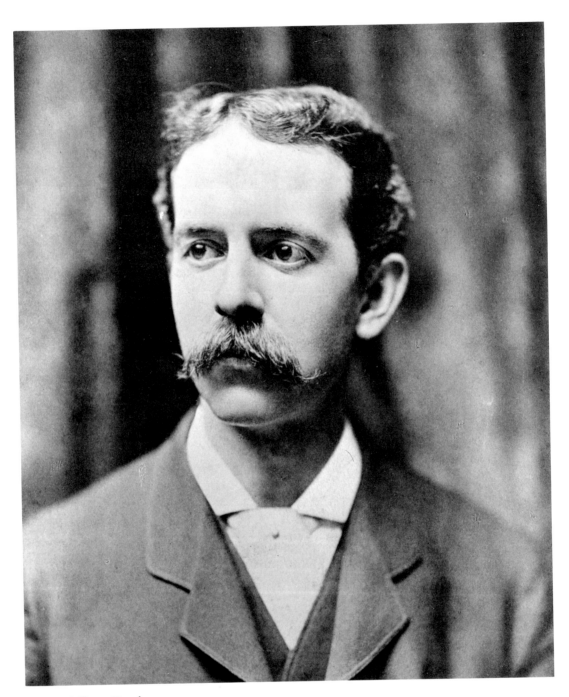

1. Daniel Chester French
 Mounted photograph by H. G. Smith, 1882
 Inscribed in French's hand: *D.C.F.* / *June 1882*

 Archives, Chesterwood, Stockbridge, Massachusetts

Daniel Chester French
1850–1931

Daniel Chester French (fig. 1) was born in Exeter, New Hampshire, on April 20, 1850, the son of Anne Richardson and Henry Flagg French. His youth was spent in Cambridge, Amherst, and Concord, Massachusetts. Upon graduating from high school, he enrolled at the Massachusetts Institute of Technology where a disastrous academic career of two semesters ended in the spring of 1868. His interest in sculpture was initially fostered by May Alcott, who gave young French modeling tools, clay, and some elementary instruction. By the winter of 1869, he had executed a portrait bust of his father and a relief of his sister, Sarah. One month as an apprentice in John Quincy Adams Ward's New York studio during March and April of 1870, and two winters as a special student of the anatomical draughtsman and sculptor William Rimmer, were the extent of French's formal art training.

After the successful completion of the *Minute Man* (1873–1875) for his native Concord, the young sculptor was inspired to travel to Europe, choosing to study his craft in Florence, rather than in Paris. Returning to America after twenty months, French executed decorative groups for government buildings in Saint Louis, Philadelphia, and Boston from November 1876 until June 1883. During this period a series of remarkable portrait busts—*Amos Tuck, John Elliott Cabot, Ebenezer Hoar,* and *Ralph Waldo Emerson*—were produced. Commissions for public monuments came sporadically: *John Harvard* for Harvard University (1883–1884); *Lewis Cass* for the United States Capitol (1886–1889); the *Thomas Gallaudet Memorial* in Washington, D.C. (1887–1889); and the *Milmore Memorial* in Jamaica Plain, Massachusetts (1889–1892). During these years favorable response in the press secured French a prominent place among America's sculptors.

French was an extremely prolific artist from the opening of the World's Columbian Exposition in Chicago in 1893 until his death on October 7, 1931. Maintaining a studio in New York City, where he had moved in 1888, and a summer studio after 1897 in Stockbridge, Massachusetts, French executed nearly one hundred portrait statues, allegorical memorials, and architectural sculptures. This prodigious output was not supported by a large studio staff; to the contrary, only one assistant was employed on any given project. French's ability to conceive the finished form and character of a monument in a small sketch enabled the process of enlargement to be an efficient rather than a painstakingly creative act.

His portrait memorials include the *Ulysses S. Grant Equestrian* (1893–1899) in Philadelphia, Pennsylvania (the collaborative contribution of Edward Clark Potter is formally recognized); the *Abraham Lincoln* (1909–1912) in Lincoln, Nebraska; the *Wendell Phillips* (1913–1915) in Boston; and the seated *Lincoln* (1915–1922) in the Lincoln Memorial, Washington, D.C.

The sculptor's architectural masterworks are the *Doors* for McKim, Mead, & White's Boston Public Library (1894–1904) and the *Four Continents* for Cass Gilbert's United States Custom House (1903–1907) in New York City.

He excelled as an allegorical sculptor in monuments like the *John Boyle O'Reilly Memorial* (1893–1896) in Boston; the *Melvin Memorial* (1907–1909) in Concord; the *Spencer Trask Memorial* (1913–1915) in Saratoga Springs, New York; and the *First Division Memorial* (1921–1924) in Washington, D.C. After 1907 he was regarded as this country's foremost sculptor.

French's career spanned six decades. Several of his assistants—Andrew O'Connor, Henry Augustus Lukeman, Adolph Alexander Weinman, Evelyn Beatrice Longman, and Edmond T. Quinn—attained some prominence as twentieth-century monument makers. French's professional accolades were numerous; he was the first American

sculptor to win a medal at the Paris Salon, the honorary president of the National Sculpture Society, and the second chairman of the Commission of Fine Arts. From 1903 until 1931 he served on the Board of Trustees of the Metropolitan Museum of Art in New York and, in his capacity as chairman of the Committee of Sculpture, he formed one of this country's important collections of American sculpture and organized the great Saint-Gaudens retrospective exhibition of 1907–1908.

Throughout his career of sixty-two years, Daniel Chester French's working methods remained constant. The first step in the production of a statue was to execute a small sketch in clay. (There is one reference in a letter to his brother, William Merchant Richardson French, to his experiments with modeling wax; occasional plasticine studies for projects begun toward the end of his life survive at Chesterwood.) The clay would be cast in plaster, from a waste mold, often with the addition of iron rods in the cast for reinforcement. A working model, anywhere from two to three times the size of the first study, would be executed by the sculptor and subsequently cast. The preparation of the full-scale or half-size clay model was the responsibility of an assistant, with French involved only at the final stages of the enlargement process. All statues in bronze required a full-scale model, while a smaller model sufficed for works to be carved in marble. (In the case of both the *Emerson* and *Memory*, however, the marbles were carved from full-size models.) With the completion of the final clay version the statue was again cast in plaster, but this time in sections, held together by pinned "Roman joints." This procedure facilitated the transportation to the foundry or carver.

In the spring of 1881, French hired his first assistant, Frank Edwin Elwell, to help with the half-scale enlargements of the groups that were to decorate the United States Post Office and Subtreasury in Boston, Massachusetts.[1] During the winter of 1883–1884 another sculptor, Edward Clark Potter, worked on the large clay of the *John Harvard*.[2] Potter's relationship with French developed from assistant to collaborator. The two

executed together four groups for entrances of the Agriculture Building and a *Quadriga* for the 1893 Chicago Fair, as well as four equestrian monuments.[3]

After 1897 French maintained a studio in New York City from November to May and worked during the summer months in Stockbridge. It was not unusual for several projects to be in progress simultaneously; and at these times French kept more than one assistant. Occasionally the sculptor might return to New York to oversee the completion of a statue, but work begun at Chesterwood was finished by the end of the season. Of the several assistants who worked briefly for French, Paul Manship and Adolph Alexander Weinman are the most notable. In fact, the master was so pleased with the enlargements of the half-scale models for the *Continents* that he added Weinman's name to the bases of the four groups. Often, French, if unable to accept a commission, would urge a prospective client to consider Andrew O'Connor, Augustus Lukeman, or Evelyn Longman. He frequently agreed to supervise, providing a younger sculptor with welcome professional support.[4]

During the six decades of French's sculptural activity he employed several plaster casters. Throughout his years in Concord and Boston, French relied exclusively on the services of Paul A. Garey, whose professional credentials, at least in 1874, identified him as an "Importer and Dealer in Antique and Modern Statuary," a seller of "English, French, and American Plaster at Wholesale and Retail," who was also able to pack, unpack, and ship marble statuary.[5] Garey's working methods are described in a letter French wrote to a client:

. . . I was to furnish you with one bust in plaster. That one was made from the clay by means of a "waste mould" as it is called, from which only one cast can be made. [The clay] is destroyed in removing it from the cast, and it is impossible to make a mould on the clay that can be used more than once, as the surface of the clay is so soft and easily injured.

Upon this first plaster . . . , a "gelatine mould" is made by making what Garey calls a "shell," (a plaster form large enough to enclose the bust, with an inch

space between) and filling the space between it and the bust with a preparation of glue. This mould is elastic, like rubber, and admits of a number of casts being made—from five to ten.[6]

In his studios in New York City and Stockbridge, French had special rooms where plaster casting could be undertaken, and two workmen—Eugenio Contini and Vicenzo Russo—seem to have been regularly employed. Interestingly, there is not a single reference to either in the Account Book; their identity was learned through French's correspondence.[7] Among other artisans paid for part-time work were Walthausen, Moynihan, Mascetti, and Kawamura.[8]

None of the documentation suggests who was responsible for casting the second or third version of *Emerson*, the seated statue, the late bust, or the large *Memory*. Production of the first plasters of the *Emerson* bust must have been Garey's responsibility. The control of manufacture was retained by the sculptor, but French seems to have been divorced from the actual reproductive process. Several letters in the French Family Papers at the Library of Congress clarify this business relationship. To his brother, William Merchant Richardson French, the sculptor wrote on August 22, 1879, ". . . I have sold one or two plaster casts of the Emerson bust at $30.00. If you see anybody [in Chicago] who wants one at that price let me know."[9] Two months later, Henry French corresponded with his son: "Send me a bust of Emerson to my address at the Treasury Department and bill the U.S. in your name or Garey's for $30.00 and your country will pay for it."[10] In May 1880, French notified William: "I will send the bust as soon as it is ready—the middle of next week. Price $30.00. I am obliged to you for the commission."[11] The following year a perplexed Henry French queried: "Who do you think will buy 15 Emersons?"[12]

The production of plaster casts continued after the marbles were ordered and the two versions in bronze were conceived. In March 1886 French asked his brother if he wished to order additional busts as "I have just had a fresh lot cast!"[13] Several years after French left Concord, Doll & Rich-

ards reported that a bust of *Emerson* (catalogue number 564), "consigned by and for sale for the account of Daniel C. French," was sold on January 9, 1894, for $30.[14] That the cost remained constant suggests that Garey and not the firm of P. P. Caproni and Bro. was responsible for the production. Caproni sold a commercial copy of the bust (in a 1911 catalogue the number was given as 5460) for $15,000.[15]

The decision to sell plaster replicas of the *Emerson* seems to have been made in large part to help develop a market for a marble bust. During the 1880s all of French's portraits—with only two exceptions, the reworked *Emerson* and a bust of Amos Bronson Alcott (1889)—were conceived in clay for translation into marble. Two letters indicate how French wished to have this metamorphosis accomplished. To a client and friend, George Frisbie Hoar, the artist wrote:

As I told you the other day, $350.00 would certainly cover all the expenses of the work and it might not cost more than $250.00. This wide difference is due to the uncertainty of the marble, which now and then turns out to be worthless after much time and labor have been expended upon it, and it is necessary to begin anew on another block.

I have always sent my marbles to Italy to be cut, as being cheaper, and in general more satisfactory. . . .[16]

A letter written eighteen months earlier to a Concord official, Reuben N. Rice, who was awaiting a marble *Emerson*, further clarifies French's attitude toward having his busts carved in Italy. It suggests under whose guidance and jurisdiction this work was accomplished.

It mortifies me that the bust should be so tardy and I am sorry I must ask your patience a little longer.

The bust was nearly done, if I remember rightly, the first of Sept. when Mrs. [Thomas] Ball wrote that they should send it with a statue that is to come as soon as the letter was finished. I wrote back to send it without waiting for the statue and in due time (a month after) got Mrs. Ball's reply that I had not sent the necessary certificate. This was her mistake. I then saw Mr. Ball who was in Boston and about to return to Florence, explained matters to him and told him to

send things along as soon as possible. I have not heard from him and cannot understand the delay.

Having my marble work done in Italy has its inconveniences, but both marble and workmanship are far superior to what I could get here.[17]

Efforts to trace the artisans responsible for carving French's marbles have been inconclusive. In 1878, the hiring of carvers to execute the *Awakening of Endymion* (1875–1879) was conducted by Preston Powers, the son of the noted neoclassical sculptor Hiram Powers and a neighbor of Thomas Ball in Florence. It is quite possible that French shared the services of Ball's and Powers' carvers.[18] From 1888, with the arrival of the Piccirilli family—the father and six sons—in New York City, talented Italian craftsmen were accessible to American sculptors.[19] Daniel Chester French was one of the first to discover these artisans and, as his Account Book verifies, nearly all of his marble carving after 1901 was executed by the Piccirillis.[20]

French was always pleased with the performance of American foundries. With the single exception of the *Milmore Memorial*, which was cast in Paris by E. Gruet Fondeur, the sculptor's public monuments were put into bronze in this country. Nine firms—Ames, Bureau Brothers, Gorham, Henry-Bonnard, A. Kunst, M. H. Mosman, Roman Bronze Works, John Williams, and B. Zoppo—cast French's statues, statuettes, and busts. Again the Account Book documents the artist's practice of seeking bids from foundries whose credentials and competency were recognized and then accepting the lowest bid received. Since the majority of American companies were located in metropolitan New York, it is possible that a representative might have come to the sculptor's studios. A letter written to Eugene F. Aucaigne of the Henry-Bonnard Bronze Company is illuminating.

. . . I regret extremely that I forgot my promise to let you have another chance to see the Wolcott statue before giving out the commission; but your price was so much higher than either of the other estimates that I received, that I felt that there was no chance of your coming to my terms, besides you know I am averse to bargaining or to asking a reduction on an estimate.[21]

When choosing foundries for his smaller works, French was motivated strictly by price. The Account Book entry for the bust of Emerson records the casting fees of four companies: Henry-Bonnard, $100; John Williams, $65; Gorham, $105; and B. Zoppo, $60. The first and second prices appear to have been entered in 1910, at the time French introduced this category in the ledger. The sculptor's third entry stated that the Gorham Company was paid that amount on February 24, 1919. The last foundry charge was recorded in February 1920.[22] Regrettably the information in the Account Book provides limited assistance in determining the production sequence of the *Emerson* bronzes. For example, the bust at Williamsport High School, Williamsport, Pennsylvania, a Zoppo casting, was a gift to the school by the sculptor on July 1, 1918 (see figs. 13, 13a).

The selling price of the bust increased steadily from 1910 until the sculptor's death. On September 21, 1910, French recorded that the Gorham Company sold one bronze (apparently not cast by this firm) for $200 and received a 30 per cent commission. On making this entry, the sculptor indicated that he had asked Gorham to increase the price to $225; their commission was reduced to 25 per cent. In February 1919, the price was set at $250, and two years later, French noted that a bronze had been sold for $300. Although this is the final entry under the "Bust of Emerson" heading, bronzes were still for sale after May 30, 1921. In fact, less than a year passed before the sculptor noted that the price was raised to $500.[23] The last price increase contemplated was recorded on the reverse of a photograph of the first plaster (figs. 2, 3). The amount proposed was $600.

The sale and distribution of the Emerson bronzes was not a lucrative enterprise for French. By 1910 three companies—Theodore B. Starr, Tiffany, and Gorham—were authorized to sell the head, but during the eleven years the *Emerson* entry was maintained, Gorham and Starr sold only one bronze apiece and French sold but two. (This practice was used with the plasters. Doll & Richards as well as A. Williams and Company

were permitted to sell the bust, but French also acted as his own business agent.)[24] Of the bronzes extant, more were gifts of the sculptor than commissioned sales for a dealer.[25] This method of operation strongly suggests that French must have retained a few bronzes ordered directly from the foundries. To ask a commercial gallery to forego its commission would not have been an acceptable business practice for any sculptor. During the 1920s French's bronzes were sold through the Grand Central Gallery and the Ferargil Gallery. Only one *Emerson* was sold by the former in December 1930.[26]

Unquestionably the multiplication of the *Emerson* portrait was not inspired by dreams of instant wealth. It would be naive, however, to think that French was unaware of the financial potential of the reproductive process. As a novice sculptor in Concord, French began his career as a maker of decorative figurines. These Parianware groups, designed between 1870 and 1873, were manufactured in England. All of French's models were copyrighted at the Library of Congress, but his American agent, Nathaniel Plympton, was able to secure only a paltry royalty—one per cent of the retail price.[27] With the completion of the *Minute Man*, French abandoned Parianware reproductions, but was soon convinced by his father to copyright the model for the statue, in order that Doll & Richards might manufacture plaster duplicates.[28]

When many American sculptors were actively involved in the production of bronze multiples, French, unexplainably, was more moderate in his commitment. Although bronzes of the *Emerson* and *The Concord Minute Man of 1775* (a reworking, completed in 1889, of the first model) were

available on a limited basis by 1900, it was not until the completion of the standing *Lincoln* in 1912 that French willingly engaged in promoting an edition.

The Board of Public Lands and Buildings of [Lincoln] Nebraska, in consideration of $2890.00, the balance due me on the Lincoln Monument, grant me the sole right and privilege of making and selling copies in miniature of the statue.[29]

Between 1912 and 1917, ten bronzes were produced, at a cost of $180 for one bronze cast, or $165 when two were ordered.

Two events that occurred later in French's career document his disinterest in sculptural multiplication. In the winter of 1924–1925, French permitted the Jennings Brothers Manufacturing Company of Bridgeport, Connecticut to rework for commercial sale his copyrighted statuette of the seated *Lincoln* into a lamp base and bookends. French received $6,000 from this business venture, a royalty of ten per cent over a six-year period.[30] Three years later French entered into a second agreement. To benefit the Irving Monument Fund, French arranged with Mrs. H. V. D. Black to furnish copies of a statuette of Rip Van Winkle at cost. A monument to Washington Irving had been executed by French during 1926 and 1927 and erected in Irvington-on-Hudson, New York. The original figure of the Irving character was modeled in relief on the monument, but French now created a free-standing statuette. Although the sculptor recorded that twenty-five bronzes were cast, no edition numbers appear on any of the works that have been examined. All casting was executed by the Roman Bronze Works.[31]

223

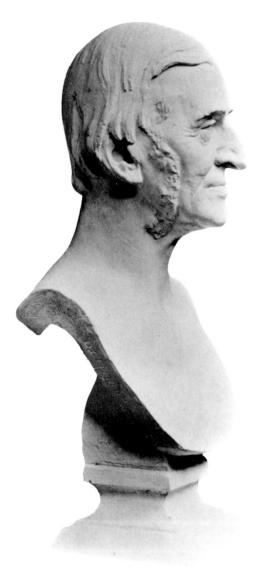

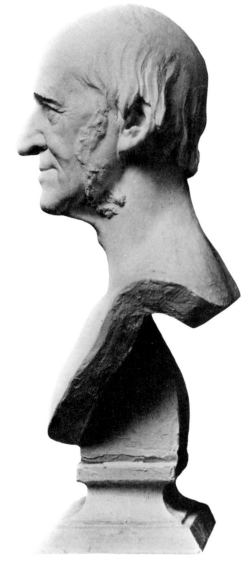

2. First plaster of *Emerson* from photograph taken by
H. G. Smith, Boston

Archives, Chesterwood, Stockbridge, Massachusetts

3. Proper left profile of first plaster of *Emerson* from
photograph taken by H. G. Smith, Boston

Archives, Chesterwood, Stockbridge, Massachusetts

These profile views are mounted in an album
compiled by William M. R. French, *Sculpture.
D. C. French.*, now at Chesterwood.

Ralph Waldo Emerson

By mid-June 1878, French had decided to leave Washington, D.C. While his work on a sculptural group to decorate the United States Custom House and Post Office in Saint Louis, Missouri had provided nearly two years of practical training, the young sculptor's failure to secure a single portrait commission in the nation's capital was disheartening. A return to the cordial environment of his native Concord offered a better chance of success.

In a letter to his brother William, French mentioned one project he was eager to undertake: ". . . I want to make a statuette of Mr. [Ralph Waldo] Emerson and a bust of the same."[32] This plan was held in abeyance, until a stimulus was provided by the sculptor's stepmother, Pamela Prentiss French, who wrote on January 3, 1879:

. . . Some day when you don't expect it Mr. Emerson will die. Those lights often go out so suddenly and don't let Mr. Milmore's horror be the latest memory of him. Now if you w'd make a bust as good as you could without a sitting and let Dr. [Edward] Emerson see it, he w'd be so charmed that he w'd instantly procure his father's consent to all you want—I know how he feels about the other.[33]

By mid-January, French must have spoken with the elder Emerson, for the sculptor's father was pleased to learn of his son's successful interview with the "Philosopher."

Certainly the opportunity to make a bust of Emerson was challenging. French recalled an early encounter with Concord's most famous resident:

The unaffected simplicity as well as the kindliness of the man may be illustrated by his attitude toward me, a youth of twenty. When spending an evening at his house soon after his return from abroad, he seated me comfortably in a chair before a big magnifying glass and, himself standing, placed in position for me to see a collection of photographs of pictures and statues and places in which he knew I would be interested. Had I been of his own age and importance he could not have treated me with more deference. . . .[34]

French's project was also encouraged by the fact that Emerson had appealed to the Town of Concord in March 1876 to compensate the sculptor for

his *Minute Man*: "If I ask an artist to make me a silver bowl and he gives me one of gold I can not refuse to pay him for it if I accept it."[35]

The exact date of the first sitting cannot be determined, but it must have been in mid-March 1879. French later recalled:

My improvised studio was, for his convenience, a room on the lower floor of the house, and here almost daily for a month, patiently and uncomplainingly, this good man sat for me, more from a wish to do me a favor than from any great interest in the work itself.[36]

French's deferential recollection of 1926 should be tempered by remarks the sculptor's father made on March 30, 1879, which concluded, "I am glad you and the philosopher are getting on so well."[37] By the end of April the bust must have been completed, for French wrote to William on the twenty-second: "My bust of Mr. Emerson is pronounced a success by those who have seen it. It is nearly done."[38]

Efforts to develop an accurate chronology of the events that transpired after the modeling was finished have been inconclusive. A waste mold of the clay certainly was not made in the Emerson home. It must be assumed that this task was turned over to French's plaster caster, Paul A. Garey, in Boston. It seems likely that the plaster was photographed by H. G. Smith, and a print was sent to French's mentor, John Quincy Adams Ward, in New York City (figs. 2, 3). On learning of Ward's reaction, Henry French wrote his son: "An artist's reputation depends ultimately upon artists' opinions and Mr. Ward's praises will help you in every way."[39]

The number of plasters that Garey initially made of the bust cannot be established, but the decision to issue a series of duplicates was not made until the middle of the summer. In the interim, one plaster was presented to the Emerson family. French learned what had transpired from Ellen Emerson on July 26, 1879: "We have had . . . a ceremonious unveiling, and mounted it on a pedestal, and there she [Lidian, Emerson's wife] says the likeness is perfect."[40]

This brief statement by the wife of Edward Emerson does not tell us whether the bust was

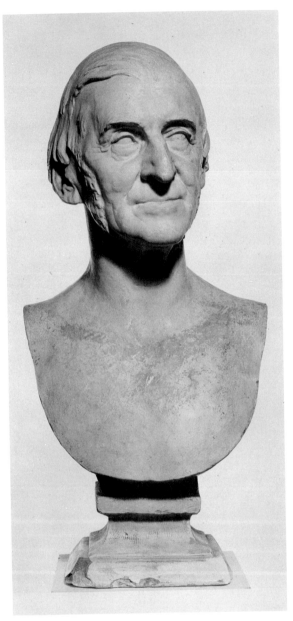 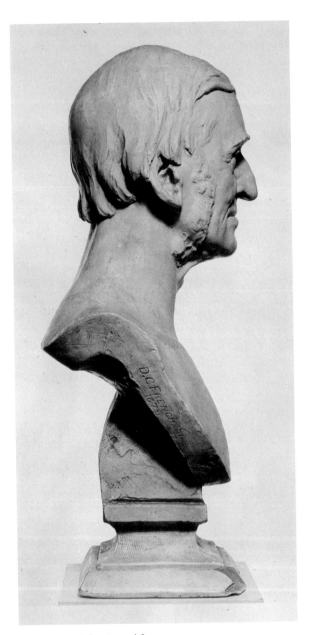

4a. Proper right view of fig. 4

4. EMERSON
Plaster; H. *c.* 59 cm.
Markings
 shoulder rim, proper right: D.C.FRENCH. SC. 1879

Concord Free Public Library, Concord, Massachusetts

Among the seven extant copies of this version, the
Concord plaster appears to be from the first group of
casts.

226

dedicated at the Emersons' house or at the Concord Free Public Library. The sharpness of detail on the surface of the plaster now in the Library's collection (figs. 4, 4a) suggests that it was an early cast. However, its provenance is not complete. There are two plasters in the Ralph Waldo Emerson House in Concord, but both appear to be authorized duplicates.

There is no evidence that Emerson's approval was either sought or given in the matter of reproducing his bust. Nor is there a single reference in the sculptor's correspondence that documents his motives for creating a series of plaster duplicates. The most logical inference to be drawn from an examination of the early history of the *Emerson* sequence is that the decision was made for promotional reasons. With plasters available at a modest price, the bust would receive greater exposure. This in turn increased the probability that French would be commissioned to execute a marble portrait. In an attempt to control the production of the plasters, French applied for a copyright from the Library of Congress on August 8, 1879.[41]

No sooner were the busts being manufactured than French reported to his brother that he had an order for a marble *Emerson*.[42] Their father was somewhat incredulous, asking, "Has anybody really ordered the Emerson in marble?"[43] Henry Flagg French was discouraged about the prospects of this business venture, admonishing his son: "I am afraid we made a mistake in allowing the sale of plaster copies and . . . it is too late to correct it."[44] He continued in a letter dated December 7, 1879:

The failure of a subscription for Emerson and the failure to sell his bust by Doll is not surprising. A wealthy Bostonian is more likely to order and pay for a bronze statue of Emerson than to pay $30.00 for his bust.[45]

French apparently did not share his father's pessimism; under the sculptor's control, but not his direct supervision in the manufacturing process, Garey was authorized to expand the edition. Busts were sold in galleries in Boston and distributed by French—the plaster now at Wellesley College was a gift to the sculptor Anne Whitney.[46]

The *Emerson* was also placed in exhibitions. Reviewing an 1880 exhibit at the Boston Arts Club, George P. Lathrop reported in the *American Art Review*:

Among the pieces sent by sculptors, the most important [is] Mr. D. C. French's portrait bust of Emerson, . . . imbued with a great deal of dignity, and abounding in strong and graceful lines.[47]

The following year French displayed the bust in New York City, at the fourth annual exhibition of the Society of American Artists. The influential critic Samuel G. W. Benjamin commented:

Mr. French's portrait of Mr. Ralph Waldo Emerson is a very graphic and characteristic work which entitles the artist to a high position among our portrait sculptors.[48]

The sculptor's intentions were commendably clear. In the association's catalogue French noted that a marble could be ordered for $600.[49]

Exactly when the sculptor received a commission for a marble cannot be definitely determined. An article appearing in the *New York Times* of November 29, 1879 stated: "it is proposed to have the bust cut in marble and have it placed in Harvard Memorial Hall, . . . if $600.00 can be raised."[50] A note in the February 1880 number of *The Art Amateur* reported that "French's bust of Ralph Waldo Emerson has been sent, in plaster, to Florence to be put in marble. It will be returned early in the spring. . . ."[51] Henry Flagg French's skepticism and the sculptor's advertisement for a marble in 1881 (both mentioned above) undermine the truthfulness of these two published accounts. A more plausible, though unsubstantiated, chronology is that funds were collected after Emerson's death (April 27, 1882) and the formal order from two Harvard graduates, Henry Lee and Henry C. Higginson, was received shortly thereafter.

Several changes from the plaster to the marble —the increased dimensions of the base, the elimination of the asymmetrical shaft, and the treatment of the shoulder terminus—suggest that the Italian carver was provided with explicit instructions (figs. 5, 5a). After the bust arrived in Concord, French completed the carving. Facial fea-

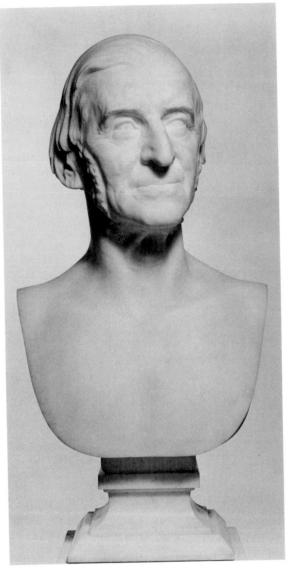

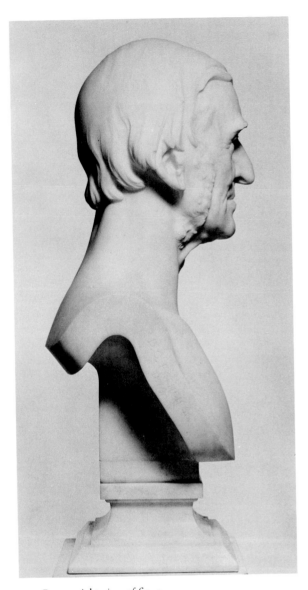

5a. Proper right view of fig. 5

5. EMERSON
Marble; H. *c.* 59.5 cm.
Markings
proper right: D.C. FRENCH Sc. / 1879

Memorial Hall, Harvard University, Cambridge,
Massachusetts

For the sculptor, this was the "original" version of the
Emerson. The bust was modeled in clay with the
realization that it would ultimately be executed in
marble. The plaster model used to make this example
has not survived.

tures were sharpened; the surface of the stone was rubbed and polished to give it an almost lifelike translucency. The portrait of Emerson, by the time of its presentation to Harvard University on June 25, 1883, was a fitting example of French's sculptural talents.[52]

For over three years, the sculptor had waited for a commission to put this bust in permanent form. French was told of a second order by his father, who offered some paternal advice in a letter of January 28, 1883:

Mr. [Reuben] Rice wrote me that they proposed to put a marble Emerson into the Library.... Now don't let them fool you out of half the price of it by appeals to your townsmanship.[53]

It must be assumed that French did not send a second plaster to Florence, but the substitution of what appears to be a commercial base (the marbles are different), the enlargement of the bib, and the shift of the signature placement prove that he did not want the primacy of the Harvard marble diminished by a "replica."[54] Since French was not opposed to the multiplication of his sculpture, the decision to make changes was motivated by practicality. The artistic integrity was not altered (figs. 6, 6a).

French does not seem to have finished the Concord marble—perhaps delay in shipping caused him to send the bust directly to the Library. One sentence in his letter to Reuben Rice intimates that French was, indeed, making a gift to the Library. He wrote on November 16, 1883: "I hope the bust will be satisfactory eno' to compensate for the long wait."[55] While the carving of the Concord bust does not have quite the vitality of the Harvard portrait, it is a competent translation which pleased its recipients. The town report of 1884 acknowledged the Library's recent acquisition:

... Mr. French himself ... was the largest contributor, and to whose artistic skill and public spirit the town is thus renewedly a debtor. We regard it as a precious possession.[56]

The first stage of the Emerson metamorphosis was now completed. Although the sculptor would continue to sell plasters—one account indicated that French planned to issue only fifty casts[57]—his ambition to execute Emerson's portrait in marble had been realized. What prompted the sculptor to consider the introduction of bronze versions into the sequence? The literature offers no clues. French first mentioned to his brother, William, on December 7, 1884: "I am meditating having the Emerson cast in bronze. It will cost about $100.00."[58] Was French urged by a foundryman to take this action? Evidence suggests that stimulus was provided by Eugene F. Aucaigne of the Henry-Bonnard Company. In October 1884, this firm had completed French's John Harvard. Both artist and artisan were praised: one critic called the statue one of the best in America; another remarked that the casting was a triumph of foundry work.[59] French's uncle, a resident of Brooklyn, New York, reported on his visit to the Henry-Bonnard offices:

I could not but say yes when the president of the foundry said: "If he never does another work, this immortalizes him." He also told me it [the statue] had been visited by many artists who only expressed approving admiration of the work and there had not been one "adverse criticism."[60]

The Harvard was only the second statue that French executed to be cast in bronze. His pleasure with Henry-Bonnard's workmanship was tangibly demonstrated: the firm cast the sculptor's next outdoor monument, the Gallaudet, in 1889. With the appointment of Aucaigne as president in 1882, the company quickly established a national reputation with its work on John Quincy Adams Ward's George Washington and French's Harvard. In fact in 1891, a writer in the New York Times cited the foundry as the most proficient in America.[61] The last bit of evidence linking Aucaigne with the bronze versions of the Emerson is the Account Book notation that the Bonnard charge for casting a bust was $100.

That this company might have been involved in the initial casting seems logical, but the early history of the Emerson sequence is filled with unanswered questions. One problem is that the bust appears in two versions. The image in both is the

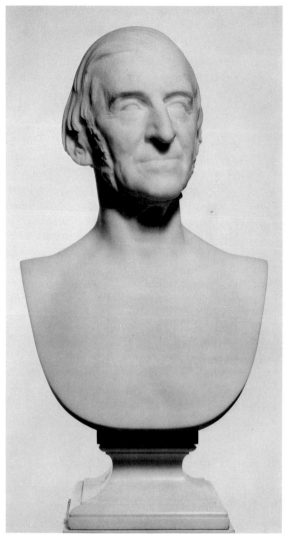 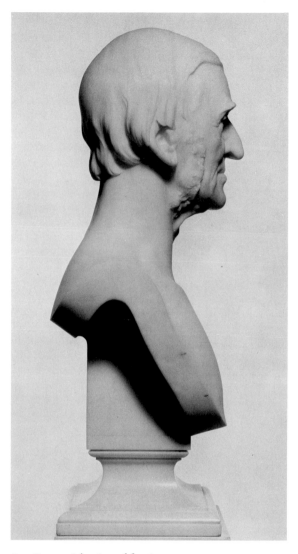

6. EMERSON
 Marble; H. *c.* 62.5 cm.
 Markings
 rear shaft: D.C FRENCH. SC. / 1879

 Concord Free Public Library, Concord, Massachusetts

6a. Proper right view of fig. 6

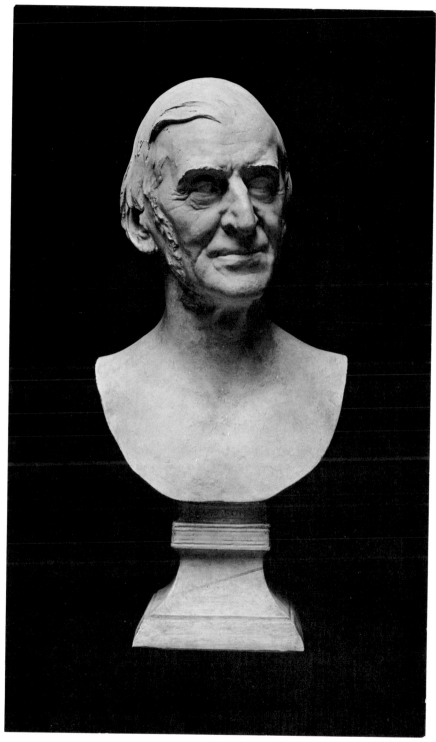

7. Second version of *Emerson* plaster from a print by
 Peter A. Juley & Son, New York City, taken from a
 glass plate negative originally by either A. B. Bogart or
 de Witt Ward

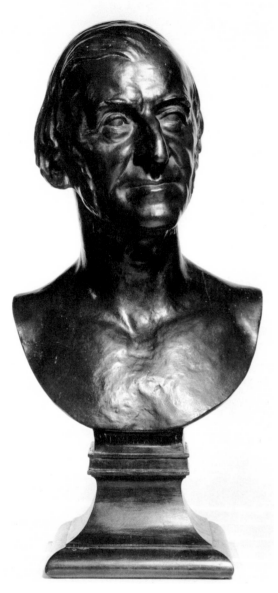

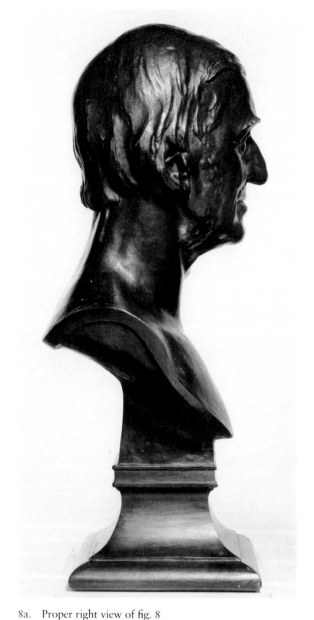

8. EMERSON
Bronze; H. *c.* 55.5 cm.
Markings
 front: EMERSON
 proper left, engraved: D.C.FRENCH / 1879
 rear, engraved: GORHAM. CO. FOUNDERS

Chesterwood, Stockbridge, Massachusetts

8a. Proper right view of fig. 8

The inclusion of this sand-cast bronze in the
Chesterwood collection suggests that it might be one
of the later castings. The name, date, and foundry mark
were all engraved, apparently by the same hand. Five
other bronze casts with this same machine-worked
base have been located.

same, but the base configurations differ. One type (fig. 7) is handwrought with gently curved scotia and torus elements and a linear pattern incised in the upper molding. The other base (figs. 8, 8a) has a machine-worked preciseness, with a continuous band characterized as an indented rectangular panel. Does the inclusion of a large photograph in French's own album, labeled "bronze bust of Ralph Waldo Emerson" (fig. 9), indicate that the sculptor preferred the hand-worked second version? Or does the rectangular banded, or third, version's place on the mantelpiece of the Concord studio reception room (fig. 10) suggest a primacy of this type?

Although there are no records of when the bronzes were first cast or when the photographs were inserted in the albums, the prints must have been mounted by 1887.[62] Regrettably, the literature provides not a single clue as to why the sculptor decided to rework the format of the bust. Some of the changes—the reduced size of the chest, the remodeling of the rim, the reworking of the shaft, and the redesigning of the back—were dictated by the anticipated use of new materials; a reduction of the surface area directly affected the cost. However, these pragmatic considerations alone cannot justify the adoption of the tightly controlled vertical format and the startling innovation of the Emerson plaque beneath the bib. A portrait in plaster, sold to a Concord or Boston resident or given to a friend, was easily recognizable. As Bronson Alcott commented:

His "Head of Emerson" represents the man as he now is, touched with age yet youthful in his manly features and expression. It is the form in which we wish to perpetuate our friend.[63]

French was now creating a national icon. By inscribing Emerson's name on the work itself, French became the creator of the archetypal Emersonian portrait.

Apparently the sculptor never contemplated a large sale of these bronzes; with no documentary evidence, any statements about this phase of the *Emerson* sequence are conjectural. But several substantive comments can be made. French was more concerned with the accuracy of the likeness than with control of production. In presenting the portrait to the Metropolitan Museum in 1907, he declared:

. . . It will give me great pleasure to present a copy of it in bronze to the Museum. Whatever the artistic merits of the bust may be, it should be valuable as a record of Emerson's head. It . . . is the result of not only the closest study, but of countless measurements.[64]

Apparently the sculptor did not care to note the obvious differences that exist in the plaster, marble, and bronze *Emerson*s. He wrote in 1896 about the Exeter plaster (figs. 11, 11a):

The bust is in plaster and is a copy of the one I made in Concord, Mass. in 1879. It was modelled at Mr. Emerson's house where he kindly gave me as many sittings as I required—perhaps twenty in all. It is as faithful a copy of his head as compasses and my eyes could make it and, as a record of facts, has some value. This bust in marble is in the Concord Library and there is also one in Memorial Hall at Cambridge.[65]

Thirty years later the discussion was still going on:

There are two marble copies of the bust, one in Memorial Hall and the other in Concord Library. There are several bronzes, and a number of plaster casts were sold soon after the bust was made. It was soon after the bust was made that I gave Miss. Whitney the one that she has left to you, and it is one of the very early copies.[66]

That French, in his correspondence, chose not to discriminate among the various versions of the *Emerson* should not allow the inference to be drawn that he exercised no control over production. Garey prepared plasters at the sculptor's request and the marbles were carved in a manner consistent with French's working habits. What steps were followed in the production of the bronzes during the artist's lifetime? The fact that as many as four foundries cast examples of *Emerson* suggests that each time an order was received, the sculptor would send a plaster to the foundry. The plaster at Chesterwood (fig. 12) with its rather thick center core, was itself made from a gelatin mold and was in turn used as a model to make other casts in plaster and wax. A study of

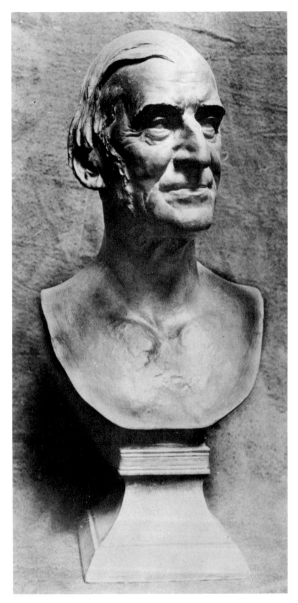

9. EMERSON
Bronze from a photograph in an album designated "Large Book," assembled and labeled by the sculptor no later than 1888

Archives, Chesterwood, Stockbridge, Massachusetts

The base here is the rougher finished, hand-worked variation.

10. Photograph of the interior of the sculptor's studio reception room in Concord, Massachusetts

Archives, Chesterwood, Stockbridge, Massachusetts

On the mantel at center is the bust of Emerson in bronze (third version with paneled molding) and to its left is a plaster of the small *Memory*. A copy of this print in the album compiled by French's brother, William, is labeled, "Interior of Concord studio, 1886," demonstrating that a bronze of this type was executed by February of that year.

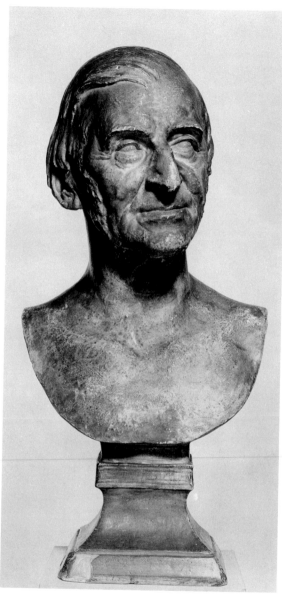

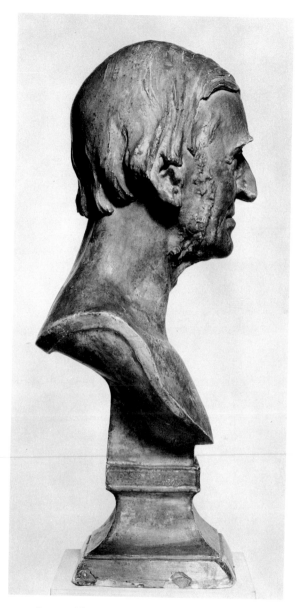

11a. Proper right view of fig. 11

11. EMERSON
 Plaster; H. *c.* 56.7 cm.
 Markings
 front: EMERSON
 proper right: D.C.FRENCH- / -1879-
 rear shaft: D.C. FREN Sc

 Exeter Public Library, Exeter, New Hampshire

 Two other plaster busts with this base format have
 been located.

235

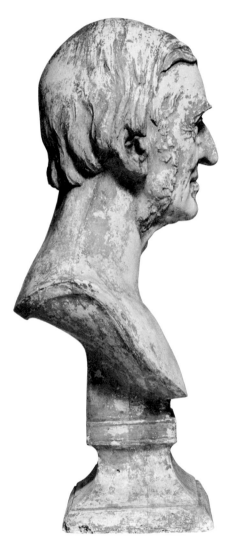

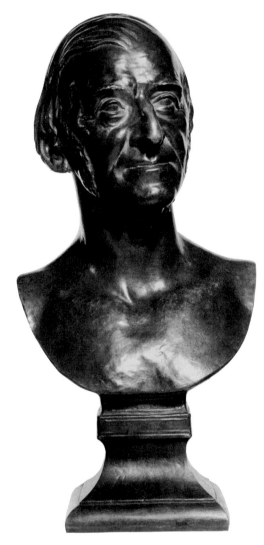

12. EMERSON
 Plaster; H. *c.* 58 cm.
 Markings:
 front: EMERSON
 rear shaft: D.C. FREN Sc (letters obscured)

Chesterwood, Stockbridge, Massachusetts

This bust was taken from a gelatin mold and in turn
used to make another cast.

13. EMERSON
 Bronze; H. *c.* 55.5 cm.
 Markings
 front: EMERSON
 proper left: Daniel C FreNch / 1879
 rear shaft: D C (faintly visible)
 rear, stamped on foot of pedestal: B. ZOPPO. /
 FOUNDRY. N.Y.

Williamsport Area School District, Williamsport,
Pennsylvania

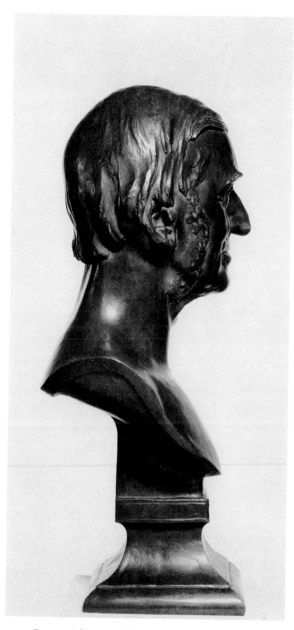

13a. Proper right view of fig. 13

This bust is a lost-wax casting. The reddish tint is from patination which seems to have been used consistently by the Zoppo foundry. Two other bronze casts with this same handwrought base format have been located.

mold lines has shown a close relationship between the Chesterwood plaster and the plaster in the Exeter Public Library, Exeter, New Hampshire (fig. 11). Negative piece mold lines and traces of "French sand" inside the cast indicate that the Exeter plaster itself was used as a model in sandcasting a bronze not yet located. A lost-wax bronze cast with this base format is the *Emerson* in the collection of the Williamsport Area School District, Williamsport, Pennsylvania (figs. 13, 13a).

The *Emerson* plasters appear to have been made when the occasion demanded. These were probably executed either in New York City or at Chesterwood by an available caster. Perhaps the earliest of these plasters were made by Garey, who would still have been manufacturing busts of the first type (see fig. 4) at this time. French's long and friendly relationship with his assistants would insure that his primary concern of preserving the Emerson image would not be defeated by improper mechanical execution.

The Henry-Bonnard Company executed two extant versions of the *Emerson* at different times. The National Portrait Gallery's bronze is, significantly, the only bust on which a casting date appears. A bronze in the collection of the Metropolitan Museum of Art, New York City, was produced some time after June 1906. French's letter of that month to the founder, Aucaigne, was addressed to a New York City office. The company had moved to Mount Vernon, New York by the time this bust was donated to the museum. The placement of the signatures is radically altered; in fact, the Metropolitan's bronze was signed after the foundry had finished its work. Moreover, the entire question of the founder's role in the signing of casts remains unclear. Perhaps the sculptor subtly controlled the production of the *Emerson* by the inclusion, relocation, or, for that matter, exclusion of his signature. No two extant bronzes are inscribed in a consistent manner.

Also confusing is the apparently random order in which the sculptor produced bronzes with different bases. Perhaps as more *Emerson* busts come to light a pattern might be discernible. At this

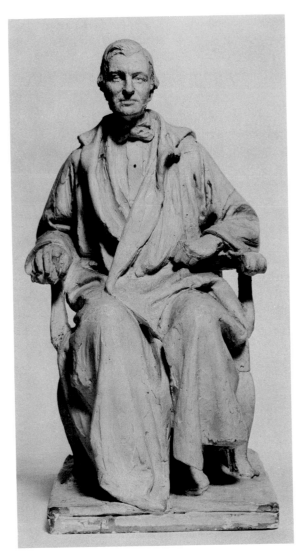

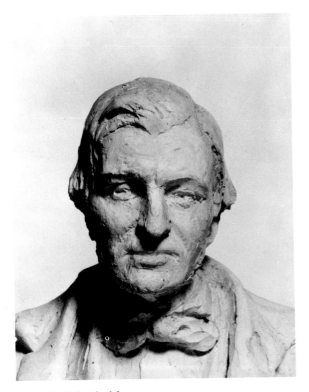

14. EMERSON maquette
 Plaster; H. *c.* 32.5 cm.
 Markings
 proper right: AUG 17 1911 DCF

Chesterwood, Stockbridge, Massachusetts

This plaster maquette was made directly from the
original clay into which French inscribed his concise
notation of initials and date of completion. The metal
point insets for enlarging this model can be seen as
dark spots on the shoulders and chest.

14a. Head detail of fig. 14

time, however, the available evidence suggests that the image of Emerson fascinated the sculptor more than production control or monetary rewards. Although the bust was copyrighted, no copyright mark appears on any extant bronze, marble, or plaster. French continually raised the price of the bronze in the first three decades of this century, yet more busts were given by the artist or sold at a special price than were sold by commercial dealers. As the artist wrote in 1926:

Emerson's face . . . , in spite of the boldness of the general plan, had an infinity of detail, the delicacy of which evinced the refinement of the soul that evolved it.[67]

French's personal and professional admiration for Emerson was lifelong, and the sculptor's ambitions went beyond the portrait.[68] The opportunity to develop a new artistic conception came in 1891.

The Concord Phidias, Mr. French, was undertaken to model for a place in the new Boston Library building . . . a sitting statue of Emerson, in marble, and a subscription for the purpose has already begun in Boston and Concord. The treasurer of the Emerson Statue Fund is J. S. Russell. . . . The originators of this excellent project . . . are Messrs. T. Quincy Browne [sic] and Nathan Appleton.[69]

The project was held in abeyance for several years, until the spring of 1896, when French received a request for a similar statue from George A. King. The sculptor replied:

My instinct is to give my services to any project in which Concord is interested and to enter upon it at once; but in one as important as this, which will take a year of my time, this is out of the question.

My price in general for a portrait statue in bronze is from twelve to fifteen thousand dollars and . . . I could not promise it before the end of three years. . . .

As regards the time I should not be able to do better. . . . In regards to the cost I can make a suggestion.

Several years ago Mr. Nathan Appleton and Mr. Quincy Brown conceived the project of having a statue of Mr. Emerson for the Boston Public Library. . . . Owing I imagine to the hard times no progress or little was made towards raising the funds. The last

time I talked with [them] about it, they were sanguine of ultimate success, nothing definite in the way of a commission has been given me.

It occurs to me that if your project and theirs could be combined, it might be a mutual advantage. As the chief expense is in producing the model, the cost of two copies in bronze would only be two or three thousand dollars more than one—the expense of casting the second copy. I can see no objection to there being two copies of the same statue, and I hope this idea may appeal to you.

As to material, I should be strongly in favor of bronze. Granite is too hard a material for portrait use and marble will not endure out of doors.[70]

French apparently took no other action at this time on either proposal. The Boston project—a marble statue inside the Library—never materialized, but it was nearly ten years before further action was taken on the Concord scheme. Then, on December 6, 1905, the sculptor wrote again to King:

Whether the statue should represent Mr. Emerson as seated or standing would depend a good deal upon the site which it is intended the statue shall occupy. In considering the matter in times past, I have always thought of the statue as a seated one. Whether it should be executed in marble or bronze is, again, largely a matter of environment. If it were going in a very light room I should advise bronze. As regards the likeness, marble is a finer material than bronze; while bronze gives the general forms, the fineness of expression is often somewhat interfered with by the blackness and sheen of the material.

My price for a portrait statue . . . is $16,000, which is, of course, more than anything of mine is worth, but people seem to be willing to pay for my things and, after all, any one who lives in New York needs all the money he can get.

I need not say how much it gratifies me to know that you and Edward Emerson wish me to make the statue. I should feel aggrieved to have anyone else make it. I should at least bring to the task the greatest reverence and love for my subject.[71]

Plans for a public subscription were announced in Concord in the winter of 1906 (whether funds col-

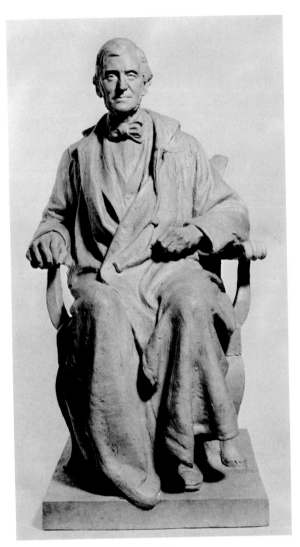

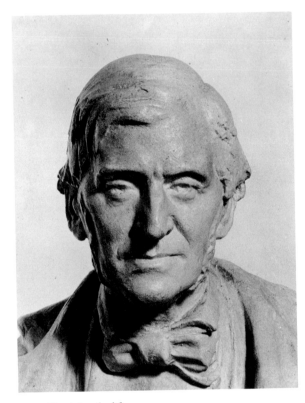

15. EMERSON working model
 Plaster; H. *c.* 67 cm.
 No markings

 Chesterwood, Stockbridge, Massachusetts

 Reworking of the pedestal after the bronze had been
 executed eliminated French's documentary inscription.
 This statue was given to the New-York Historical
 Society in 1953 but returned, on permanent loan, to
 Chesterwood in the late 1960s.

15a. Head detail of fig. 15

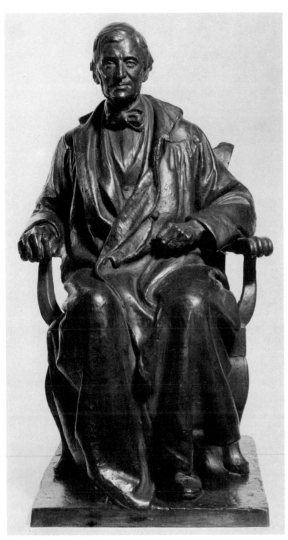

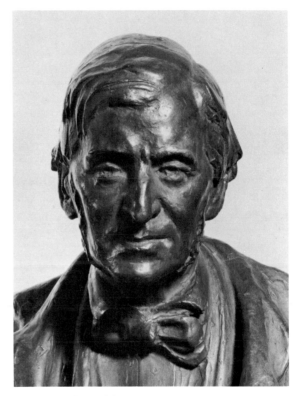

16. EMERSON bronze working model
Bronze; H. *c.* 65 cm.
Markings
 proper right: D.C.F. OCT. 1911
 rear: ROMAN BRONZE WORKS N- Y-

Harvard College Library, the Houghton Library,
Harvard University, Cambridge, Massachusetts

The statuette, a gift to Harvard University in 1916
from the sitter's daughter, Edith Emerson Forbes, was
cast from a plaster made directly from the working
model.

16a. Head detail of fig. 16

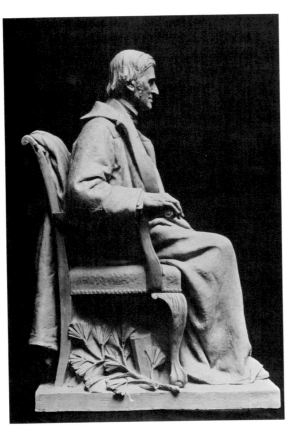

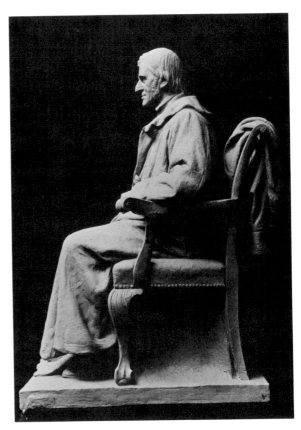

17. Photograph of clay model for seated *Emerson* taken by A. B. Bogart in French's studio

18. Photograph of clay model for seated *Emerson* taken by A. B. Bogart in French's studio

lected in Boston were added to this solicitation is not known), but the sculptor, asked about the possibility of making a small study during the ensuing year, declined.

By 1911, sufficient monies had been raised for the Concord officials to commission French formally and by August the maquette (figs. 14, 14a) had been completed at the sculptor's Chesterwood studio, modeled in a plastic material and cast in plaster. In order to enlarge the 32.5 cm. maquette to a working model scale of 67 cm. several small metal "points," to be used as mathematical frames of reference, were first driven into the shoulders and chest of the plaster maquette. A semi-mechanical enlargement was thus accomplished in clay and then cast in plaster. Details and refinements of features were left unfinished in this sketch, but the essentials of pose, mass, and composition were masterfully realized at the outset. In his previous seated statues, the sculptor had posed the figure in a relaxed position, resting on the chair. With the *Emerson*, the posture is erect; one possible source of inspiration might have been Houdon's *Voltaire* in the Théâtre Français. A photograph of this monument is in the sculptor's study collection.[72]

With the preparation of the working model (figs. 15, 15a), the formal elements were further articulated. French explained his working methods:

My statue of Emerson . . . was made . . . from such materials in the way of photographs and daguerreotypes as could be collected, together with my study of his head as a foundation. It seemed proper to represent him in his prime, and again I endeavored to fix the elusive, illuminated expression . . ; also, to perpetuate the peculiar sidewise thrust of the head on the neck that was characteristic of him, conveying an impression of mental searching. The gown which was used as drapery was the one he wore in his study in the winter and took the name by which it was known in the household, "the Gaberlunzie. . . ." It is a heavy, wadded and quilted, dark blue garment, and one can easily believe that its voluminous folds were very grateful to the poet and essayist of a winter's morning. . . .[73]

Noticeably, the details of the portrait are carefully constructed. The penetrating stare of the 1879 bust, accentuated by the axial twisting of the head to the left, was revised in the 1911 working model (fig. 15a). As he had outlined in the maquette (see fig. 14), the portrait was to be in a precise frontal position; the slight tilt of the head in the sketch was now eliminated. Emerson juts rigidly forward; a characteristic lock of hair articulates the forehead. The sartorial elements are more accurately rendered, and the peripheral accoutrements are given definition. The Chippendale chair is roughly sketched in and the frock coat hanging over the back of the chair is incorporated into the composition.

While the plaster working model at Chesterwood is not marked, a bronze statuette cast from it, in the Houghton Library, Harvard University, Cambridge, Massachusetts (figs. 16, 16a), is characteristically initialed and exactly dated: D. C. F. OCT. 1911. As was his practice, French executed a bronze of the working model or maquette, at cost, for a donor or, in this case, a member of his family, Edith Emerson Forbes. The roughly treated surface of the platform with its irregularly worked edges is in marked contrast to the smooth, thick-bordered pedestal in the Chesterwood plaster. One explanation seems logical—the platform of the latter has been reworked. Many coats of paint cover the Chesterwood statuette, making it impossible to determine if it might have been used by the Roman Bronze Works, damaged in the casting, and repaired at some later date.[74]

The rapid execution of the maquette and working model during a three-month period was not repeated in the production of the large clay. French did not receive his first payment until December 12, 1912, which suggests that the enlargement was not begun in his New York City studio until after that date.[75] The clay might well have been completed by April 1913, for on the twenty-fifth of that month the sculptor was in possession of his second installment.[76] The operation of casting the statue in plaster was completed during the summer of 1913, while French was at Chesterwood. Although there is no record, it must be assumed that French returned to New

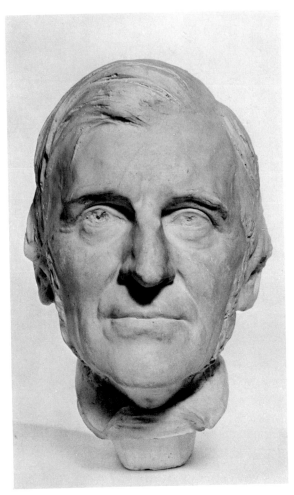

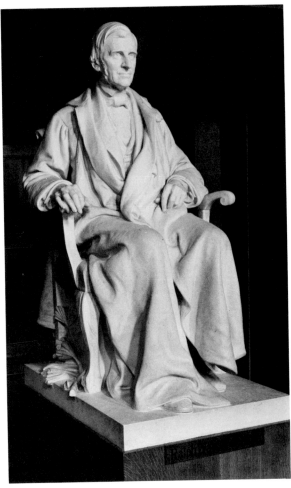

19. HEAD OF EMERSON
Plaster; H. *c.* 33 cm. (with tenon)
No markings

Chesterwood, Stockbridge, Massachusetts

In preparing the final model, the caster made the
plaster in sections. These were then attached by
Roman joints as seen below the neck of this head. The
lack of pointing marks indicates that this piece was not
used in the execution of the marble but is probably a
duplicate cast.

20. EMERSON
Marble; H. *c.* 165.25 cm.
Markings
proper right rear: DANIEL C. FRENCH SC / 1914

Concord Free Public Library, Concord, Massachusetts

The working model was enlarged in French's New
York City studio at 125 W. 11th Street during the
winter of 1912–1913. The identity of the artisan who
cast the plaster cannot be determined but the
Piccirilli Brothers carved this marble in 1914.

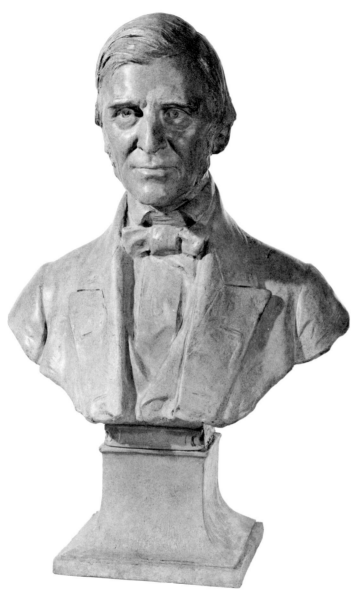

21. EMERSON
 Plaster; H. *c.* 79.5 cm.
 Markings
 proper right: D.C. FRENCH

The New-York Historical Society, New York,
New York

The bronze, cast from this or a duplicate plaster of
1923 is at the Hall of Fame, Bronx, New York. This
plaster was given by Margaret French Cresson in 1953
to the New-York Historical Society.

245

York to make changes in the plaster before sending it to the Piccirillis for cutting into marble.

Photographs of the model (figs. 17, 18), taken by A. B. Bogart in French's studio, reveal the sculptor's modeling techniques in clay or plasticine and document the exactness with which all compositional details were completed. A spruce bow and an octagonal cannister were added under the right portion of the chair to obscure the marble that was needed for structural support. The correct details of a Chippendale chair—the cambriole leg with acanthus molding, the ball-and-claw foot, even the brass upholstery tacks—are all included. Neither the dates of the plaster molding and casting from the model nor the date of the shipment (in sections) to the Piccirillis is recorded.[77]

The large plaster head at Chesterwood (fig. 19) was a duplicate gelatin mold cast from one of these sections. It is an enduring document that demonstrates visually both the necessary fragmentation of the image during this step in the casting process and the "Roman joint" which was used to reassemble the various elements of the plaster. Although the surface has not been worked, the character of the face, even the telltale lock of hair, was permanently fixed at this stage for French's future involvement with the Emersonian image.

After the unveiling of the seated statue in the Concord Free Public Library (fig. 20) on May 24, 1914 (French, already at Chesterwood for the summer season, motored to the ceremonies), orders for the 1879 busts did not increase. To preserve the uniqueness of the monument, French apparently did not arrange with his patrons to market any reductions. Nineteen fourteen marked the achievement of the sculptor's first aspiration—to make a bust and a statuette. There would be two more episodes in the *Emerson* metamorphosis: one of passing, the other of permanent, importance.

On May 17, 1921, French received an order for an *Emerson* from a Spencer Kellogg of Buffalo, New York. The sculptor quoted him a price in bronze—$300—and a second estimate of $2,000

for a marble bust. Whether the sculptor contemplated a reworking of the second or third versions for this project—the large price suggests he might have—will never be known. Two weeks later, Kellogg received a bronze, which has not been located.[78]

French's third reworking was initiated by a commission he received from Alice Brown of Boston (fig. 21). Few of the historical details of this project have come to light, but the importance of its location and formal setting in the Hall of Fame at New York University demanded a fresh conception. For the last time in his career, French executed a portrait of Emerson, but once again for a modest fee: his contract, signed on February 23, 1923, called for the payment of $1,000, with foundry expenses extra.[79] The sculptor created a memorial portrait of Emerson, evolving more from the 1914 than the 1879 image. The bust presents the Concord philosopher in middle age, but the larger-than-life format, the inclusion of the costume, and the forward positioning of the head (the chin is closer to the chest) enhance the overall romanticizing effect. The elongated proportion of the pedestal and the broad expanse of the shoulders were essential reworkings, dictated by the placement of the bronze in an outdoor setting. Perhaps the sculptor's preference for executing portraits in marble prevented him from capturing the subtleties of Emerson's intense portrait in a work that was ultimately to be cast and not carved.

We seemingly have come full circle in the *Emerson* metamorphosis—from head to seated figure and back to a bust format—but the creative spontaneity, so evident in the 1879 portrait and carefully restudied in the 1914 statue, is not present in the 1923 bust. The plaster in the New-York Historical Society might be one of only two copies made. The first was sent to the Roman Bronze Works for casting; the other was retained in French's New York City studio and eventually shipped to Chesterwood.[80]

Memory

Although French was primarily a creator of public monuments, throughout his career he did make small sketches, often of female figures, which were not related to any commissioned work. Although none of the early works survive, several photographs in the Chesterwood collection suggest that French may have begun this practice in the early 1880s.

One small painted plaster of a seated figure was given as a Christmas present in 1893 to one of French's longtime friends in Concord, Massachusetts.[81] A bronze study of a female nude, entitled *Narcissa*, was executed in 1901 and eventually came into the possession of John Gellatly.[82] At Chesterwood there is a study, no more than five inches in height, of a woman, legs crossed and her head almost touching her knee, which French executed in November 1915 and subsequently had cast in bronze.[83]

Although French had several of these independent studies, as well as reductions and fragments of larger monuments, cast in bronze during the 1900s, the sculptor never became enthusiastically involved in the production of large editions. He certainly was aware of the financial rewards to be gained from this process, but his interest was only occasional.

The existence and duplication of one of two small plaster sketches of *Memory* (figs. 23, 24) for the large marble now at the Metropolitan Museum of Art, New York City, attest to the fact that French was pleased with the study. He dated the plaster model for one of the sketches (February 1886) and apparently had his plaster caster Paul Garey execute at least two duplicates for his studio.

Unfortunately, there is no reference to the *Memory* in any of the letters French wrote to his brother in 1886, and the available literature in the collections at the Library of Congress and the Metropolitan Museum of Art do not explain why or when French decided to enlarge this model. A possible chronology can only tentatively be proposed. It does seem clear, however, that this was a private exercise in no way related to a public commission.

In 1912, French, a member of the Board of Trustees at the Metropolitan Museum of Art since 1903, asked the patron of the sculptor's Civil War monument in Sleepy Hollow Cemetery in Concord, Massachusetts if he would permit a marble replica of the *Melvin Memorial* to be given to the museum. This was the first instance where French copied a public work for a museum collection. The marble replica was carved by the Piccirilli Brothers, between 1912 and 1915.[84] The successful reception given to this marble must have encouraged French to consider the production of another work. The sculptor now undertook the enlargement of the *Memory* sketch he had executed nearly thirty years before.

One of the earliest plaster sketches of *Memory* to survive at Chesterwood (figs. 24, 24a) was cast from a gelatin mold. The original plaster, made by a waste mold from the clay, has not survived, although it might be the form barely visible to the right of the Emerson bust in the late 1880s photograph of the Concord studio (fig. 10). In the extant

22. Photograph of Daniel Chester French and Rosalie Miller taken at Chesterwood, *c.* 1919

Archives, Chesterwood, Stockbridge, Massachusetts

The sculptor with Rosalie Miller, probably the model for *Memory*. French wrote to Rosalie Miller on March 2, 1919: "Somebody else said my 'Memory' looked like you. I should like to think so."

plaster, the retention of the wedge support for the mirror and the unfinished, unchased areas of this example suggest that it was retained as a studio copy—more as a visual record than as a working sketch.

The bronze cast, either of this piece or of a plaster molded at the same time (figs. 25, 25a), has both signature, date, and foundry mark. While the date was put into the plaster (see fig. 24a), the

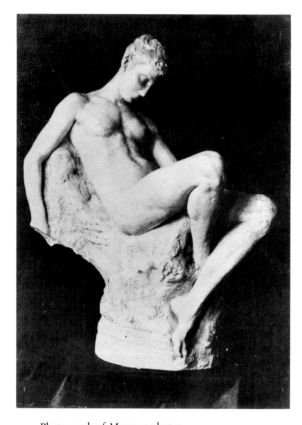

23. Photograph of *Memory* plaster

Archives, Chesterwood, Stockbridge, Massachusetts

This photograph appears to be of a plaster, since seam marks from a mold are visible along the left leg. There is unfortunately no identification on the mount. While the piece might be a rejected first sketch, it is more likely an intermediate study in which the sculptor was experimenting with various positions of the legs, hair styles, and different body postures.

signature was inscribed in the wax prior to the bronze casting. The handwriting is not French's, but the signature is typical of the sculptor's work. The foundry mark was added after casting, cold-stamped into the metal. Unfortunately there is no record of when this *Memory* was cast or how many examples were produced.

French took at least one of the plasters cast from the same mold as figure 24 and incised a dated dedication into the base (figs. 26, 26a). The piece was then possibly cast in bronze and presented to the proprietor of the Knoedler Gallery, Inc., New York City, which sold the large marble *Memory* (see fig. 29) to Henry Walters. There is no record in either French's Account Book or in Knoedler's Stock or Sales Books for 1918 or 1919 that identifies such a bronze, indicating that it was a personal gift.[85]

Curiously, there is not a single reference to the production of the marble in the Account Book. It seems logical to suggest that a clay enlargement (fig. 27) was made in French's New York City studio with an informal understanding but no formal agreement that the finished marble would be purchased for the Metropolitan Museum of Art. The surviving photograph of this intermediate figure shows how the sculptor translated his idea from small sketches to larger working models. The attenuated sweep of the nude body, accented in the sketches (see figs. 24, 26), is now properly proportioned for the final carving. The facial details and the hair style suggested in the 1886 study are more accurately reworked in this intermediate clay. One important detail—the drapery—remained to be added.

A full-sized plaster, with a coat of terra-cotta-colored paint applied according to the instructions of the sculptor's daughter, Mrs. Margaret French Cresson, still survives at Chesterwood (fig. 28). The paint has obscured the surface of the plaster and it is impossible to determine whether this piece was used in the execution of the marble.[86]

Soon after the final carving was completed (see fig. 29) the statue was sent on consignment from the sculptor to Knoedler's. In February 1919 it was purchased by Henry Walters, the Second Vice-

President of the Metropolitan Museum, who in turn presented it as a gift to that institution.

After French's death, his daughter apparently took one of the plasters made from the group that included figures 24 and 26 and inscribed it with the sculptor's name and copyright mark by incising them in the plaster (figs. 30, 30a). Accomplished sometime in the 1930s, this was apparently not an unusual practice, as several small plasters and bronzes in the Chesterwood collection have similar markings. Mrs. Cresson was obviously attempting to identify her father's original works by duplicating his normal signature, "D. C. FRENCH" (see figs. 30a, 31a). Thus the sculptor's daughter took this plaster of the early working sketch (see fig. 30) and had it recast in bronze (figs. 31, 31a), sometime after the sculptor's death in October 1931.

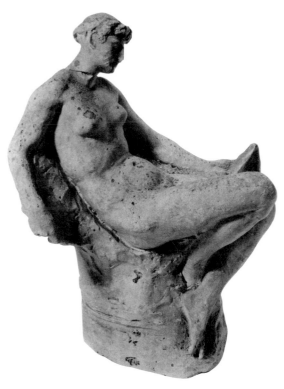

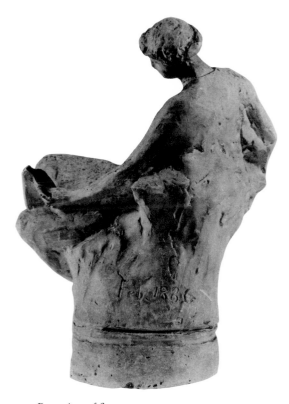

24. MEMORY
Plaster; H. *c.* 27.6 cm.
Markings
on back: FEB. 1886

Chesterwood (NT.69.38.1083), Stockbridge, Massachusetts

This plaster as well as the other two plasters in this sequence (see figs. 26, 30) were apparently cast from the same gelatin mold. Note the support behind the mirror.

24a. Rear view of fig. 24

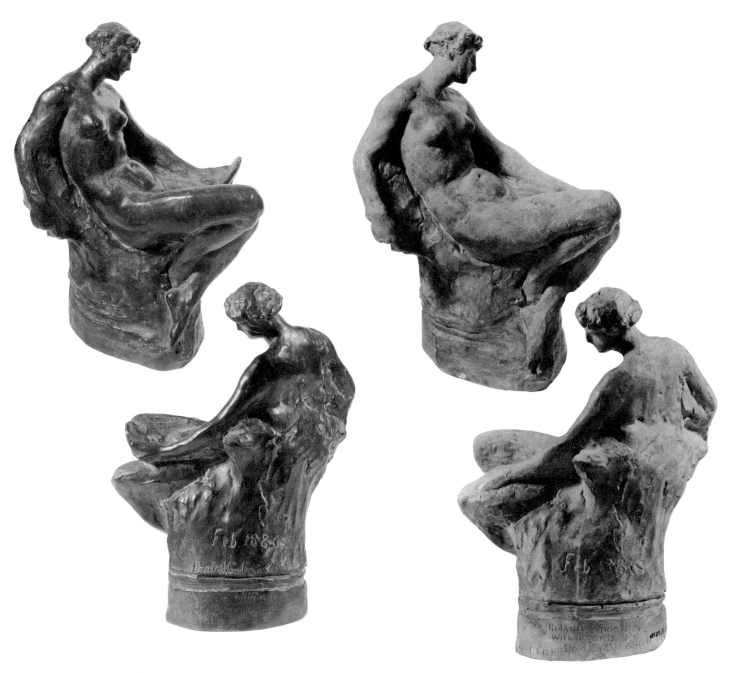

25. MEMORY
Bronze; H. *c.* 25 cm.
Markings
 on back: Feb. 1886 / Daniel C. French
 stamped on base: B. Zoppo. / Foundry. N.Y.

Chesterwood (NT.69.38.260), Stockbridge,
Massachusetts

This bronze is a lost-wax cast made indirectly from the
same model as fig. 24. The mirror support probably
was removed in the wax model and the signature
added at that stage.

25a. Rear view of fig. 25

26. MEMORY
Plaster; H. *c.* 28.2 cm.
Markings
 on back: feb. 1886
 incised on base: To Roland Knoedler / with
 regards of / Daniel C. French /
 feb. 18, 1919

Chesterwood (NT.69.38.119), Stockbridge,
Massachusetts

A repair made in the plaster before 1969 incorrectly
restored the left wrist and hand of the figure.

26a. Rear view of fig. 26

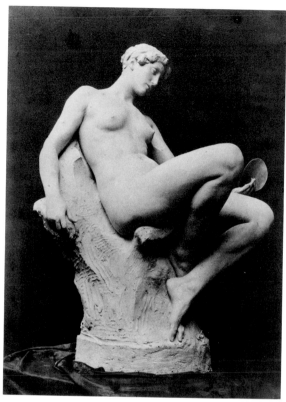

27. Photograph of clay model of *Memory*, c. 1917–1918, by A. B. Bogart

Archives, Chesterwood, Stockbridge, Massachusetts

Although this is probably an intermediate model made prior to the final carving, there is no indication of scale or size from the photograph.

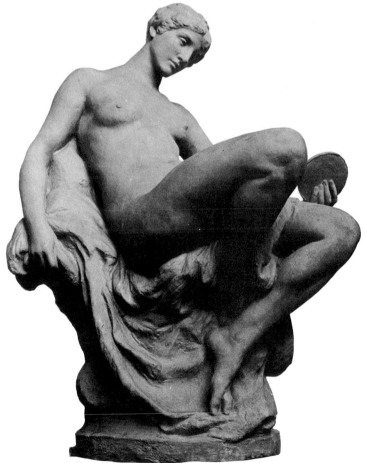

28. MEMORY
Plaster (terra-cotta-colored paint); H. *c.* 142.5 cm.
No markings

Chesterwood, Stockbridge, Massachusetts

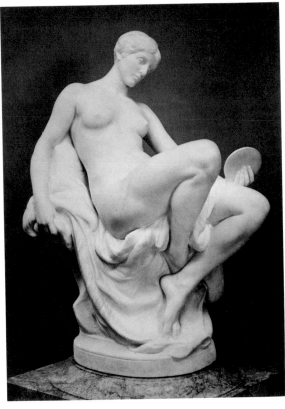

29. MEMORY
Marble; H. *c.* 145 cm.
Markings
 D.C.FRENCH SC. / 1919

The Metropolitan Museum of Art, New York,
New York

This is the large finished marble given to the
Metropolitan Museum in 1919 by the then Second
Vice-President of the Museum, Henry Walters.

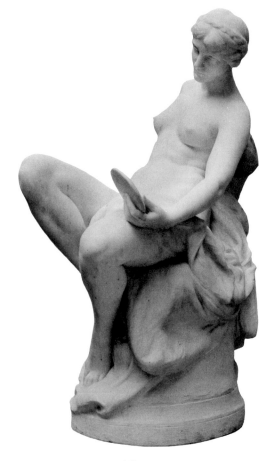

29a. Oblique view of fig. 29

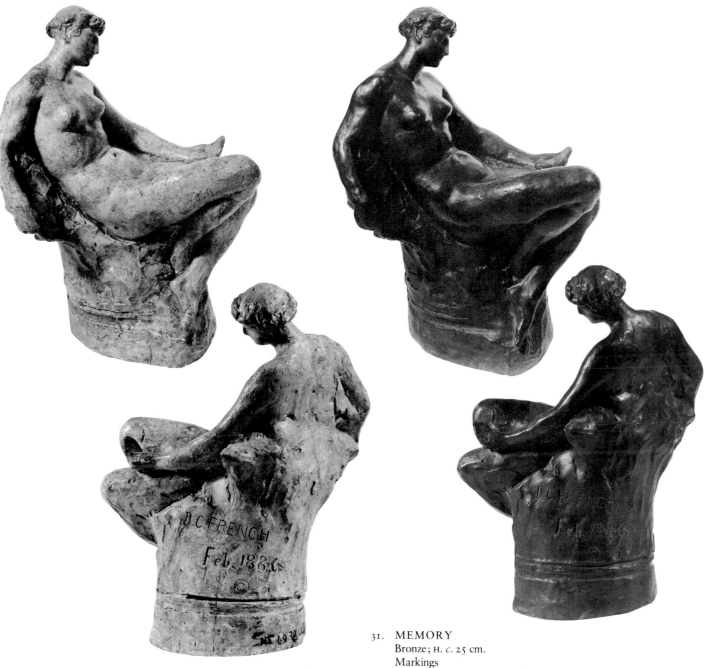

30. MEMORY
Plaster; H. *c.* 27.6 cm.
Markings
 on back: D.C.FRENCH / FEB. 1886 /©

Chesterwood (NT.69.38.202), Stockbridge,
Massachusetts

French's name and the copyright mark were added by
the sculptor's daughter, Margaret French Cresson,
sometime in the 1930s.

30a. Rear view of fig. 30

31. MEMORY
Bronze; H. *c.* 25 cm.
Markings
 on back: D.C.FRENCH / FEB. 1886 /©
 near edge of base, cold-stamped: QIAR GORHAM CO
 on bottom, stamped: 8

Chesterwood (NT.73.45.1380), Stockbridge,
Massachusetts

This casting was done after the artist's death in
October 1931. The number "8" on the bottom of the
bronze can be interpreted either as one number in a
series or as a foundry identification recording a
particular order received from Margaret Cresson. The
model for this bronze is fig. 30.

31a. Rear view of fig. 31

Notes

1. Daniel Chester French to William Merchant Richardson French, March 3, 1881, Box 81, the Daniel Chester French Family Papers, Manuscript Division, Library of Congress, Washington, D.C. Hereafter the sculptor's name will be abbreviated to DCF, his brother's to WMRF, and the collection at the Library of Congress will be designated F.F.P.

2. DCF–WMRF, December 2, 1883, Box 82, F.F.P.

3. Michael Richman, "Ulysses S. Grant," in *Sculpture of a City: Philadelphia's Treasures in Bronze and Stone* (New York: Walker Publishing Co., 1974), pp. 188–195. In this cooperative partnership, French received the commission and credited Potter's execution of the working and full-scale models of the animals. Their equestrian monuments included the *Grant* (1893–1899) in Philadelphia; the *George Washington* (1897–1900) in Paris, France; the *Joseph Hooker* (1899–1903) in Boston; and the *Charles Devens* (1902–1906) in Worcester, Massachusetts.

4. Account Book, pp. 14, 31, 87, 113, and 130, Archives, Chesterwood, Stockbridge, Massachusetts. French supervised O'Connor's *Lawton Memorial* (1903–1906) in Indianapolis, Indiana; Augustus Lukeman's decorative figures of *Franklin* and *Joseph Henry* (1909–1910) at Princeton University; Longman's *Nichols Memorial* (1909–1910) in Boston; and Adolph Weinman's *Pediment for the Brooklyn Institute of Art and Science* (1909–1913), now the Brooklyn Museum. Paul Manship worked as French's assistant in 1914 on a fountain for Danville, Illinois.

5. A bill submitted to the Town of Concord on September 11, 1874, listed Garey's business proficiencies. Archives, Chesterwood. Garey's office was located at No. 10 Province Court. It must be assumed that French took the *Emerson* bust in clay to Garey's shop in Boston. Mr. Paul Ivory initially suggested that Garey was so closely linked to French.

6. DCF–Edwin W. Gay, June 13, 1885, Archives, Chesterwood.

7. DCF–Piccirilli Brothers, May 30, 1906, Box 27, F.F.P. This letter identified Eugenio Contini. DCF–Audry Munson, June 6, 1915, Private Collection. This letter indicates that Vicenzo Russo was at Chesterwood to make a duplicate plaster of the bust that French had executed of this New York City model.

8. Account Book, pp. 20, 159, 166, and 186, Archives, Chesterwood.

9. DCF–WMRF, August 22, 1879, Box 82, F.F.P.

10. Henry Flagg French–DCF, November 26, 1879, Box 17, F.F.P. Hereafter French's father will be identified with the abbreviation HFF.

11. DCF–WMRF, May 21, 1880, Box 82, F.F.P.

12. HFF–DCF, April 17, 1881, Box 17, F.F.P.

13. DCF–WMRF, March 27, 1886, Box 82, F.F.P.

14. Doll & Richards Sales Catalogues, Archives of American Art, Smithsonian Institution, Washington, D.C.

15. *Catalogue of Plaster Reproductions* (Boston: P. P. Caproni and Bro., 1911), p. 76.

16. DCF–George Frisbie Hoar, July 9, 1885, Archives, the Massachusetts Historical Society, Boston, Massachusetts.

17. DCF–Reuben N. Rice, November 16, 1883, Archives, Chesterwood.

18. Preston Powers–DCF, December 8, 1878, Harvard College Library, the Houghton Library, Harvard University, Cambridge, Massachusetts. In this letter Powers explains to French that it will cost him $1,200 to have his model of the *Awakening of Endymion* (1875–1879) pointed up and carved into marble. Powers mentioned that Thomas Ball "has been consulted in everything."

19. Albert TenEyck Gardner, *American Sculpture* (New York: The Metropolitan Museum of Art, 1965), p. 94.

20. Account Book, Archives, Chesterwood.

21. DCF–Eugene F. Aucaigne, June 8, 1906, Box 27, F.F.P.

22. Account Book, p. 36, Archives, Chesterwood.

23. *Ibid.*, pp. 36 and 86.

24. "Emerson and Hawthorne," *The New York Times*, November 29, 1879, p. 2.

25. Gifts were made to the National Academy of Design; Williamsport High School, Williamsport, Pennsylvania (figs. 13 and 13a); the American Academy of Arts and Letters; the Metropolitan Museum of Art, New York City; the Montclair Art Museum, Montclair, New Jersey; and to Dartmouth College, Hanover, New Hampshire. In addition to the bronzes at the National Portrait Gallery in Washington, D.C., and the Gilcrease Institute, French sold one cast to Miss Elsie A. Rasor of Macon, Missouri at a discount of $75, and another to Spencer Kellogg, Buffalo, New York, for $300. Between 1886 and 1910, additional bronzes could have been for sale; however, no records have survived to document when or how many purchases were made.

26. A bust was placed on consignment with the Grand Central Gallery on March 1, 1923, in compliance with French's membership in the Painters and Sculptors Gallery Association. It seems plausible to believe only one bust was given to this gallery.

27. HFF–DCF, January 31, 1876, Box 17, F.F.P.

28. As the sculptor was still in Italy, Henry Flagg French applied for the copyright on November 12, 1875. The elder French wrote to his son: "I wrote to Wm [the sculptor's brother] about putting the statuette of the Minuteman into the market and he agreed with me that we had better go ahead. It is near enough like the statue to fairly represent it. Doll is very earnest to publish it, and thinks money can be made of it. I have carried him the small plaster. He says it is the best thing extant and cannot fail of a sale in the Centennial. He proposed to do the whole, have the casts made, painted in some unique tint not like Rogers, . . . and give you half the net profits." HFF–DCF, November 12, 1875, Box 82, F.F.P.

29. Account Book, p. 90.

30. *Ibid.*, p. 18.

31. *Ibid.*, pp. 72 and 142.

32. DCF–WMRF, August 25, 1878, Box 82, F.F.P.

33. Pamela Prentiss French–DCF, January 3, 1879, Box 37, F.F.P.

34. Daniel Chester French, "A Sculptor's Reminiscences of Emerson," *The Berkshire Eagle*, September 28, 1926, p. 4.

35. Quoted in a letter from HFF–DCF, March 5, 1876, Box 17, F.F.P.

36. "A Sculptor's Reminiscences of Emerson," p. 4.

37. HFF–DCF, March 30, 1879, Box 17, F.F.P.

38. DCF–WMRF, April 22, 1879, Box 82, F.F.P.

39. HFF–DCF, May 3, 1879, Box 17, F.F.P.

40. Ellen Tucker Emerson–DCF, July 26, 1879, Box 1, F.F.P.

41. Book 4, Entries 10531 and 10550, Volume K, 1879, Copyright Records, Library of Congress, Washington, D.C. Unfortunately, the photographs which the sculptor sent with his copyright application have not survived in the collections of the Prints and Photographs Division. The author wishes to acknowledge the help he has received from Milton Kaplan, who first informed him of this collection in 1972.

42. DCF–WMRF, August 22, 1879, Box 82, F.F.P.

43. HFF–DCF, November 16, 1879, Box 17, F.F.P.

44. HFF–DCF, November 1, 1879, Box 17, F.F.P.

45. HFF–DCF, December 7, 1879, Box 17, F.F.P.

46. DCF–George Herbert Palmer, February 8, 1915, Archives, Wellesley College Library, Wellesley, Massachusetts.

47. George P. Lathrop, "VII–Boston Arts Club," *The American Art Review*, I (August 1880), 443.

48. Samuel G. W. Benjamin, "VIII–Society of American Artists," *The American Art Review*, II (June 1881), 77.

49. *Society of American Artists, Catalogue of Fourth Annual Exhibition, March 28–April 29, 1881* (New York: The Society of American Artists, 1881), no pagination. In the collection of the Archives of American Art. The bust of Emerson is no. 104.

50. "Emerson and Hawthorne," p. 2.

51. "Art News," *The Art Amateur*, II (February 1880), 52.

52. Corporation Records, Archives, Harvard University, June 25, 1883.

53. HFF–DCF, January 28, 1883, Box 17, F.F.P.

54. A printed list of Daniel Chester French's principal works, issued on August 8, 1885, refers to the Concord marble as a replica. Archives, Chesterwood.

55. DCF–Rice, November 16, 1883, Archives, Chesterwood.

56. *Annual Report of the Selectmen and Other Officers of the Town of Concord, From March 1, 1883 to March 1, 1884* (Boston: Tolman and White Printers, 1884), p. 52.

57. "Emerson and Hawthorne," p. 2.

58. DCF–WMRF, December 7, 1884, Box 82, F.F.P.

59. "The Statues of Harvard and Dupont," *The New York Herald*, September 28, 1884, p. 17, and "Three American Statues," *The New York Times*, October 12, 1884, p. 5.

60. Phineas Parkhurst Wells–HFF, October 6, 1884, Box 17, F.F.P.

61. "How Statues Are Made," *The New York Times*, January 25, 1891, p. 14. I wish to thank George Gurney, Smithsonian Predoctoral Fellow, National Collection of Fine Arts, for calling my attention to this interesting essay.

62. Large Book (an album of photographs assembled by Daniel Chester French), Archives, Chesterwood.

63. Odell Shepard, *The Journals of Bronson Alcott* (Boston: Little Brown and Co., 1938), p. 501.

64. DCF–Robert W. deForest, February 7, 1907, Archives, the Metropolitan Museum of Art, New York, New York.

65. DCF–Arthur Cilley, February 25, 1896, Exeter Public Library, Exeter, New Hampshire.

66. DCF–George Herbert Palmer, February 8, 1915, Archives, Wellesley College Library, Wellesley, Massachusetts.

67. "A Sculptor's Reminiscences of Emerson," p. 4.

68. HFF–DCF, January 4, 1879, Box 17, F.F.P. French's father inquired of his son: "I hope you are not content with a *bust* of Mr. Emerson."

69. "Notes," *The Critic*, XV (March 14, 1891), 148.

70. DCF–George A. King, April 5, 1896, Archives, Concord Free Public Library, Concord, Massachusetts. The author is grateful for the assistance of Marcia Moss, Reference Librarian, who alerted me to this letter and several others in the Library's collection.

71. DCF–King, December 6, 1905, Concord Library.

72. During a visit to Chesterwood in May 1975, Professor H. W. Janson, seeing a photograph of the *Voltaire* in French's study collection, noted the relationship of this statue to the sculptor's seated *Lincoln*. The comparison is appropriate not only to French's masterpiece, but to the *Emerson* begun four years earlier.

73. "A Sculptor's Reminiscences of Emerson," p. 4.

74. There is no citation for this bronze statuette in the Account Book.

75. Account Book, p. 37. At this time French received $5,000.

76. *Ibid.* The second installment was for $2,500.

77. *Ibid.* The Piccirillis received $1,791.31 for carving the *Emerson* on June 8, 1914. French, however, did not receive his final payment—all that apparently remained from the subscription, $7,762.82—until October 11, 1914.

78. *Ibid.*, p. 36.

79. *Ibid.*, p. 39. French noted that the contract was signed on February 23, 1923. The foundry was paid $210 on May 4, 1923, for casting the bronze. "On July 16, 1921 [sic], the sculptor received his fee and reimbursement for the foundry expenses."

80. This plaster was in the Chesterwood collection until 1953, when it was given by Margaret French Cresson to the New-York Historical Society.

81. This plaster is located in a private collection in Concord, Massachusetts.

82. Three bronzes of this statuette are known. The figure that belonged to Gellatly is one in the possession of the National Collection of Fine Arts. A second is at Chesterwood and a third casting is in the Speed Museum, Louisville, Kentucky.

83. This piece, entitled *Muted Strings* by Margaret Cresson, appears to be a unique casting.

84. French's patron, James C. Melvin, agreed to donate this statue to the Metropolitan Museum in 1912. The work was not actually received until 1915. The Piccirilli Brothers provided a carving estimate on November 9, 1912: "We propose to reproduce in Italian Bianco P. marble the figure [the Melvin relief] to scale about 6'–0 or a little over for the amount of $1,700 . . ." (Account Book, p. 98).

85. Sales Book, Knoedler Galleries, Inc., 1919, p. 238. The author is grateful to the Librarian of the gallery, Richard Finnegan, for permitting me to examine these records. A perusal of these written records failed to uncover a single reference to any bronzes being consigned to or sold by the gallery.

86. E.R. [Edward Robinson], "Memory by French," *Bulletin of the Metropolitan Museum of Art*, XIV (March 1919), 46.

Selected Bibliography

ARCHIVAL COLLECTIONS:

The William Brewster Papers, Archives of the Museum of Comparative Zoology, Harvard University, Cambridge, Massachusetts.

Chesterwood (A Museum Property of the National Trust for Historical Preservation), Stockbridge, Massachusetts.

Concord Free Library, Concord, Massachusetts.

The Daniel Chester French Family Papers, Manuscript Division, Library of Congress, Washington, D.C.

The Metropolitan Museum of Art, New York, New York.

Stockbridge Public Library, Stockbridge, Massachusetts.

Adams, Adeline. *Daniel Chester French, Sculptor.* Boston and New York: Houghton Mifflin Co., 1932.

Caffin, Charles H. *American Masters of Sculpture.* New York: Doubleday Page and Co., 1903.

Coffin, William A. "The Sculptor French." *The Century Magazine*, LIX (April 1900), 871–879.

Cortissoz, Royal. "New Figures in Literature and Art: Daniel Chester French." *The Atlantic Monthly*, LXXV (February 1895), 223–229.

Cresson, Margaret French. *Journey into Fame*. Cambridge: Harvard University Press, 1947.

Emerson, Helen B. "Daniel Chester French." *The New England Magazine*, XVI (May 1897), 258–274.

French, Daniel Chester. "A Sculptor's Reminiscences of Emerson." *The Berkshire Eagle*, September 28, 1926, p. 4.

French, Mary. *Memories of a Sculptor's Wife*. Boston and New York: Houghton Mifflin Co., 1928.

Gardner, Albert TenEyck. *American Sculpture*. New York: The Metropolitan Museum of Art, 1965.

"How Statues Are Made." *The New York Times*, January 25, 1891, p. 14.

Proske, Beatrice Gilman. *Brookgreen Gardens Sculpture*. Brookgreen, South Carolina: Printed by order of the Trustees, 1968.

Richman, Michael. "The Early Career of Daniel Chester French, 1869–1891." Unpublished doctoral dissertation, the University of Delaware, Newark, Delaware, 1974.

———. "Ulysses S. Grant," in *Sculpture of a City: Philadelphia's Treasures in Bronze and Stone*. New York: Walker Publishing Co., 1974.

———. "Daniel Chester French's Portrait Reliefs, 1869–1900." *The Currier Gallery of Art Bulletin*, II (1974), 18–36.

Rusk, Ralph L. *The Life of Ralph Waldo Emerson*. New York and London: Columbia University Press, 1949.

Taft, Lorado. "Daniel Chester French, Sculptor." *Brush and Pencil*, V (January 1900), 145–168.

———. *The History of American Sculpture*. New York: The Macmillan Co., 1925.

Title, Walter. "A Sculptor of the Spirit of America." *The World's Work*, LVI (July 1928), 298–305.

Checklist of the Exhibition

RALPH WALDO EMERSON

4. Plaster (Bust); H. *c.* 59 cm.
 Concord Free Public Library, Concord, Massachusetts

5. Marble (Bust); H. *c.* 59.5 cm.
 Memorial Hall, Harvard University, Cambridge, Massachusetts

6. Marble (Bust); H. *c.* 62.5 cm.
 Concord Free Public Library, Concord, Massachusetts

8. Bronze (Bust); H. *c.* 55.5 cm.
 Chesterwood, Stockbridge, Massachusetts

11. Plaster (Bust); H. *c.* 56.7 cm.
 Exeter Public Library, Exeter, New Hampshire

12. Plaster (Bust); H. *c.* 58 cm.
 Chesterwood, Stockbridge, Massachusetts

13. Bronze (Bust); H. *c.* 55.5 cm.
 Williamsport Area School District, Williamsport, Pennsylvania

13b. Bronze (Bust); H. *c.* 57.2 cm.
 Markings
 front: EMERSON
 rear shaft: DCF (faint)
 rear, foot of pedestal: JNO WILLIAMS INC. / BRONZE FOUNDRY N.Y.
 inside: 1803
 Dartmouth College, Hopkins Center Art Galleries, Hanover, New Hampshire

13c. Bronze (Bust); H. *c.* 57.2 cm.
 Markings
 front: EMERSON
 rear shaft:
 D.C.FRENCH Sc. / 1879
 THE HENRY-BONNARD BRONZE Cº. / FOUNDERS. N.Y. 1901
 National Portrait Gallery, Smithsonian Institution, Washington, D.C.

14. Plaster (Seated Statue); H. *c.* 32.5 cm.
 Chesterwood, Stockbridge, Massachusetts

15. Plaster (Seated Statue); H. *c.* 67 cm.
 Chesterwood, Stockbridge, Massachusetts

16. Bronze (Seated Statue); H. *c.* 65 cm.
 Harvard College Library, the Houghton Library, Harvard University, Cambridge, Massachusetts

19. Plaster (Head from Seated Statue); H. *c.* 33 cm.
 including tenon
 Chesterwood, Stockbridge, Massachusetts

21. Plaster (Bust); H. *c.* 79.5 cm.
 The New-York Historical Society, New York, New York

MEMORY

24. Plaster; H. *c.* 27.6 cm.
 Chesterwood, Stockbridge, Massachusetts

25. Bronze; H. *c.* 25 cm.
 Chesterwood, Stockbridge, Massachusetts

26. Plaster; H. *c.* 28.2 cm.
 Chesterwood, Stockbridge, Massachusetts

28. Plaster (terra-cotta-colored paint); H. *c.* 142.5 cm.
 Chesterwood, Stockbridge, Massachusetts

30. Plaster; H. *c.* 27.6 cm.
 Chesterwood, Stockbridge, Massachusetts

31. Bronze; H. *c.* 25 cm.
 Chesterwood, Stockbridge, Massachusetts

Index

A

Abraham Lincoln (French): 219.
See also Lincoln
Academic system: 58, 62
Academy of Painting and Sculpture:
French, 61, 62
Accuracy: questions of, 88
Adams (family of sculptors): 57
Adams Memorial (Saint-Gaudens): 181
Advertisements: for Carpeaux's studio,
112fig.
Age of Bronze, The (Rodin): 145, 147
casting of, 148
commission for, 150
Alcott, Amos Bronson: bust of, 221, 233
Ames (founder): 222
Amor Caritas (Saint-Gaudens): 181
Amour à la Folie (Carpeaux): 50fig.
Animal Combats (Barye): 79
Apollo (Houdon): 69
Appleton, Nathan, 239
Ardison, Gaetan (plaster molder): 183,
184, 185, 191, 193, 195
Armand (*praticien*): 126, 127
Armour, George: 189
Arnason, H. Harvard: xii
on Houdon, 57–70
Arnould, Madeleine Sophie: 2, 60
Houdon's bust of, 15n, 66, 67
Artists: 1
clients of, 2–3
ownership rights of, 23–24 (n68, n69)
and producers, 19 (n36). See also
Sculptors
Association Internationale des
Travailleurs: 9
Aubry Brothers (founders): 183, 209
Aucaigne, Eugene F. (founder): 222,
229, 237
Auteuil Studio: Carpeaux's, xii, 6, 7,
110, 113, 119, 134
inventory of, 123, 132, 134, 139
Awakening of Endymion (French): 222

B

Babb, George F. (architect): 203
Bacchante (Carpeaux): busts of, 132
Bacchante aux yeux baissés (Carpeaux):
132
Bacchante criant (Carpeaux): 132

Bachelier (painter): 67
Baffier, Jean (marble carver): 149
Baird, Julia (Dudie): 209
Ball, Thomas: 222
Balzac (Rodin): 150, 173 (n6)
Banjean (founder): 148
Barbedienne, Ferdinand (founder): 6, 7,
8, 20n, 21n, 80, 170
suit against counterfeiters, 10, 22–23
(n64)
Barbedienne foundry: 80, 112, 147, 183,
193
Barlow, Joel (Houdon): plaster of, 62
Barre (sculptor): 7
Bartlett, T. H.: 147, 157
Barye, Antoine-Louis: xii, 6, 7, 18 (n26),
76fig., 77–104
Monument to, 104
numbered proofs for, 82
royal patronage of, 78, 89
suppliers for, 82. See also specific
works
Barye and Company, 79
Beale, Arthur, xii, xiii, xiv, 29–55, 71–74
Beaman, Mrs. Charles: 183
Bear Attacked by Dogs (Barye): 37fig.
Benge, Glenn F., xii
on Barye, 77–107
Benson, George W. (dealer): 186
Bernaërts, Bernard (marble worker):
112, 126fig., 127, 131fig., 133
Bernard, Jacques (architect): 110, 112
Bernier, Stanislas: 104
Beuret, Rose: 145
Bibi (Rodin's model): 153
Biennais, Martin Guillaume
(goldsmith): 77
Bigelow-Kennard (dealer): 185
Billings, Charles (Saint-Gaudens): 183
Bingen, C. (founder): 147
Biot, Gustave: 150, 154fig., 157
Black, Mrs. H. V. D.: 223
Bogart, A. B.: 246
Bonnard, Henry (founder): 183, 184,
189. See also Henry-Bonnard Bronze
Company
Bonnat, Leon Joseph Florentine: 76
Bosio, Baron F. J. (sculptor): 4,
17 (n19), 77
Boston Library Groups (Saint-Gaudens):
182
Bourdelle, Antoine: 149
Bourson, Amédée: 150

Braunwald, Annie: 113, 119, 122, 123,
132, 133, 134, 138n, 139
on Carpeaux, 109–143
Brewster, Charles: 185
Bronze sculpture: eighteenth-century, 69
manufacturers of, 7
small, 77. See also specific pieces
Brooks Monument (Saint-Gaudens):
183
Brown, Alice: 246
Brown, Quincy: 239
Browning, Robert Barret: 154, 157
Bull Hunt (Barye): 88
Bureau Brothers (founders): 183, 222
Burghers of Calais (Rodin): 145, 147
Burin: 104. See also Points
Bust of Child (Houdon): 34fig.
Bust of Woman: 44fig.

C

Cabot, John Elliott (French): bust of,
219
Cachet: Carpeaux's, 130fig.
of Musée Rodin, 149
Canova: 4
Capellaro, Charles-Romain (*praticien*):
110
Caproni and Bro., P. P. (founders): 221
Carfax Gallery: 150
Carpeaux, Jean-Baptiste: 109–124
biography of, 138 (n1)
education of, 109
enterprise of, 6 (see also Auteuil
Studio)
estate of, 7, 11
portrait of, 108fig.
posthumous exploitation of, 11
reproduction of works by, 109–110.
See also specific works
Carpeaux, Emile (brother): 112, 113
Carpeaux, Joseph (father): 112,
138 (n14)
Carpeaux-Dervillé dispute: 122
Carrier-Belleuse, Albert (sculptor): 7,
109, 145
Carving: 49
definition of, 29
of marble, 112, 113, 122, 127, 149
Cass, Lewis (French): 219
Casting: definition of, 33
in plaster, 2, 14 (n2), 33

Casting business: 14 (n4)
Casts: counterfeit, 14–15 (n5, n7)
 lost-wax, 12, 13, 26 (n86), 33, 35
 venting system for, 40fig.
Catherine the Great: 59, 60
Chapin Relief (Saint-Gaudens): 183
Chaplet: 38, 40, 41
Charles VI Frightened in the Forest of Mans (Barye): 88
Charpentier, Alexandre: 148
Chartier (founder): 183
Chasing: 41–44
 of serial sculpture, 13, 26 (n84)
Chérier, Bruno (painter): 108, 122
Christofle (founder): 6, 8, 122, 123, 139
Chronology: 29
 Cire-perdue process: 69
 Rodin's use of, 147. *See also* Lost-wax casting
Clark, Davida: 201
Claudel, Camille (sculptor): 147
Clay: 2
 casting with, 35
 chasing of, 42
 marking, 49
Clay slip: 34fig.
Clemenceau, Georges: 145
Clement-Carpeaux, Louis (son): 11
Clésinger (sculptor): 7, 13
Clients: 122
Colin (founder): 11
Collas (founder): 8
Collas Process: 8, 112, 113
Collas sculpture-reducing machine: 47fig., 102, 104
Coloring: of metal, 45
Colvin, Sidney: 192, 193, 194
Combatting the Centaur Biénor (Barye): 78
Comtesse du Cayla (Houdon): 60
Concord: town of, 239, 243
Concord Minute Man: 219, 223
Condorcet: 62
Contini, Eugenio: 221
Contini family (plaster molders): 183
Contract: for model reproduction, 18–19 (n31)
Contre moulage: 2
Cooper, Peter (Saint-Gaudens): 182
Cooper Monument (Saint-Gaudens): 183
Cores: 40
Coring process: 40
Cornish collection: 182, 195
Cortissoz, Royal: 201

Counterfeiting: of sculpture, 9
Coustous (sculptors): 57
Cresson, Margaret French (daughter): 248, 249, 253

D

Dalou, Jules (sculptor): 11, 109
 Rodin's bust of, 148
Daly Monument (Saint-Gaudens): 183
d'Angers, David (sculptor): 5, 71
Dantan (sculptor): 7
Dante: 113, 169
Dating: xi
Debaisieux (plasterer): 110
de Breaux (founder): 7
de Caso, Jacques: xiv, 1–28
Decorative Masks (Barye): 78
Degas, Edgar: 125
Delacroix, Ferdinand, V. E.: 77
Delafontaine, Jean: 8
Delécluze: 77
Delius, Jelka Rosen (painter): 150
Deloye, Gustav (sculptor): 69
Demand: for serial sculpture, 2–3
de Montfort, Amélie (Carpeaux's wife): 109
de Musset, Alfred: 89
Denière (founder): 8
de Racowitza, Hélène: Carpeaux's bust of, 134, 139 (n33)
de Rothschild, Alphonse, 150, 175 (n53)
Dervillé, M. Cyr-Adolphe, 119
Desbois, Jules (marble carver): 147, 148, 149, 153
Despair (Rodin): 147
Despian, Charles (marble carver): 149
Deux femmes bacchantes (Rodin): 150
Dewing, Thomas W. (painter): 203
Diana: 53fig., 58, 68fig., 183, 201–213
 on Agricultural Building, 203fig.
 in bronze, 204fig., 207fig., 208fig., 210fig.
 bust of, 213fig.
 casting of, 184
 changes in, 203, 209, 211
 clay sketch of, 202fig.
 on Collier's cover, 201
 copyrights for, 185
 early plaster model for, 202fig.
 editions of, 184
 first version of, 202
 head of, 202fig., 212fig., 213fig.
 inscription of, 51fig.

"large," 207, 209
 on Madison Square Garden tower, 201, 203, 205fig.
 notoriety of, 201
 in plaster, 206fig., 212fig.
 plaster piece-mold cast for, 34fig.
 reproduction of, 69
 sale of, 186
 second version of, 204fig., 206fig.
 in sheet copper, 207fig.
 "small," 210
"Diana of the Tower": 209, 211, 213fig.
 molds for, 30fig.
Diderot, Denis: 58, 59, 60
 Houdon's bust of, 58, 59, 60, 69
Dillens, Julien: 150
Dimensions: 49
 published, 53
Divine Comedy, The: Count Ugolino in, 113
Dodge, Sarah Hoadley: 198
Dolivet (marble carver): 170
Doll & Richards (dealers): 186, 221, 222–223
Doors (French): 219
Dosia (Rodin): 148, 150
Droit moral: 11, 23
Druet, E.: 160
Dryfhout, John: xiii, xiv
 on Saint-Gaudens, 181–217
Dudley Gallery: 154
de Pont de Nemours, Pierre Samuel: 63
Duret, Françisque-Joseph (sculptor): 109, 110
Duval (founder): 11

E

Eagles (Barye): 78
Earth, The (Rodin): 167
École des Beaux-Arts: 109, 110
Electroplating: definition of, 47
Electrotype: 46fig., 198
Electrotyping: 8, 20–21 (n44)
 definition of, 47
Ellsworth, William: 185, 186
Elsen, Albert E.: xi
Elwell, Frank Edwin (sculptor): 220
Emerson, Ralph Waldo (French): xiii, 219, 222, 225–246
 in bronze, 232fig., 234fig., 236fig., 241fig.
 carving of, 220
 editions of, 223

first plaster of, 224fig.
head of, 244fig.
lost-wax casting for, 38fig., 237fig.
in marble, 228fig., 230fig., 244fig.
"original" version of, 228 fig.
in plaster, 30fig., 226fig., 231fig.,
235fig., 236fig., 245fig.
plaster maquette of, 238fig.
reproduction of, 227
sale of, 222, 233
sand-cast bronze of, 38fig.
sand piece mold for, 36fig.
seated, 242fig.
signature on, 51fig., 53fig.
working model for, 240fig.
Emerson, Edward: 225, 239
Emerson, Ellen: 225
"Engraving": 43
Enlargement: 8
Enlarging: definition of, 47
Épreuves: 87
Escoula, Jean (marble carver): 149
Esquisses cires: 88
Estampages: 147
Eternal Spring, The (Rodin): 148
Eve (Rodin): 145
Exemplaires: 1, 3
signatures on, 16n
Expositions des Produits de
l'Industrie: 9
Expositions Universelles: 9, 102

F

Fallen Caryatid Carrying Her Stone,
The (Rodin): 147
Farragut Monument (Saint-Gaudens):
181, 183, 201
Fauconnier (sculptor): 6, 18 (n26)
Faune (Carpeaux): 132
Ferargil Gallery: 186, 223
Finishing: 41–44
of bronze *exemplaire*, 12
reworked detail, 44fig.
"Fire skin": 43
First Division Memorial (French): 219
Flanagan, John (sculptor): 181
"Flashing": 41
Flask: 32fig., 33
Flow systems: 41
Fontaine de l'Observatoire (Carpeaux):
6, 109
Forbes, Edith Emerson: 241
Foundries: bronze, 2

Paris, 183
Founders: 6
Barye and, 79, 81
Houdon and, 68, 69
Rodin and, 148
Saint-Gaudens', 183–184. *See also*
specific founders
Foundry: Barbedienne's, 80, 112, 147,
183, 193
Barye's, 6
Foundry workers: 8, 21–22 (n51)
Four Continents (French): 219
Franklin, Benjamin (Houdon): xiii,
60, 61, 63, 65
Beale on, 71–74
à l'antique, 64–65, 73
Barbedienne replica of, 69, 73
in Boston Athenæum, 70 (n2), 72fig.
in bronze, 42fig., 66fig., 70, 71, 73
in marble, 63, 71
measurements of, 53
in modern dress, 65
in Musée du Louvre, 71
in plaster, 65fig., 69, 71, 72fig.
portrait busts of, xii, 62, 63–75
signature on, 50fig.
in terra cotta, 43fig., 67fig., 68fig.,
69, 73
Fraser, James E. (sculptor): 181, 184
Fratin (sculptor): 7
Freemasonry: 61
Frémiet (sculptor): 5
French, Daniel Chester: xiii, xi, 219–223
education of, 219
equestrian monuments of, 254 (n3)
marble carvers for, 222
photographs of, 218fig., 247fig.
studio of, 234fig. *See also specific*
works
French, Henry Flagg (father): 219, 221,
227, 254 (n10), 255 (n28)
French, Pamela Prentiss (stepmother):
225
French, William Merchant Richardson
(brother): 220, 221, 229
French Academy of Painting and
Sculpture: 61, 62
"French sand": 33fig., 100, 237
Frères, Thiébaut (founders): 147, 183
Frileuse (Houdon): 68
Fugit Amor (Rodin): 147
Fulton, Robert (Houdon): plaster of, 62
Fumière and Gavignot (founders): 12,
148

G

Gallaudet, Thomas Memorial
(French): 219, 229
"Galvanos": 47. *See also* Electrotypes
Garey, Paul A. (plaster caster): 220, 221,
225, 227, 233, 237
Garfield Monument (Saint-Gaudens):
182, 183
Garnier, Charles: 109, 125, 138
Gates of Hell (Rodin): 145, 147, 148,
150, 167
Gating and venting system: 40, 41fig.
Gelatin mold: 30fig., 31fig.–33
signature in, 51fig.
Gelatin molding: 14n
Génie de la Marine (Carpeaux): 109
Georges Petit Gallery: 150
Giacometti, George: 69
Gluck (Houdon): 59, 60
Glue molding: 31
Goldscheider, Cécile: 149
Gonon, Eugène (founder): 147
Gonon, Honoré (founder): 93
Gorham (founder): 183, 222
Governor Flower Monument (Saint-
Gaudens): 183
Graillon (sculptor): 5, 17–18 (n24)
Grand Central Gallery: 223
Gréber, H. (marble carver): 170
Griffoul, Auguste (founder): 147
Griffoul, P. (founder): 147
Gros (painter): 77
Grosvenor Gallery: 154
Gruet, E. (founder): 183, 194, 209, 222
Gruet ainé, A.: 148
Guioché (mouleur): 147

H

Hallmarks: 3–4
Halou, Alfred (marble carvers): 149
Hanna Monument (Saint-Gaudens): 183
Harvard, John (French): 219, 220, 229
Hébrard, A. A. (founder): 11, 132, 147
Henley, W. E.: 154, 157
Henri IV, enfant (Barye): 77
Henry-Bonnard Bronze Company:
222, 229, 237
Hercules Killing a Lion (Barye): 88
Hering, Henry (sculptor): 181
Hiawatha (Saint-Gaudens): 181
Higginson, Henry C.: 227

Hill, David J. (Saint-Gaudens): bust of, 185
Historians: art, 29
Hoar, George Frisbie: 221
Hoar, Ebenezer (French): bust of, 219
Hoffman, Malvina (sculptor): 146
Homer, Augusta: 181. *See also* Saint-Gaudens, Augusta
Homer, Tom: 209
Houdon, Jacques (father): 57
Houdon, Jean-Antoine: xi, xii, 2, 4, 57–62
 counterfeiting, 3
 reproduction techniques of, 58, 60, 61, 66, 67
 studio of, 56. *See also specific works*
Hugo, Victor Inspired by the Muses (Rodin): 147

I

Iconography: 63
Industry: art and, 9
Inscription: in plaster piece mold, 51fig.
 Robert Louis Stevenson relief, 189
Investment: 33, 38fig.
 removal of, 45fig.
Ionides, Constantine A.: 157

J

Jacobsen, Carl: 170
Jacques, Narcisse (marble carver): 131, 133
Jaguar Devouring a Hare (Barye): 78
Janvier, Victor (founder): 195, 198
Jefferson, Thomas (Houdon): portrait of, 62
Jennings Brothers Manufacturing Company: 223
Jeune pêcheur à la coquille (Carpeaux): 109, 112
Jones, John Paul (Houdon): portrait of, 61, 65
Journal (Émile Martin): 80, 81, 82
July Monarchy: 89

K

Kawamura (plaster caster): 221
Kent, H. W.: 211
Keppel, Frederick: 185

King, George A.: 239
Kiss, The (Rodin): xiii, 47, 145, 148, 169–173
 Barbedienne edition of, 170
 in bronze, 171fig., 173fig.
 editions of, 169
 founders' signature in, 52fig.
 in marble, 169, 171fig., 172fig.
 origins of, 169
 in plaster, 168fig.
 reductions of, 170, 176 (n90)
 struck metal inset on, 52fig.
Kornfeld and Klipstein (dealers): 151
Kunst, A. (founder): 222

L

La Comédie et le Drame (Carpeaux): 125
La Danse (Carpeaux): xii, 6, 109, 110
 in bronze, 140
 censure of, 129
 commission for, 125
 criticism of, 139 (n37)
 drawings for, 111
 in Echaillon stone, 126fig.
 financing of, 127
 modeling for, 111
 in plaster, 140
 replicas of, 138 (n9)
 reproduction of, 112
 signature on, 50fig.
 support elements for, 34fig.
 in terra cotta, 113, 124fig., 127, 128fig., 132, 140
 works extracted from, 132
Lafayette (Houdon): 65
L'Amour à la folie (Carpeaux): 134fig.
La Reine de Saba apportant des présents à Salomon (Houdon): 57
La Sculpture romantique: xi
La tendresse maternelle (Carpeaux): 15 (n10), 112
Lathrop, George P.: 227
Laurens, Jean-Paul: 147
Laurent-Daragon, Charles (plaster caster): 110
Law: 9, 10. *See also* Rights
Lawton, Frederick: 160
Leblanc-Barbedienne (bronze firm): 12, 148. *See also* Barbedienne
Le Bossé, Henri (reducteur): 147
Lechesnes (sculptor): 5

L'Écorché (Houdon): 58, 68, 69
Lee, Henry: 227
Le Génie de la Danse (Carpeaux): 37fig., 132, 134
 in bronze, 129fig., 130fig., 131fig., 140, 141
 features of, 139
 editions of, 133
 figure of, 125, 127
 in marble, 131fig., 133
 in plaster, 140, 141
 in terra cotta, 128fig., 140, 141
Legros, Alphonse (plaster): 154
Leighton, Sir Frederick: 154, 157
Le Jeune pêcheur à la coquille (Carpeaux): 109, 112
Lemoynes (sculptor): 57
L'Empereur reçoit Abd-el-Kader à Saint-Cloud (Carpeaux): 109
Lenoir (Houdon): 69
Lenormant, Charles: 89
Les Emigrants (Daumier): 39fig.
Les Trois Grâces (Carpeaux): 134
 in bronze, 137fig., 141
 plaster model of, 48fig., 135fig.
 stamp on, 50fig.
 in terra cotta, 135fig., 136fig., 141
Liards (founder): 183
L'Idylle (Rodin): 25 (n79), 175 (n38)
L'Impératrice protégeant les orphelins et les arts (Carpeaux): 112
Lincoln (French): 219
 (Saint-Gaudens), 181, 182, 186
Lion Crushing a Serpent (Barye): 77, 89–104
 assembled elements for, 101
 Barbedienne cast of, 104
 in bronze, 90fig., 93, 95fig.
 detail of, 90fig.
 exploded view of, 97fig.
 founders' mark stamped into, 52fig.
 largest free version of, 101
 measurements of, 53
 mechanical reductions of, 102–104
 non-mechanical small versions of, 99
 reduction of, 47
 reduction No. 1 of, 99–100, 101
 reduction No. 2 of, 100–101
 studies of, 91, 92fig.
 in terra cotta, 91, 95fig.
 Variation No. 1 of, 94fig.
 Variation No. 2 of, 93, 96fig.
 in wax and plaster, 95fig.
Lion Devouring a Boar (Barye): 77
Lion's Head (Barye): 102

Lion Hunt (Barye): 88
Lion Striking a Serpent (Barye): 96fig., 97fig., 98fig., 103fig.
Lion of the Zodiac (Carpeaux): 78, 104
Lipchitz (sculptor): 67
Little Man with the Broken Nose (Rodin): 42fig., 166fig.
Logan (Saint-Gaudens): 183
Longman, Evelyn Beatrice (monument maker): 219, 220
Lost-wax casting: 12, 13, 26 (n86), 33, 35
Louis XVI (Houdon): 62
Low, Will H.: 187
Luc-Benoist: 80
Lukeman, Henry Augustus (monument maker): 219, 220
Luppens, Henri (founder): 148
Lytton, Lord: 154

M

Madison Square Garden: *Diana* for, 201, 203, 205fig.
Mahler, Gustave, 145
Maison Collin (founders): 133
Maison Dervillé, 119–122
Maison Thiébaut: 112, 118. *See also* Thiébaut foundry
Manship, Paul (sculptor): 220
Manufactory at Sèvres: 3
Manufacturers: Barbedienne, 8 (*see also* Barbedienne foundry)
Christofle, 6, 8, 122, 123, 139
and sculptors, 8
Susse, 7, 8, 11, 17 (n23)
Man with the Broken Nose (Rodin): xiii, 145, 153–166
in bronze, 154fig., 155fig.–157fig., 159fig., 161fig., 164fig., 165
carved version of, 165fig.
Group I, 154, 160
Group II, 165
on jardinière, 164fig.
in marble, 152fig.
measurements of, 53fig.
modeling of, 146
in plaster, 152fig.
reductions of, 176 (n90)
sale of, 150, 151
sand casts of, 157
signature on, 52fig.
in terra cotta, 162fig.

Marble: casting from, 176 (n87)
French's work with, 221
Marchand (founder): 8
Marketing: of serial sculpture, 7
Markings: 52fig.
of Alexis Rudier, 149
die-stamped numbers, 53fig.
methods of, 49
in plaster waste-mold cast, 50fig. *See also* Signatures; Stamps
Marquis de Miromenil (Houdon): 59
Martin, Émile: journal of, 79, 80, 81, 82
Martiny, Philip (sculptor): 181
Martin-Zédée, Mme, 79
Mascetti (plaster caster): 221
Massengale, Jean Montague: 70 (n2)
Mathet, Louis (marble carver): 149
McGuiness, Mary: 181
McKim, Mead and White: 203
Measurements: 49. *See also* Points
Medieval Knight (Barye): 87
Melvin, James C.: 256 (n84)
Melvin Memorial (French): 219, 247
Memory (French): 247–253
in bronze, 250fig., 253fig.
carving of, 220
clay model of, 251fig.
in marble, 252fig.
in plaster, 248, 249fig., 250fig., 251fig., 253fig.
signature on, 50fig.
Mène (sculptor): 5
Meštrović, Ivan (sculptor): 150
Metal: casting in, 35
chasing of, 42
marking in, 49
patinating of, 45
Metropolitan Museum of Art, New York City: 182
Meynier, Emille: 11, 113, 131fig.
contract with Carpeaux, 25 (n73)
Meynier process: 138
Michelangelo: 115
Mignon (Rodin): 145
Miller, Rosalie: photo of, 247fig.
Milmore Memorial (French): 219, 222
Minute Man (French): 219, 223
Mirabeau (Houdon): portrait of, 62
Model: reduction of, 15 (n10). *See also* Reductions
Modèle: 93
Modeling: Carpeaux's method of, 110, 117
definition of, 29
Rodin's technique of, 146

Moine, Antonin (sculptor): 5, 17 (n22)
Mold: damage to, 34fig.
investment, 33fig.
"mother," 30fig.
Molding: definition of, 31–32
Molière: 60
Monet, Claude: 150
Montagutellis (*mouleurs*): 147
Montgomery Relief (Saint-Gaudens): 183
Moses, Lionel (architect): 201
Mosman, M. H. (founder): 222
Mouleur réparateur: 2
Mouleurs: 147
Moynihan (plaster caster): 221
Mullins, W. H., Manufacturing Company: 203
Musée Rodin: 12, 145, 148, 149, 169, 170

N

Napoleon (Houdon): portrait of, 62, 69
Napoleon Bonaparte in Coronation Robes (Barye): 78
Napoleon Crowned by History and Arts (Barye): 78
Napoleon III as Roman Emperor (Barye): 78
National Endowment for Arts: viii
Natorp, Gustave (sculptor): 154, 157
Necker (Houdon): portrait of, 62
Nichols, Rose: 185
Niehaus, Charles Henry (sculptor): 190

O

O'Connor, Andrew (monument maker): 219, 220
O'Reilly, John Boyle Memorial (French): 219
Oreste: 17 (n18)
Originality: xi, 54
Orléanist circle: 89
Orléanist monarchy: 79
Osthaus, Karl-Ernst: 150
Ownership: right of, 10

P

Paillard (founder): 8, 112
Paine, Robert Treat: 182
Panther of India (Barye): 87
Panther of Tunis (Barye): 86fig., 87
Parianware groups: 223
Paris International Exposition: of 1900,
 145
Paris Opéra: Carpeaux commission
 for, 125
Patinas: Saint-Gaudens', 183
Patinating: definition of, 45, 47
Peasant Girl of Frascati (Houdon): 58
Pêcheur Napolitain (Duret): 26 (n84)
Peening: 53fig.
Personification groups (Barye): 78
Perzinka, Leon (founder): 147
Peter, Victor (marble carver): 149
Petermann, J. (founder): 148
Petit, Georges: 170
Petite École: 109, 145
Piccirilli family (marble carvers): 222
Piece mold: 31
Piece molding: 14 (n1)
Pigalle, Jean-Baptiste (sculptor): 57
Planche, Gustave: 89
Plaquettes: 32fig.
Plaster: Barye's preference for, 85
 casting in, 2, 14 (n2), 33
 chasing of, 42
 marking in, 49
 as mold material, 31
 patinating of, 45
Plaster cast: struck copper inset in,
 51fig.
Plaster casters: 2, 14 (n2)
 French's, 220. *See also specific casters*
Plaster of Paris: 31, 66
Plasticine: markings in, 49
Plinth: in *Lion Crushing a Serpent*,
 101, 102
Plympton, Nathaniel: 223
Podenas (Daumier): die-stamped
 numbers on, 53fig.
 founders' stamp in, 52fig.
 gelatin mold for, 31fig.
 wax cast of, 38fig.
Pointing: definition of, 49
Pointing machine: 48fig.
Points: 47, 48fig.
 on *Les Trois Grâces*, 135fig.
Poirrot (founder): 183
Polishing: 43. *See also* Finishing

Portraiture: 58, 59
 Carpeaux and, 109
Potter, Edward Clark (sculptor): 220
Powers, Hiram (sculptor): 222
Powers, Preston: 222
Pradier (sculptor): 7
Praticiens (professional marble carvers):
 112, 113, 122, 127, 149
Préault (sculptor): 5
Press-molding: 35
Priest of Lupercalia (Houdon): 58
Prince Imperial (Carpeaux): 3, 6,
 15 (n11), 110
Prodigal Son, The (Rodin): 145
Pulitzer, Joseph: 145
"Punching": 43fig.
Puritan (Saint-Gaudens): 181, 184
Python Killing a Gnu (Barye): 77,
 84fig., 93

Q

Quatre parties du monde (Carpeaux):
 for *Fontaine de l'observatoire*, 111
Quesnel (founder): 13
Quinn, Edmond T. (monument
 maker): 219

R

Rabache, Anne: 57
Radiography: 54
Ranvier (founder): 11
Reducing: definition of, 47
Reductions: 8, 10, 12
 mechanical, 102–104
Relief: lost-wax cast, 39fig.
 sand-cast bronze, 39fig.
Representation: problem of, 125
Reproduction: 26 (n83)
 by pointing method, 49
 rights to, 9, 10, 23 (n65), 24 (n69),
 27 (n93)
Rheims, Maurice: xi
Rice, Reuben N.: 221, 229
Richardson, Anne: 219
Richardson, Henry Hobson: 201
Richman, Michael: xiv
 on French, 219–257
Rights: artist's, 10–11, 27 (n93)
Rimmer, William (sculptor): 219
River Gods (Barye): 78
Rodin, Auguste: xiii, 109, 145–151

counterfeits of work of, 173 (n14)
 education of, 145
 estate of, 7, 111
 larger sculptures of, 59
 modeling technique of, 147
 portrait of, 144fig.
 posthumous exploitation of, 11
 reproduction techniques of, 67, 146.
 See also specific works.
Rodin Museum: 170. *See also* Musée
 Rodin
Rogers, Jacob (Saint-Gaudens): 183
Roman Bronze Works (founders): 222,
 223, 243, 246
Rosebery, Lord: 192
Ross, M. C.: 79
Rothenstein, William: 150, 170
Rousseau, Jean Jacques (Houdon):
 portrait of, 60, 61
Roux, Antony: 150
Royal Academy of Painting: 57
Rude, François (sculptor): 5, 109, 110
Rudier, Alexis (founder): 147, 157, 160,
 165, 167
Rudier, Eugène (founder): 148
Rudier, François (founder): 148
Rudier, Georges (founder): 148, 160,
 167, 170
Rudier, Victor (founder): 148
Russo, Vicenzo (plaster caster): 221

S

Saint Bruno (Houdon): 58
St. Clotilde (Barye): 78, 88
Saint-Gaudens, Augusta (wife): 181,
 185–186, 209, 211
Saint-Gaudens, Augustus: xiii, 181–186
 education of, 181
 portrait of, 180fig.
Saint-Gaudens, Bernard (father): 181
Saint-Gaudens, Homer (nephew): 182,
 187, 193, 198, 201
Saint-Gaudens, Louis (brother): 181,
 182
Saint-Gaudens retrospective exhibition:
 220
St. Giles Memorial (Saint-Gaudens):
 182, 192–195
Saint John the Baptist (Houdon): 58
 Rodin's, 148, 151
Sand-cast bronze: 52fig.
Sand-casting: 12, 35
 flow system for, 41

in Rodin's studio, 147
Sanders, Patricia: xiii
 on Rodin, 145–179
Sand mold: 32fig., 33
 for *Lion Crushing a Serpent*, 99
Sauvage (founder): 8
Scale: 49
Schnetz, Jean-Victor: 114
Schoelcher, Victor: 89
Scientific analysis: 54
Sculptors: 4–7
 dynasties of, 57
 industrial production of, 21 (n49)
 and manufacturers, 21 (n49)
 market for, 7
 portrait, 227
 rights of, 9–10. *See also* Artists
Sculpture: bronze, 7, 69, 77
 miniature, 78
 nineteenth-century, vii
 portrait, 57
 rights of reproduction of, 16 (n15),
 19 (n34)
 signatures on, 16 (n17). *See also*
 Serial sculpture
Seated Emerson (French: 46fig., 50fig.
 See also Emerson
Seated Lion (Barye): 79
Serial form: 3
Serial sculpture: 1, 4–7
 as art form, 13
 art history and, 12
 demand for, 2–3
 legal aspects of, 9
 market for, 7–12
 popular, 20 (n139)
 subjects of, 25–26 (n81)
Shaw, George Bernard: 145, 146
Shaw Memorial (Saint-Gaudens): 181,
 182
Sherman (Saint-Gaudens): 181, 183
Shrinkage: of casting materials, 73
Signatures: 3–4
 Carpeaux's, 140
 as foil to counterfeit, 16 (n17)
 Houdon's, 59
 incised, 50fig.
 in lost-wax bronze cast, 50fig.
 in marble, 53fig.
 mold-impressed, 50fig.
 on plaster cast, 51fig.
 in terra cotta, 50fig.
Signing: methods of, 49
Simart, M. (founder): 4, 5, 16–17 (n18)
Simpson, Kate: 170

"Skeleton of a Lioness" (Barye): 92fig.
Slip-casting: 35
Slodtz, Michel-Ange (sculptor): 57
Slodtz, Rene-Michel. *See* Slodtz,
 Michel-Ange
Slush casting: 35
Smith, H. G.: 225
"Snake's Head" (Barye): 92fig.
Société de Crédit Mutuel des Ouvriers
 du Bronze: 9
Siot-Decauville (founder): 183
Solutions: patinating, 45
Soulant (founder): 183
Soumy, Joseph (engraver): 109
Specialists: technical, 29
Sprue: 40fig.
Stag Attacked by a Lynx (Barye): 36fig.
Stamp: Carpeaux's, 111fig., 113, 123,
 124fig., 130fig., 132, 133, 136fig.
 founders', 52fig.
 Saint-Gaudens', 184
 in terra cotta, 50fig.
Standing Lincoln (Saint-Gaudens): 182,
 186
Statuettes: vogue for, 5
Stevenson, Robert Louis (Saint-
 Gaudens): xiii, 154, 182, 183,
 187–200
 in bronze, 188fig., 189, 190fig., 191fig.,
 192fig., 193fig., 194fig., 195fig.,
 196fig., 197fig., 198fig., 199fig., 200fig.
 casting of, 184
 copyrights for, 185
 Edinburgh reduction, 186, 199fig.
 electrotype of, 46fig.
 gilded copper electrotype of, 200fig.
 inset in, 51fig.
 in plaster, 190, 192fig., 197fig., 198fig.
 sale of, 186
Stevenson Memorial (Saint-Gaudens):
 196fig., 197fig.
Stirbey, Prince: 110
Stone: finishing of, 43
 markings in, 49
 patinating of, 45–47
Strength (Barye): 88
Supply: for serial sculpture, 2–3
Support elements: clay, 35
 internal, 34fig.
Surface: treatment of, 45
Surmoulages: 2, 54, 87
 counterfeit, 14–15 (n7)
 definition of, 53
Susse (founder): 7, 8, 11, 17 (n23)
Suzon (Rodin): 148, 150

T

Tate Gallery: 170
Technical analysis: 49–54
Technology: of 1830s, 8
Terra cotta: casting with, 35
 chasing of, 42
 marking in, 49
 patinating of, 45
Thiébaut (founder): 6, 8
Thiébaut Brothers (founders): 148, 183
Thiébaut foundry: 147
Thinker, The (Rodin): 145, 147, 167
Thorwaldsen (sculptor): 4
Three Cavorting Putti (Barye): 81
Tiffany (dealers): 186
Tiger Attacking a Peacock (Barye):
 51fig., 84fig., 85, 86fig., 87, 88
Tiger Devouring a Gavial Crocodile
 (Barye): 77, 79
Tiger Hunt (Barye): 85, 86fig.
Tiger Seizing a Pelican (Barye): 88
Tonetti, Mary Lawrence (sculptor): 181
Tools: enlarging instrument, 46fig.
 plaster-working, 28fig.
 sculpture-modeling, 28fig.
Tourville: 68
"Toying Lion" (Barye): 91, 93
"Tracing": 43fig.
Transfer: 48fig., 49
Transformations: technical, 1
Trask, Spencer Memorial (French): 219
Triumphant Youth (Rodin): 148, 149
Tuck, Amos (Saint-Gaudens): bust of,
 219
Turcan, Jean (marble carver): 149
Turgot, Anne-Robert-Jacques: 59, 60
Two Bears Wrestling (Barye): 87

U

Ugolin et ses enfants (Carpeaux): xii, 6,
 109, 114fig.
 in bronze, 116fig., 122fig., 123fig.,
 139, 140
 casting of, 112
 composition of, 115, 118
 drawings for, 111
 editions of, 119
 interpretations of, 114
 lost-wax bronze cast of, 115
 in marble, 119, 120fig.–121fig.
 modeling for, 111

in plaster, 41fig., 116fig., 117fig.,
122fig., 139
in plaster retouched with wax, 118fig.
reductions of, 123
reproduction of, 112
signature on, 51fig.
in terra cotta, 118fig., 119fig., 139,
140
unbaked clay cast of, 116, 117fig.
Ultraviolet light: 54
Ulysses S. Grant Equestrian (French):
219
Undercuts: 35
Uniqueness: 54
United States Coinage of 1907 (Saint-
Gaudens): design for, 181

V

Venting system: 40
Vestal (Houdon: 57)
Victory (Saint-Gaudens): 181, 186
Visat, Sébastien (Model): 139 (n33)

Visual analysis: 54
Voltaire: 60

W

Wagner, Anne Middleton: xiii
on Carpeaux, 109–143
Walking Lion (Barye): 78
Walking Man, The (Rodin): 148, 150
Walters, Henry: 248, 252
Walthausen, John H. A. (plaster
molder): 183, 209, 221
Ward, John Quincy Adams: 225
Warren, Edward Perry: 150, 170
Washington, George (Houdon): 60,
62, 65
Washington Inaugural Centennial
medal (Saint-Gaudens): design for,
185
Wasserman, Jeanne L.: xi–xiv
Waste molds: 31
Wax: 2
chasing of, 42

markings in, 49
Wax cast: 32fig. *See also* Lost-wax
casting
Wax gating: 40fig.
Weights: 54
Weinman, Adolph Alexander (monu-
ment maker): 219, 220
Welding: 43
White, Stanford: 201, 209
Whitney, Anne (sculptor): 227
Whittelsey, Fanny (Saint-Gaudens): 182
Williams, A., and Company: 223
Williams, John (founder): 183, 184, 222
Winters, Col. Jonathan: 66
Wunderlich (dealer): 185

Z

Zinc: as base metal: 21 (n46)
Zoological specimens: plaster casts of, 88
Zoppo, B. (founder): 222

Photographic Credits

Unless listed below, illustrations are from museum photographs or from photographs kindly furnished by the owners.

Michael A. Nedzweski, Fogg Art Museum: "Technical View" 2, 3, 4a, 4b, 5a, 5b, 6a, 6b, 7, 8, 12, 13a, 13b, 15, 16, 16a, 17, 17a, 18, 19a, 19b, 20, 21a, 22, 23, 26, 27, 29, 33, 34a, 35, 36, 37, 38, 39, 40, 41a, 41b, 42, 43, 44, 45, 47a, 47b, 48, 49; Houdon 6, 9, 10; Barye 4, 4a, 17, 17a, 25, 26, 26a, 28, 29; Carpeaux 5, 25, 28; Rodin 4, 7, 7a, 8, 9, 10, 13, 14, 19, 20, 27; Saint-Gaudens 2, 4, 6, 8, 8a, 10, 11, 19, 20, 21, 22, 23, 36, 37, 38, 40, 40a, 42, 42a, 43; French 4, 4a, 5, 5a, 6, 6a, 6b, 8, 8a, 11, 11a, 12, 13, 13a, 14, 14a, 15, 15a, 16, 16a, 19, 24, 24a, 25, 25a, 26, 26a, 30, 30a, 31, 31a.
Ernesto Regales, Museo Nacional de Bellas Artes: Rodin 22
Cecil W. Stoughton, National Park Service, United States Department of the Interior: Saint-Gaudens 33
Eric Sutherland, Walker Art Center: Carpeaux 5
A. J. Wyatt, Philadelphia Museum of Art: Barye 19

Armen Photographers, Newark, New Jersey: Barye 27
Glenn F. Benge, Rome, Italy: Barye 9a, 9b; Carpeaux 4a
Borel-Boissonnas, Geneva, Switzerland: Rodin 11
James Breese: Saint-Gaudens 1
Geoffrey Clements, Staten Island, New York: Saint-Gaudens 7
George M. Cushing, Boston, Massachusetts: Houdon 5, 11

Jacques de Caso, San Francisco, California: "Technical View" 9; Carpeaux 9, 13
François De Léppinay, Florence, Italy: Carpeaux 4
deWitt Clinton Ward (Peter Juley and Co., New York City): Saint-Gaudens 17, 31
Eeva-Inkin, New York, New York: Carpeaux 28
J. Evers, Angers, France: Houdon 12
Libby Joy, Washington, D.C.: Saint-Gaudens 5
O. E. Nelson, New York, New York: Carpeaux 24, 26, 27
Photographie Giraudon, Paris, France: Houdon 2; Barye 9
Photographie Hauchard, Valenciennes, France: Carpeaux 1
Michael Richman, Washington, D.C.: French 28
Schopplein Studios, San Francisco, California: Rodin 5
Tom Scott, Edinburgh, Scotland: Saint-Gaudens 18
H. Roger Viollet, Paris, France: Carpeaux 18

Courtesy of the Art Gallery of Ontario: "Technical View" 34b
Courtesy of Mme Annie Braunwald: Carpeaux 14, 29
Courtesy of Archives, New York Life Insurance Co.: Saint-Gaudens 32
Courtesy of The Saint-Gaudens Family Collection, Dartmouth College Library, Hanover, New Hampshire: Saint-Gaudens 14, 15, 34
Courtesy of Saint-Gaudens National Historic Site, Cornish, New Hampshire: Saint-Gaudens 29, 39, 39a
© by S.P.A.D.E.M., Paris, 1975: Rodin 3, 24

Designed and composed by
The Stinehour Press

Printed by
The Meriden Gravure Company